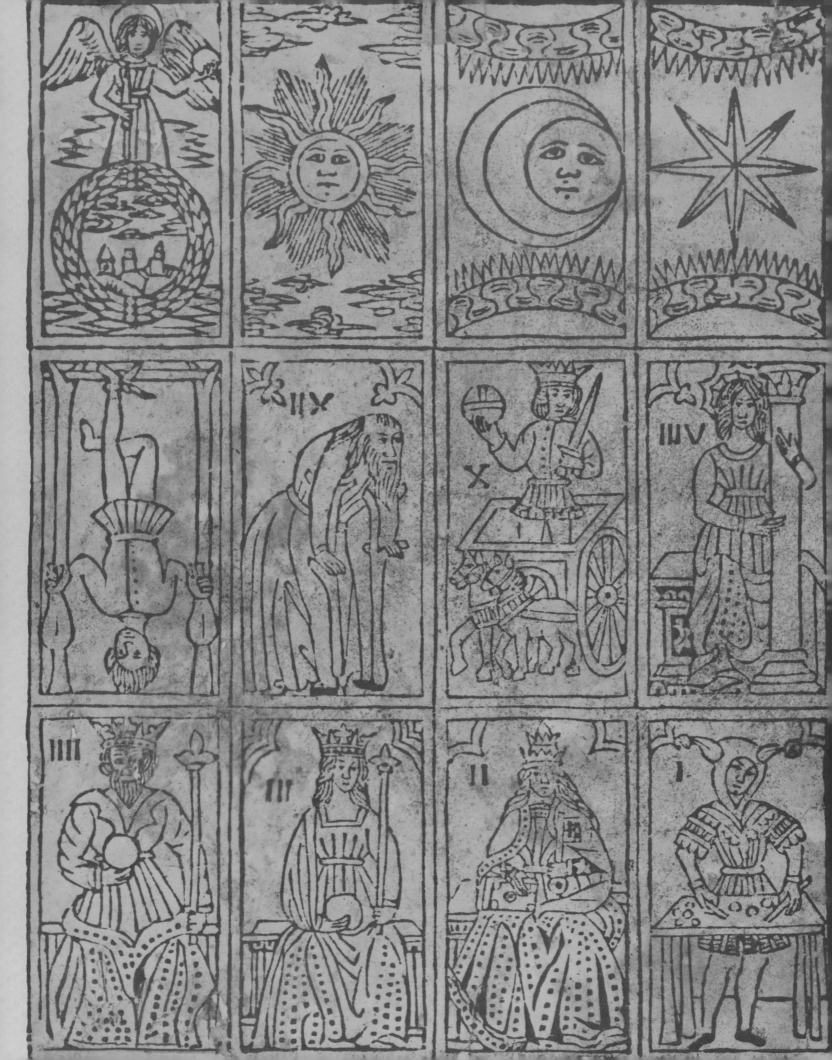

To Edith Goodkind Rosenwald

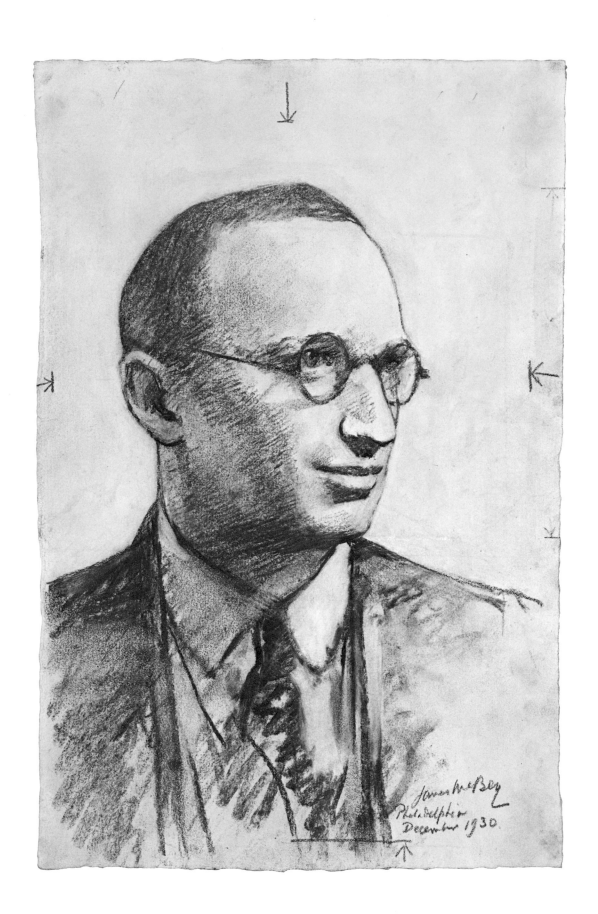

James McBey
Philadelphia
December 1930.

Lessing J. Rosenwald
Tribute to a Collector

Ruth E. Fine

National Gallery of Art, Washington

This catalogue was produced by the Editors Office, National Gallery of Art, Washington. Printed by the Meriden Gravure Company, Meriden, Connecticut. The type is Electra, set by Composition Systems Inc., Arlington, Virginia. The text paper is eighty-pound Mohawk Superfine; the cover, sixty-five-pound Strathmore double-thick.
Designed by Melanie B. Ness
Edited by Mei Su Teng

Published in conjunction with the exhibition *Lessing J. Rosenwald: Tribute to a Collector* held at the National Gallery of Art, 7 February-9 May 1982.

Cover: Karl Schmidt-Rottluff. *Yellow Iris*, c. 1935. Watercolor over pencil. B-12,499. Cat. no. 72, detail.
Endpapers: Anonymous Italian. *Playing Cards*, detail and ornaments. B-19,823.
Frontispiece: James McBey. Study for *Portrait of Lessing J. Rosenwald*, 1930. Charcoal. B-31,644.

All black and white illustrations in this catalogue were reproduced directly from the works of art with the exception of the following: catalogue numbers 3, 57c, 57d, 58 (full image), and 62; figures iv, xi, xvi, 16-18b, 31a, 32b, 59b, 62a, 62c, 71a, 73a, 73b, 74a, 93-95a, and 98-100a. Robert A. Grove took the color photographs. Joseph Marchetti took the photographs reproduced in figures xx-xxv and figure 1-4b.

Library of Congress Cataloging in Publication Data
Fine, Ruth, 1941-
Lessing J. Rosenwald: tribute to a collector.
Bibliography: p.
Includes index.
1. Prints—Exhibitions. 2. Drawing—Exhibitions. 3. Rosenwald, Lessing J. (Lessing Julius), 1891-1979—Art Collections—Exhibitions.
I. National Gallery of Art (U.S.) II. Title.
NE57.R64F5 760'074'0153 81-14133
ISBN 0-89468-004-8 AACR2

Contents

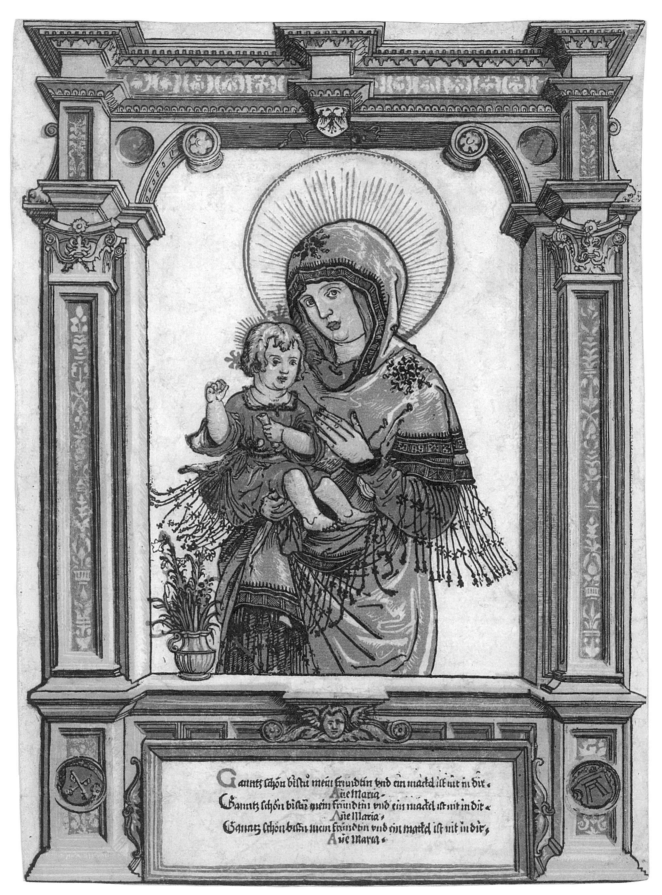

Albrecht Altdorfer. *The Beautiful Virgin of Regensburg.* Cat. no. 50. B-22,307.

Foreword

*T*he exhibition *Lessing J. Rosenwald: Tribute to a Collector* honors one of the Founding Benefactors of the National Gallery of Art and the Gallery's foremost donor of prints and drawings. The Rosenwald Collection, encompassing works of graphic art from medieval times to the present, is the finest of its kind ever to be formed in the United States by a single individual. Lessing Rosenwald's discrimination as a collector is acknowledged throughout the world, and his perceptiveness and generosity have placed the Graphic Arts Department at the National Gallery among the most respected in the country.

Anyone who visited Alverthorpe Gallery, where the collection was housed during the last forty years of Mr. Rosenwald's long and productive life, knows that his love of the prints and drawings he acquired was immediately apparent and contagious. Studying his collection with Mr. Rosenwald as one's guide was always a stimulating and informative experience, and the gracious hospitality of his extraordinary wife Edith immeasurably enhanced one's visits to their Jenkintown home and gallery.

We must remember, of course, that the collection of prints and drawings that Lessing Rosenwald presented to the National Gallery, and upon which this exhibition is based, is only one aspect of his monumental achievement in the field of graphic arts. Others include the extraordinary collection of rare books, approximately twenty-six hundred volumes, that he presented to the Library of Congress, as well as his remarkable reference library on the graphic arts, which was appropriately divided between the two institutions. In addition, during his lifetime he gave numerous works of graphic art to the Philadelphia Museum of Art and many other institutions throughout the country. These tangible memorials should also be appreciated in the context of his tireless efforts on behalf of education related to the graphic arts, including his foundation and lifelong support of the Print Council of America.

One of the most remarkably generous aspects of Lessing Rosenwald's gifts to the National Gallery was the unselfish enthusiasm with which he positively encouraged the Gallery and other donors to continue collecting and improving upon the work he had accomplished. His 1943 deed of gift specified that should the Gallery already own or subsequently acquire by gift or purchase a duplicate print of equal or superior quality to any in the Rosenwald Collection, it would be free to dispose of the Rosenwald impression and to use the proceeds for new acquisitions of graphic art. During Mr. Rosenwald's lifetime dozens of important works

were added to the collection in accordance with this mandate, and many subjects were "traded up" for impressions of finer quality that came onto the market.

Another aspect of Lessing Rosenwald's generosity was that he never intended his collection to dominate the collecting of graphic art at the National Gallery. He always expected and hoped that other donors would expand and strengthen the Gallery's collections, improving the holdings in areas he loved but also adding new areas of emphasis which had not happened to appeal to him personally. Thus, although the Rosenwald Collection has been handsomely complemented, deepened, and expanded over the years by numerous other gifts, its own extraordinary range and quality is clear from the fact that even today, almost forty years after the initial gift, it still comprises almost half of the Gallery's total holdings in the graphics field.

An exhibition by its very nature is a tribute of a defined and finite character. It is our hope, however, that a more far-reaching tribute to Lessing Rosenwald will be the continuing expansion of the Gallery's graphic arts collection toward the high goal of becoming a truly great national collection. This will be the finest possible celebration of Mr. Rosenwald's generosity and a fulfillment of his vision for the National Gallery of Art.

The exhibition and catalogue have been prepared by Ruth E. Fine, curator in the Gallery's Department of Graphic Arts who was curator of Alverthorpe Gallery from 1972 until the Rosenwald Collection was transferred to Washington in 1980, under the supervision of our curator of graphic arts, Andrew Robison. She was ably assisted by the many other members of the staff indicated in her acknowledgments. We are grateful to all of them for their efforts.

J. Carter Brown
Director

Acknowledgments

\mathcal{T} his exhibition and catalogue immediately follow the transfer of the Rosenwald Collection from Jenkintown, Pennsylvania, to Washington, D.C. The projects were in many ways integrated, and they were accomplished through the efforts of numerous individuals. The interest and assistance of Mrs. Lessing J. Rosenwald has continually been gratifying; she and other members of the Rosenwald family, particularly Julius Rosenwald II, Robert L. Rosenwald, and Isadore M. Scott, have graciously responded to my many requests. Elizabeth Mongan's years of work with the Rosenwald Collection provided the base of information from which this catalogue was written. Kathleen T. Hunt, Mrs. Carl A. Larson, Mrs. William A. Mackie, Anthony Rosati, and Starr Siegele— all on the staff at Alverthorpe Gallery when the collection was transferred—provided invaluable assistance. Mrs. C. F. Bauman, Lessing Rosenwald's secretary during the collection's foundation years, shared some of her recollections; and Whitfield J. Bell of the American Philosophical Society provided biographical information. Colleagues at a number of galleries, libraries, and museums have been repeatedly helpful: at Associated American Artists, Sylvan Cole, Jr.; at the Historical Society of Pennsylvania, Peter J. Parker; at the Library Company of Philadelphia, Edwin Wolf II; at the Library of Congress, Karen F. Beall, J. William Matheson, and Peter VanWingen; at the Philadelphia Museum of Art, Ellen Jacobowitz; at the Rosenbach Museum and Library, Suzanne Bolan and other members of the staff; at the Tate Gallery, Martin Butlin; and at the University of California, Riverside, Robert N. Essick. Lois Fern read the manuscript and made many helpful suggestions. I would also like to thank John Peckham and the Meriden Gravure Company, particularly Robert Hennessey, who is responsible for most of the black and white catalogue photography; and *The Washington Post* for reproduction permission.

My greatest appreciation, however, goes to the staff at the National Gallery who have been exceedingly responsive to the demands of the collection's transfer and then the exhibition and catalogue. The director, J. Carter Brown, and assistant director, Charles Parkhurst, have shown keen interest in this tribute to Lessing J. Rosenwald. I am also indebted to Andrew Robison, curator of the Department of Graphic Arts, and H. Diane Russell, the department's assistant head, for their vital support and many suggestions; indeed, the entire staff of the department has been of assistance in numerous ways. Outside the department, Mark A. Leithauser shared his expertise on questions of printmaking techniques, and Thomas F. J. McGill, Jr., made transla-

9

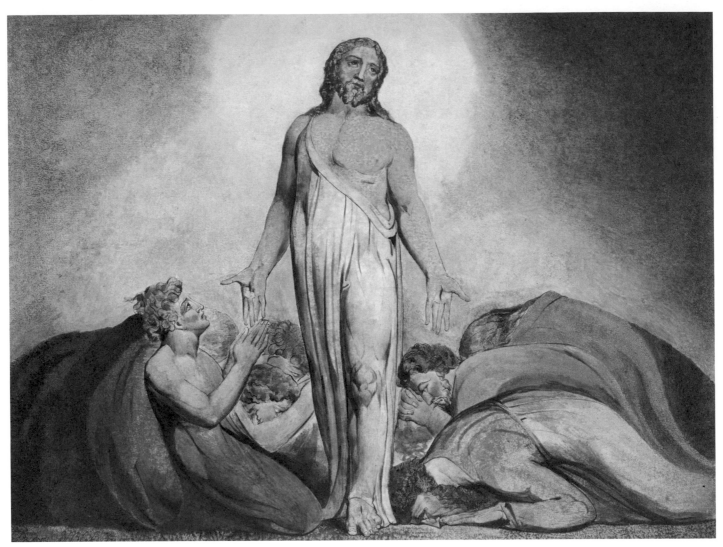

William Blake. *Christ Appearing to His Disciples after the Resurrection*. Cat. no. 16. B-11,060.

tions from Latin. In addition I would like to thank the directors and staffs of the following: the Administrator's Office; the Office of the Building Superintendent; the Conservation Laboratory; the Guard Office; the Library; the Photographic Laboratory; Photographic Services; the Registrar's Office, the office of the Secretary-General Counsel; and the Editors Office, particularly Mei Su Teng, whose skillful editing added clarity to the catalogue manuscript, and Melanie B. Ness, who provided the catalogue's elegant design. The Department of Installation and Design is responsible for the exhibition's handsome presentation. All of these colleagues have been helpful beyond the immediate demands of their positions and I am grateful for their collaboration.

R.E.F.

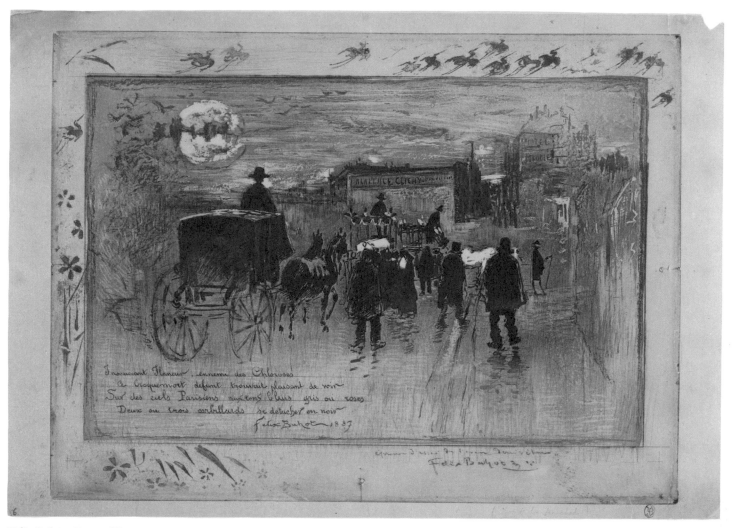

Félix Buhot. *Funeral Procession on Boulevard Clichy*. Cat. no. 31. B-3776.

A Note to the Reader

*I*n this catalogue, entries for works on exhibition are somewhat unusual in that the discussion of the works of art themselves is held to a minimum. These entries are meant to extend the introductory description of the Rosenwald Collection's formation and significance by discussing particular works within that context. Catalogue raisonné citations for the objects have been confined to one commonly used reference and National Gallery of Art scholarly publications when pertinent.

Measurements are given in centimeters followed by inches in parentheses. Height precedes width. Unless otherwise specified, measurements for drawings refer to sheet size; for lithographs, to the outermost points of the image; and for woodcuts, engravings, and other metal-plate media, to the block- or platemark (along the left and bottom edges).

Provenance references to Lugt (see bibliography) indicate that the collector's mark to which the Lugt number refers is found on the object. Other provenance information is based on a variety of sources—purchase records, publications, etc. Restrictions of time have prevented more exhaustive provenance research.

"B" numbers refer to National Gallery of Art (NGA) accession numbers.

Abbreviated reference citations are listed in full immediately following this note.

Uncommon technical terms and printmaking processes have been defined and described within the appropriate entries, but a basic knowledge on the part of the reader of printmaking processes and the terminology of print connoisseurship has been assumed. A few general references are listed, however, for those who require them.

KEY TO ABBREVIATED REFERENCE CITATIONS

Ackley, *Printmaking*	Clifford S. Ackley, *Printmaking in the Age of Rembrandt*, exh. cat. (Boston, 1980).
American Prints Today	*American Prints Today/1959*, exh. cat. (New York, 1959) and *American Prints Today/1962*, exh. cat. (New York, 1962).
Arms	(John Taylor Arms) Chronological list of the prints of John Taylor Arms, from the studio of John Taylor Arms. Greenfield Hill, Fairfield, Connecticut. Unpublished manuscript catalogue of the artist's published plates; citations taken from Karen F. Beall, *American Prints in the Library of Congress: A Catalog of the Collection* (Baltimore and London, 1970), 12-35.
Bartsch	Adam Bartsch, *Le Peintre-Graveur*, 21 vols. (Vienna, 1802-1821).
Baudicour	Prosper de Baudicour, *Le Peintre-Graveur Français continué, ou catalogue raisonné des estampes gravées par les peintres et les dessinateurs de l'école Français nés dans le XVIIIᵉ siècle . . .*, 2 vols. (Paris, 1859-1861).
Benesch	Otto Benesch, *The Drawings of Rembrandt*, 6 vols. (London, 1973; enlarged and edited by Eva Benesch from 1954-1957 ed.).
Bentley, *Blake Books*	G. E. Bentley, Jr., *Blake Books* (Oxford, 1977).
Bloch	Georges Bloch, *Pablo Picasso: Catalogue de l'oeuvre gravé et lithographié, 1904-1967* (Berne, 1968).
Bourcard/Goodfriend	Gustave Bourcard, *Félix Buhot: Catalog descriptif de son oeuvre gravé* with additions and revisions by James Goodfriend (New York, 1979; reprint of Bourcard, Paris, 1899).
Breeskin, *Paintings*	Adelyn Dohme Breeskin, *Mary Cassatt: A Catalogue Raisonné of the Oils, Pastels, Watercolors, and Drawings* (Washington, D.C., 1970).
Breeskin, *Prints*	Adelyn Dohme Breeskin, *Mary Cassatt: A Catalogue Raisonné of the Graphic Work* (Washington, D.C., 1979; second edition revised from Breeskin, 1948).
Butlin	Martin Butlin, *The Paintings and Drawings of William Blake*, 2 vols. (New Haven and London, 1981).
Carlson, D'Oench, Field, *Saint-Aubin*	Victor Carlson, Ellen D'Oench, and Richard S. Field, *Prints and Drawings by Gabriel de Saint-Aubin, 1724-1780*, exh. cat. (Middletown and Baltimore, 1975).
Comstock	Francis Adams Comstock, *A Gothic Vision: F. L. Griggs and His Work* (Boston and Oxford, 1966).
DeVesme	Alexandre DeVesme, *Le peintre-graveur italien* (Milan, 1906).
Dacier (1914)	Emile Dacier, *L'Oeuvre gravé de Gabriel de Saint-Aubin* (Paris, 1914).
Delteil	Loys Delteil, *Le Peintre-Graveur illustré*, 31 vols. (Paris, 1906-1926).

Dodgson	Campbell Dodgson, *Etchings and Dry Points by Muirhead Bone, 1898-1907* (London, 1909) with supplement "List of Dry-points and Etchings by Muirhead Bone," *The Print Collector's Quarterly* 9 (April, 1922): 190-200.
Dube	Annemarie and Wolf-Dieter Dube, *E. L. Kirchner: Das Graphische Werk*, 2 vols. (Munich, 1967).
Dutuit	Eugène Dutuit, *Manuel de L'Amateur d'Estampes*, 1, *Introduction générale, 2ème Partie, Nielles*, ed. Gustave Pawlowski (Paris, 1888).
Eisler	Colin Eisler, *The Master of the Unicorn: The Life and Work of Jean Duvet* (New York, 1979).
Essick, *Separate Plates*	Robert N. Essick, *A Catalogue of William Blake's Separate Plates* (forthcoming from Princeton University Press).
de la Faille	J.-B. de la Faille, *The Works of Vincent van Gogh: His Paintings and Drawings* (Amsterdam, 1970).
Field, *Johns*	Richard S. Field, *Jasper Johns: Prints, 1960-1970*, exh. cat. (Philadelphia, 1970).
Field, *Woodcuts*	Richard S. Field, *Fifteenth Century Woodcuts and Metalcuts from the National Gallery of Art, Washington, D.C.*, exh. cat. (Washington, D.C., 1965).
Fine Lehrer, Blake Checklist	Ruth Fine Lehrer, "A Checklist of Blake Material in the Lessing J. Rosenwald Collection, Alverthorpe Gallery," *Blake Newsletter* 35, 9 (Winter 1975-1976) and *Blake, An Illustrated Quarterly* 54, 14 (Fall 1980), 111.
Glassman and Symmes, *Cliché-verre*	Elizabeth Glassman and Marilyn F. Symmes, *Cliché-verre: Hand-Drawn, Light-Printed, A Survey of the Medium from 1839 to the Present*, exh. cat. (Detroit, 1980).
Guérin	Marcel Guérin, *Forain aquafortiste*, 2 vols. (Paris, 1912).
Guérin, *Gauguin*	Marcel Guérin, *L'oeuvre gravé de Gauguin*, 2 vols. (Paris, 1927).
Harrington	H. Nazeby Harrington, *The Engraved Work of Sir Francis Seymour Haden, P.R.E.* (Liverpool, 1910).
Harris	Tomás Harris, *Goya: Engravings and Lithographs*, 2 vols. (Oxford, 1964).
Haverkamp-Begemann	E. Haverkamp-Begemann, *Hercules Segers: The Complete Etchings* (Amsterdam and The Hague, 1973).
Hind	Arthur M. Hind, *Early Italian Engraving*, 7 vols. (London and Washington, 1938-1948).
Hollstein	F. W. H. Hollstein, *Dutch and Flemish Etchings, Engravings, and Woodcuts, c.1450-1700* (Amsterdam, 1949-) or *German Engravings, Etchings, and Woodcuts, c.1400-1700* (Amsterdam, 1954-), depending on the nationality of the artist.
Janis	Eugenia Parry Janis. *Degas Monotypes*, exh. cat. (Cambridge, 1968).
Kennedy	Edward G. Kennedy, *The Etched Work of Whistler* (New York, 1910).
Keynes, *Separate Plates*	Geoffrey Keynes, *Engravings by William Blake: The Separate Plates, A Catalogue Raisonné* (Dublin, 1956).
Kist, *Daumier*	Jan Rie Kist, *Honoré Daumier, 1808-1879*, exh. cat. (Washington, D.C., 1979).
Klipstein	August Klipstein, *The Graphic Work of Käthe Kollwitz* (New York, 1955).

LCRC	*The Lessing J. Rosenwald Collection: A Catalog of the Gifts of Lessing J. Rosenwald to the Library of Congress, 1943 to 1975* (Washington, D.C., 1977).
Lebeer	Louis Lebeer, *Catalogue raisonné des estampes de Pierre Bruegel l'ancien* (Brussels, 1969).
Lehrs	Max Lehrs, *Geschichte und Kritischer Katalog des deutschen, niederländischen und französischen Kupferstichs im 15. Jahrhundert*, 9 vols. (Vienna, 1908-1934).
Levenson, Oberhuber, Sheehan, *Italian Engravings*	Jay A. Levenson, Konrad Oberhuber, and Jacquelyn L. Sheehan, *Early Italian Engravings from the National Gallery of Art*, exh. cat. (Washington, D.C., 1973).
Lieure	Jules Lieure, *Jacques Callot*, 8 vols. (New York, 1969; Collectors Editions reprint of Lieure, 1924-1927).
Lister	Raymond Lister, *Samuel Palmer and His Etchings* (London and New York, 1969).
Locher	J. L. Locher, ed., *De werelden van M. C. Escher* (Amsterdam, 1971).
Lugt and Lugt supp.	Frits Lugt, *Les marques de collections de dessins et d'estampes* (Amsterdam, 1921; supplement, The Hague, 1956).
Mongan, "Fornovo"	Elizabeth Mongan, "The Battle of Fornovo," *Prints*, ed. Carl Zigrosser (New York, Chicago, San Francisco, 1962), 253-268.
Parthey	Gustav Parthey, *Wenzel Hollar: Beschreibendes verzeichniss seiner Kupferstiche* (Berlin, 1953).
Paulson, *Hogarth*	Ronald Paulson, *Hogarth's Graphic Works*, 2 vols. (New Haven and London, 1965).
Petitjean & Wickert	Ch. Petitjean and Ch. Wickert, *Catalogue de l'oeuvre gravé de Robert Nanteuil*, 2 vols. (Paris, 1925).
Portalis and Béraldi	Le Baron Roger Portalis and Henri Béraldi, *Les graveurs du dix-huitième siècle*, 3 vols. (Paris, 1880).
Pully	Hans R. Hahnloser, intro., and Margrit Hahnloser-Ingold, cat., *Henri Matisse: Gravures et lithographies de 1900 à 1929*, exh. cat. (Pully, 1970).
Recollections	Lessing J. Rosenwald, *Recollections of a Collector* (Jenkintown, 1976; privately printed in an edition of 250 copies).
Rinder	Frank Rinder, *D. Y. Cameron: An Illustrated Catalogue of His Etchings and Dry-Points, 1887-1932* (Glasgow, 1932).
Robert-Dumesnil	A.-P.-F. Robert-Dumesnil, *Le Peintre-Graveur Français, ou Catalogue Raisonné des estampes gravées par les peintres et les dessinateurs de l'école française*, 11 vols. (Paris 1835-1871).
Robison, *Drawings*	Andrew Robison, *Master Drawings from the Collection of the National Gallery of Art and Promised Gifts*, exh. cat. (Washington, D.C., 1978).
Roger-Marx, *Vuillard*	Claude Roger-Marx, *L'oeuvre gravé de Vuillard* (Monte Carlo, 1948).
Roger-Marx, *Bonnard*	Claude Roger-Marx, *Bonnard lithographie* (Monte Carlo, 1952).
Rosenwald, "Niello Prints"	Lessing J. Rosenwald, "Niello Prints," in Jay A. Levenson, Konrad Oberhuber, and Jacquelyn L. Sheehan, *Early Italian Engravings from the National Gallery of Art*, exh. cat. (Washington, D.C., 1973), Appendix B, 528-531.
Russell, *Callot*	H. Diane Russell, *Jacques Callot: Prints and Related Drawings*, exh. cat. (Washington, D.C., 1975).

Russell, *Tiepolo*	H. Diane Russell, *Rare Etchings by Giovanni Battista and Giovanni Domenico Tiepolo*, exh. cat. (Washington, D.C., 1972).
Schiefler	Gustav Schiefler, *Emil Nolde · Das Graphische Werk*, 2 vols. (Cologne, 1966-1967).
Schreiber	Wilhelm Schreiber, *Handbuch der Holz- und Metallschnitte des XV. Jahrhunderts*, 8 vols. (Leipzig, 1926-1930).
Schwarz	Karl Schwarz, *Augustin Hirschvogel: Ein deutscher Meister der Renaissance*, 2 vols. (New York, 1978; Collectors Editions reprint of Schwarz, 1917).
Shestack, *Engravings*	Alan Shestack, *Fifteenth Century Engravings of Northern Europe from the National Gallery of Art, Washington, D.C.*, exh. cat. (Washington, D.C., 1967).
Singer	Hans W. Singer, *Jakob Christoffel Le Blon* (Vienna, 1901).
Talbot, *Dürer*	Charles W. Talbot, ed., *Dürer in America: His Graphic Work*, exh. cat. (Washington, D.C., 1971).
Vikan, *Miniatures*	Gary Vikan, ed., *Medieval and Renaissance Miniatures from the National Gallery of Art*, exh. cat. (Washington, D.C., 1975).
Way (1905)	Thomas Way, *Mr. Whistler's Lithographs* (London, 1905; second edition).
Winzinger	Franz Winzinger, *Albrecht Altdorfer: Zeichnungen* (Munich, 1952).
Wright	Harold J. L. Wright," Catalogue of the Etchings of G. L. Brockhurst, A.R.A., R.E.," *The Print Collector's Quarterly* 22 (January 1935): 63-77.
Wuerth	Louis A. Wuerth, *Catalogue of the Etchings of Joseph Pennell* (Boston, 1928).
Wuerth, *Lithographs*	Louis A. Wuerth, *Catalogue of the Lithographs of Joseph Pennell* (Boston, 1931).

GENERAL REFERENCES:

Fritz Eichenberg, *The Art of the Print: Masterpieces, History, Techniques* (New York, 1976).

Arthur M. Hind, *A History of Engraving and Etching: From the 15th Century to the Year 1914* (Boston and New York, 1923 [3rd edition]; reprint, New York, 1963).

Arthur M. Hind, *An Introduction to a History of Woodcut, with a Detailed Survey of Work Done in the Fifteenth Century*, 2 vols. (Boston and New York, 1935; reprint, New York, 1963).

William M. Ivins, Jr., *How Prints Look* (New York, 1943; second edition, Boston, 1960).

William M. Ivins, Jr., *Prints and Visual Communication* (Cambridge, 1953; reprint, Cambridge, 1968).

A. Hyatt Mayor, *Prints and People: A Social History of Printed Pictures* (New York, 1971).

Donald Saff and Deli Sacilotto, *Printmaking: History and Process* (New York, 1978).

Lessing Julius Rosenwald
A Profile 1891-1979

Lessing Julius Rosenwald, eldest of five children of Julius and Augusta (Nusbaum) Rosenwald, was born on 10 February 1891. After attending Cornell University (1909-1911), he began working in the family business, Sears, Roebuck and Co. His father had purchased an interest in the new company in 1895 and had been instrumental in its rapid expansion into one of the country's foremost mail-order businesses by the turn of the century. Lessing started out in the stockroom, and over the next several years he learned company policy at all levels. In 1920 he was assigned to establish a Philadelphia branch of the firm; the choice of a site in the northeast section of the city amid the corn fields was a fortunate one, for this was the direction in which Philadelphia grew during the following decades. Rosenwald remained in Philadelphia for the rest of his life. In 1932 he succeeded his father as chairman of the board of Sears, a position he held until his retirement in 1939.

In 1913, Lessing Rosenwald married Edith Goodkind. In the preface to his *Recollections of a Collector* (privately published in an edition of 250 copies in 1976), he wrote, "By far the most important person in my life is my Edith whatever I may have accomplished is due to her strong impetus, her understanding, and loving guidance." The couple's union of almost sixty-seven years produced five children—two sons and three daughters—nineteen grandchildren, and twenty-one great-grandchildren. Over the years the Rosenwalds gave the largest portion of Alverthorpe, their estate, to Abington Township, for a community park—tennis courts, playing fields, picnic areas, a boating pond, trails, and so forth. On special occasions the Rosenwalds' gifts to each other were additions to the Alverthorpe Park facility. On one of her birthdays, for example, the collector's gift to his wife was a bicycle path for the park. The residence and adjacent gallery now house an active art center and music school.

Rosenwald played an important role in the activities of Philadelphia. Among the arts institutions in which he took the most avid interest were the Philadelphia Museum of Art, the Philadelphia Orchestra Association, and the Print Club; he served on the boards of directors of all three and also on various committees. He was also the first chairman of the board of trustees of the Philip H. and A.S.W. Rosenbach Foundation (recently renamed the Rosenbach Museum and Library), serving the institution for more than two decades. His dedication was not confined to the arts, however. Civic associations, hospitals, and educational institutions equally received his attention. Among them were the Abington Memorial Hospital and the Thomas Jefferson University and

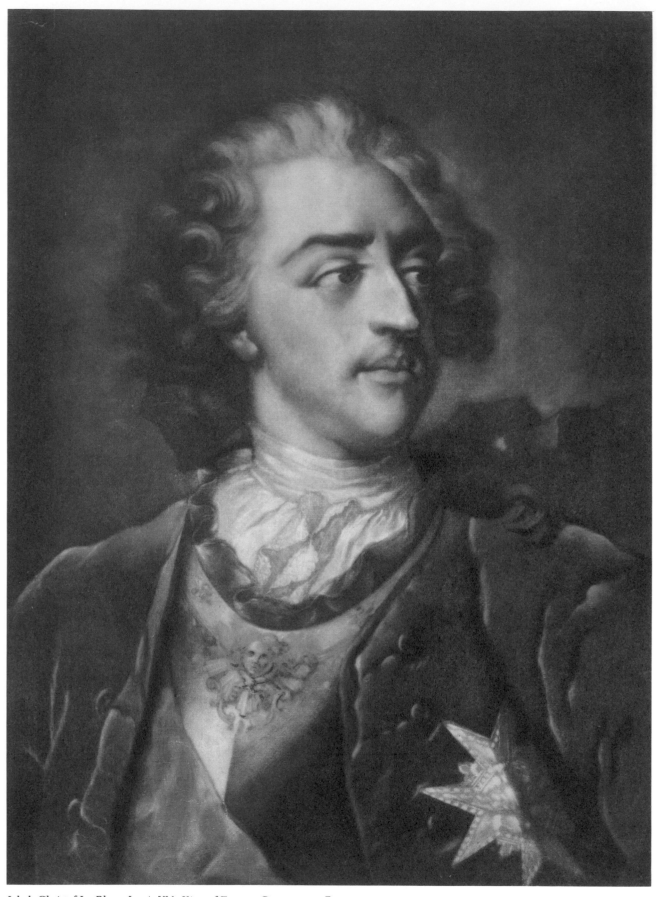

Jakob Christof Le Blon. *Louis XV, King of France*. Cat. no. 59. B-21,575.

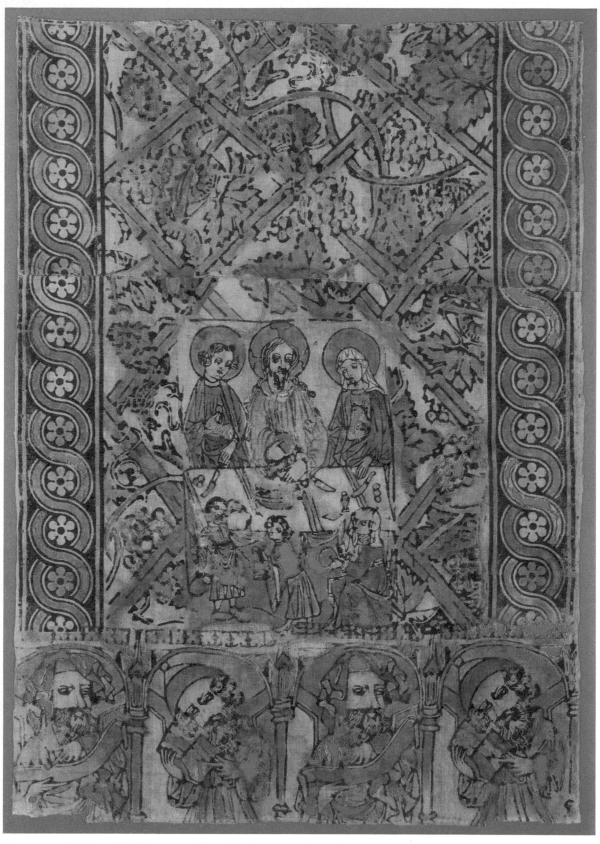

Anonymous Tirolian. *The Marriage at Cana* (?). Cat. no. 3. B-15,387.

Hospital—he served as a trustee at both—and the University of Pennsylvania, where he was president of the Friends of the University of Pennsylvania Libraries.

Rosenwald's wide scholarly interests and far-reaching social concerns were hardly limited to Philadelphia. Apart from the National Gallery of Art (which he served as a trustee) and the Library of Congress (which he served as an honorary consultant in rare books), others that benefited from his munificence were Amherst College's Folger Shakespeare Library, the Fogg Art Museum at Harvard University, the Institute for Advanced Study at Princeton (of which he was a trustee and president of the board), and the William Blake Trust in London. An associate trustee, he lent several of his illuminated books by Blake, thus facilitating the production of the Trianon Press facsimile editions of these unique volumes.

Rosenwald's name is most closely associated with the liberal arts, but his interest in the sciences was also keen, perhaps because of his youthful connection with the Museum of Science and Industry in Chicago, which was founded through his father's generosity. In the late 1940s, believing that the country needed a scientific journal, he played a major role in supporting today's *Scientific American*. Ten years later, long before there was a widespread awareness of dwindling energy reserves, he foresaw this country's need for alternative sources. When he was introduced to the potential of oil derived from shale as such an alternative resource, he became a strong supporter of the Oil Shale Corporation (now TOSCO) which has made great strides in investigating the oil shale potential. Rosenwald was also one of the founding directors of American Research and Development Corporation, thus supporting, among many research efforts, investigations in high voltage engineering, ultrasonics, and the desalinization of water by ionization. A member of the American Philosophical Society and an active contributor to its library committee, he was the first to suggest that the institution collect material on lasers and their application, a subject which fascinated him.

Rosenwald's philanthropies included the Community Chest of Philadelphia, of which he was a trustee, and, later, the United Fund. After his father's death in 1932 he was the director of the Julius Rosenwald Foundation, which was devoted to expanding educational opportunities for blacks (Julius Rosenwald did not believe in perpetual endowments, but rather that each generation should respond to its own needs; in accordance with his wishes the fund was exhausted within twenty-five years of his death). Lessing Rosenwald was also president of the Federation of Jewish Agencies of Greater Philadelphia as well as a member of its board of directors. Strongly opposed to Zionism, he was a founder and officer of the American Council for Judaism. A key figure in the passage of the Displaced Persons Act, Rosenwald assisted survivors of the Nazi concentration camps; beginning in the 1950s and until the time of his death, he was an avid supporter of the International Rescue Committee, an organization which continues to resettle refugees throughout the world.

Despite impaired vision in one eye, Rosenwald was a Seaman, Second Class, in the United States Navy during World War I, and

during the Second World War, he was a director of the Bureau of Industrial Conservation of the War Production Board. During the 1930s he was a member of the Philadelphia Labor Mediation Tribunal, and he later served on the board of appeals of the Selective Service System.

The awards and honorary degrees given to Rosenwald over the years were numerous. Among them were the Philadelphia Award in 1967 for "more than 40 years of dedicated service to the arts." That same year he received the Donald F. Hyde Award from Princeton University "in recognition of his distinction in book collecting and service to the community of scholars." He was a Knight First Class of the Royal Order of Vasa in Sweden, and posthumously, he was made an officer of the Order of the Crown of Belgium.

Rosenwald was a great chess enthusiast. He loved to play the game, and his library on the subject was a substantial one. He also acquired a number of historically important and beautiful chess sets and made frequent contributions to international competitions.

Lessing Rosenwald's life was one of many dimensions. More often than not his splendid generosity was quietly and privately offered. His most public aspect was his great collection of graphic art—prints and drawings and rare books. Often asked to speak about the collection and his collecting philosophy, Rosenwald always made it clear that he believed collecting was a serious business not to be confused with indiscriminate acquiring. He believed, moreover, that a collector must educate himself about his interest although he made a point of distinguishing himself—an amateur—from the graphic arts professionals whom he greatly admired. When he gave talks at Alverthorpe, where he was surrounded by the collection, he selected his favorite objects and discussed them as fully as he was able, offering information about subject, technique, quality, and so on. He also included information about the place of the particular piece within the total production of the artist (or printer) and discussed the artist's life and cultural milieu.

Especially important to Rosenwald in his life as a collector were the many friends that he made, and when he described his collecting experiences, he spoke as often of "collecting people" as he did of collecting prints and books. Those who had the good fortune to have been "collected" by this exceptional man are numbered in the tens of thousands. Many he did not know, but they knew him, most frequently because of his unprecedented generosity in sharing the collection of prints and drawings which is the subject of this catalogue.

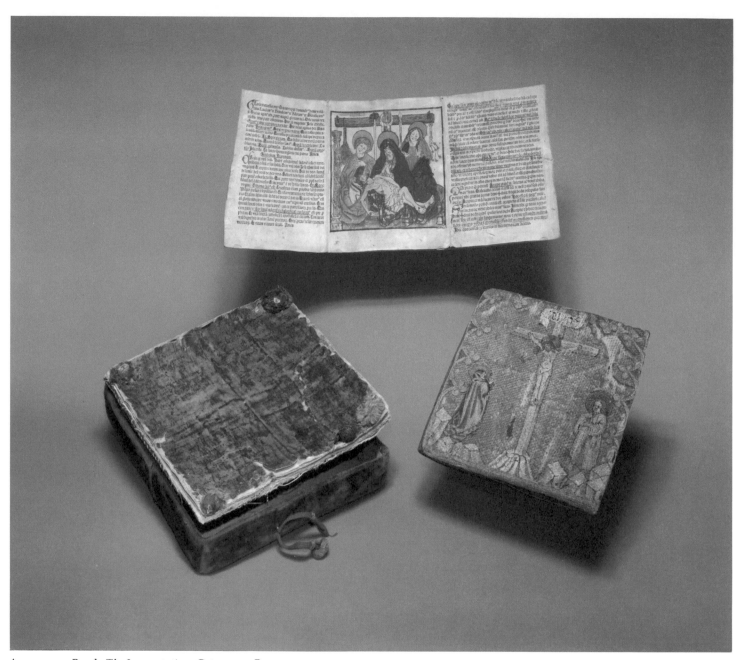

Anonymous Basel. *The Lamentation*. Cat. no. 4. B-22,141.

Introduction

\mathcal{B}etween 1925 or 1926, when he purchased his first etching, and 1979, when he died, Lessing J. Rosenwald acquired approximately twenty-two thousand old master and modern prints and drawings. Until 1939 when Rosenwald retired from his position as chairman of the board of Sears, Roebuck and Co., the collection was essentially a splendid and time-consuming avocation, but for most of the last forty years of his life, Rosenwald's prints and rare books became the focus of his attention. This attention had two equally important aspects: collecting and sharing. Each of these aspects had far-reaching reverberations for the collector himself, and also, in varying ways and to varying degrees, for artists and art historians and for a broad non-professional public interested in prints and drawings.

By presenting his extraordinary collection of prints and drawings to the National Gallery of Art, Rosenwald became the Gallery's foremost donor of graphic arts; he also gave an exceptional collection of illustrated books to the Library of Congress and his place as a benefactor of that institution is one of equal importance. The exhibition documented by this catalogue, organized to honor Rosenwald's memory, has been drawn entirely from the National Gallery's Rosenwald Collection and will mention the Library's only in passing. Neither the exhibition nor the catalogue is meant to be comprehensive. The exhibition presents only one hundred prints, drawings, and bound volumes selected from all the items in the Rosenwald Collection at the Gallery, and no small number of objects can possibly offer anything but a glimpse into the riches that were assembled. This particular group was culled in an attempt not only to focus on the masterpieces in the collection but also to give a sense of the collection's full and varied flavor.

The core of the exhibition is organized to reflect Rosenwald's developing interests over the more than half a century during which he was collecting. It is divided into two parts: the foundation years (mid-1920s-1938) followed by the Alverthorpe years (1939-1979). This chronological core is flanked by an introductory section presenting works by a few of the collector's favorite artists and a closing section which highlights aspects of the art of the print that distinguish it from the other arts. The prints and drawings in this section, collected no doubt for aesthetic reasons, also ably serve an instructional function that was of great importance to the collector.

The catalogue, too, although attempting more fully to imply the collection's scope by reproducing double the number of objects actually shown in the exhibition, remains little more than an introduction to the

Rosenwald Collection. Also presented selectively, like the exhibition itself, will be the catalogue account of the collection's growth and the ways in which Rosenwald's generosity in sharing his treasures with as broad a public as possible enhanced appreciation of the graphic arts, particularly in the United States. The limitations of time and context have dictated that a cross-section of events, associations, and acquisitions be condensed to give an overview rather than an in-depth account. This introduction will be organized into four overlapping categories. The first part will attend to the development of the collection itself; the second will indicate some of the dealers with whom Rosenwald was closely associated and the curators who cared for the collection; the third will describe Alverthorpe Gallery in Jenkintown, Pennsylvania, a suburb of Philadelphia, where the collection was housed for forty years; and the fourth will touch upon the ways in which Rosenwald shared his collection with others, always believing in the ability of the printed image to communicate the essence of Western humanistic concerns.

The Composition of the Collection

Lessing Rosenwald's serious interest in prints apparently had been whetted by 1923, when he began to order important print reference books. Among the first of these were Arthur M. Hind's *History of Engraving and Etching*, two large-paper copies of *The Etchings of Sir Francis Seymour Haden, P.R.E.*, by Malcolm C. Salaman, and Campbell Dodgson's *Old French-Colour Prints*, this last, a genre which never particularly captured Rosenwald's fancy nor took a large place in his collection. All of these print reference books were ordered from The Rosenbach Company in downtown Philadelphia, owned by Philip H. and A.S.W. ("Doc") Rosenbach.

What sparked his curiosity at this particular time is uncertain, but we do know that Lessing's mother, Mrs. Julius Rosenwald, was a modest collector of prints, particularly of turn-of-the-century etchings, and as a young collector Lessing frequently credited his initial interest in prints to her. Parts of Mrs. Rosenwald's collection were donated anonymously by her family to institutions in New York and Chicago a few years after her death, while some of her prints had earlier found their way into Lessing's nascent collection. Among the prints of this latter group now in the National Gallery is *Cliffside* (fig. i) by Ernest David Roth (1879-1964), an American etcher quite popular with collectors in the early years of this century.

The precise date of Rosenwald's own first purchase, D. Y. Cameron's *Royal Scottish Academy* (cat. no. 23), remains a mystery. It appears certain, however, that he made his earliest print purchases from Charles Sessler, a center-city Philadelphia book and print dealer whose records list sales to Rosenwald beginning in the summer of 1926. Definitely documented to that year are purchases of prints by three artists: the English etcher Arthur Briscoe and two Americans, Edward Borein and Roth.

With these beginnings Rosenwald's purchases throughout the following year virtually entirely comprised works by artists who participated in the revival of etching in France, England, and the United States in the

Fig. i. Ernest David Roth. *Cliffside*, 1916. Etching. B-9860.

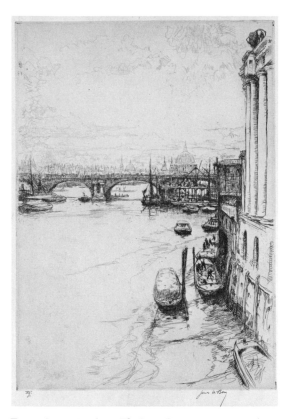

Fig. ii. James McBey. *The Lion Brewery*, 1914. Etching. B-8472.

late nineteenth and early twentieth centuries. They were works in keeping with his mother's taste as well as that of many print collecters of the period. Purchases included hundreds of prints, drawings, and watercolors by Charles Meryon, D. Y. Cameron, Muirhead Bone, Francis Seymour Haden, James Abbott McNeill Whistler, and Jean-Louis Forain. The influence of Whistler was paramount, and the subjects of the prints for the most part were landscape views and cityscapes. Typical of the sort of print that would have been popular is Roth's *Cliffside* or James McBey's *The Lion Brewery* (fig. ii), an etching that Rosenwald must particularly have liked. Along with Haden's *Breaking Up of the Agamemnon* (cat. no. 26), it hung in his Chicago office in the late 1920s and early 1930s, having been taken there several months after its purchase in January 1928. In its use of selectively drawn forms in a broadly defined open space as well as its quiet exploitation of the etching medium's propensity to allow for atmospheric effects, *The Lion Brewery* is strongly Whistlerian in conception.

With a solid base as a collector of modern prints established by the end of 1927, throughout the following year Rosenwald continued to buy works by the artists mentioned above as well as by many other etchers of the period. He formed substantial collections of prints (and often drawings as well) by Frederick Landseer Griggs, Alphonse Legros, Auguste Lepère, Gerald Leslie Brockhurst, and Joseph Pennell. The current popularity of these artists was documented in the annual editions of *Fine Prints of the Year*, compiled by Malcolm C. Salaman and published in England from 1923 to 1938. This publication was undoubtedly an influence on all collectors of modern prints, including Rosenwald. In fact one of his print storage boxes was labeled "Fine Prints of the Year," and in 1934 an exhibition of prints from his collection that had been selected over the years for these volumes was held at the Print Club in Philadelphia. Rosenwald continued to purchase modern prints throughout 1928, but the year became a pivotal one in the life of his collection because it was then that he began to purchase works by the old masters.

In January 1928, Rosenwald acquired from Sessler Albrecht Dürer's *Melancholia I* (see cat. no. 8) and Rembrandt van Rijn's *Self-Portrait at a Sill* (Hollstein 21) probably the first prints by these two giants in the history of the graphic arts to be purchased for the collection. A passion for old master prints took hold immediately. Over the next two years, Rosenwald's extensive purchases of prints and drawings from all periods established his collection as one of great historical significance.

These early years—1928, 1929, and 1930—were the three years in the entire period of the collection's formation and development in which the greatest number of prints was purchased. Indeed by October 1929, the size of the collection already was estimated at about forty-three hundred items (Rosenwald's first large gift to the National Gallery fourteen years later included approximately double that number of objects). Of particular importance during these formative years were the great auction sales taking place in Europe and dispersing some of the world's most important print collections. Rosenwald's agent at these sales was J. Leonard ("Dick") Sessler (see below), and his first buying trip on Rosenwald's behalf was to the sale of the collection of Friedrich

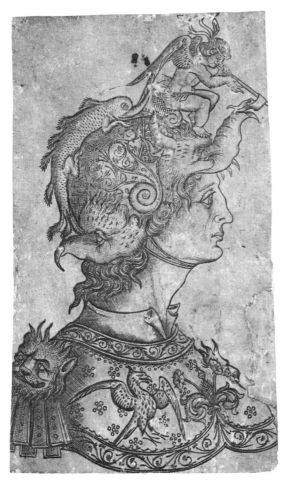

Fig. iii. Anonymous Florentine(?). *Man in a Fantastic Helmet*, c. 1470-1480. Engraving. B-11,136.

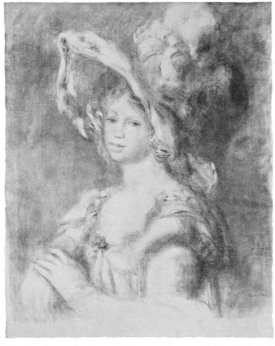

Fig. iv. Auguste Renoir. *Young Woman (Miss Diéterle)*, 1892. Lithograph. B-24,346.

August II, Duke of Saxony, which took place in Leipzig, Germany, 7-9 May 1928. Rosenwald purchased 136 lots (many with several prints per lot) from the material that Sessler brought back from the sale. Of the almost fifty artists whose work was acquired at this time, among the most important were the early Italian engravers, including Benedetto Montagna, Christofano Robetta, and Domenico Campagnola. Several subjects by masters of the Mantegna School, a group of nielli, and an impression, thought to be unique, of a *Man in a Fantastic Helmet* (fig. iii) by an anonymous fifteenth-century Italian artist were also part of the purchase.

In addition to early works from Italy, the Friedrich August sale brought into the collection prints by Martin Schongauer, Dürer, Rembrandt, and Israhel van Meckenem. Works by Canaletto and Giovanni Battista Tiepolo and engravings after paintings by Jean Baptiste Siméon Chardin and Benjamin West were included as well.

A month after the Friedrich August sale, from 13-15 June, the sale of the collection of Loys Delteil, an important cataloguer of French nineteenth-century prints, was held in Paris. Again Sessler made a number of purchases on Rosenwald's behalf, all by artists working in the nineteenth and twentieth centuries, mainly in France. The purchases included prints by Meryon, Whistler, and Legros, each already represented in the collection. The Delteil collection was the source for the first Auguste Renoir (1841-1919) Rosenwald purchased, a rare first state of the drypoint *On the Beach at Berneval* (Delteil 5). Thus the sale gave a start to another aspect of the collection. Rosenwald's holdings of prints by the French impressionists were not seriously developed until a decade later, beginning about 1940 and continuing through the 1950s and into the early 1960s. Among the additions at this time were a number of Renoir's softly modeled lithographs including *Young Woman (Miss Diéterle)* (fig. iv).

Some months after the Delteil sale, in November 1928, a second group of nineteenth- and twentieth-century prints was purchased in Frankfort, at auction from the sale of the collection of Dr. A. W. von Dietel. Among them was Francisco Goya's *Isabella of Bourbon* (Harris 8), after Velázquez, one of Rosenwald's first purchases by the artist.

May of 1929 brought the next several sales, first in Berlin with the Schloss "E" collection offered from 6-8 May, and then in Leipzig, with the von Passavant-Gontard sale from 10-12 May, immediately followed by the sale of the collection of Julius Model. Sessler's purchases at the Schloss "E" sale introduced prints by Jost Amman, Bartel Beham, and Jerome Hopfer (fig. v), among others, into the collection and added significantly to the holdings of other artists including Heinrich Aldegrever, Hans Sebald Beham, and Wenceslaus Hollar. The von Passavant-Gontard sale the following week was the source of the only prints by Adam Elsheimer and Giuseppi Scolari to enter the collection (one print each), and numerous works by Albrecht Altdorfer, Hans Baldung Grien, Jacques Callot, Lucas Cranach, and Rembrandt, among others, were purchased as well. In all, approximately 150 lots were acquired.

Among Rosenwald's continuing favorites from the von Passavant-

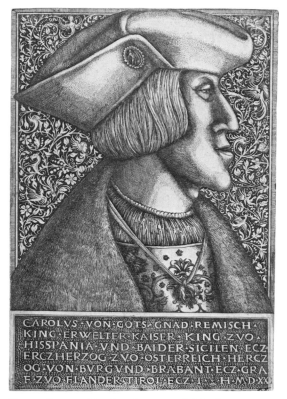

Fig. v. Jerome Hopfer. *Portrait of Charles V*, 1520. Etching. B-7577.

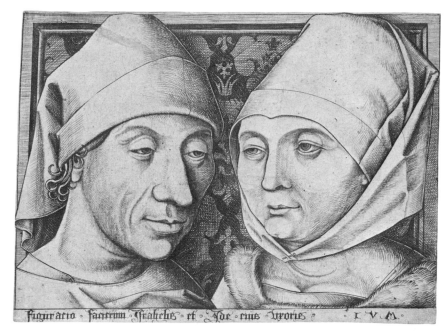

Fig. vi. Israhel van Meckenem. *Double Portrait of Israhel van Meckenem and His Wife Ida*, c. 1490(?). Engraving. B-2654.

Gontard sale was van Meckenem's *Double Portrait of Israhel van Meckenem and His Wife Ida* (fig. vi). The print is the first known engraved self-portrait as well as the first engraving that is indisputably a portrait of a known subject. Rosenwald enjoyed recounting how the great French collector Baron de Rothschild, upon learning that it was Rosenwald who had acquired the double portrait, immediately offered to purchase the print from him for considerably more than he had paid. Rosenwald steadfastly refused to part with his treasure (*Recollections*, 116). The double portrait is one of three engravings by van Meckenem acquired from the von Passavant-Gontard sale, and Rosenwald's collection of this artist's work eventually grew to be one of the great strengths of his holdings, including approximately one hundred of more than six hundred subjects.

The Julius Model sale a few days after the von Passavant-Gontard sale once again broke new ground for the collection with purchases of eighteenth-century French prints: Jean-Honoré Fragonard's series of four *Bacchanales* (Portalis & Béraldi 1), and prints by various artists after Sigmund Freudenberger and Augustin de Saint-Aubin. Prints by Honoré Daumier and Gavarni and an album of caricatures by Henri Monnier were acquired as well.

Later that year, forty-nine lots were acquired from the November sale at Hollstein and Puppel in Berlin; among them were eight drawings including Hans Baldung Grien's *Half Figure of an Old Woman with a Cap* (Robison, *Drawings*, 24) which became part of the collection of Mrs. Lessing J. Rosenwald and was presented to the National Gallery in 1978.

Two sales in 1930, one at Hollstein and Puppel in April (13 lots purchased), and the other at C. G. Boerner in Leipzig the following month (35 lots purchased) added significantly to the collection,

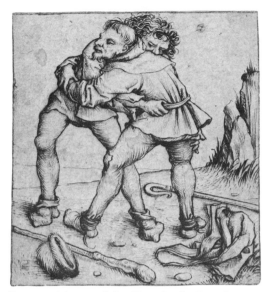

Fig. vii. Master of the Housebook. *Two Peasants Fighting*, c. 1475-1480. Drypoint. B-11,144.

although only one new name was among those whose work was acquired: Bartolomeo Coriolano (after Guido Reni).

These important European auctions were not the only occasions for purchases, of course, but they do provide a framework and important points of reference for the foundation of the collection. Frequently, however, large groups of prints were purchased in single non-auction-related sessions, mainly from Sessler and The Rosenbach Company (see below), but also from M. Knoedler and Company, Frederick Keppel and Co., and a few other dealers. For example, more than seventy-five prints ranging from Legros, Lepère, and Cameron back through Félix Buhot to Schongauer and Robetta were purchased one day in December 1928; a group of thirty-six Whistler and twenty-two Rembrandt prints was acquired in a single purchase in November 1929; and fifteen Daumier drawings, along with a number of other items, were purchased in June 1930. Many similar examples could be cited.

By 1929 the Rosenwald Collection included prints by approximately 250 artists, among them 45 by Aldegrever, 48 by Altdorfer, 118 by Hans Sebald Beham, 25 by Cranach, 200 by Daumier, 175 by Dürer, 63 by Lucas van Leyden, 7 by Mantegna or his school, 50 by van Meckenem, 10 nielli, and the Charles Petitjean Collection of more than 200 prints by Robert Nanteuil. Important single examples by artists whose work is quite rare were entering the collection as well, like the *Man in a Fantastic Helmet* mentioned above (fig. iii). Another such is the *Two Peasants Fighting* (fig. vii) by the Master of the Housebook (active c. 1465-1500) who is also known as the Master of the Amsterdam Cabinet because eighty-two of his ninety-one surviving engravings are to be found in the print room of the Rijksmuseum in Amsterdam. Most of the Master's prints are known in unique impressions only, and the *Two Peasants* drypoint is known only in one other impression in Amsterdam.

In some instances during these formative years Rosenwald purchased only one or two prints by an artist whose work was later to become more important to the collection. Mary Cassatt and Claude Lorrain (fig. viii) are two examples. In other instances, such as Coriolano, he purchased

Fig. viii. Claude Lorrain. *The Brigands*, 1633(?). Etching. B-14,963.

28

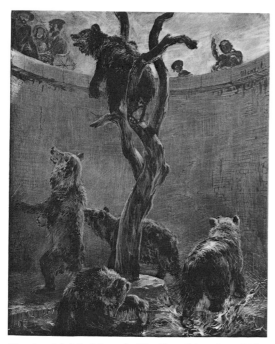

Fig. ix. Adolph Menzel. *The Bear Pit*, 1851. Lithograph. B-8643.

prints by an artist during this early period, never again to add to that aspect of the collection.

Frank Weitenkampf's 1926 publication *Famous Prints* apparently functioned for Rosenwald as a basic pattern book for a well-rounded collection. Among the earliest storage boxes for Rosenwald's prints some were labeled "Weitenkampf Prints," and the collector's own working copy of the book, now in the Library of Congress, is carefully annotated as to which items he had purchased, often with descriptions of state and Rosenwald's opinion about the quality of his particular sheets (see cat. no. 26). When Rosenwald's purchases were to be found in *Famous Prints*, the bills from Sessler were annotated with Weitenkampf numbers. In certain instances, the works included in *Famous Prints* are the only examples by an artist to enter the collection. A case in point is Adolph Menzel's (1815-1905) *The Bear Pit* (fig. ix). One would assume that Rosenwald was willing at the start to try to understand the nature of what was considered good through Weitenkampf's eyes, but eventually, as his own taste became more clearly established, he came to trust his critical powers, adding to his collection only in the directions important to him.

These directions, of course, were far reaching. By 1930, Sessler was discussing the collection with Rosenwald in terms of gaps which might be filled, and two years later, C. G. Boerner, writing to thank Sessler for sending a catalogue (probably *Prints from the Collection of Lessing J. Rosenwald, Philadelphia*, held at the Lakeside Press Galleries in Chicago, January-March 1932, see below), called the Rosenwald Collection "one of the greatest achievements of modern print collecting and a most important example of American culture."

After the extraordinary flurry of buying activity from 1928 to 1931, Rosenwald's purchasing came to a standstill in 1932. For the next few years he was engaged in settling his father's estate and in repaying debts contracted during the earlier period of heavy buying. By this time, however, his great generosity in lending his prints had been established (see below), and throughout the early 1930s the collection remained active and visible in circulating exhibitions.

Late in 1935, Rosenwald resumed adding to his print collection and his rare book collection; by 1936 purchases were once again steadily being made. The late 1930s also brought three closely linked changes of importance to the development of the Rosenwald Collection, and although they will be discussed at greater length below, it is important to note them in passing here. First, Rosenwald's plans to build a new family residence with sufficient and appropriate space for his print collection and library were undertaken, and in 1939, Alverthorpe Gallery, a wing of the Rosenwald residence was opened (the name of the property was specified by the deed to the land). Second, given the public attention that his collection was already receiving, Rosenwald no doubt recognized that in their new quarters, the prints and rare books would increasingly be in demand and demanding of attention. Thus, he sought a curator, and in the summer of 1937, Elizabeth Mongan came to Jenkintown as the first and ultimately the most important curator of the Rosenwald Collection. Third, with the completion of Alverthorpe Gallery and the move of the collection from his offices at the Sears

building, Rosenwald retired from business to devote himself more fully to philanthropic activities and to the collection itself.

Throughout the period during which much of Rosenwald's attention was focused on the physical requirements of his new gallery, a number of important purchases were made at auction, and several rather extraordinary transactions were conducted privately. In 1936, from the collection of Cortlandt F. Bishop, Sessler purchased for Rosenwald twenty-five items, among them five Nanteuils, three eighteenth-century British mezzotints, three McBeys, and ten Meryons. Also that year, the sale of the collection of Louis E. Stern yielded prints by Albert Besnard, Buhot, the Mexican artist José Clemente Orozco, Pennell, and Whistler, as well as several reference works.

The William Blake collection was particularly enriched in 1937 with the acquisition, through William H. Robinson, Ltd., of a number of items formerly in the collection of Blake's patron, the painter John Linnell. The following year the Rembrandt collection was enhanced by the addition of a number of pieces which had belonged to Fritz Lugt, whose splendid collection is now housed in the Institut Néerlandais in Paris. Also in 1938, when Paul J. Sachs, Rosenwald's childhood friend, then co-director of the Fogg Art Museum at Harvard, decided to part with prints in his personal collection in order to concentrate more fully on drawings, he offered them first to Rosenwald, writing that he "had rather have them in your hands than anywhere else, for I realize that they will have a good home and be appreciated fully as much by you as by me." The best known of Rosenwald's acquisitions from the Sachs collection is the heavily reworked impression of Antonio Pollaiuolo's *Battle of the Nudes* (see Evelyn Erlich and John H. Neff, *The Gott Impression of Pollaiuolo's Battle of The Nudes* [Washington, D.C.: National Gallery of Art, 1973]), but less sensational acquisitions included several important Italian engravings, two Hans Baldung Grien chiarosuro woodcuts, and the Burgkmair woodcut *Samson and Delilah* (fig. 49a).

The year 1939 not only marked the opening of Alverthorpe, but also brought one of Rosenwald's most significant purchases in his life as a collector: the Martin Aufhäuser Collection of more than three hundred fifteenth-century woodcuts, metal cuts, and paste prints.

The 1940s started well, with the 17-18 January sale of the collection of Clendenin J. Ryan, from which Rosenwald purchased three prints by Rembrandt (including an impression of *The Three Trees* [Hollstein 212]), four by Dürer, nine by Schongauer, two by van Dyck, five by Meryon, and three by Anders Zorn. The sale caused quite a stir in art circles; according to newspaper accounts, William Ivins of the Metropolitan Museum of Art stormed out of the auction room in a huff thinking his bids were being ignored (see cat. no. 48).

About 1940, the collection began to move in additional directions. Late nineteenth- and twentieth-century French prints, particularly those in color, and German twentieth-century prints began to enter the collection in significant numbers: works by Paul Gauguin, Pierre Bonnard, Edouard Vuillard, Camille Pissarro, Pablo Picasso, Paul Klee, Käthe Kollwitz, Ernst Ludwig Kirchner, Emil Nolde, Georges Braque, Odilon Redon, and Edvard Munch among others. The reasons for this

expansion of Rosenwald's buying patterns at this time no doubt were numerous and complex. For one thing, the new, modern home which he had built for his collection might itself have made demands on him to extend his more conservative tastes. Then, too, he might have become more confident in the recommendations of his young curator, Elizabeth Mongan. He indicated in his *Recollections* (37):

As anyone with reasonable intelligence would, I leaned very heavily on her judgment, discernment, and ability during the most active portion of my collecting career. If, as I hope, my collection is of fine quality, it is due in large measure to her advice for which I cannot thank her sufficiently.

In addition to Mongan's advice, Rosenwald was also able to call for the counsel of another print connoisseur, Carl Zigrosser. In 1941, Zigrosser became the first curator of prints at the Philadelphia Museum of Art. Formerly employed by the Weyhe Gallery in New York, Zigrosser was as interested in modern prints and drawings as he was in the work of the old masters. He and Rosenwald became close personal friends, consulting each other about various purchases as both of their collections were growing. Rosenwald's expanded taste undoubtedly can also be attributed to the fact that from the late 1930s, when he began to devote increasingly more time to his collection, he bought prints from a larger range of dealers (see below) and thereby was offered a much broader selection of works from which to make his acquisitions. All of these factors worked together, no doubt, to extend the breadth of Rosenwald's buying at this time.

Following the entry of the United States into World War II, throughout 1942, Rosenwald spent weekdays in Washington, working on the War Production Board, returning to Jenkintown only for weekends. Fewer than 100 prints were purchased during this period. Public and scholarly awareness of the collection steadily increased, however, and the way was thus prepared for the enthusiasm that greeted the announcement early in 1943 of Rosenwald's first great gift to the National Gallery.

Actually, Rosenwald's very first gift to the National Gallery was presented in 1941, the year the Gallery opened. It consisted of thirty prints (all duplicates of other prints in Rosenwald's collection), including works by Schongauer, Dürer, Mantegna and the Italian School, Nanteuil, Lepère, Buhot, and Burgkmair. Two years later, in January 1943, Rosenwald showed the first director of the National Gallery, David Finley, through Alverthorpe, and this personal introduction to the Rosenwald Collection was followed, in mid-February, by Finley's second visit, this time to discuss Rosenwald's plan for giving his prints and rare books to the people of the United States. Present at the meeting in addition to the collector and Finley was Archibald MacLeish, then Librarian of Congress. Both guests were extremely enthusiastic after their trips in notes to Mrs. Rosenwald thanking her for her hospitality. Finley wrote (19 February 1943) that their discussion would "influence the National Gallery for many years to come," and MacLeish reported (19 February 1943) that he "had a feeling as we sat and talked together that the wheels of history were turning and that we would all remember that evening." Indeed, the wheels of history were turning, and on 10 March 1943, Lessing Rosenwald, who spoke of himself as a temporary

caretaker of his collections, offered them to the National Gallery of Art and the Library of Congress for the American people. The country was in the throes of war, and when the gift was announced by the press on 18 March, it was hailed as an act of great patriotism. Letters of congratulation and commendation poured in from many parts of the world. Philip Hofer, the Boston collector who had anonymously donated a number of prints to the National Gallery when it opened in 1941, wrote on 19 March to Rosenwald, "At one stroke you have given them more than they could otherwise have obtained in a generation—if ever." Perhaps summarizing all of the letters was the one from "Doc" Rosenbach (18 March 1943): ". . . coming in on the train this morning I read of your gift to the nation of your magnificent collection. I would like you to know what a thrill it gave me. It will not come as a surprise though, to people who know you because it is so consistent with your always generous, wise, and patriotic performances."

To the Library of Congress Rosenwald presented his rare book collection and much related material. To the National Gallery of Art he presented the following: prints, paintings, sculpture, and photographic equipment; copper plates, woodblocks, etc.; drawings other than those included in the gift to the Library (the Library received drawings bound into books and those made specifically for book illustrations, particularly books in the Rosenwald Collection); letters, reference books, files, and photographs pertaining to the above. The prints and drawings numbered between six and seven thousand at the time; the few paintings were by Whistler (one has since been reattributed to Beatrix Whistler), Forain, and Blake; and the sculpture included a group of Daumier bronzes. Conditions of the gift provided that the collection remain at Alverthorpe until the donor's death, at which time the National Gallery and the Library of Congress were to decide whether to maintain the collections in Jenkintown or transfer them to Washington, the latter route being the one that eventually was taken. During the intervening years, parts of the collection were sent temporarily to Washington for research and/or exhibition (the first exhibition at the Gallery of material from the Rosenwald Collection to be held after the announcement of the gift was a William Blake exhibition which opened on 25 March 1943). Concurrent with the 1943 gift, Elizabeth Mongan was appointed Curator of Prints at the National Gallery of Art, and for the next twenty years she divided her time between Jenkintown and Washington.

Essentially, the framework of Rosenwald's old master holdings was established before the 1943 gift to the National Gallery, the exception being the important collection of manuscript illuminations that was formed beginning in the late 1940s. Stellar old master prints continued to be added, however, among them the traveling altarpiece (cat. no. 4), Altdorfer's color woodcut *The Beautiful Virgin of Regensburg* (cat. no. 50), and the anonymous *Battle of Fornovo* (cat. no. 55). The purchases at auction continued, although they were not as spectacular in scope as they had been during the formative years of the collection. Nevertheless, more than twenty prints, mainly by Gauguin, were purchased in the October 1943 Parke-Bernet sale of Frank Crowninshield's collection, and fifty prints, mainly by Whistler, came from the January 1949 sale of Harris Whittemore's etchings, also at Parke-Bernet. Even as late

as 1967, when Rosenwald had virtually pulled out of the old master print market, he acquired a few Rembrandts, including the counterproof of *The Goldweigher's Field* (fig. 12-15b), from the first part of the Parke-Bernet sale of the distinguished Rembrandt collection formed by Gordon W. Nowell-Usticke. Important old master works continued to be acquired privately, among them the group of drawings from the Liechtenstein Collection, the Danube School engravings from the Harrach Collection, and the Zeitlin Bruegel collection. Upgrading the collection, too, was important to Rosenwald, and during this later period, he frequently exchanged lesser impressions of particular subjects for finer ones that were brought to his attention.

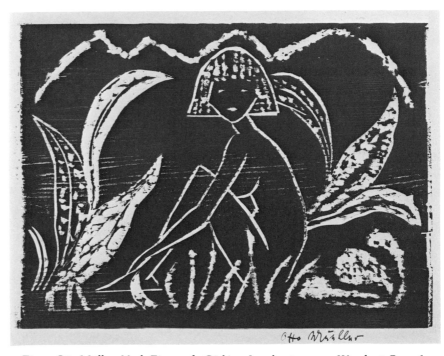

Fig. x. Otto Müller. *Nude Figure of a Girl in a Landscape*, 1912. Woodcut. B-19,645.

Great strides were also made with the modern collection during these later years. For example, in a single purchase in May 1950, Rosenwald acquired more than 300 prints and drawings from Henri Petiet including works by Raoul Dufy, Théodore Géricault, Paul Cézanne, Aristide Maillol, Carle Vernet, and Picasso. That same year brought the major acquisition of several hundred northern expressionist prints and drawings (see cat. no. 71), including Otto Müller's *Nude Figure of a Girl in Landscape* (fig. x). The following year, Kleinmann's prints by Henri de Toulouse-Lautrec were acquired (see cat. nos. 86-87). Less extensive purchases were more typical. For example in July of 1951, along with four of Redon's (1840-1916) lithographs, again from Petiet, Rosenwald also purchased a single drawing by the artist, *Head of a Veiled Woman* (fig. xi), and it remained the only one to enter the collection. At the same time he obtained etchings by Johann Barthold Jongkind, Jean-Baptiste-Camille Corot, Joseph Hecht, Eugène Isabey, Rodolphe Bresdin (1825-1885) and others for a total of nineteen items. Among the Bresdins were two impressions of the *Flemish Interior* demonstrating the artist's use of an etching (fig. xii) as a transfer image for a lithograph (fig.

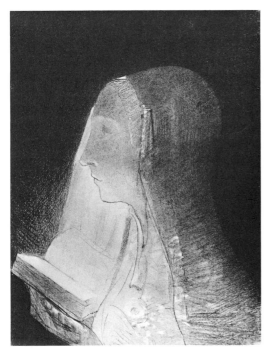

Fig. xi. Odilon Redon. *Head of a Veiled Woman*, c. 1892-1900. Charcoal. B-19,880.

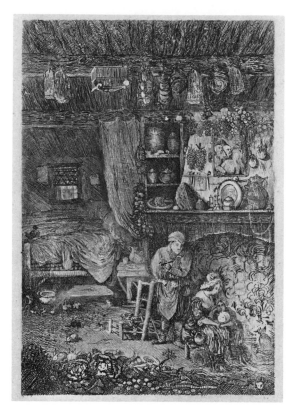

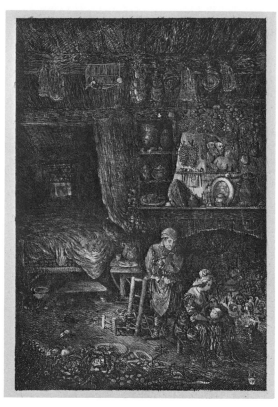

Fig. xii. Rodolphe Bresdin. *Flemish Interior*, c. 1876-1880. Etching. B-17,439.

Fig. xiii. Rodolphe Bresdin. *Flemish Interior*, 1873. Lithograph. B-17,438.

xiii). This would have been of great interest to Rosenwald, who always was intrigued by unusual printmaking techniques.

Beginning in the mid-1940s, Rosenwald increasingly purchased the work of young contemporary artists. Important in this regard, no doubt, was his contact with Stanley William Hayter, a champion of American printmaking who brought about a renaissance of interest in the art of the print and stimulated the growth of printmaking workshops, especially in academic institutions throughout the country. Also important would have been Rosenwald's own connections with the Print Club in Philadelphia, which was a hub of activity for generations of area artists. In addition to Hayter and Benton Spruance, among the artists whose prints Rosenwald acquired, particularly in the 1940s and 1950s, were Bernard Reder, Louis Schanker, and Imre Reiner. He took a great interest in the several new American print publishing ventures that began at the end of the fifties: all of the works in the collection from Universal Limited Art Editions, for example, date from its earlier years, and those from the Tamarind Lithography Workshop were produced during its first three years, 1960-1963. During the last decades of his life Rosenwald favored the young artists who visited Alverthorpe to study the treasures he had acquired and to show him their work; most of the prints he purchased during this period were from these visitors rather than from dealers or agents. He particularly enjoyed talking with printmakers about their work — the ideas behind their images and the processes they used.

34

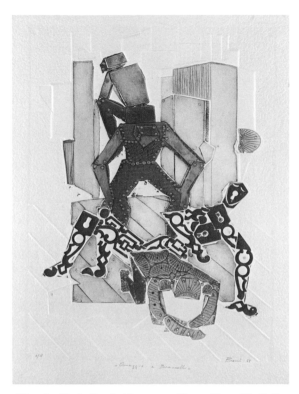

Fig. xiv. Paolo Boni. *Homage to Braccelli*, 1968. Collagraph. B-31,633.

Rosenwald was never affected by trends, however, and his respect for innovation was always tempered by an admiration for tradition.

As early as 1930 Rosenwald had commissioned both the McBey portrait of himself (frontispiece and fig. 23-25a) and the D. Y. Cameron Rosenwald bookplate (fig. 23-25c), and on a few occasions in later years he commissioned artists to produce editions especially for him. Among the most interesting is Paolo Boni's (born 1926) *Homage to Braccelli* commissioned in 1968 (fig. xiv). The print was produced in an edition of fourteen with twelve progressive proofs printed from a metal collage plate which is itself a multi-part relief sculpture. The image is based on a plate in *Bizzarie di varie figure di Giouanbatista Braccelli* ([Livorno], 1624). When Boni visited Alverthorpe in April 1968, Rosenwald gave him one of the 1963 Paris facsimiles of his copy of *Bizzarie* (the only complete copy known, now in the Library of Congress). The book delighted Boni so much that he decided to use it as the source for the print that Rosenwald commissioned from him.

In his 1943 deed of gift to the Gallery, Rosenwald generously reserved the right to make additions of a similar nature to the collection with the provisions of the 1943 gift to remain applicable to all of them. Such additions were presented over the years with large numbers of prints given to the Gallery in 1945 (approximately thirteen hundred items); 1946 (seven hundred items); 1949 (five hundred items); 1951 (fifteen hundred items); and 1964 (four thousand items). Smaller numbers of objects were presented in most of the intervening years and about one thousand works, including James Ensor's *Christ in Hell* (fig. xv), were bequeathed to the Gallery by the Rosenwald estate, thus bringing the total number of objects in the National Gallery of Art Rosenwald Collection to approximately twenty-two thousand.

Fig. xv. James Ensor. *Christ in Hell*, 1895. Etching. B-31,638.

Dealers and Curators

The printseller who played the largest role during the formative years of Rosenwald's print collection was J. Leonard ("Dick") Sessler, the son of Charles Sessler whose book shop and print gallery on Walnut Street was established in downtown Philadelphia in 1882. The young Sessler's full role in the foundation and direction of the Rosenwald Collection has never been clearly defined, however. Perhaps Sessler introduced Rosenwald to the range of possible roads open to a print collector as exemplified by Frank Weitenkampf's *Famous Prints*, mentioned above. If so, he may have effected Rosenwald's shift from being a collector of turn-of-the-century etchings to becoming a collector of such landmark prints in

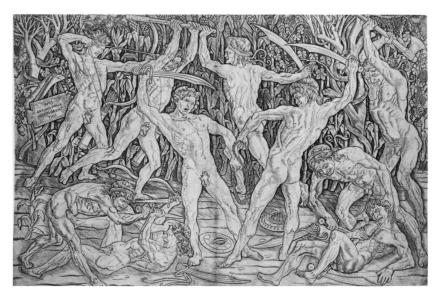

Fig. xvi. Antonio Pollaiuolo, *Battle of the Nudes*, c. 1470-1475. Engraving. B-9348.

the history of the graphic arts as Pollaiuolo's (1431/1432-1498) *Battle of the Nudes* (fig. xvi). At the start, as a champion of McBey, Cameron, Bone, Zorn (fig. xvii), and other early twentieth-century etchers, including the Philadelphian Salvatore Pinto (1905-1966) (fig. xviii), Sessler applauded each new print edition as it was issued by the artists in much the manner of today's dealers and publishers. He worked closely with Rosenwald and helped him form important collections of several contemporary printmakers popular at the time. Sessler also played a role in the formation of Rosenwald's old master collection by directing him to such lovely drawings as Hendrick Avercamp's *River Scene with a Tower to the Left* (fig. xix) and by acting as his purchasing agent at the sensational European print sales described earlier. In his *Recollections* (116), Rosenwald recounted the rather spontaneous way in which these vast purchases by Sessler were initiated, saying, "I am not sure that he knew much more about the prints than I did, but nevertheless he plunged."

The two men had made the agreement that Sessler would attend the sales, purchasing prints on his own account, but giving Rosenwald first refusal, at ten percent commission, after his return. If Rosenwald did not make adequate purchases to cover Sessler's expenses, Rosenwald

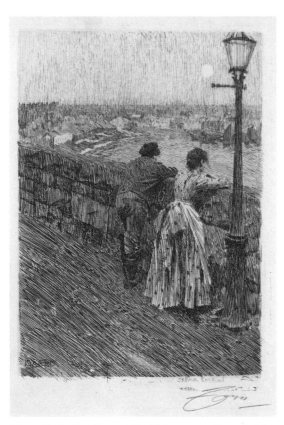

Fig. xvii. Anders Zorn. *The Fisherman*, 1891. Etching. B-10,908.

Fig. xviii. Salvatore Pinto. *The Repair Gang*, c. 1926. Etching. B-9114.

agreed to make up the difference in cash. As it turned out, Rosenwald's purchases, as described earlier, were so vast that this form of reimbursement was never necessary.

Until the two men had a falling out in the 1940s over a proposed purchase, Sessler continued to represent Rosenwald at auction and to bring prints he had otherwise obtained to the collector's attention. He also acted as a go-between for prints held by other dealers with whom Rosenwald had not established such a fruitful working relationship.

Beyond that, Sessler also functioned in many curatorial ways for Rosenwald during his early years as a collector. With the exception of prints and drawings which hung at the Rosenwald residence, until Alverthorpe Gallery was completed in 1939, the collection was main-

Fig. xix. Hendrick Avercamp. *River Scene with a Tower to the Left*, c. 1620. Watercolor. B-31,632.

tained in Rosenwald's office in the Sears, Roebuck and Co. building on Roosevelt Boulevard in the northeast section of Philadelphia. Housing such large numbers of prints had almost immediately become a problem, and by May 1928, Rosenwald had placed an order with Sessler for print storage portfolios, the labels for which surely indicate the collection's strengths at that time: Cameron, Dürer, Little Masters, McBey, Rembrandt, [Louis] Rosenberg, Whistler, and Fine Prints of the Year. In addition to arranging for these storage portfolios, throughout the 1920s and thirties, Sessler took care of the matting and framing of the Rosenwald prints, supplied "waxed paper" to protect them, handled conservation problems, and generally kept the collector informed of new print publications and essential reference books.

A. S. W. ("Doc") Rosenbach was the other dealer of importance during the formative years of the Rosenwald Collection. The Rosenbach Company, owned by the brothers Philip and Doc, was the source of Rosenwald's print reference book purchases as early as 1923. Rosenwald and Doc Rosenbach came to form a strong working relationship and warm personal friendship that lasted until Rosenbach's death in 1952. Over the years, Lessing and his wife Edith made numerous purchases of antique furniture and silver from The Rosenbach Com-

pany (this was the area of Philip's expertise), and although Doc Rosenbach is generally associated with the formation of the Rosenwald rare book collection and the acquisition of the Levis library (see below), the company, in fact, was also a source for many of the Rosenwald print acquisitions. From the late 1920s, prints by Whistler, Rembrandt, Blake, and other Rosenwald favorites were purchased in large numbers from Rosenbach; and well into the 1940s, the company acted as an agent for Rosenwald at sales of old master and contemporary prints as well as rare books. Rosenwald's admiration for Doc Rosenbach's knowledge and connoisseurship enabled the dealer to play a clear advisory role in the direction the rare book collection took and presumably, although to a lesser degree, the direction of the print collection as well.

Beginning about 1940, both Richard H. Zinser and William H. Schab made frequent visits to Jenkintown to show Rosenwald works that were "in their control" to borrow Zinser's oft-used phrase, and these two dealers became the most important sources for old master prints during the later years. For modern prints, and French prints in particular, Jean Goriany (who moved from New York to South America in the mid-1940s) and Henri Petiet of Paris, with whom Goriany was associated, were important throughout the forties and fifties. From the early 1950s, Gérald Cramer of Geneva introduced important modern works into the collection. As demonstrated by the various dealers listed under the provenance and otherwise mentioned in the entries for objects in the exhibition, Rosenwald eventually came to purchase prints from a circle of dealers too large to enumerate here. It is worth noting, however, that as the collector traveled throughout the world he made a point of visiting booksellers and print dealers who handled both old master and contemporary material, often making one-time purchases, and he acquired a number of prints from the various printmakers' societies, like The Woodcut Society, that grew up in this country in the mid-decades of the century.

While planning for Alverthorpe Gallery, Rosenwald realized his need for a curator to work with his rapidly growing collection. As early as 1934, Rosenwald's friend Paul Sachs had written to him recommending one of his former students in the Fogg's Museum Studies Program as a possible curator/cataloguer. Rosenwald was not interested at the time, but he contacted Sachs two years later, in 1936, and the Bostonian responded by suggesting that he consider Elizabeth Mongan, who, with a degree in art history from Bryn Mawr College, had taken a library studies course at Simmons College, and had also completed the Fogg's Museum Studies Program. At the time of Rosenwald's inquiry she was in Europe, but she returned home in September 1936 to talk with her prospective employer. Confirming her interest in the job, she went off to work with Sachs at the Fogg for a year in a program specially planned to sharpen her expertise in print history and connoisseurship. While studying in Cambridge, Mongan remained in close contact with Rosenwald, and she was consulted from the outset in his efforts as described to her (letter of 8 April 1937) "to have [his] library wing as fine, complete and convenient a place for housing [his] collection as [he could] possibly build."

In mid-1937, Elizabeth Mongan took up her appointment as curator

of the Rosenwald Collection, a position she retained until 1963. Until Mongan's arrival, no continuing professional care or scholarly attention had been directed toward the Rosenwald Collection, although Rosenwald himself, even given his hectic business schedule during these years, had studied his purchases fully, painstakingly comparing his impressions with catalogue descriptions and illustrations. Indeed, in 1929, he brought unrecorded states of D. Y. Cameron's *Upper Clyde Valley* (Rinder 31) and *Bothwell* (Rinder 34) in his own collection to the attention of Frank Rinder, the cataloguer of Cameron's prints (letter of 30 August 1929). Catalogue citations and other information about the objects, however, until Mongan's tenure essentially consisted of facts supplied by the dealers from whom works were purchased. During the early years when Rosenwald was on his frequent business trips, his secretary showed the collection to scholars who wrote ahead requesting permission to visit and also handled the arrangements for the ongoing loan exhibitions of Rosenwald Collection prints that began as early as 1929 (see below).

Needless to say, the job into which Mongan entered was a demanding one, with more than five thousand prints already in the collection waiting for attention. At the outset, however, much of her time was devoted to working with her employer, planning the use of the new Alverthorpe Gallery and determining the best materials for the storage and conservation of prints and books; after the collection was presented to the National Gallery, she divided her time between Jenkintown and Washington. For the next twenty years, she handled the curatorial tasks related to both the Rosenwald prints and those in the other National Gallery collections: mounting exhibitions, conducting research, answering public inquiries, keeping in touch with dealers and artists, and, as indicated earlier in the words of the collector himself, working closely with Rosenwald during the central years of his career as a collector.

Late in 1962 Richard S. Field arrived at Alverthorpe to assist Mongan with her ever-increasing obligations, and when she retired shortly thereafter, he assumed her curatorial responsibilities. In 1965 Field took a leave of absence to pursue his research abroad, and Alan Shestack replaced him in Jenkintown. The two men worked jointly with the collection for a brief period in 1967 after Field returned, but soon, both had moved on to other curatorial positions. The slot at Alverthorpe was then filled by J. Fred Cain, who had started there as Shestack's assistant in 1966. In 1972, this writer replaced Cain at the Rosenwald Collection, coordinating the activities of Alverthorpe first with Christopher White, curator of graphic arts at the National Gallery, and then later with Andrew Robison, who moved into that position in 1974. In 1979, upon Lessing Rosenwald's death, Alverthorpe Gallery was closed, and curatorial responsibilities in Jenkintown required the coordination of the transfer of the collection to Washington, a process that was completed by July 1980.

There is little evidence that any of the curators who followed Mongan played a substantive role in the composition of the Rosenwald Collection. They did, nevertheless, make some acquisitions suggestions, and they cared for the collection from the standpoints of conservation and

39

public service. Perhaps most important, however, particularly in the instances of Field and Shestack, were their contributions to the scholarship related to the collection.

Alverthorpe Gallery

In the late 1930s when the Alverthorpe Gallery facility was being planned, every detail was carefully considered. Like the rest of the residence, the gallery wing was designed by Ernest A. Grunsfeld (a Chicago architect and a cousin of Rosenwald) in association with Wallace E. Yerkes. Apart from the offices (fig. xx), the gallery consisted

Fig. xx. Alverthorpe Gallery: Lessing J. Rosenwald's office, 1979. Some of Rosenwald's Daumier bronzes can be seen flanking the fireplace and above the cabinets housing the collector's chess sets.

Fig. xxi. Alverthorpe Gallery: print storage bay.

Fig. xxii. Alverthorpe Gallery: exhibition aisle showing concealed cabinet for catalogue storage. Meryon's *The Apse of Notre-Dame, Paris*, fig. 19-22a, is seen at the far left.

of two long print exhibition aisles with five print storage bays equally spaced perpendicularly between them (fig. xxi). The outer walls of the exhibition aisles concealed storage cabinets which functioned to house auction and dealers' catalogues, and these cabinets were interspersed with window desks for the use of visiting scholars (fig. xxii). The inner walls of the aisles were designed to open out, thus closing off easy access to the storage bays but allowing a larger number of prints to be placed on exhibition. Above the print storage bays was a balcony library (fig. xxiii) and at the far end of the storage/exhibition/library space was a study room (fig. xxiv) with additional exhibition space (a maximum of fifty-eight objects could be hung at Alverthorpe at any one time). One wall of this room was lined with book cabinets, and a corner closet housed a sink at which visitors were asked to wash their hands before working with the collection. When the Rosenwalds moved from Alverthorpe Manor to a small residence on the same property in 1960, a sun porch behind the study room was converted to accommodate the expanding rare book library (fig. xxv).

Rosenwald's longstanding relationship with Paul Sachs and the Fogg, as well as Mongan's active affiliation with that institution, enabled them to consult the museum's staff for advice during Alverthorpe's planning stages. Sources of supplies, too, were found thanks to the Fogg, and the museum's laboratory staff was frequently consulted about conservation

Fig. xxiii. Alverthorpe Gallery: balcony library.

Fig. xxiv. Alverthorpe Gallery: the study room with a group of students enjoying Picasso's *Minotauromachy* (cat. no. 69). Carl Milles's *Head of Orpheus* hangs on the rear wall.

Fig. xxv. Alverthorpe Gallery: the sun porch as converted into a rare book study room.

issues. No doubt this close affiliation with a teaching museum influenced Rosenwald's early interest in a scientific approach to print scholarship (see below).

Alverthorpe's print storage boxes were especially designed by the S. K. Smith Company in Chicago. The initial order for 750 large boxes (to house 15 x 20 inch mats) and 200 small boxes (to house 8 x 11 inch mats) was placed in January 1939, and the company started shipping the boxes to Jenkintown in April. Drawers were especially designed in the storage units to house larger prints and drawings. Finally, after years of planning and preparation, in July 1939 the Rosenwald family and the Rosenwald Collection moved into Alverthorpe. When the gallery first opened it was praised by all who saw it, soon becoming a model for architects planning small libraries and print rooms. After his first visit, Paul Sachs wrote (letter of 13 February 1939) that he considered "the print room and

gallery the very best equipped that I have ever seen anywhere:—a worthy home for so great a collection." In fact, a few years later, during the most perilous period of World War II, officials of both Sachs's Fogg Art Museum and the Pierpont Morgan Library sent prints and drawings from their collections to Alverthorpe for safekeeping.

Although it never was able comfortably to house the giant prints of the 1970s (which were not to Rosenwald's taste anyway), for the most part the Alverthorpe facility readily accommodated the collection as it grew for forty years after the gallery was opened. For forty years, too, with Rosenwald as the most gracious host one might possibly desire, his gallery functioned as a center for the study and appreciation of the art of the print (and the art of the book), attracting scholars, printers, artists, and lay people from throughout the world.

The Uses of the Collection

In the late 1920s, when Lessing Rosenwald began his collecting career, newspapers applauded The Rosenbach Company and Charles Sessler for bringing "the best of European culture and objects of art to our shores for the joy and edification of American citizens" (*American Business World*, August 1931). As if to help fill this implied cultural void, Rosenwald took the educational value of his collection very seriously. It actually was understood by some of his friends at the time that the collection primarily was brought together for the purpose of public instruction, and that Rosenwald felt it was his responsibility to share it with as wide an audience as possible.

One means to this end was to have the collection placed on view at major public institutions, and Philadelphia institutions were particularly fortunate in this respect. Among the first to benefit was the Free Library, which exhibited Rosenwald's Nanteuil collection in 1929, the collector having been approached to show the prints by Ellis Ames Ballard, another Philadelphia print collector with an important Nanteuil collection. This exhibition was followed by one of Rosenwald's Daumiers in 1930, and his Whistlers in 1931.

Throughout the 1930s, before Carl Zigrosser became the first print curator of the Philadelphia Museum of Art, the Rosenwald Collection was among the main sources for the museum's print exhibitions. For example, in December 1933-January 1934, Whistler prints were on display in the museum's galleries, followed by Lucas van Leyden for the month of February. In March, the museum hung Rosenwald's prints by Piranesi supplemented by impressions from other sources including the Free Library; and to close the season, in April and May Rosenwald's Blakes were on view. Subject exhibitions were proposed by the museum to Rosenwald for 1934-1935. They included "Famous Personages by Famous Artists," "The Old Testament" or "Prints of Peasants," "The Nativity," and "The Passion."

Philadelphia institutions were hardly alone, however; Rosenwald's prints were shown throughout the country. Rosenwald's generosity may be gleaned from a letter of 1929 to Blanchard Randall of Baltimore, in which he wrote, "Please rest assured that I will try to cooperate with you in any way that I may be able and that I am delighted with the opportunity of displaying to the public some of the prints and books from

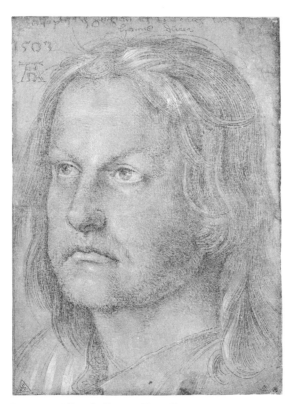

Fig. xxvi. Albrecht Dürer. *Hans Dürer*, 1503 or c. 1510. Silverpoint heightened with white on brown prepared paper. B-6724.

which I have derived a tremendous amount of pleasure personally." A few months later Rosenwald's secretary forwarded to Roland McKinney, the director of the Baltimore Museum of Art, a list of the artists included in the collection, annotated with the approximate number of prints by each. In response to this list, a specific exhibition request was made, and the next month, in November, sixty-five prints by Dürer, as well as his silverpoint drawing of his brother Hans (fig. xxvi) and three portraits of him (two by Wenceslaus Hollar and one by Melchior Lorch) were loaned to the Baltimore Museum for exhibition. The Dürer display was immediately followed by an exhibition of Rosenwald's Rembrandt collection. The Rembrandt exhibition was delivered to Baltimore by Doc Rosenbach's chauffeur and at the same time the Dürers were collected. Apparently the Dürer exhibition closed on Saturday, the thirtieth of November, and the museum staff worked with staggering efficiency, making the Rembrandts available to the public the very next day. Over the years, Rosenwald's Rembrandt prints remained number one in popularity, and their early exhibition history is indicated in the entry for cat. nos. 12-15.

Generally, Rosenwald absorbed all of the shipping expenses and the costs of checklists and catalogues for exhibitions drawn from his collection. If prints needed rematting as a result of the frequent handling they underwent during their travels, he authorized the work to be done by the institutions involved, with the bills sent to him for payment. These rapidly circulating loans were not without their mishaps; in 1931, for instance, the Rosenwald impression of Rembrandt's *Christ Healing the Sick* (fig. xxvii) was sent to Carl Schweidler in Berlin for removal of a half inch scratch which appeared as a result of an accident at some point between the close of the Fogg Rembrandt showing and the arrival of the prints at the Pennsylvania Museum (see cat. nos. 12-15). While such accidents were of course lamentable, Rosenwald accepted the risks in

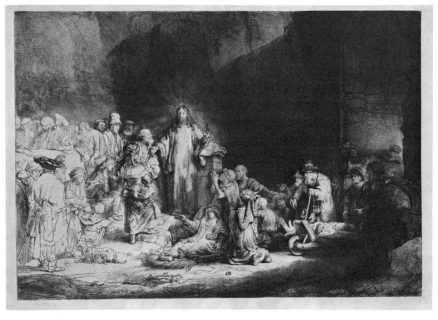

Fig. xxvii. Rembrandt van Rijn. *Christ Healing the Sick*, c. 1649. Etching, drypoint, and engraving. B-9536.

exchange for the great pleasure he received from having others enjoy his collection firsthand.

As the importance of the collection and the generosity of the collector grew in reputation, requests for loans increased markedly, and the Rosenwald Collection functioned almost as a beacon introducing the graphic arts to a broad American public. Writing about the collection in *Prints* magazine (2 [May 1932]: 1-12), Philadelphia art critic Dorothy Grafly indicated that "it is almost impossible to find the entire Rosenwald collection at home. While the Little Masters are being shown in one city, a general survey of six centuries may be on view in another, with various one man exhibitions of Dürer, Rembrandt, Blake or Whistler to be found in some other museum or gallery." While the Rembrandts remained the favorites, the Dürers often served as an acceptable second choice for exhibition when necessary. Other strengths of the collection offered to institutions when the Rembrandts and Dürers were committed were the Nanteuil collection; the Meryon prints and drawings; Whistler etchings, lithographs, copper plates, and books; a collection of Forain paintings, drawings, and prints; early German or early Italian prints; and the Blake collection. In 1936, a year no more or less busy than any other, among the organizations and institutions which borrowed prints from Rosenwald were the Carnegie Institute of Art, the City Art Museum of St. Louis, the College Art Association (which for several years in the mid-1930s circulated traveling exhibitions of Rosenwald prints), the Dallas Museum of Fine Arts, the Honolulu Academy of Fine Arts, the Philadelphia Print Club, and the University of Pennsylvania Library. The loans included works by Blake, Dürer, Forain, Rembrandt, and Whistler. The process was rather circular in that the prints which were exhibited were the prints which were known and the prints which were known were the prints requested for exhibition over and over again. Juggling exhibition dates was often necessary and, on occasion, especially popular prints were withdrawn from one exhibition to be included in another. On other occasions, exhibitions in process were enlarged by new Rosenwald acquisitions.

Of particular importance among the hundreds of exhibitions of prints from the Rosenwald Collection which took place over the years was the *Five Centuries of Printmaking* exhibit held at the Philadelphia Print Club in 1931, the year Rosenwald was elected vice-president of the club (he and Mrs. Rosenwald had become members in October of 1928). Arthur M. Hind's scheduled lecture on the art of the print was the stimulus for the show, which included prints from the fifteenth through the twentieth centuries. An illustrated catalogue was produced, and quotes from print reference books including Hind's A *History of Engraving and Etching*, Weitenkampf's *Famous Prints*, and John B. Jackson's *History of Wood Engraving* served as captions for the illustrations. This exhibition was followed in February 1932 by an enlarged version (238 prints) at the Lakeside Press Galleries in Chicago, *Prints from the Collection of Lessing J. Rosenwald, Philadelphia*, also with an illustrated catalogue. Both exhibitions were selected by Rosenwald himself, whose methodically worked lists are evidence of his careful selection process. These print history exhibitions, drawn entirely from

Fig. xxviii. Mr. and Mrs. Lessing J. Rosenwald at the opening of the
Herbert F. Johnson Museum of Art, Cornell University, 1973.

the Rosenwald Collection, as well as exhibitions of more limited scope,
continued for four decades, long after the prints were given to the
National Gallery. In 1973, for example, when the Herbert F. Johnson
Museum of Art opened at Cornell University, Rosenwald's alma mater,
a group of fifteenth- and sixteenth-century prints from his collection was
one of the feature exhibitions (fig. xxviii).

Rosenwald also was of assistance in lending prints to be used in
specific academic frames of reference. For instance, early in 1942 a
rather extensive exhibition of important old master prints was mounted
at the University of Chicago in conjunction with a seminar on prints
from the fifteenth through eighteenth centuries; and, on another occa-
sion, a professor writing to request slides of prints was asked if he had
considered using original works and told that a small exhibition from the
collection might be coordinated with his course. The offer was rapidly
accepted. Even as late as 1976, an exhibition of Old Testament and
New Testament subjects was lent to be shown at the newly renovated art
gallery at Newcomb College, Tulane University, and correspondence
would indicate that the show was a catalyst for a number of related
studies and activities.

Shortly thereafter, however, it became increasingly clear that the
growing demands being placed on the collection, especially the rare
early material, were not in line with current thought regarding paper
(and therefore print) conservation. This fact, added to the rising costs of
insuring and shipping the works of art and other expenses attendant to
loan exhibitions, caused Rosenwald to monitor more closely the cir-
culation of prints from his collection during the final years of his life.

Rosenwald lent his full support (in respect to both objects and fund-
ing) to important scholarly loan exhibitions drawn from a number of
sources and to the accompanying catalogues. Among the earliest exam-
ples are *William Blake* at the Philadelphia Museum of Art in 1939, *The
First Printers and Their Books* at the Free Library of Philadelphia in
1940, and *The First Century of Printmaking, 1400-1500* at the Art
Institute of Chicago in 1941. All three of these exhibitions reflect

strengths of the Rosenwald Collection, and in all cases, Elizabeth Mongan co-authored the catalogues. A letter of 11 February 1941 to Mongan from Carl O. Schniewind, her colleague in writing the catalogue, expresses his disappointment that the last of these three important exhibitions received relatively little publicity or attention at the time it was mounted, presumably because a Goya show, simultaneously on view, stole most of the critical thunder. The Blake exhibition two years earlier, on the other hand (letter of 6 April 1939 from Fiske Kimball, director of the Philadelphia Museum of Art, to Rosenwald), had been an

extraordinary public success. Over 45,500 people visited the galleries, many of them coming specially from distant cities and even from abroad. An unusual degree of attention was paid the exhibition in the press; art and literary magazines, both in America and abroad, were very favorable in their comments. The catalogue was widely distributed; orders for it are still being received from booksellers and others. Scholars, who came in numbers, were particularly happy to have the opportunity for study and comparison, in the largest assemblage of Blake material ever gathered in this country . . . your amazing group of material formed the largest unit in the exhibition, and I wish you might have heard all of the praise each item elicited on all sides.

The Blake material, in fact, has remained more in demand than any other aspect of the collection.

From the time the collection was presented to the National Gallery in 1943, it was the source of an ongoing graphic arts exhibition program in Washington. Few catalogues were published at first, the exceptions being *Selections from the Rosenwald Collection* (1943), which celebrated the initial gift, and *Rosenwald Collection: An Exhibition of Recent Acquisitions* (1950), both compiled by Elizabeth Mongan. Over the years, Rosenwald was the guiding force behind almost all of the important graphics arts exhibitions at the National Gallery. *Fifteenth Century Northern Woodcuts and Metalcuts from the National Gallery of Art*, organized by Richard S. Field in 1965, was the first in a series of exhibitions and catalogues conceived by Rosenwald and intended as a chronological study of the Gallery's graphic arts holdings. It was followed by three additional exhibitions of fifteenth-century material, mainly drawn from Rosenwald's collection, but the ongoing chronological study was eventually replaced by other kinds of projects. Many of these, too, were suggested by Rosenwald. For example, in the acknowledgments to her 1972 Tiepolo exhibition catalogue, H. Diane Russell expresses her gratitude to the collector both for bringing the Tiepolo albums to her attention and for suggesting the exhibition.

In addition to circulating his prints in exhibitions and supporting the accompanying catalogues, Rosenwald helped scholars engaged in various research projects. The role of his collection in Louis Wuerth's Pennell lithographs catalogue as early as 1930 is noted in cat. no. 29. More than a decade later (letter of 13 January 1942), Erwin Panofsky wrote to Mongan that his book on Dürer could be published in spite of the world situation and inquired whether it would be possible for the reproductions of the prints (about 125) to be made from the Alverthorpe Dürer collection. He further inquired whether the Alverthorpe photographer would be able to do the work, indicating that "nowhere would [he] find originals of the same quality, and to hire a commercial photographer would be beyond [his] means." Although the war did

interrupt the photographic work at Alverthorpe, arrangements were made for Panofsky's request to be fulfilled.

More esoteric photographic work was undertaken at Alverthorpe as well. Equipment was installed to make infrared and ultraviolet photographs. The results of studies of fifteenth-century prints and books showing "renovations, alterations and various treatments they have gone through" were published almost immediately in two issues of *Photo Techniques* (September 1940 and June 1941). These articles established Alverthorpe's reputation as a pioneer in the realm of the scientific photographic study of prints, and in 1942, a set of x-rays was made of the watermarks in the Rosenwald Italian engravings to be forwarded to Arthur M. Hind, who was then working to complete his monumental Italian engravings catalogue. Publication began in 1938 and the last three volumes eventually were issued a decade later under the sponsorship of the National Gallery of Art through the generosity of Lessing J. Rosenwald.

During the war, Hind had sent part of his typescript for the catalogue to Rosenwald for safekeeping, and in 1958 he presented his complete manuscript to the collector. Both are now in the Library of Congress (LCRC 2261 and 2262). To celebrate the catalogue's publication and to honor Hind, from April to June 1949, a major loan exhibition of 105 early Italian engravings was mounted at the National Gallery; unfortunately no catalogue was produced. Not until 1973 was another large show of the work of this period mounted at the Gallery. Drawn largely from the Rosenwald Collection, more than two hundred items were included, and an important scholarly catalogue was produced.

Among Rosenwald's most important contributions to the print world was the founding of the Print Council of America. Begun in 1956 (see cat. no. 76), the council evolved into a professional organization for prints and drawings curators in the United States and Canada, and its annual meetings were fully supported by Rosenwald until the end of his life. Like the curators who gathered, Rosenwald (president of the council from its inception until he stepped down in 1968) always enjoyed learning about the latest findings in the field of paper conservation, forthcoming exhibitions and catalogues, newly designed print rooms throughout the country, and, most important, everyone's exciting recent acquisitions.

Such a serious print collector certainly needed to have a good working library, and in July 1929, Doc Rosenbach wrote to his brother Philip that the library of Howard Coppock Levis, author of A *Descriptive Bibliography of the Most Important Books in the English Language Relating to the Art and History of Engraving and the Collecting of Prints* (among other titles), was available for purchase and that it was "a very necessary thing for Mr. Rosenwald's collection as it contains all the important books on prints—over 2,300 items." Rosenwald agreed that the library was essential to his needs, and he purchased the Levis Collection. Presumably with the exception of a few volumes that were used on a frequent basis, the library was stored in the Rosenbach warehouse until September 1931, when the twenty-five boxes of books were deposited at the Free Library of Philadelphia, first to be catalogued (at Rosenwald's expense) and then to be placed in public use. In 1939

the library was transferred to Alverthorpe. The collection of books was indeed a splendid one, and it contained many volumes that even in the 1920s were known to be quite rare. Several were extra-illustrated with original prints, and many of the albums of prints that Levis had collected or assembled became part of Rosenwald's print collection rather than remaining with the reference library.

When Rosenwald made his presentations to the National Gallery and the Library of Congress, the Levis Collection was divided, with the greatest portion of the material destined for the Library. Before Alverthorpe was closed in 1979, however, the entire Levis resource functioned as a single working unit and provided another aspect of the riches of Alverthorpe at the service of scholars who sought them out.

The role that Rosenwald's collection played in print exhibitions for more than half a century and his assistance on so many levels to scholars and artists in all phases of their careers would be reasons enough for his memory to be paid homage by all who share his love for the printed image. Yet there is still another aspect to his generosity to be touched upon: from the very start, anyone who wanted to see his collection was welcome to do so, by appointment, first at his Sears offices, and then later at Alverthorpe. During the early years, Rosenwald's secretary showed the collection to visitors to Sears if he was not there to do so himself. And from the time Alverthorpe opened in 1939, showing the collection was an important part of all of the curators' responsibilities. Classes as well as individuals came to study the prints, and it appears that the first group to visit the new building was one of Paul Sachs's Museum Studies classes in April 1939. From then on, classes came steadily, often from great distances, until Alverthorpe was closed at the time of Rosenwald's death.

By the late 1970s, so many groups were requesting to visit the collection that the calendar was filled some weeks in advance and the Alverthorpe staff was no longer able to mount a specific exhibition for each new group, as had often been the practice during the earlier years. Instead, individual prints that were requested to be examined were brought to the study room where they were viewed in a round-table setting monitored by the staff. The collection was clearly a splendid resource for students, comprising prints in all media, among them the important landmarks like Benjamin West's *Angel of the Resurrection* (fig. xxix), one of the monuments in the history of early lithography.

When he was in Jenkintown, Rosenwald could generally be found in his gallery, and his hospitality became legendary. He enjoyed meeting and welcoming his visitors, learning about their interest in his collection. Scholars and artists returned to Alverthorpe again and again, and they were obviously delighted when Rosenwald wandered up to them offering a warm handshake, a welcoming smile, and an inquiry as to whether they had everything they wanted and needed. When they said "yes," as they invariably did, he responded that if his gallery could supply them with everything they needed then they must not require a great deal. There were always chuckles on both sides. But Rosenwald was equally cordial to non-professional visitors at Alverthorpe—the Jenkintown residents, for example, who wanted to know what was in the building behind the stone wall on Meetinghouse Road. He was espe-

Fig. xxix. Benjamin West. *Angel of the Resurrection*, 1801. Lithograph. B-14,180.

48

cially pleased when he and his collections helped to initiate an interest in prints and books in the schoolchildren and adult groups who came to the gallery. Meeting and conversing with the collector was no doubt as memorable for Alverthorpe visitors as the works of art which they saw. The contribution Lessing Rosenwald made to the appreciation of graphic arts in America stems as much from his unselfish public sharing of his collection as from his private dedication to the prints and print-makers he loved.

James Abbott McNeill Whistler. *Drury Lane Rags*. Cat. no. 28. B-10,745.

PART I

Favorite Artists

FIFTEENTH-CENTURY WOODCUTS AND METALCUTS

1

Anonymous Upper Rhine
The Martyrdom of Saint Sebastian, 1440-1460

Woodcut, printed in black and hand-colored with red, orange, green, yellow, tan, and reddish brown
29.4 x 20 (11⁹/₁₆ x 7⅞)
Schreiber *1676c; Field *Woodcuts* 244
PROVENANCE: C. G. Boerner, cat. 175, 6-9 May 1930, no. 516; Martin Aufhäuser, Munich, from whom purchased, 1939; presented to NGA, 1943
B-3183

2

Anonymous Upper Rhine
The Crucifixion, c. 1460

Metalcut, printed in black with traces of hand-coloring throughout
18 x 11.9 (7¹/₁₆ x 4¹¹/₁₆)
Schreiber 2341; Field *Woodcuts* 342
PROVENANCE: Eugène Dutuit, Rouen; Weiss & Co., Munich; Martin Aufhäuser, Munich, from whom purchased, 1939; presented to NGA, 1943
B-7890

3

Anonymous Tirolian (Upper Austrian)
The Marriage at Cana (?), c. 1400

Woodcut on linen, printed from at least six blocks in black and hand-colored in red and light brown
120 x 85 (46¾ x 33¼)
Field *Woodcuts* 1
PROVENANCE: Innichen, Upper Austria; Count Wilczek, Schloss Seebarn (Kreutzenstein), Lower Austria; Robert Forrer, Strassbourg; Leopold Heinemann; purchased through William H. Schab, 1949; presented to NGA, 1949
B-15,387

The incunabula of printing (books and printed single images produced prior to 1500) that Lessing Rosenwald assembled are among the most remarkable aspects of his collection. These rare early pieces—some quite primitive and others extraordinarily sophisticated—were among his favorite objects almost from the time he began to collect old master material. Certainly the collection of ten block books and more than 550 typographic volumes printed in the fifteenth century is a cornerstone of the collection that he gave to the Library of Congress, and similarly, the single sheet woodcuts and engravings from the period hold an equally important place in the collection given to the National Gallery. The woodcuts and metalcuts in particular, characterized by simplified and often schematic forms, frequently enhanced by broad color areas applied directly or through a stencil, had a special appeal for Rosenwald. In admiring their primitive qualities, he often referred to them as "children only a mother could love."

The primary centers of woodcut production during the fifteenth century were Germany and Switzerland, and the Rosenwald Collection reflects this fact, although sheets from the Netherlands, France, and Italy are included as well. A few playing cards and other secular subjects are represented, but the collection primarily shows that almost all of the early woodcuts treated religious subjects. They served a wide variety of didactic and devotional functions and were used in a number of ways (pasted onto walls, sewn into clothing, placed in the lids of boxes, to name just a few). They no doubt were, in effect, used until they were "used up," or destroyed. As a result, although they were produced in large numbers, they are today quite scarce, and several sheets in the collection are the only impressions known. Rosenwald began to acquire these single sheet woodcuts in mid-1929, the year after he started to collect incunabula volumes (the first major documented purchase of books dates from October 1928 and includes twelve fifteenth-century volumes acquired from The Rosenbach Company).

The 1929 woodcut purchases included sheets from the Schloss "E" and von Passavant-Gontard sales in Berlin and Leipzig. Among the more important sources for further acquisitions were Sotheby's sale in December 1936 of the Amsterdam collection of A.W.M. Mensing; the London dealer Charles Stonehill, from whom a number of sheets were acquired in the late 1930s; and William H. Schab, who sold Rosenwald a number of prints of this period (including the *Marriage at Cana* [?] lectern cloth) beginning in the early 1940s and continuing until 1960 when the last fifteenth-century woodcut purchases were made. Fewer in number but equally important were works acquired from Rosenbach, H. P. Kraus, and Erwin Rosenthal. The core of the Rosenwald holdings, however, is the collection of fifteenth-century woodcuts, metalcuts, and paste prints formed by Martin Aufhäuser, a Munich banker, who managed to wrest his treasure out of Nazi Germany. This collection of more than 300 examples, a source of great pride and delight to Rosenwald throughout his life, was purchased in 1939 after months of negotiation.

Commemoracio Beati Sebastiani martiris Antiphona

Obsecro te beate sebastiane quia magna est fides tua in teroede pronobis ad dominum
Jhesum xpm ut a peste siue morbo ypidimie liberemur. Versicl: Ora pronobis beate
sebastiane. R. Ut digne efficiamur promissionibus xpi. Oracio

ompotens sempiterne deus qui meritis Beati Sebastiani martiris tui gloriosissi
mi quedam generalem pestem ypidimie hominibus mortiferam reuocasti psta
supplicibus tuis ut qui hanc oracionem super se portauerint aut in domibus mansientibus
g suis uel de eam cordibus ipsorum memoriam habuerint in tuo nomine a te festi
uitatis die deuote legerint prosim lieg peste ypidimie reuocanda sub eius confiden
aa adte confugerint ipsius precibus et meritis ab ipsa peste et morbo ac ab omni
bus mearmentie veneno sie necnon ab omnibus corporis et anime periculis
ac subitanea et improuisa morte et ab omnibus inimicis visibilibus et invisi
sibilibus singulis diebus horis ac momentis liberemur per xpm dnm.

Early in 1938, Paul J. Sachs, Rosenwald's old and trusted friend at the Fogg Art Museum, brought the existence of the Aufhäuser woodcuts to his attention. It then took an entire year of intermittent correspondence before Martin Aufhäuser's son Walter was able to give a positive report to Rosenwald: his father's collection was successfully removed from Munich to London and was available for shipment to the United States. On the basis of a checklist of the prints, Rosenwald anticipated that he surely would be interested in purchasing certain items, but doubted that he would wish to acquire the entire lot. He therefore wrote to the younger Aufhäuser that if the prints were brought to this country, he would very much want to see them before making any decision about their purchase. In the preface to Richard S. Field's *Fifteenth Century Woodcuts*, Rosenwald recalled his first meeting with Walter Aufhäuser:

Many more months passed and finally Mr. Aufhäuser, Jr. walked into my office. . . . He had a package under his arm that looked like something from the delicatessen. I was fearful, from appearances, that this was going to be a debacle. The package was unwrapped and much to my astonishment everything inside was carefully protected in its own glassine envelope. And such prints! I could not believe what I was seeing; there was no such thing. After some time I finally returned to my usual equanimity and carefully examined each and every one minutely. The quality and condition left absolutely nothing to be desired.

After consultation with Paul Sachs, who immediately shared his enthusiasm for the Aufhäuser prints, Rosenwald acquired the collection and had a special collector's stamp made to mark the prints in it (fig. 1-4a). The impression (thought to be unique) of the *Saint Sebastian* woodcut, complete with the xylographic prayer for the martyred saint's intercession with God, showing superbly expressive use of the woodcut medium's potential for formal grace, and *The Crucifixion* metalcut, distinctive for its elegantly elongated figures with their mannered gestures, were both part of the Aufhäuser purchase. A selection of fifty of the prints was first exhibited in this country in 1940 at the Fogg Museum. Many of them appeared the following year in the important *First Century of Printmaking* exhibition at the Art Institute of Chicago (see cat. nos. 33-34).

In 1941, Martin Aufhäuser and his wife emigrated to the United States, landing in New York in June. Before settling in Los Angeles, the German collector visited Rosenwald at Alverthorpe. The two men started an occasional correspondence, and the hundreds of laudatory letters Rosenwald received at the time of his gift to the National Gallery included one from Martin Aufhäuser indicating how pleased he was that the woodcuts and other objects formerly in his collection were part of the Rosenwald gift to the American people, thus allowing Aufhäuser to repay a debt to an American friend who had assisted his escape from Germany.

The lectern cloth and the traveling altarpiece (cat. no. 4) came into the collection somewhat later. The lectern cloth, a splendidly preserved example of a Gothic printed textile, is not only the earliest print in the Rosenwald Collection, but also one of the earliest extant western woodcuts. It is actually half of a lectern cloth, the other half of which has recently been located in the Abegg Foundation in Bern,

Fig. 1-4a. Collectors' stamps: left, Lessing J. Rosenwald; center, Lessing J. Rosenwald/Aufhäuser Collection; right, National Gallery of Art, Rosenwald Collection.

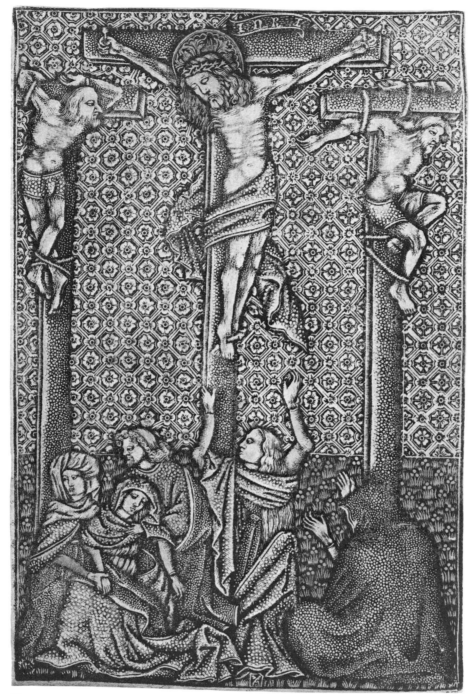

Cat. no. 2

by the National Gallery's textile conservator, Joseph V. Columbus. The central subject of that half is the raising of Lazarus. Among the most important later additions to the fifteenth-century woodcuts collection, for many years the Rosenwald textile was hung above a fireplace in the Alverthorpe study room (fig. 1-4b).

Fig. 1-4b. Alverthorpe Gallery study room with the *Marriage at Cana* (?) lectern cloth above the fireplace, 1979.

The traveling altarpiece with *The Lamentation* woodcut is also quite extraordinary. The texts at the left of the image are the Gloria and the Credo, and at the right, the accompaniment to the offering of the bread and wine during the Mass. By substantial internal evidence, the name of the original owner of the piece is known (Apollonia von Freyberg, who became a nun in the Convent of Saint Clara in Mülhausen, twenty-five miles north of Basel), the name of the printer in whose shop it was produced (Lienhart Ysenhut, who was active in Basel at the end of the fifteenth century), the source for the image (an engraving of *The Lamentation* by Master E. S., Lehrs, 33), and the year when the box was made (1491 or 1492, based on an account book that is part of the box's construction). For the piece to have survived intact in such splendid condition is remarkable.

REFERENCE: Field, *Woodcuts*

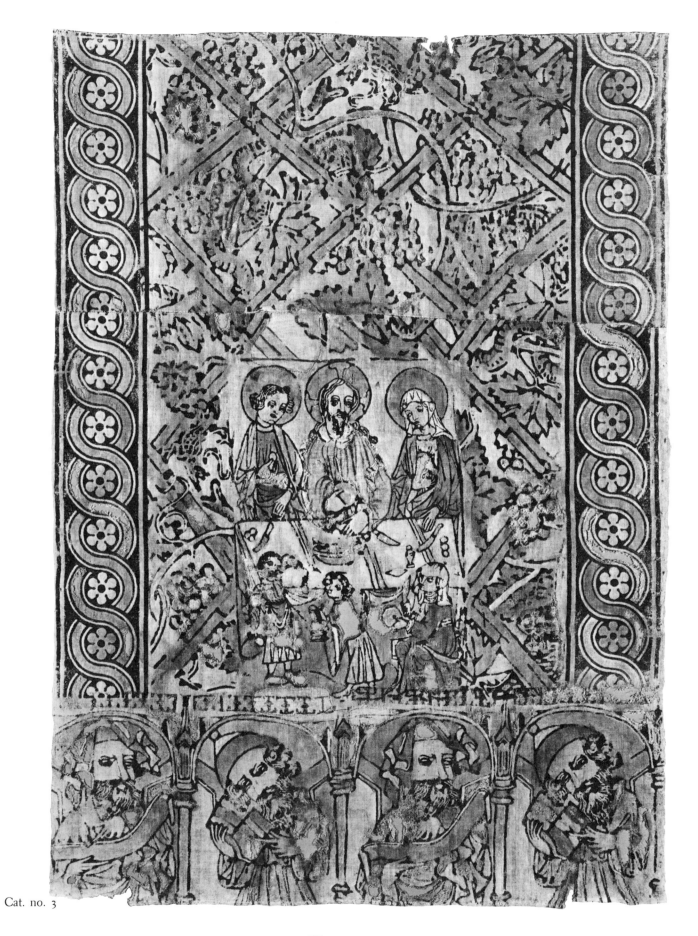

Cat. no. 3

4

Anonymous Basel
The Lamentation, c. 1490

Traveling altar with a woodcut printed on parchment
in black and hand-colored in blue, green, brown, tan,
orange, and red; set between two panels of printed text
to form a triptych; housed in a slipcase with an embroi-
dered crucifixion scene on the front and backed in
leather; in turn housed in a velvet, silk, and linen box,
strengthened with layers of parchment from an account
book, with ornamental tassels at each corner
Woodcut: 12.7 x 12.7 (5 x 5); parchment: 15.5 x 38.8
(6⅛ x 15⅝); slipcase: 17.5 x 17.8 (7 x 7); box: approx-
imately 21.1 x 21.1 (8 x 8)
Mark of Lienhart Ysenhut's printing shop, a helmet,
cut into block, lower right
Field *Woodcuts* 78
PROVENANCE: Edmund Schilling, Basel; purchased
from Heinrich Eisemann, London, 1956; presented to
NGA, 1959
B-22,141
See page 22 for color plate of woodblock, parchment,
slipcase, and box.

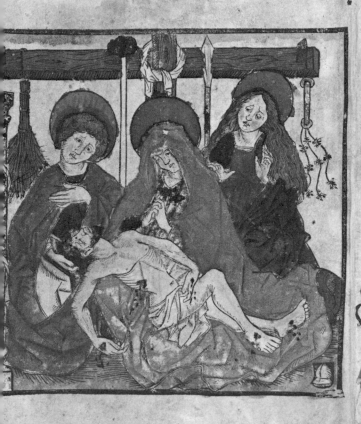

Suscipe sancte pater omps eterne deus hanc inmaculatam hostiam. quã ego indign9 famul9 tu9 offerero tibi deo meo viuo et vero p̃ in numera bilib9 peccatz z offensionibz et neglige̅tis meis: et p̃ oib9 circustatib9 sed z p̃ oib9 fidelib9 xp̃ianis viuis et defu̅ctz ut michi z illis p̃ ficiat ad salute̅ i vita̅ eterna̅ amn ꝯe9 q̃ hu̅ae substa̅cie dignitate̅ mirabilit̃ p̃ didisti et mirabili9 reformasti. da nobis p̃ hui9 aque ✝ et vini misterium ei9 diuinitatz esse ꝯsortes. q̃ hr̃e h̃u̅anitatz fieri dignat9 e̅ p̃ticeps ih̃b9 xp̃9 fili9 tu9 dñs ñr Offerim9 tibi dñe calice̅ salutarz tua̅ dep̃ca̅tes cleme̅cia̅. vt in ꝯspectu̅ diuine maiestatz tue pronostra et protutius mu̅di salute cu̅ odore suauitatz ascedat. per xp̃m dñm ñr̃m amen ✝ In spu̅ h̃u̅ilitatis et in anio ꝯtrito suscipiamur ate dñe, et sic fiat sa crifitiu̅ ñr̃m in ꝯspectu tuo hodie. vt placeat tibi domine deus. Veni sanctificatur omps ete̅r ne de9. et bene ✝ dic hoc sacraficium tuo no̅ıni sancte p̃paratum ꝯ Suscipe sa̅cta trinitas ha̅c oblacione̅z quã tibi offerim9 ob memoriã passio̅is. resurectio̅is ascensio̅is Ih̃u̅ xp̃i d̃ñi ñr̃. et in honore beate marie se̅p̃ virginis et beati joha̅nis ba tiste. et sancto̅r apostolo̅r tuo̅r petri et pauli. isto̅r et o̅ım sancto̅r vt illis p̃oficiat ad h̃onore̅ nobis aut ad salute̅. et illi pronobis i ter cedere digne̅tur in celis quo̅r memoriã facim9 interris. p̃ xp̃in dñm̃.

Ui pridie q̃ paterē: Accepit pane̅ in sanctas ac venerabiles man9 suas. Et eleuatis oculis in celu̅ ad te deu̅ patre̅ suu̅ om̅i potente̅ tibi gratias agens: bene ✝ dixit fregit dedit discipulis suis dice̅s: Accipite et ma̅ducate ex hoc oīnes (Hoc est eı̅n corp9 meu̅:.

Imili modo postq̃ cenatu̅ est: accipiens et h̃u̅c p̃claru̅ calice̅ insanctas ac venerabiles man9 suas. Item tibi gracias agens: bene ✝ dixit deditqz dis̃ıpulis suis dice̅s Accipite z bibite exeo om̅ nes (Hic est eı̅n calix sanguinis mei noui z eterni testame̅ti: misteriu̅ fidei: qui p̃o vobis z p̃omultis effunde̅r in remissionem peccato̅r) Hec quociensc̃u̅qz seceritis in mei memoriam facietis.

MASTER E.S.
Swiss or South German, active 1450-1467

5
Martyrdom of Saint Sebastian, c. 1450-1460

Engraving
14.7 x 10.7 (5¹³⁄₁₆ x 4¼)
Lehrs 157; Shestack *Engravings* 6
PROVENANCE: R. Weigel, Katalog der Sammlung Weber, I, 1855, no. 6; Count Yorck von Wartenburg (Lugt 2669); C. G. Boerner, Auction 176, May 1932, no. 58; purchased from Richard H. Zinser, 1939; presented to NGA, 1943
B-2748

6
The Visitation, c. 1450-1460

Engraving
9.3 x 6.7 (3⅝ x 2⅝)
Lehrs 14; Shestack *Engravings* 7
PROVENANCE: Meyer-Hildburghausen; N. Clément; Count Yorck von Wartenburg (Lugt 2669); C. G. Boerner, Auction 176, May 1932, no. 53; purchased from Richard H. Zinser, 1939; presented to NGA, 1943
B-11,166

7
The Madonna and Child with a Bird, c. 1465-1467

Engraving, printed relief in black and retouched with white and blue watercolor
10.7 (4¼) diameter
Lehrs 70; Shestack *Engravings* 14
PROVENANCE: S. Maltzan, Militsch; purchased from William H. Schab, 1959; presented to NGA, 1961
B-22,301

Rosenwald acquired more than 250 fifteenth-century northern European engravings by more than twenty-five known artists and several others who remain anonymous. Like the woodcuts and metalcuts of the time (cat. nos. 1-4), these more elegant sheets were central to Rosenwald's collecting interest from the start, and his

Fig. 5-7a. *The Knight and Lady,* c. 1460-1465. Engraving. B-2749.

enthusiasm for specific artists and prints never waned. Although it is difficult to single out one engraver from this period as a "favorite," the fourteen prints in the collection by the Master E.S. did, in fact, seem to be particularly special to Rosenwald, perhaps because he managed to acquire so many of them despite their great rarity.

Rosenwald's first three engravings by Master E.S. (the first engraver known to sign prints with his monogram) were purchased in 1929. Among them was *The Knight and Lady* (fig. 5-7a), formerly in the collection of Friedrich August II of Saxony. A genre subject in contrast to the religious themes included in the exhibition, it shows another aspect of the work of E.S. who was one of the earliest engravers seriously to treat secular themes. Two additional E.S. prints were acquired in 1930, and all but one of these first five E.S. acquisitions came from Charles Sessler. The other nine, purchased after Alverthorpe was opened, came principally from Richard H. Zinser and William H. Schab, who replaced Sessler as the main sources for old master material during this later period. The *Martyrdom of Saint Sebastian, The Visitation,* and *The Madonna and Child with a Bird* were among the later acquisitions. All of them, but especially the *Saint Sebastian* sheet (which one might compare with the Saint Sebastian woodcut, cat. no. 1), give evidence of E.S.'s mannered, strongly gestural style. *The Visitation,* by contrast, emphasizes the Master's humane warmth and expressive

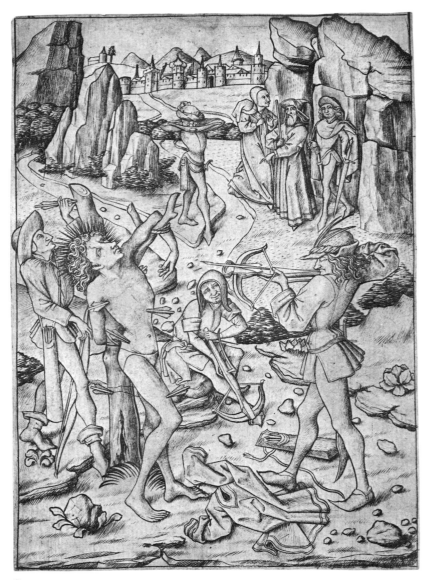

Cat. no. 5

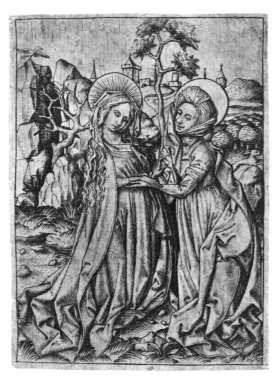

Cat. no. 6

Fig. 5-7b. Follower of Master E.S. *Ornament with Wild Folk*, c. 1460-1465. Engraving. B-8316.

gentleness. *The Visitation* is one of ninety-five (of a total of more than 315) engravings by E.S. thought to be extant only in unique impressions. *The Madonna and Child with a Bird*, although not unique, is one of very few known impressions, and it is the only known white-line engraving of the fifteenth century. Like the Mair von Landshut engraving of *The Nativity* (cat. no. 34) of three decades later, and the chiaroscuro woodcuts of the early sixteenth century, Master E.S.'s white-line engraving no doubt was meant to imitate the drawings of the period that were executed on prepared papers and heightened with white paint (fig. 35a).

The Master E.S., like many of the earliest engravers, is thought to have been a goldsmith. His use of cross-hatching and systematic burin work contributed significantly to the sophistication of the engraver's technical and formal vocabulary. In addition to fourteen prints by the Master himself, Rosenwald also acquired three by E.S.'s contemporaries and close followers. Among them is an impression of *Ornament with Wild Folk* (fig. 5-7b) thought to be unique.

REFERENCE: Shestack, *Engravings*

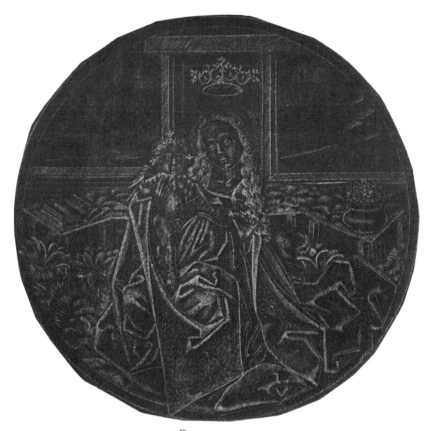

Cat. no. 7

ALBRECHT DÜRER
German, 1471-1528

8
Melancholia I, 1514

Engraving
24.1 x 18.8 (9½ x 7⅜)
Hollstein 75 I/II
PROVENANCE: A.F.T. Bohnenberger (Lugt supp. 68);
purchased from Gutekunst and Klipstein, 15 August
1939, no. 95; presented to NGA, 1943
B-6547

9
Saint Eustace, c. 1500-1501

Engraving
35.5 x 26 (14 x 10¼)
Hollstein 60
PROVENANCE: EK in oval (not in Lugt); purchased from
Charles Sessler, 1928(?); Lessing J. Rosenwald; Robert
L. Rosenwald; presented to NGA, 1971
B-25,613

10
Christ on the Mount of Olives, 1515

Etching on iron
22.4 x 15.9 (8¹³⁄₁₆ x 6¼)
Hollstein 19
PROVENANCE: Hollstein and Puppel, 29 and 30 April
1930, no. 307; purchased from Charles Sessler, 1930;
presented to NGA, 1943
B-6557

11
The Life of the Virgin: "The Circumcision," c. 1504-1505

Woodcut
29.5 x 21 (11⅝ x 8¼)
Hollstein 198
PROVENANCE: A. Alferoff (Lugt 1727); Clendenin J.
Ryan (Parke-Bernet, 17 January 1940, no. 105); pur-
chased from Richard H. Zinser, 1940; presented to
NGA, 1943
B-6610

Rosenwald's initial acquisition of a work by Albrecht Dürer, the most widely admired graphic artist of the late fifteenth and early sixteenth centuries, was an impression of the second state of *Melancholia I*, Dürer's mysterious visual statement about philosophical and practical knowledge and perhaps his most famous engraved subject. Rosenwald bought the print from Sessler in January 1928, and it was one of his earliest old master purchases. Eventually the collection grew to include a comprehensive representation of Dürer's approximately three hundred prints: engravings, etchings, drypoints, and woodcuts, often in more than one impression of a subject. Several of the Dürer compositions absent from the collection were impossible to obtain, as they are known only in unique impressions, mainly in old European collections.

Among the purchases of the late 1930s was the superb impression, seen here, of the first state of *Melancholia I* (far more rare than the second state acquired earlier), before the number nine, which appears in reverse in the first column of the magic square, was removed and reengraved in the proper direction. The impression is brilliant and luminous, as is the impression of *Saint Eustace*, Dürer's largest engraving, and also one of his most complex, in which the tonal possibilities of the medium are stretched to their limits.

In the Saint Eustace legend, the saint, then a Roman general named Placidas, was pursuing a large stag when suddenly he noticed a cross with the image of Christ between the animal's antlers. The stag, speaking in God's voice, asked why Placidas was chasing him, whereupon Placidas fell from his horse and converted to Christianity. This rich impression of Dürer's *Saint Eustace* is probably the one Rosenwald bought from Sessler in 1928, shortly after he acquired the second state of *Melancholia I*. It is one of several prints that Robert Rosenwald, the collector's younger son, a sculptor, selected at his father's suggestion to keep for himself before the bulk of the Rosenwald Collection was given to the National Gallery in 1943. In 1971, when Robert gave it to the Gallery, he reunited it with the rest of the Rosenwald Dürers.

Christ on the Mount of Olives was purchased early too, at auction with twelve other prints by several artists, among them, Heinrich Aldegrever, Albrecht Altdorfer, Lucas Cranach, and Lucas van Leyden. Four additional Dürers were purchased then also, including *Erasmus of Rotterdam* (fig. 8-11a) a print which Rosenwald particularly liked and hung in most special exhibitions of his collection beginning with the one held in 1931 at the Philadelphia Print Club. The *Christ on the Mount of Olives* etching is a rich and dark impression taken before the appearance of the rust spots found on many impressions of early etchings on iron. This problem may, in part, account for Dürer's eventual rejection of the medium after making only six etchings between 1514-1515 and 1518.

"The Circumcision" woodcut from *The Life of the Virgin* series is part of a complete set of proof sheets, before the text was printed on the versos, acquired in 1940 from the celebrated Clendenin J. Ryan Collection (the Ryan sale contributed a number of works to Rosenwald's collection, among them, eleven by Schongauer [see cat.

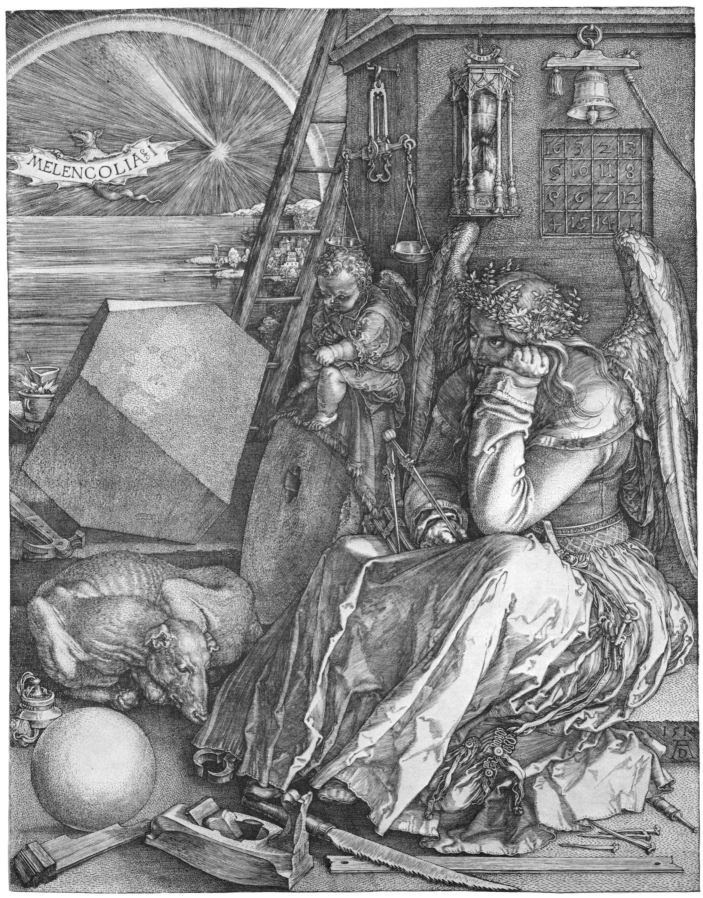

Cat. no. 8

Fig. 8-11a. *Erasmus of Rotterdam*, 1526. Engraving. B-6578.

no. 48], three by Rembrandt, two by van Dyck, five by Meryon, and four by Dürer in addition to *The Life of the Virgin* cycle). When the Ryan set was purchased, Rosenwald already owned six of the twenty subjects included.

Over the years, Rosenwald also acquired proof sheets of *The Great Passion* and *The Small Passion*, and of several prints in *The Apocalypse* series as well. This last cycle is best represented, however, in a volume, bequeathed by Rosenwald to the Gallery as part of his estate, which contains complete sets of the 1511 editions, with text, of *The Apocalypse*, *The Great Passion*, and *The Life of the Virgin* bound together. Rosenwald also obtained most of Dürer's single sheet woodcuts, and his last Dürer acquisitions, purchased in 1961, include nine proof sheets of illustrations often ascribed to the master, for the Nuremberg 1503 *Salus anime*.

One Dürer drawing came from Sessler in 1929: a silverpoint portrait of the artist's brother Hans (fig. xxvi), formerly in the Mariette, Marquis de Lagoy, and Seymour Collections. The bulk of the National Gallery Rosenwald Dürers were purchasd early, in 1928 and 1929, and from the start they were second only to the Rembrandts in popularity (see cat. nos. 12-15). Numerous important additions were made in 1940, among them *The Small Passion* proofs, the Ryan Collection purchases, most of the *Knots* woodcuts, and several individual sheets. About twenty-five prints were added in later years, after the collection was given to the National Gallery.

To indicate the true extent of Rosenwald's Dürer collection, one must note that the 1977 Library of Congress catalogue of its Rosenwald Collection lists more than twenty-five volumes written and/or illustrated by the artist, or with illustrations attributed to him and/or his followers. Among these is the 1511 edition of *The Small Passion* as well as the artist's several treatises on proportion.

REFERENCE: Talbot, *Dürer*

Cat. no. 9

66

Cat. no. 10

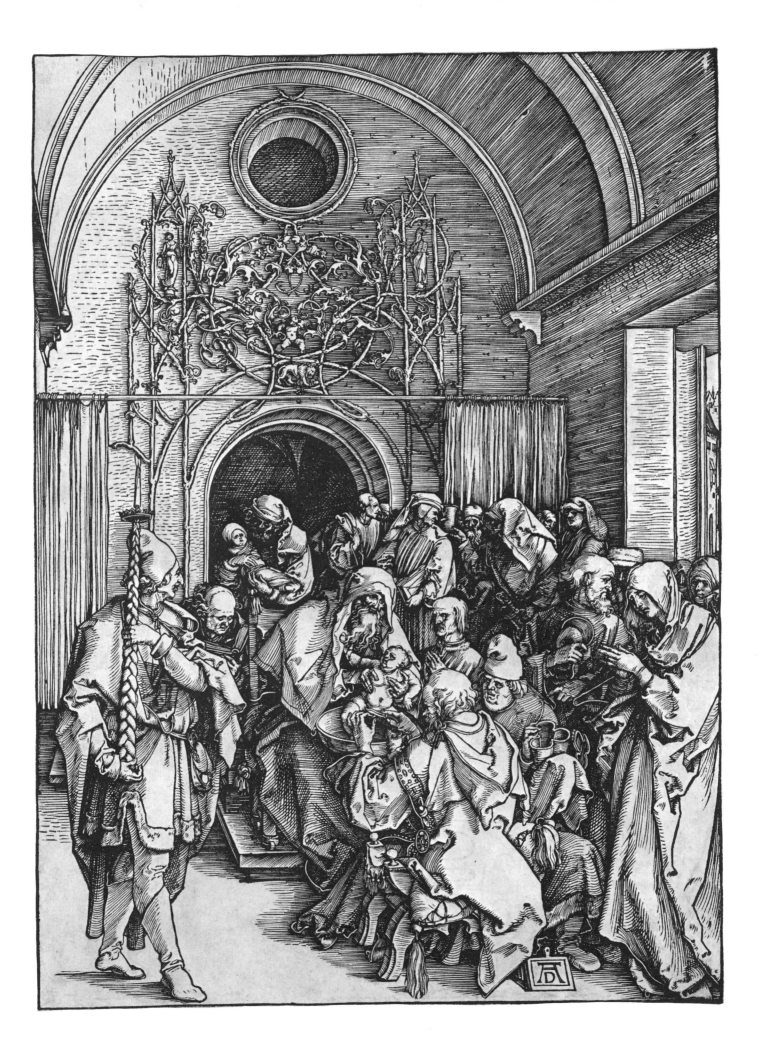

REMBRANDT VAN RIJN
Dutch, 1606-1669

12

St. Francis beneath a Tree Praying, 1657

Drypoint and etching
18.2 x 24.1 (7⅛ x 9½)
Hollstein 107 II/II
PROVENANCE: Purchased from The Rosenbach Company, 1929; presented to NGA, 1943
B-9518

Rosenwald's Rembrandt prints were applauded as the core of the collection in practically all of the news accounts published when the prints were given to the National Gallery in 1943. The Rembrandts actually had been a focal point of Rosenwald's old master holdings from the very start. Their first major public display was at the Baltimore Museum of Art in December 1929. Some idea of the demands placed on the collection at quite an early time, can be gathered from the itinerary the Rembrandts followed at the close of this first showing. From Baltimore they went to the Albany Institute of Art, next, to Cornell University, the Philadelphia Art Alliance, the Fogg Art Museum in Cambridge, and finally to the Pennsylvania Museum of Art (now the Philadelphia Museum of Art) in December 1930.

William Rosenwald had given the Rembrandt collection its start with a 1927 gift to his older brother Lessing. It was an impression of *The Baptism of the Eunuch* (fig. 12-15a). Rosenwald's own first Rembrandt purchase, a second state of the *Self-Portrait at a Stone Sill* (Hollstein 21) took place in January of the following year, on the same day that he bought his first Dürer, the second state of *Melancholia I* (see cat. nos. 8-11). By the time the Rembrandts were shown in Baltimore almost two years later, the collection had already grown to include 150 prints, in varying states, and three drawings. This rapid expansion continued, and when the exhibition reached the Pennsylvania Museum of Art in December 1930, the accompanying catalogue listed two hundred etchings and five drawings, presumably the entire Rembrandt collection at that date. Among the prints which were on display at the Pennsylvania Museum was *St. Francis beneath a Tree Praying*, printed on

Fig. 12-15a. *The Baptism of the Eunuch*, 1641. Etching. B-9474.

13
The Goldweigher's Field, 1651

Etching and drypoint
12.3 x 31.8 (4¾ x 12½)
Hollstein 234
PROVENANCE: H. Whittemore; purchased from Richard
H. Zinser, 1940; presented to NGA, 1943
B-11,135

14
The Woman with the Arrow, 1661

Etching, drypoint, and engraving
20.4 x 12.4 (8¹/₁₆ x 4¹⁵/₁₆)
Hollstein 202 II/II
PROVENANCE: Sir E. Astley (Lugt 2774); P. Remy (Lugt
2173); W. Esdaile (Lugt 2617); H. LeSecq (Lugt 1336);
H. Whittemore (Lugt supp. 1384ª); purchased from
Richard H. Zinser, 1943; presented to NGA, 1944
B-4379

15
Self-Portrait, c. 1636-1637

verso: brief sketches of a deposition or an entombment
Red chalk
12.9 x 12 (5¹/₁₆ x 4¾)
Benesch 437
PROVENANCE: V. Röver; F.U. Meek; P. & D.
Colnaghi; purchased from Charles Sessler, 1930;
presented to NGA, 1943
B-9404

Japanese paper with a heavy surface tone throughout, making it a particularly rich and dark impression. In his "Foreword" to this exhibition catalogue, Rosenwald summarized the attitude about sharing his collection that he maintained throughout his life: "The further opportunity offered by the Pennsylvania Museum of Art for the public to view and enjoy this collection of Rembrandt prints is deeply appreciated."

Like the rest of Rosenwald's collecting, the Rembrandt acquisitions came to a standstill in 1930, and no additions were made again until he started steadily to purchase books and prints in 1936. Throughout the 1940s, 1950s, and 1960s, special items were added. *The Goldweigher's Field*, for example, was a subject of particular interest to Rosenwald, and he purchased this very fine early impression with the drypoint burr still quite strong in 1940, to improve upon the one included in the earlier exhibitions. A counterproof of this popular landscape subject (fig. 12-15b), purchased through Robert M. Light from the 1967 Parke-Bernet sale of Part I of the Gordon W. Nowell-Usticke Collection, was among the last Rembrandt prints to enter the collection (see cat. nos. 80-81 for an explanation of the term "counterproof").

The Woman with the Arrow, purchased shortly after the impression of *The Goldweigher's Field*, was the next to the last print Rembrandt executed and his last etching of a nude. With many of his etched subjects, Rembrandt experimented with his inking techniques, printing each of his impressions a little bit differently from the others. This impression of *The Woman with the Arrow*, for example, is particularly richly inked, with full surface tone throughout, light areas being cleared only on parts of the figure and on the drapery. The impression is also of interest because the provenance or collecting history of the sheet is well documented. The collectors' marks and inscriptions both on the front and on the reverse of the print allow us to trace it back to the noted Rembrandt collection of Sir Edward Astley. The flowerlike stamp, unfortunately placed within the image at the right center, is the mark of Astley, and the "WE" at the lower right is evidence of the sheet's ownership by William Esdaile. Obtaining prints from collections of such distinction is always a point of pride for the print connoisseur.

From the five drawings shown at the Pennsylvania Museum in 1930, the collection of Rembrandt's drawings grew to include nine sheets, both landscape and figure studies. The red chalk *Self-Portrait* was among the earlier drawing acquisitions, however, and as one of the very few Rembrandt self-portrait drawings which is widely accepted as authentic, it remains among the most important of the Rembrandt drawings in the collection.

Cat. no. 13

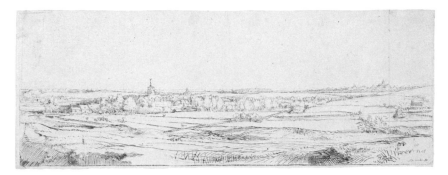

Fig. 12-15b. *The Goldweigher's Field*, 1651 (counterproof). Etching and drypoint. B-25,224.

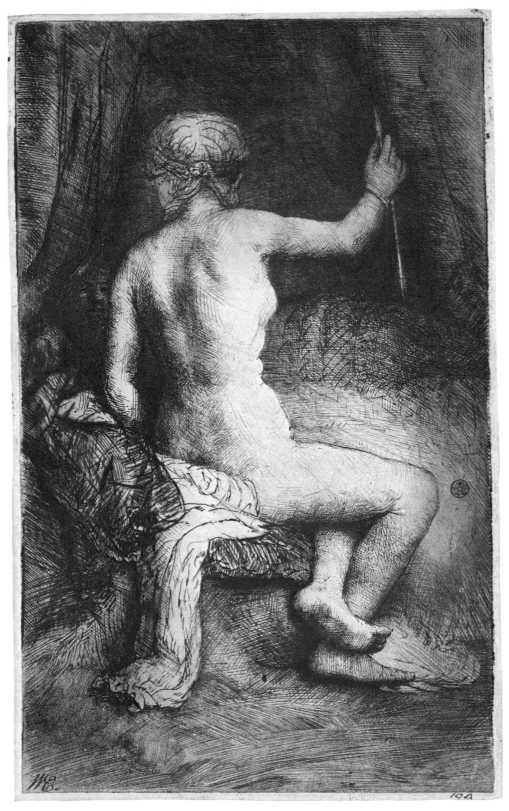

Cat. no. 14

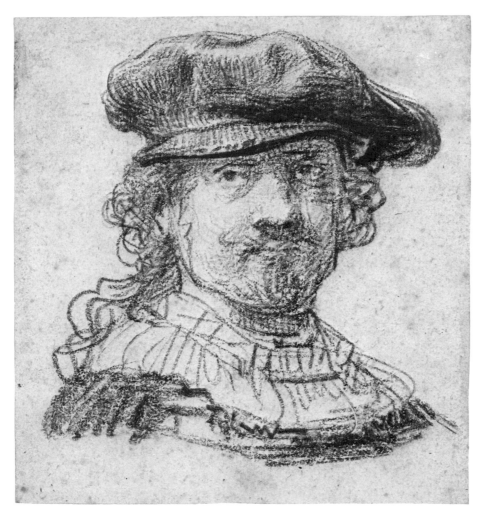

Cat. no. 15

WILLIAM BLAKE
British, 1757-1827

16

Christ Appearing to His Disciples after the Resurrection, c. 1798

Monotype, reworked with watercolor and touches of pencil
43.3 x 57.5 (17 x 22⅝)
Signed lower left in black paint: *Fresco W Blake inv.*
Butlin 326
PROVENANCE: Frederick Tatham (Sotheby's, 29 April 1862, no. 186); Palser; W.A. White; purchased from The Rosenbach Company, 1930; presented to NGA, 1943
B-11,060

17

Queen Katherine's Dream, c. 1825

Watercolor, opaque white and gold
41 x 34.2 (16¼ x 13½)
Signed lower right in gold paint: *W Blake inv.*
Butlin 549, as *The Vision of Queen Katherine*
PROVENANCE: Sir Thomas Lawrence (Christie's, 20-21 May 1830, no. 235); J. C. Strange; E. B. Tyler; Mrs. Sydney Morse (Christie's, 26 July 1929, no. 16); purchased through Charles Sessler from P. & D. Colnaghi, 1930; presented to NGA, 1943
B-11,197

In dividing his world-renowned Blake collection between the National Gallery of Art and the Library of Congress, Rosenwald gave the Gallery the paintings and watercolors, most of the pencil drawings (the exceptions were drawings related to book illustrations), the engravings series and single sheet prints, and all of the copper plates including the only known example of a Blake relief-etched copper, the fragment of the plate from a rejected page of *America.* The Gallery also received a representative group of the artist's commercial book illustrations; and a single page from A *Small Book of Designs,* three pages from A *Large Book of Designs,* and a copy of *On Homer's Poetry [and] On Virgil* (fig. 16-18a) provide examples of Blake's distinctive illuminated books.

The Blake collection was extraordinary from its very start. In 1929, through The Rosenbach Company (the source for much of the Rosenwald Blake material), Rosenwald acquired seventeen items from Brooklyn collector William A. White. Included were ten of Blake's highly personal illuminated books, and the beautiful colored version of *War* or *The Accusers of Theft, Adultery, Murder* (cat. no. 96). Immediately established, Rosenwald's interest in Blake remained firm; and buying one or two items at a time, or large numbers of works at important sales, he continued to add to his holdings. *Christ Appearing to His Apostles after the Resurrection* (other versions of which are in the Yale University Art Gallery and the Tate Gallery), the one full-scale Blake monotype (or color-printed drawing as the technique is called in the Blake literature) to enter the collection, was among the important items acquired in 1930 (see cat. nos. 65-66 for an explanation of the monotype process). Also that year, Rosenwald bought the *Queen Katherine's Dream* watercolor. Like so many of Blake's subjects, it is known in several versions, and Blake first approached it in his engraving after Fuseli published in 1805. Blake's 1804 squared pencil study for the engraving is also in the National Gallery Rosenwald Collection. In 1931, the year after the monotype and *Queen Katherine's Dream* watercolor acquisitions, one of the important Blake purchases was the exceedingly rare first state impression of *The Canterbury Pilgrims* (fig. 16-18b). Second and fourth states were added in 1937.

That same year, 1937, through the British booksellers William H. Robinson, Ltd., Rosenwald purchased part of the Linnell Blake collection. Included were works formerly on deposit at the British Museum that had been given by John Linnell, Blake's late patron, to his family. The purchase comprised several drawings and a number of other items of such great importance that Arthur M. Hind, Keeper of Prints at the British Museum, with whom Rosenwald had a warm relationship (see introduction), was prompted to write to Rosenwald in June 1938, "If I can ever be a little sad at any of your acquisitions it was to hear that the Blake copperplates of Dante, and the proofs of the Book of Job had all gone to you."

During the late 1930s, in addition to purchasing privately, Rosenwald also purchased heavily at auction. From the W. E. Moss sale (Sotheby, 2 March 1937) came most of his Blake commercial engravings, including several rare portraits; and the George C. Smith

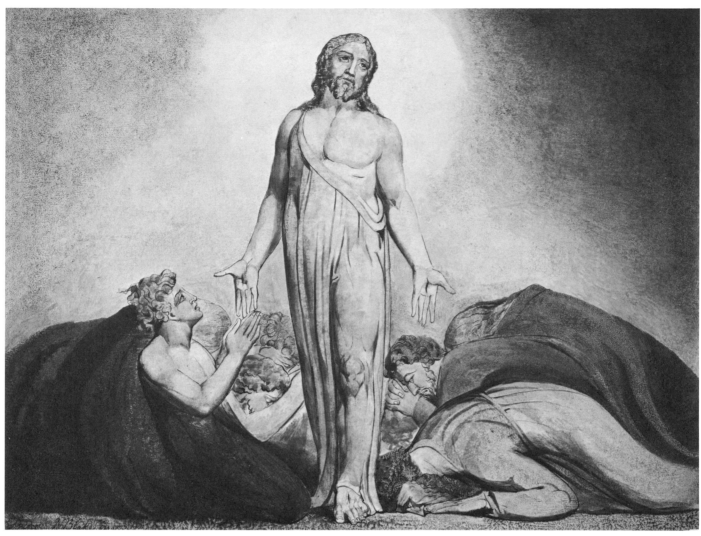

Cat. no. 16

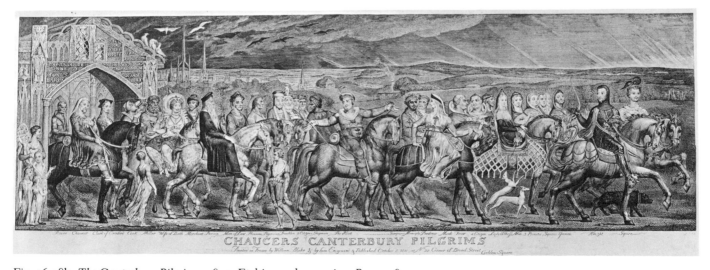

Fig. 16-18b. *The Canterbury Pilgrims,* 1810. Etching and engraving. B-11,058.

Fig. 16-18a. *On Homer's Poetry [and] On Virgil*, 1822. Etching, printed relief. B-4203.

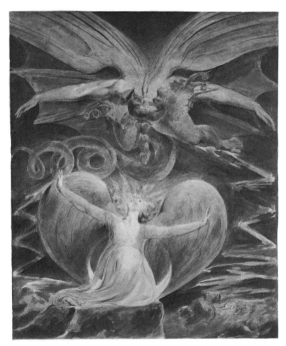

Fig. 16-18c. *The Great Red Dragon and the Woman Clothed with the Sun*, c. 1805. Watercolor. B-11,064.

sale (Sotheby's, 2 March 1937) came most of his Blake commercial engravings, including several rare portraits; and the George C. Smith sale (Parke-Bernet, 2 November 1938) brought a large number of pencil studies and other extremely rare unique items, among them the uncolored version of *War* or *The Accusers of Theft, Adultery, Murder* (cat. no. 97) and *The Chaining of Orc* (cat. no. 18).

Orc, in Blake's symbolic universe, represents revolution in the material world, and the Rosenwald impression of this particular Orc subject is thought to be unique. It is difficult to determine both how the copperplate for *The Chaining of Orc* was executed and how the plate was then printed. Comparison of *The Chaining of Orc* with an impression of *Mrs. Q.*, a stipple engraving by Blake after Villiers, also in the collection, suggests that the *Orc* plate was printed by conventional intaglio methods. It appears, however, that the image was etched into the plate by methods similar to those Blake used for his illuminated books (which, themselves, were printed from the relief, rather than from the intaglio, surface). That is to say, the plate was etched to various depths, leaving different parts of the image at various levels of relief. The areas that are seen as whitest in the print (the halos, areas of the flames, and areas in the clouds) remained the highest level, the figures were a middle level, and parts of the background appear to have been etched most deeply. Blake probably then polished the surfaces of the various levels of the copperplate and worked back into the plate by a stippling process, either through an acid-resist ground, or by direct engraving. The broad gray areas of the print (the upper right corner and across the bottom) appear to have been printed from a few unpolished etched areas.

April 1941 marked the last of the auctions in which Rosenwald made major Blake acquisitions. On the block at Parke-Bernet was the library of A. Edward Newton, another suburban Philadelphia collector, and Rosenwald acquired several lots. Included among his purchases were a number of items for another important aspect of his rare books library, the incunabula, as well as several beautiful works by Blake. One of these was *The Great Red Dragon and the Woman Clothed with the Sun* (fig. 16-18c). This was the second of the two Blake watercolors from his dramatic series of subjects based on the Book of Revelations (done c. 1805-1809 for his early patron Thomas Butts) that Rosenwald acquired. Rosenwald's Blake collection was virtually completed with his 1951 purchase of *The Last Supper*, a tempera painting on canvas (one of two in the collection), acquired from the William Blake Trust in London of which he was an Associate Trustee.

As demonstrated by *The Chaining of Orc*, the unusual techniques that Blake employed in his work make much of his printed art as unique as his drawings and paintings. Rosenwald's Blake collection is exemplary in its range and therefore holds a place of special importance within the collection as a whole.

REFERENCE: Fine-Lehrer, "Blake Checklist"

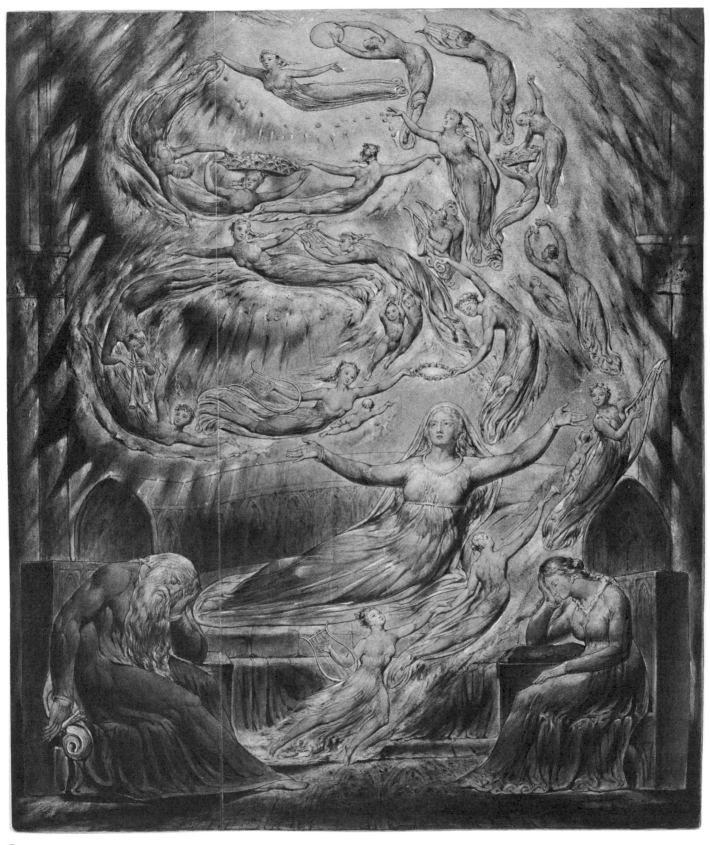

Cat. no. 17

18

The Chaining of Orc, 1812

Open plate etching with stipple
11 x 8 (4�5⁄16 x 3⅛)
Keynes *Separate Plates*, xvvi; Essick *Separate Plates*,
xvii (forthcoming)
PROVENANCE: G. A. Smith (Christie's, 1 April 1880,
no. 168); W. Muir(?); B. B. MacGeorge (Sotheby's, 1
July 1924, no. 133); Maggs Bros., cat. 456, item 53
(1924); G. C. Smith, Jr. (Parke-Bernet, 2 November
1938, no. 42); purchased from The Rosenbach Com-
pany, 1938; presented to NGA, 1943
B-11,040

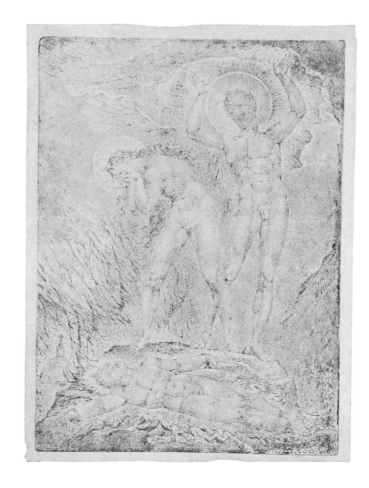

CHARLES MERYON
French, 1821-1868

19
College of Henry IV, 1864

Etching
22.2 X 41.4 (8¾ x 16⁵⁄₁₆)
Delteil 43 I/XI
PROVENANCE: P. Burty (Lugt 2071); Seymour Haden;
L. R. Garnier (Lugt 2211); unidentified collector's
stamp; Cortlandt F. Bishop (American Art Association,
Anderson Galleries, 19 November 1935, no. 138);
purchased from Charles Sessler, 1935; presented to
NGA, 1943
B-8658

Rosenwald's Meryon collection is splendid, consisting of approximately seventy-five etchings, many in multiple states, as well as the copper plate for *Fluctuat Nec Mergitur* (Delteil 22). Like so many aspects of his collection, the Meryon purchases were concentrated in 1928, but there were extensive additions of importance in later years, particularly from the collections of Cortlandt F. Bishop (1935), Clendenin J. Ryan (1940), and Joseph H. Seaman (1948).

All of the prints shown here were among the later Meryon acquisitions. The rare first state proof of *The College of Henry IV* is one of three different impressions of the subject in the collection. All of them were purchased at the Bishop sale. The beautiful impression of *The Petit Pont, Paris*, printed on greenish paper, and the first state of *The Morgue* as well as an impression of *The Gallery, Notre-Dame, Paris* (Delteil 26), not on exhibition, came from the distinguished Seaman Collection, which also was the source of Rosenwald's *Nocturne: Salute* (Kennedy 226) by Whistler. Rosenwald did have some bad luck at the Seaman sale, however, losing two other prints for which he placed bids: Whistler's *The Church, Amsterdam* (Kennedy 411), which he never acquired, and Rembrandt's *Landscape with Sportsman and Dogs* (Hollstein 211). An impression of this subject, formerly in the Liechtenstein Collection, was eventually acquired from Richard H. Zinser in 1953.

20

The Morgue, 1854

Etching (before the addition of drypoint)
23.2 x 20.8 (9⅛ x 8³⁄₁₆)
Delteil 36 I/VII
PROVENANCE: J. Niel; A. W. Thibaudeau (Lugt 2412);
B. B. MacGeorge; A. W. Scholle (Lugt supp. 2923ª);
J. H. Seaman (Parke-Bernet, 1 December 1948,
no. 138); purchased from Charles Sessler, 1948; presented to NGA, 1949
B-15,213

21

The Petit Pont, Paris, 1850

Etching and drypoint
25.8 x 18.8 (10⅛ x 7⁷⁄₁₆)
Delteil 24 III/VIII
PROVENANCE: J. Niel (his stamp as librarian of Ministère de l'Intérieur on mount); A. W. Scholle (Lugt supp. 2923ª); unidentified collector's stamp; J. H. Seaman (Parke-Bernet, 1 December 1948, no. 128); purchased from Charles Sessler, 1948; presented to NGA, 1949
B-15,215

22

The Apse of Notre-Dame, Paris, 1854

Etching
16.5 x 30 (6½ x 11¹³⁄₁₆)
Delteil 38 I/VIII
PROVENANCE: J. Niel; J. J. Heywood; B. B. MacGeorge;
A. Curtis; A. W. Scholle (Lugt supp. 2923ª); Hôtel
Drouot, 2 June 1955, no. 156; purchased from Henri
Petiet, Paris, 1955; presented to NGA, 1958
B-21,968

Long before the purchase of the Seaman green paper copy of *The Petit Pont, Paris* in 1928, Rosenwald had acquired a fine impression of the earlier second state of the subject. That year, too, he purchased a third state of *The Morgue*, a presentation proof inscribed to Gustave Salicis, Meryon's close friend. Both of these early acquisitions, along with one of the two Rosenwald impressions of *Tower of Rue Tixeranderie* (Delteil 29) were hanging in the collector's dressing room where he could study and enjoy them frequently.

Rosenwald's extensive Meryon collection includes fifteen subjects in more than one impression, generally in different states like the instances mentioned above. Most special to him among these were his two impressions of *The Apse of Notre-Dame, Paris*, both of which would be attractive to any print connoisseur. The first state, seen here, with the work incomplete throughout the image, is thought to be unique. Of particular interest is the absence of any indication of sky, the buildings behind the cathedral, and parts of the cathedral itself, especially as these areas are seen in contrast to other areas of the plate which have been quite thoroughly worked.

The Rosenwald impression of the third state of *The Apse* (fig. 19-22a), with the subject virtually complete, is also quite special. The impression is a particularly rich one, with a film of surface tone accenting many areas of the plate—the sky behind the clouds, for example, and the reflections in the water. In addition, an inscription by Auguste Delâtre, Meryon's printer, on the verso of the sheet translates: "Fourth proof. The most beautiful that I have printed from this plate."

Meryon drawings purchases, like the prints purchases, were concentrated in 1928. Four pencil studies for *The Petit Pont, Paris* and two for the *College of Henry IV* (fig. 19-22b) are among fourteen

Fig. 19-22b. Study for *College of Henry IV* (upper left corner), 1863. Pencil and sanguine. B-8698.

Cat. no. 20

drawings, mainly pencil studies for etchings, purchased that year. Two additional drawings were acquired in 1929, and the seventeenth and last, the study for *Grenier Indigènes et Habitations à Akaroa* (Delteil 70), from the Bishop Collection, was acquired in 1935.

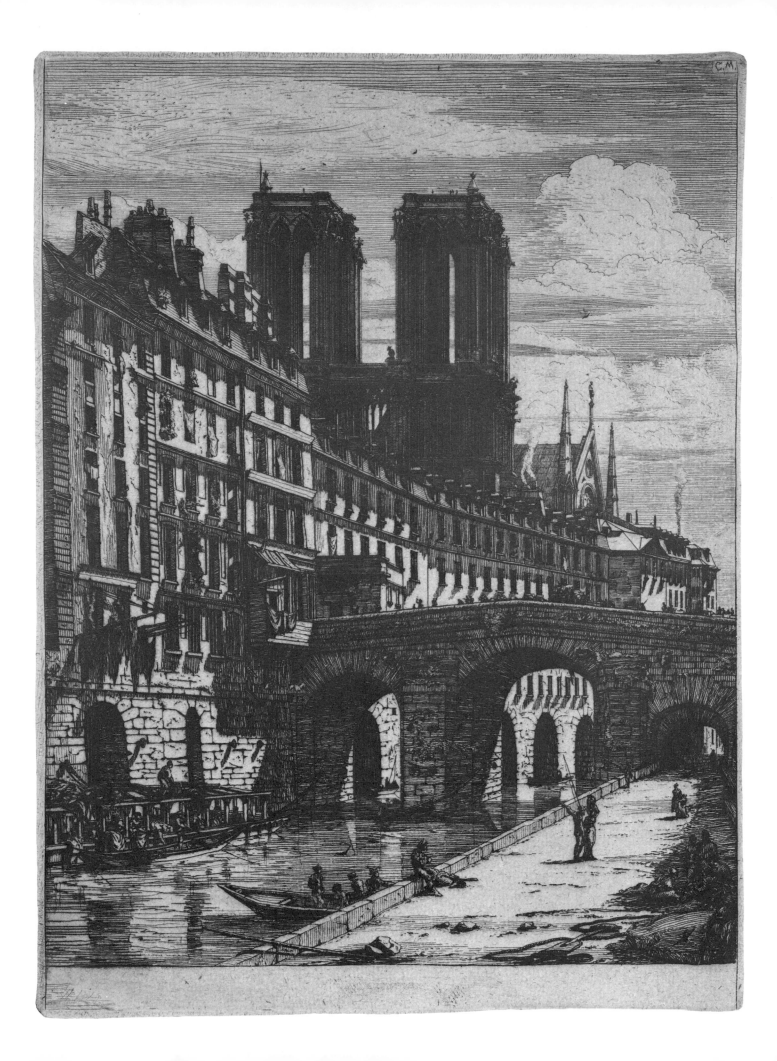

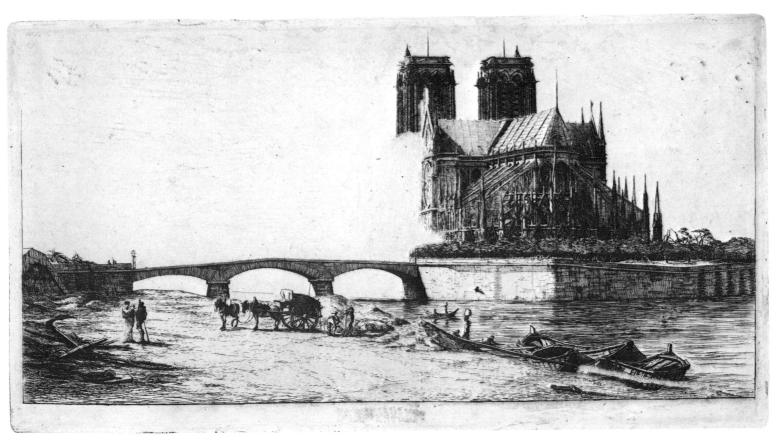

Cat. no. 22

Fig. 19-22a. *The Apse of Notre-Dame, Paris*, 1854. Etching. B-8671.

Cat. no. 21

PART II
The Foundation Years

DAVID YOUNG CAMERON
Scottish, 1865-1945

23
Royal Scottish Academy, 1916

Etching
18 x 35.3 (7¹⁄₁₆ x 13⅞)
Signed lower right in pencil: *D.Y. Cameron.*
Rinder 464 III/III
PROVENANCE: Purchase untraced; presented to NGA,
1943
B-5556

24
The Hills, 1925-1930(?)

Watercolor over pencil
31.5 x 20.7 (12⁷⁄₁₆ x 8⅛)
Signed lower right in brown paint: *DY. Cameron*
PROVENANCE: Purchased from Charles Sessler, 1930;
presented to NGA, 1943
B-5680

MUIRHEAD BONE
Scottish, 1876-1953

25
Spanish Good Friday, 1925-1926

Drypoint
32.2 x 24 (12¹¹⁄₁₆ x 8)
Signed lower right in pencil: *Muirhead Bone*; inscribed
in black crayon as described below
Produced later than Dodgson's catalogue raisonné and
supplement
PROVENANCE Purchased from Arthur H. Harlow &
Co., 1938; presented to NGA, 1943
B-5153

Rosenwald remembered his first print purchase to be his third state impression of D.Y. Cameron's *Royal Scottish Academy* (an impression of the scarce second state, of which only three or four impressions are known, was acquired somewhat later, in 1930). The Cameron etching apparently had attracted Rosenwald's eye as he was walking by the window of Sessler's bookshop in center-city Philadelphia. Sessler's records help to confirm this. Their accounts of Cameron sales to Rosenwald actually begin on 11 March 1927, but above the listing for that date is the note, "Has R.S.A." In any case, from the time of the 11 March sale, Sessler's sales to Rosenwald of Cameron prints and drawings (like the firm's other sales to the aspiring collector) appear to have been carefully listed, and one sees that they were made very frequently. The same was true for the work of Cameron's Scottish contemporaries, Muirhead Bone and James McBey, and fine representations of their work are to be found in the collection as well.

Rosenwald acquired about four hundred etchings and drypoints by D.Y. Cameron, including eighteen undescribed sheets, not included in the five hundred listed by Rinder in 1932. He also acquired sixty drawings and watercolors. They range from almost abstract landscapes such as the moody sheet *The Hills* to very carefully delineated street scenes.

Muirhead Bone is represented by more than two hundred prints, including his war lithographs. *Spanish Good Friday* is perhaps the artist's most dramatic and best-known subject, and the Rosenwald impression, a particularly fine one, was acquired in 1938 in exchange for another that had been bought in 1927. Of added interest are the artist's signed annotations: in the lower left, "This plate was made from a sketch done at Ronda on my first visit to Spain," and in the lower right, "This is a very fine impression of this state the contrast in lighting is especially good." Rosenwald also acquired more than 150 of Bone's watercolors and drawings, representing his extensive travels, including scenes from Italy, Spain, the Near East, France, England, and the United States.

James McBey (1883-1959), too, is well represented in the collection by both etchings and drypoints (about 200) and drawings and watercolors (about 75). About 1930, through Sessler's efforts, Rosenwald commissioned prints by both Cameron and McBey. The McBey was a portrait etching of the collector (fig. 23-25a) for which the artist executed at least two drawing studies during a December 1930 visit to Philadelphia (see frontispiece). When the etching was completed the following year, Edith Rosenwald, the collector's wife, found it most unflattering (although later her response was far less negative), and she requested that the edition not be distributed. Rosenwald agreed but made a few exceptions for people and institutions who he felt should have impressions so that their collections of McBey's work would be as complete as possible; among these was Martin Hardie, McBey's cataloguer. The print also came to the attention of Malcolm C. Salaman, who was so impressed with it that he included the *Portrait of Lessing J. Rosenwald* in his volume *Fine Prints of the Year, 1931*—hardly the way to keep the subject out

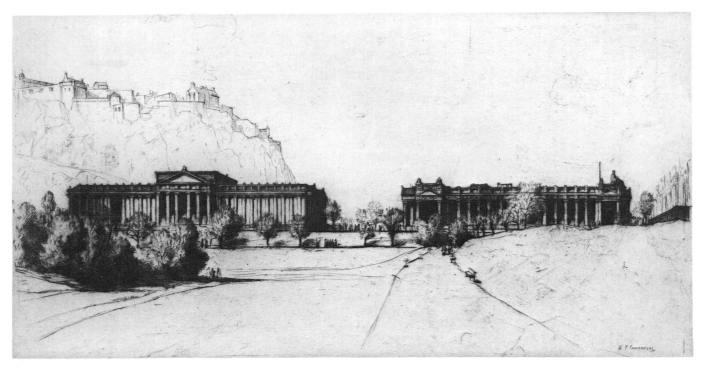

Cat. no. 23

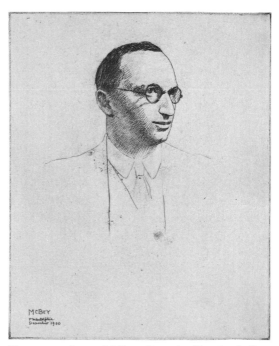

Fig. 23-25a. James McBey. *Portrait of Lessing J. Rosenwald*, 1930. Etching. B-8565.

Fig. 23-25b. James McBey. *Portrait of Lessing J. Rosenwald*, 1930 (cancellation proof). Etching with drypoint cancellation. B-31,645.

of the public eye. The copper plate for the portrait is now in the National Gallery's collection, as are a group of trial proofs and two cancellation proofs (prints showing that the plate had been defaced so that no further good impressions could be pulled). The cancellation proofs (fig. 23-25b), in which the head is effaced, also have as part of their cancellation demonstration the inscription "I PRINTED THIS/ L.J.R./ 1/25/31," indicating Rosenwald's active participation in the project.

The Cameron commission was for the *Bookplate of Edith and Lessing Rosenwald* (fig. 23-25c). In what appears to be an unsigned typed transcription of a letter from Cameron's representative in Great Britain, the bookplate is described as follows: "The idea is that the two roses are the two people and they are united below in the one big rose bound together by the outside structure of the design. The landscape of 'Ben Lomond' is, as you know, at the request of Mr. Rosenwald." The bookplate was printed in Scotland in an edition of sixty-two signed impressions and then was steel-faced to protect the image for the unsigned edition of one thousand. Another signed edition after steel-facing of forty-five may also have been issued.

Many of the prints by Cameron, Bone, and McBey are first states, or presentation proofs, or otherwise particularly rare subjects or unusually fine impressions. Almost all of the work, both prints and drawings, by the three was acquired from Sessler, with Rosenbach also an important source. A few sheets came from Frederick Keppel and Knoedler and Co. Occasionally large lots were purchased: ninety-two Cameron prints were bought at one time, and, at another, fifty-two Bone drawings. Mixed lots, too, were acquired, with drawings by all three artists, and, at times, others as well, such as Frederick L. M. Griggs (see fig. 30a). Almost everything for which purchase dates can be verified was bought by 1931. A few McBeys were acquired in the late 1930s, including some from the Cortlandt F. Bishop sale in 1935. The latest work by McBey to enter the collection was executed in 1942. About ten Bones also were added in the late 1930s. Some of them were acquired almost immediately after they were produced. And the last print by D. Y. Cameron to enter the collection was a gift from a Scottish visitor to Alverthorpe. It was an impression of A *Stairway in Genoa* (Rinder 211A), acquired in 1974.

Fig. 23-25c. D. Y. Cameron. *Bookplate of Edith and Lessing Rosenwald*, 1930. Etching. B-5614.

Cat. no. 24

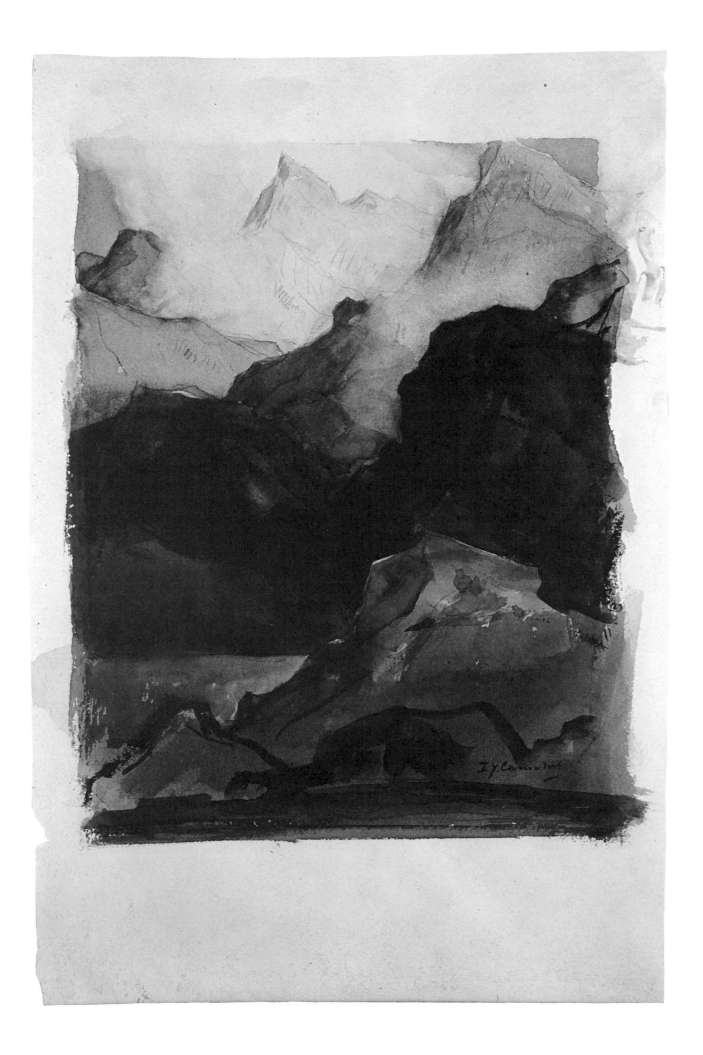

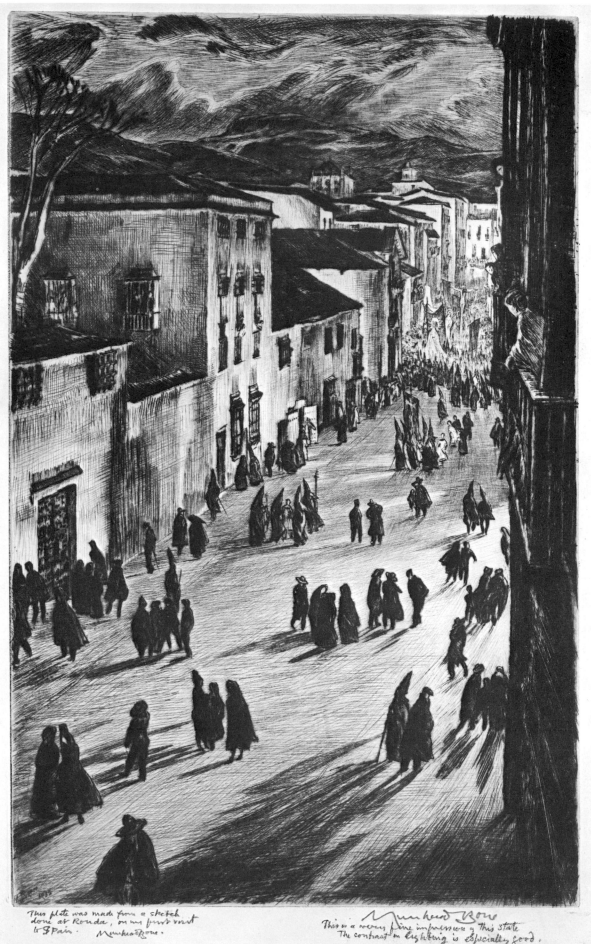

This plate was made from a sketch
done at Ronda, on my first visit
to Spain. Muirhead Bone.

Muirhead Bone

This is a very fine impression of this state
The contrast in lighting is especially good.
Muirhead Bone.

Cat. no. 25

FRANCIS SEYMOUR HADEN
British, 1818–1910

26

Breaking Up of the Agamemnon,
1870

Etching, printed in brown
19.5 x 41.3 (7⅝ x 16¼)
Signed lower right in pencil: *Seymour Haden*; inscribed
as described below
Harrington 145 II/II, trial proof
PROVENANCE: Purchased from Charles Sessler, 1928;
presented to NGA, 1943
B-7374

Seymour Haden was Whistler's brother-in-law and a surgeon by profession, but he managed to complete approximately 250 etchings, drypoints, and mezzotints. His writings and lectures on the subject of etching made him an important force in the growing popularity of the medium with both artists and collectors at the end of the nineteenth century.

Breaking Up of the Agamemnon has always been one of Haden's best-known and best-loved etchings. In 1911 Frederick Wedmore described the print in his book *Etchings* (143) as "among the great etchings of the world," and fifteen years later, Frank Weitenkampf, quoting Wedmore's comment, reinforced the praise by including the *Agamemnon* in his book *Famous Prints*. The Weitenkampf book wielded some influence on Rosenwald's earliest purchases; this might be a case in point. The collector apparently concurred with the critics, and he annotated the entry for this subject in his own working copy of Weitenkampf as follows: "I have a glorious impression— many say the most brilliant of this one they have ever seen. Traded a poorer one for this one with Sessler in 1927. It is hanging in my office in Chicago. One of my favorites."

Over the years Rosenwald actually acquired four different impressions of the *Agamemnon* print, and in reference to the particular sheet exhibited here, the collector's annotation in Weitenkampf continues, "I also have a unique proof with the following inscription in Haden's handwriting: '1st (imperfect) proof 2nd state of Agamemnon printed naturally to show real state of plate by Seymour Haden. Ink not yet in lines.'" By "printed naturally to

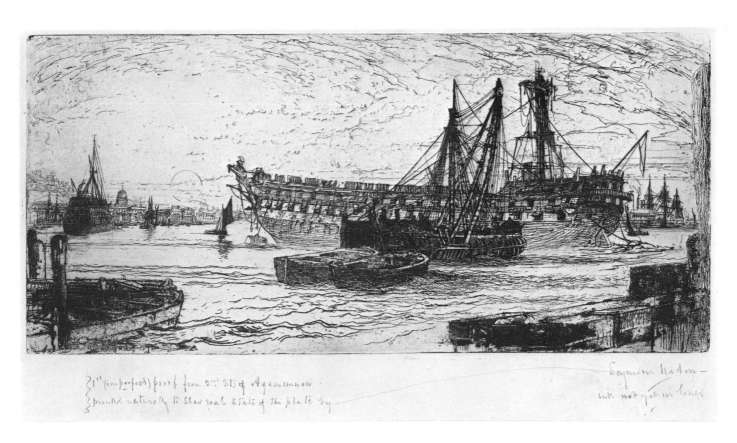

93

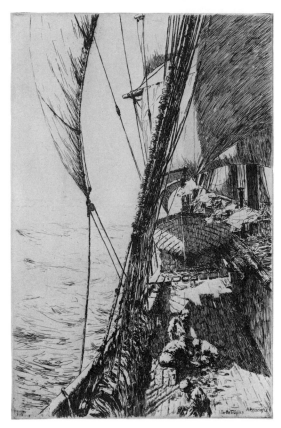

Fig. 26a. Arthur J. T. Briscoe. *In the Tropics*, 1928. Etching. B-3830.

show real state of plate," Haden meant that the plate surface was wiped cleanly so that all of the etched lines were clearly readable as sharp lines, rather than softened by means of a residue of ink pulled from the lines onto the plate directly surrounding them (*retroussage*). This latter method was frequently used to enhance the dramatic tonal possibilities of the etching medium, but it somewhat obscured the actual lines that had been etched into the plate, making it difficult for the artist to see the progress of his or her work.

In addition to his four impressions of *Breaking Up of the Agamemnon* (the last acquired in 1939), Rosenwald purchased fifty-two other Haden etchings, several in scarce or unique trial proof states. Three of the prints were purchased in the late 1930s, but the rest of them were acquired much earlier, between 1927 and 1930 (perhaps even earlier given the remarks quoted above indicating that in 1927 Rosenwald traded an impression for one he already owned; however, no record of an earlier purchase has been located). Almost all of the Haden prints were purchased from Sessler, also the source of a Haden pencil study for the etching *Griff* (Harrington 89) in 1929 and an album containing twenty-four individually mounted studies, mainly of landscapes, the following year. No Haden drawings were added to the collection after 1930.

Breaking Up of the Agamemnon, of which there are two versions, is an unusual theme for Haden, whose subjects most often were landscapes, similar to those in the drawings album. Another British artist somewhat younger than Haden, Arthur John Trevor Briscoe (1873-1943), however, is known for his etchings of the sea, particularly focusing on the heroic aspect of man's encounter with nature. Briscoe's work, like Haden's, was represented in the Rosenwald Collection from the very start. Between 1926 and 1931, thirty-eight etchings were acquired. *In the Tropics* (fig. 26a) is typical. Seven of Briscoe's drawings and watercolors of similar subjects are in the collection as well. All but one, acquired in 1938, were purchased in 1930.

JAMES ABBOTT MCNEILL WHISTLER
American, 1834-1903

27
Long House—Dyer's—Amsterdam, 1889

Etching and drypoint, printed in brown
16.6 x 26.9 (6½ x 10⅝)
Signed lower left in pencil with Whistler's butterfly tab
signature and inscribed on verso: *for Wunderlich*
Kennedy 406 III/III
PROVENANCE: H. Wunderlich; purchased from Charles
Sessler, 1928; presented to NGA, 1943
B-10, 706

Between 1927 and 1949 Rosenwald acquired approximately 300
impressions of Whistler's etchings and drypoints as well as the copper
plates for two of them: *St. James's Street* (Kennedy 169) and *Florence
Leyland* (Kennedy 110). During this same period he also assembled
more than 170 impressions of the artist's approximately 200
lithographs.

Most of the etchings were actually acquired in 1928 and 1929,
primarily from Sessler and Rosenbach. The early purchases spanned
the artist's career, forming almost immediately a comprehensive
collection of Whistler etchings that included several of the late rare
Amsterdam subjects. Among the most beautiful of these is the *Long
House—Dyer's—Amsterdam*, with its typically Whistlerian façade of
doorways and windows framing the activities of the women and
children, the flowers growing in the window boxes, and the laundry
blowing in the wind. Whereas in his earlier Venetian series (see cat.
nos. 84-85) Whistler relied on the use of plate tone for such
atmospheric effects as the reflections in the canals, in these late
Amsterdam prints the softly modeled reflections are carefully etched
into the plates themselves.

After the 1920s, the most important group of Whistler's etchings to
be added to the collection came from the January 1949 Parke-Bernet
sale of the late Harris Whittemore's etchings. Approximately thirty-
five of Whittemore's Whistler sheets were purchased at this time.

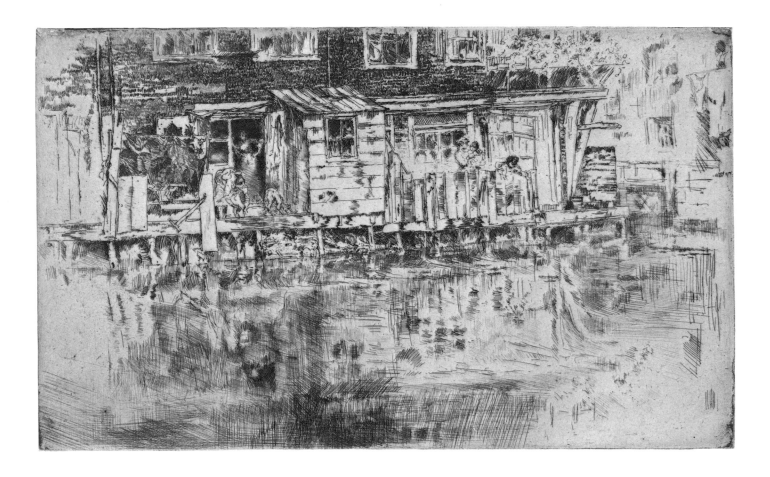

28
Drury Lane Rags, 1888

Transfer lithograph, hand-colored with colored pencils
15 x 16.5 (5¹⁵⁄₁₆ x 6½)
Signed lower left in pencil with Whistler's butterfly
signature
Way (1905) 14
PROVENANCE: Purchased from The Rosenbach Company, 1930; presented to NGA, 1943
B-10,745

Rosenwald also acquired from this sale two caricatures of Whistler, three prints by Mary Cassatt, and two drypoints by Marcellin Desboutin—portraits of Degas and Renoir (the only other Desboutin in the collection is a drypoint portrait of Vicomte Lepic, who taught Degas to make monotypes as seen in cat. no. 66). Degas's *The Actress's Dressing Room* (Delteil 28) in the rare third state was acquired at this part of the Whittemore sale as well. Most of the Whittemore Whistler acquisitions were either very rare subjects such as *Traghetto, No. 1* (fig. 27-28a), inscribed "first proof" by the artist,

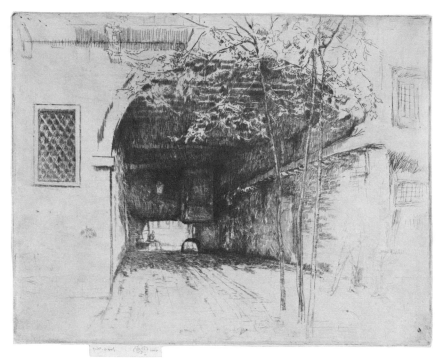

Fig. 27-28a. *The Traghetto, No. 1*, 1879. Etching. B-15,855.

who destroyed the plate after very few impressions to begin the second version, or subjects in rare early states, many of which formerly had been in the collection of Howard Mansfield, one of Whistler's early cataloguers.

So far as the Whistler lithographs are concerned, the years 1928 (from Sessler), 1930 (from Rosenbach), and 1946 (again from Sessler) marked the most significant numbers of purchases. The single 1948 lithograph acquisition was Whistler's first known work in the medium, *Song of the Graduates*, made while the artist was a cadet at the United States Military Academy at West Point.

Many of Whistler's lithographs were issued in very small editions (although some were reprinted after his death), and Rosenwald was fortunate to locate the rare lifetime impressions. He also acquired impressions of all of Whistler's known color lithographs as well as an impression of *Drury Lane Rags*, never printed in color, but here hand-colored by the artist in the delicate manner one associates with both his pastel drawings and his color lithographs.

The collection also includes seventeen Whistler drawings. Employing various media—pen and ink, pencil, chalk, pastel, and

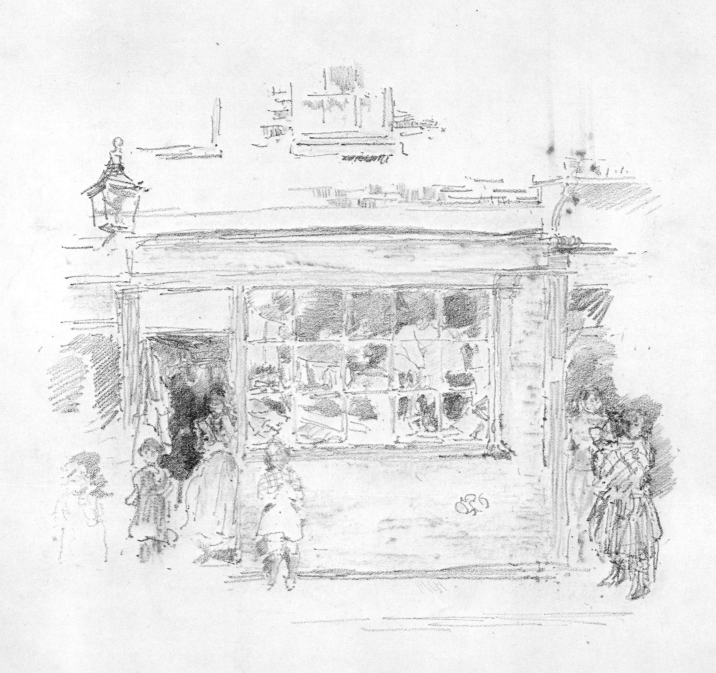

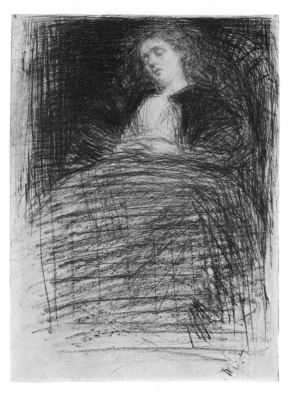

Fig. 27-28b. Study for *Weary*, c. 1860-1863. Black crayon. B-15,136.

crayon—most of them are sketches, mainly of figures. Several are related to specific paintings and prints by the artist. All but three of the drawings were purchased by 1930, the others, in 1937, 1938, and 1948. The last acquisition was one of two black crayon drawings for Whistler's etching *Weary* (fig. 27-28b), the other being in the Sterling and Francine Clark Art Institute in Williamstown, Massachusetts. The Rosenwald *Weary* study was formerly owned by Harris Whittemore.

The Whistler material was exhibited publicly for the first time at the Free Library of Philadelphia in 1931. In addition to the etchings (262 at the time), lithographs (144), and drawings (12), the exhibition included two paintings, *Arnold Hannay* and *Peach Blossom* (since reattributed to Beatrix Whistler, James's wife), now in the National Gallery collection, and two manuscripts and 202 autograph letters, receipts, telegrams, etc. This latter material is now at the Library of Congress along with the splendid Whistler reference library that Rosenwald formed.

Given the extensiveness of Rosenwald's Whistler collection, it is important to realize that completeness was not one of his goals. He simply did not buy images that did not appeal to him. For example, in Rosenwald's marked copy of the 1948 Parke-Bernet sale catalogue of Joseph Seaman's collection, from which he purchased Whistler's *Nocturne: Salute* (Kennedy 226), *Finette* (Kennedy 58) is annotated "Do not care for," and although it generally is considered one of Whistler's important etchings of a formally dressed standing female figure, it never became part of Rosenwald's collection.

JOSEPH PENNELL
American, 1860-1926

29
The Little Fête, Athens, 1913

Lithograph
42.3 x 55.5 (16⅝ x 21¾)
Signed lower center in pencil: *J Pennell*
Wuerth *Lithographs* 349
PROVENANCE: Purchased from Charles Sessler, 1928;
presented to NGA, 1943
B-9256

The Little Fête, Athens is one of 161 Pennell lithographs purchased as a lot in January 1928. From the group, Rosenwald gave 26 prints (the *Panama Series*) to another collector, retaining 135 for himself. A few months later, in April, he purchased a second large lot (75 prints) of Pennell lithographs, and several more were added in late 1928 and during the first few months of the following year. By 1930, 227 Pennell lithographs were in the collection, and no further additions were made in later years.

Eighty-two of the prints were sent to New York in 1930 to be photographed for reproduction in Louis A. Wuerth's *Catalogue of the Lithographs of Joseph Pennell*. In a letter to Rosenwald (27 October 1930) Wuerth noted, ". . . in practically every instance, your prints are of exceptional quality, this is especially true of the Greek Temples of which there are thirty-two, much the largest group I have seen together, and most of them are really superb in quality." *The Little Fête, Athens* is one of this set, although it is somewhat

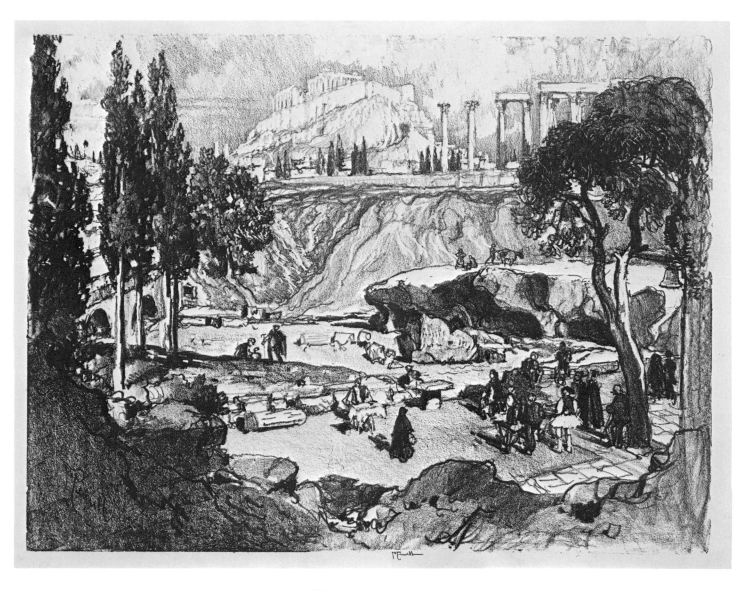

Fig. 29a. Study for *Le Stryge*, 1893(?). Pen and ink over pencil. B-9134.

atypical. Most of the prints in the series concentrate on the architecture of Greek temples, but *The Little Fête* subordinates the ancient ruins to the gala activity in the surrounding Arcadian landscape.

Apart from the *Greek Temples*, the Rosenwald Collection includes fine examples of Pennell's *New York, Yosemite Valley, Grand Canyon*, and *English* and *American War Work* lithographs, among others, and several of Pennell's Philadelphia interiors were hanging in Rosenwald's home at the time of his death.

Pennell was an extraordinarily prolific artist and illustrator, and in addition to 621 catalogued lithographs he produced more than 850 etchings, only 15 of which were acquired between 1928 and 1937 by Rosenwald, who was clearly more interested in the artist's lithographs. In 1930 he purchased his only Pennell drawing (fig. 29a), the pen study for the 1893 etching *Le Stryge*. Rosenwald acquired two impressions of the print (Wuerth 207). One of them, from the 1937 Louis E. Stern sale, inscribed "To Mrs. Gosse [an English acquaintance] from Joseph Pennell Dec. 1893," is a particularly rich impression in which the presence of a balloon in the sky indicates a state other than (and probably prior to) the state illustrated by Wuerth in his catalogue of Pennell etchings.

Joseph Pennell, like Seymour Haden before him, was a great champion of the art of the print, and one feels certain that had he lived beyond 1926, when Rosenwald was just becoming a serious print collector, the two men would have met. The next generation of American printmakers had John Taylor Arms (1887-1953) as its spokesman, and he and Rosenwald did establish some personal working contact. Five of Rosenwald's eleven Arms etchings and all four of his drawings were purchased from Grand Central Art Galleries in February 1937. Three of the four drawings were Arms's careful pencil studies for prints also acquired: *Venetian Mirror* (Arms 293), *Rio dei Santi Apostoli* (Arms 228), and *The Balcony* (Arms 239). The fourth, *Finchingfield* (fig. 29b), was sold to Rosenwald

Fig. 29b. John Taylor Arms. *Finchingfield* (study for *Reflections at Finchingfield*), 1936. Pencil. B-3926.

with the understanding that he would lend it to the artist when he wanted to make a print from it. Not long after, Arms retrieved it for several months in order to make the etching *Reflections at Finchingfield* (Arms 316).

In the margin below the drawing, in Arms's microscopic handwriting, one finds the following notes which he made to facilitate the execution of the print: "Finchingfield. The most beautiful village in Essex. The bridge is brick with stone coping and stone arch. The retaining wall at other side of stream is brick with stone coping. Two buildings at extreme left are brick. East shadows. Get texture everywhere. Stone strip at base of bridge, by water. Chickens in foreground. April 8, 1936." When the etching, complete with all of this detail, was finished in 1938, Arms presented a proof to Rosenwald inscribed "To Lessing Rosenwald with my best wishes and warm congratulations for all he has done to stimulate interest in etching in America."

GERALD LESLIE BROCKHURST
British, 1890-1978

30
Adolescence, 1932

Etching
36.8 x 26.5 (14½ x 10⁷⁄₁₆)
Signed lower right in pencil: *G.L. Brockhurst*
Wright 75 v/v
PROVENANCE: Purchased from Charles Sessler, 1937;
presented to NGA, 1943
B-3806

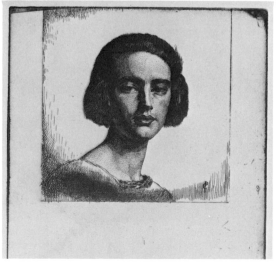

Like D. Y. Cameron and Muirhead Bone (cat. nos. 23-25), Gerald Brockhurst was counted among the popular British etchers of the 1920s, and his work, like that of the others, was applauded by the *Fine Prints of the Year* annual volumes as well as the important journal *The Print Collector's Quarterly*. In 1928, Rosenwald acquired his first six Brockhurst etchings and a single drawing, *Cypriano*, a pencil study for the print of the same title (Wright 59), also in the collection. During the next three years, two more Brockhurst etchings and three pencil drawings were added to Rosenwald's holdings. *Adolescence*, however, is one of four etchings and a sanguine drawing which were acquired in the late 1930s, after the quiet period at the early part of the decade during which virtually no purchases were made. These later Brockhurst acquisitions, reflecting Rosenwald's earliest print interests, were somewhat unusual for this period, when most of his collecting emphasis was either in the realm of the old masters or shifting toward modern French prints.

A spatially complex and psychologically intriguing study of a young woman before a mirror, *Adolescence* has in recent years become Brockhurst's most sought-after etching. It is an elaborate composition for the artist, however, who is best known for his sensitive and explicit portrait heads.

During his earliest years as a collector, Rosenwald also acquired prints and drawings by a number of other British contemporaries of Brockhurst: one finds more than thirty drawings and about forty-five etchings by Robert Sargent Austin, about fifteen prints each by Dame Laura Knight and Francis Dodd, more than fifty by Augustus John, including both etchings and lithographs, and about a dozen etchings and an equal number of drawings by Frederick Landseer Maur Griggs (1876-1938). In particular, Rosenwald was interested in drawings made as studies for prints; among his acquisitions was Griggs's *The Almonry* (fig. 30a), a pencil version of one of the artist's most favored etchings of the same title (Comstock 34).

Prints by all of these British contemporaries of Rosenwald were included in the December 1932 Lakeside Press Galleries exhibition of *Twentieth Century Prints from Several Important American Collections* which closely followed a large exhibition of prints from six centuries from Rosenwald's collection alone. Rosenwald was a major lender to this second exhibition, marking his place as an important collector of modern prints during the early years of his collection.

Purchases of work by all of these British artists, a focus of the collection during the late 1920s, ended about 1940, but as late as 1978, Rosenwald added a Brockhurst portrait, *Pepita* (fig. 30b), to the collection. One of three known proofs of the first state of the subject, *Pepita*, purchased from Zeitlen and Ver Brugge, was among Rosenwald's final acquisitions.

Fig. 30a. Frederick L. M. Griggs. Study for *The Almonry*, 1925. Pencil. B-7320.
Fig. 30b. *Pepita*, detail, 1922. Etching. B-31,634.

FÉLIX BUHOT
French, 1847-1887

31
Funeral Procession on Boulevard Clichy, 1887

Etching, acquatint, and drypoint with considerable use of the scraper, printed in blue and black
29.8 x 39.9 (11¾ x 15¾)
Signed and inscribed lower right in black chalk: *Trial proof* . . . [illegible] . . . *Felix Buhot*
Bourcard/Goodfriend 159 I/III
PROVENANCE: A. Beurdeley (Lugt 421); purchased from Charles Sessler, 1930; presented to NGA, 1943
B-3776

Although Félix Buhot studied painting and continued to paint, particularly in watercolor, throughout his life, his place as an artist is essentially based on his work as a printmaker. He experimented with lithography but executed fewer than ten prints in the medium; his true fascination was with the metal plate. Buhot etchings, like the *Funeral Procession*, generally are technically complex, combining etching with aquatint, engraving, drypoint, and roulette work, with the artist then working back into the plate by lightening areas through the use of the scraper and burnisher. Often, as seen here, impressions are subtly inked experimentally in color, with more than one color put through the press in a single run. Many elegant sheets also employ touches of gold. The *Funeral Procession* is typical of Buhot, whose most favored themes are street scenes, often with subtle reminders of mortality, either because of their mood, or because, as we see here, of their specific subjects. Also typical of Buhot is the use of the borders filled with remarques (brief sketches originally made at the edges of copper plates in order to test the strength of the etching acid) as part of his imagery. At times Buhot's borders are as highly developed as the central themes of his plates.

Rosenwald bought twenty prints by Buhot in 1928, and he added others in 1929, 1930, and 1936, eventually acquiring a total of thirty. He also acquired a single delicate, almost rococo, watercolor, one of the artist's designs for fans (fig. 31a).

Fig. 31a. Drawing for a fan. Watercolor over pencil. B-31,635.

Fig. 31b. Félix Bracquemond. *Portrait of Charles Meryon*, 1853. Etching. B-5210.

The collector's early enthusiasm for Buhot obviously waned, however, and apart from Charles Meryon (cat. nos. 19-22), Rosenwald never became particularly keen on the artists working as part of the nineteenth-century French etching renaissance. For example, fewer than ten prints and drawings by Félix Bracquemond (1833-1914), one of the foremost proponents of the movement, were acquired, and several of these Bracquemond purchases would have been important to Rosenwald for reasons other than his interest in

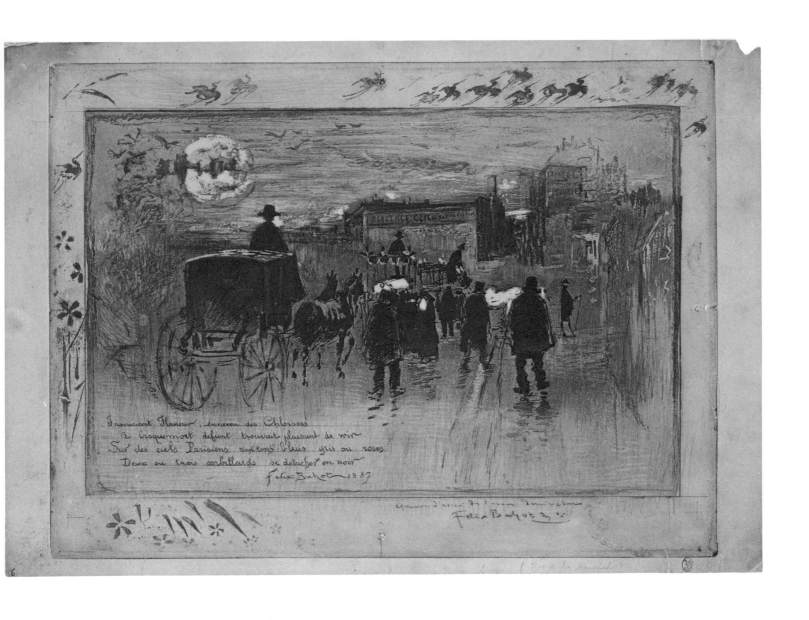

the work of the artist. Among them are the pencil and black ink study for *The Old Cock*, the Bracquemond print featured in Weitenkampf's *Famous Prints*, as well as two different states of the etching. As a group they would have fit Rosenwald's early pattern of buying, when possible, drawings and related prints; there are many examples of this tendency in the collection. On the other hand, the two different Bracquemond portraits of Charles Meryon (fig. 31b) that Rosenwald acquired no doubt were attractive because of his interest in the work of the sitter rather than the work of the artist.

105

JEAN-LOUIS FORAIN
French, 1852-1931

32
Standing Woman with a Fan,
1880-1890 (?)

verso: unfinished study of a standing man and woman
Watercolor with opaque white
44 x 31 (17⅜ x 12³⁄₁₆)
PROVENANCE: Purchase untraced, probably from
Charles Sessler prior to 1931; presented to NGA, 1981
B-31,642

The modern French artist most fully represented in the Rosenwald Collection is Jean-Louis Forain, whose work was almost as popular with American collectors at the time the collection was begun as the work of his British contemporaries discussed earlier. Rosenwald purchased his first Forain, an etching called *The Exit from the Courtroom* (Guérin 50) on 14 April 1928 (three other impressions of the subject were added over the years), and on that same day he bought the three catalogue volumes of the artist's prints by Marcel Guérin as well. From that time, almost monthly until November 1931, Forain paintings, drawings, and prints were acquired, mainly from Sessler, who apparently got many of them directly from the artist. A few items were added in the 1930s and 1940s, and some of these last purchases came from Jean Goriany, the New York associate of the French dealer Henri Petiet. Goriany was an important source for Rosenwald's purchases of twentieth-century French art during the early 1940s.

An undated list, which was probably compiled at the time the collection was exhibited at the Pennsylvania Museum of Art in November 1932, indicates that in addition to the prints and drawings, Rosenwald owned eleven Forain oil paintings. Several of them were dispersed to members of the Rosenwald family during the collector's lifetime, while seven were given to the National Gallery.

The Forain graphic arts collection is quite comprehensive. Approximately 100 etchings and 75 lithographs are included. Many are in trial proof states, and many are subjects undescribed by Guérin, whose catalogue was published in 1910, twenty-one years before the artist's death. In addition, Rosenwald also purchased about 250 watercolors and drawings—in pastel, crayon, ink, and pencil. Many of these are studies for prints and Forain's popular published caricatures. As a group they range from rapidly drawn brief sketches to more highly finished works, the most elegant of which is *Standing Woman with a Fan.* The subjects of the Forain drawings include vigorously biting genre scenes, war and courtroom scenes, and graceful ballet dancers.

Two other French artists of Forain's generation whose prints and drawings Rosenwald bought in large numbers during the years he was laying the foundation for his collection were Louis-Auguste Lepère (1849-1919) and Alphonse Legros (1837-1911). More than fifty

Fig. 32b. Alphonse Legros. *Death of the Vagabond.*
Etching. B-7887.

Fig. 32a. Auguste Lepère. *Paris in the Snow*, 1890. Wood engraving. B-8097.

Lepère etchings and six wood engravings, including *Paris in the Snow* (fig. 32a), as well as five drawings and watercolors, all landscapes, are in the collection. All but one etching, purchased in 1939, were acquired between 1929 and 1931.

Prints and drawings by Legros, who worked primarily in London, rather than in France, were acquired even more enthusiastically. About 135 etchings, drypoints, and lithographs, and more than 50 drawings—landscapes, figure studies, and mythological themes— entered the collection, again mainly prior to 1931.

The Legros which Weitenkampf included in *Famous Prints* was *Death of the Vagabond* (fig. 32b). Among Rosenwald's earliest Legros purchases, it was selected for many of the early Rosenwald Collection exhibitions. Lepère as well as Legros, both of whom had died some years before its 1926 publication, were featured by Weitenkampf in his influential volume. Forain and his somewhat younger British contemporaries Bone, Cameron, and McBey, on the other hand, still hard at work at the time, were not.

MASTER LCZ (LORENZ KATZHEIMER)
German, active c. 1480-c. 1505

33
Temptation of Christ, c. 1492

Engraving
22.7 x 16.5 (8¹⁵⁄₁₆ x 6½)
Lehrs 2; Shestack *Engravings* 125
PROVENANCE: Count Franz von Sternberg-Manderscheid, Prague; Friedrich August II of Saxony (Lugt 971); purchased from Charles Sessler, 1929; presented to NGA, 1943
B-11,149

MAIR VON LANDSHUT
German, active c. 1485-1510

34
The Nativity, 1499

Engraving, printed in black on green tinted paper with white and yellow highlights added with brush
21 x 13.6 (8¼ x 5⅜)
Lehrs 5; Shestack *Engravings* 142
PROVENANCE: C. G. Boerner, 5-7 November 1929, no. 427; purchased from Charles Sessler, 1929; presented to NGA, 1943
B-11,158

Within Rosenwald's splendid collection of fifteenth-century northern engravings are several extremely important sheets which, like the prints of Master E.S. mentioned earlier (cat. nos. 5-7), were among the collector's most prized possessions. Included are the sole prints in the collection by Master LCz and Mair von Landshut, both artists whose extant production is small and about whose lives very little is known for certain. The *Temptation of Christ*, acknowledged to be the masterpiece of LCz's twelve known prints, portrays the three-pronged temptation of Christ by Satan (gluttony, pride, and ambition) described in Matthew 4:1-11. Central is Christ's refusal (at the end of forty days of fasting in the wilderness) to turn stones to bread. At the upper right, in the background to the left of the dome of the temple, Christ is refusing Satan's request that he throw himself to the ground to prove that the angels would protect God's son from harm. At the upper left, Satan has taken Christ to a mountain to show him the riches of the world which would be his if he forsook his Lord for the Devil. The Rosenwald impression of the *Temptation of Christ*, in which the carefully engraved details of the richly foliated landscape, the ornamental architecture in the distance, Christ's serene expression, and the horrific beastlike personage of Satan are all clearly visible, is considered to be one of the richest of the subject.

In 1961 Rosenwald acquired a pen and ink drawing by Master LCz, *Gothic Ornament with a Lady and a Parrot*, possibly the only drawing by the artist to survive (see Alan Shestack, "A Drawing by Master LCz," *Burlington Magazine* 108 [July 1966]: 360,369).

Prints by Mair von Landshut, like those by the Master LCz, are few in number. His *Nativity*, set in a fanciful architectural environment, is one of only twenty-five (three woodcuts and twenty-two engravings) that are known to exist. Mair, a painter as well as engraver and woodcut designer, was a pioneer among artists in his experimentation with printing on especially prepared colored papers.

The use of these papers for printmaking, like the use of the relief printing method in Master E.S.'s white-line engraving described earlier (cat. no. 7) no doubt was an effort to imitate drawings of the period which often were executed on prepared paper and then heightened with white or pale colors. Mair's use of a similar method in his engravings anticipated the more widely used technique of the chiaroscuro woodcut which became popular in the following decade (see cat. no. 35).

Both the Master LCz and Mair von Landshut sheets were purchased in 1929, and they were exhibited in important Rosenwald Collection exhibitions right from the start. In addition, in 1941, they were among approximately one hundred prints from the collection that were included in *The First Century of Printmaking* exhibition held at the Art Institute of Chicago. In the preface to the catalogue of the exhibition, more than two-thirds of which was drawn from Rosenwald's collection, Carl O. Schniewind, Curator of Prints and Drawings at the Art Institute, wrote, "Considering quality, scope and rarity, an exhibition, such as this one is, has never before been seen in the United States." Schniewind went on to say that "Mr. Lessing

Fig. 33-34a. Master of the Bandaroles. *The Stoning of Saint Stephen* after Israhel van Meckenem, c. 1470-1475. Engraving. B-2760.

J. Rosenwald's contributions were numerous. He collaborated extensively in editing the catalogue and in selecting the prints to be displayed and in every way has been an enthusiastic supporter." Two years later, Mair's *Nativity* was also included in *Selections from the Rosenwald Collection*, the exhibition which marked Rosenwald's 1943 gift to the National Gallery of Art. Both of these prints were frequently shown in special exhibitions at Alverthorpe Galley.

Among the more than 250 engravings by more than twenty-five artists of this period in the collection, apart from those which are exceedingly beautiful, some are important in great part because they are thought to be unique impressions of the subjects. Among these is the Master of the Bandaroles's copy of *The Stoning of Saint Stephen* (fig. 33-34a) after Israhel van Meckenem, whose original is one of almost 100 van Meckenem engravings in the collection. The Bandaroles Master's *Saint Stephen* is one of two prints by him in the collection. It was discovered in 1912, pasted into an incunabulum in a library cloister in Upper Austria, a means by which many fifteenth-century prints have been preserved.

REFERENCE: Shestack, *Engravings*

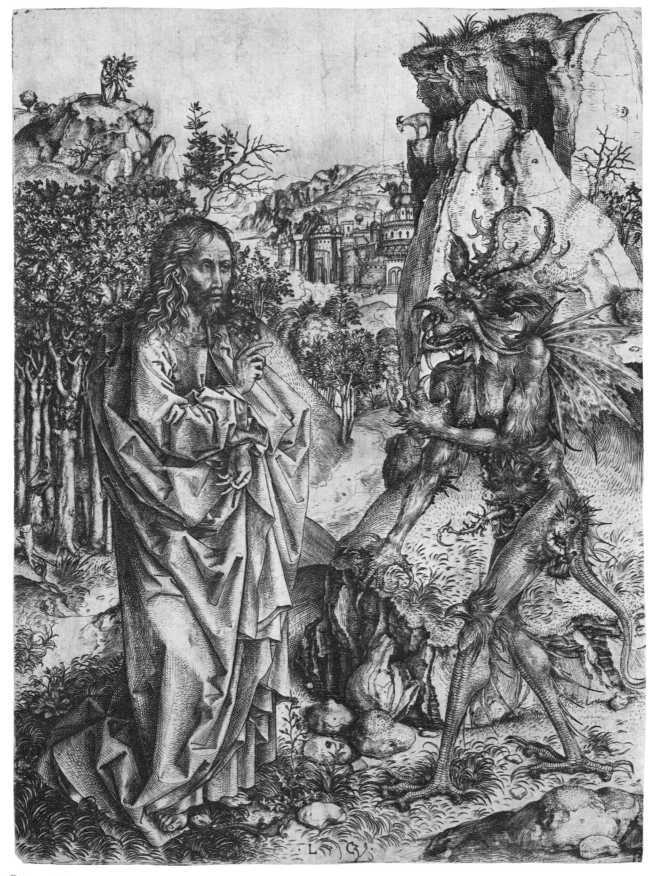

Cat. no. 33

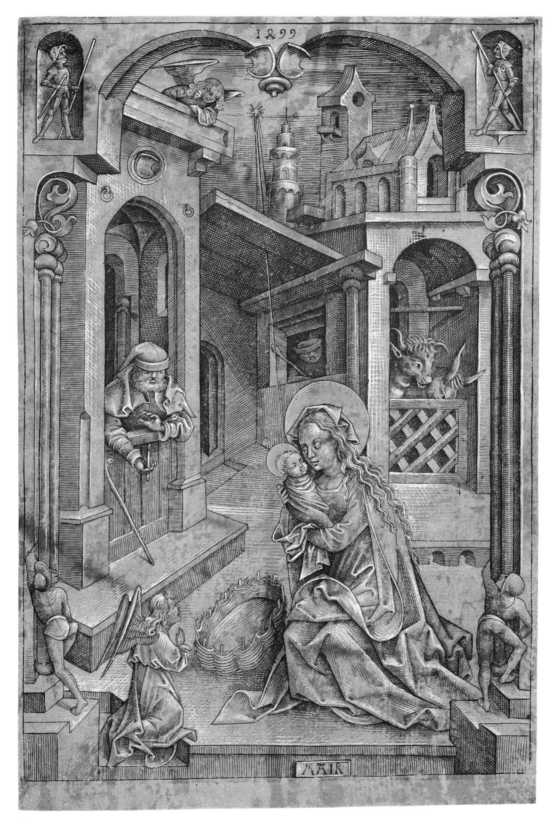

Cat. no. 34

HANS BALDUNG GRIEN
German, 1484/1485-1544

35
Crucifixion, c. 1511-1512

Chiaroscuro woodcut, printed in black and brown
37.4 x 26.2 (14¾ x 10⁵⁄₁₆)
Hollstein 11
PROVENANCE: Paul J. Sachs from whom purchased,
1938; presented to NGA, 1943
B-3457

Fig. 35a. Anonymous Swiss or German. *Christ Healing the Lame*, early 16th century. Watercolor with opaque white. B-11,084.

Chiaroscuro woodcuts are printed images made to resemble drawings, on dark prepared papers which were then heightened with white or another pale color. An example is *Christ Healing the Lame* (fig. 35a) from a series of anonymous drawings in the Rosenwald Collection. In comparing Hans Baldung Grien's chiaroscuro *Crucifixion* with the drawing, for example, we see that the white paper which remains after both the brown and the black blocks have been printed represents the drawing's white highlights. The brown tone block represents the dark ground on which the image was drawn, and the black or "key" block, as it is called, which carries the major composition of the image, is comparable to the black lines of the drawing. Historically certain printmaking processes have been used with such technical and formal consistency that the variations of time, place, and individual artistic temperament together take a place that is subordinate to the properties of the method. The chiaroscuro woodcut is among these, and Rosenwald acquired several important examples of this medium over the years.

The chiaroscuro woodcut process was developed and enjoyed a period of popularity at the start of the sixteenth century, first in Germany and shortly afterwards in Italy. Hans Baldung Grien's *Crucifixion* (one of thirty-six woodcuts and a single engraving by the artist in the collection) is one of two Baldung chiaroscuri among the fine selection of northern examples that Rosenwald acquired. In addition to the Baldungs, the collection includes two sheets by Hans Burgkmair, including *Emperor Maximilian on Horseback* (Hollstein 323), three by Hans Wechtlin (1460-1526) including *The Skull* (fig. 35b), two impressions of Lucas Cranach's *Saint Sebastian* (Hollstein 79), printed with two different color tone blocks, and the posthumous chiaroscuro impression of Dürer's *Portrait of Ulrich Varnbüler* (Hollstein 256). A number of other early sixteenth-century woodcuts known to exist in chiaroscuro impressions are in the collection, too, but printed from the black line block only and lacking the chiaroscuro tone block.

Sixteenth-century Italian chiaroscuri are represented by a few prints by Antonio da Trento and Andrea Andreani with no examples, for instance, by Ugo da Carpi, credited with introducing the medium to Italy, or by Parmigianino. The most spectacular of the Italian sheets is Andreani's *Triumph of Julius Caesar* (Bartsch 11), complete in nine panels with columns and title page, purchased in 1929.

After the early sixteenth century, interest in the chiaroscuro process was revived periodically, and Rosenwald acquired several very special pieces from a number of different periods. For example, the series of gods and goddesses by the Dutch mannerist Hendrick Goltzius is to be found in splendid impressions, as are his landscapes and seascapes. And the rare single chiaroscuro woodcut by Rembrandt's friend Jan Lievens, *Bust of a Balding Man* (Hollstein 106), was one of Rosenwald's early acquisitions as well.

Two important examples of Venetian eighteenth-century chiaroscuri are also represented. The first of these, acquired in 1936, is a copy of the John Baptist Jackson (1701? -c. 1777) volume *Titiani Vecelii, Pauli Caliarii, Jacobi Robusti et Jacobi de Ponte: opera*

selectiora a Joanne Baptista Jackson, Anglo, ligno coelata et coloribus adumbrata. Jo. Baptistam Pasquali, Venice, MDCCXLV. The volume includes seventeen chiaroscuro reproductions of paintings by various Venetian masters, and this particular copy was in the library of Joseph Smith, the famous connoisseur and British consul to Venice at the time the book was published and a patron of Jackson, who was also British. Smith's copy contained twenty-four loosely inserted sheets, all of them rare if not unique proofs of several images in early trial states, including the black proof of one block from *The Raising of Lazarus* after Leandro Bassano (fig. 35c). These proofs allow one to see very clearly the way an image is developed from several broadly cut blocks. For example, in the *Lazarus* print, the entire interior delineation of the main subject's body is lacking, and the image waits to be clarified by means of the other three blocks.

The other Venetian album comprises fifty prints including forty chiaroscuro woodcuts (Bartsch 1-40) by the publisher-printmaker Andrea Maria Zanetti. Many of the woodcuts are in first state impressions, and they are bound together with ten miscellaneous engravings by various artists published by Zanetti. The album was acquired from Pierre Bères in 1952, the year after Rosenwald purchased from the same bookseller two important albums of Tiepolo etchings formerly in Zanetti's distinguished collection (cat. no. 62).

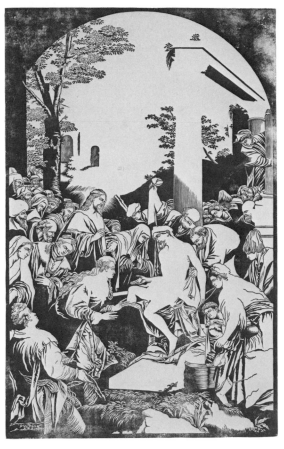

Fig. 35b. Hans Wechtlin. *The Skull*, c. 1512. Chiaroscuro woodcut. B-14,003.

Fig. 35c. John Baptist Jackson. *The Raising of Lazarus* after Leandro Bassano, 1742. Woodcut proof of one of four blocks used for the image. B-13,061.

Cat. no. 35

114

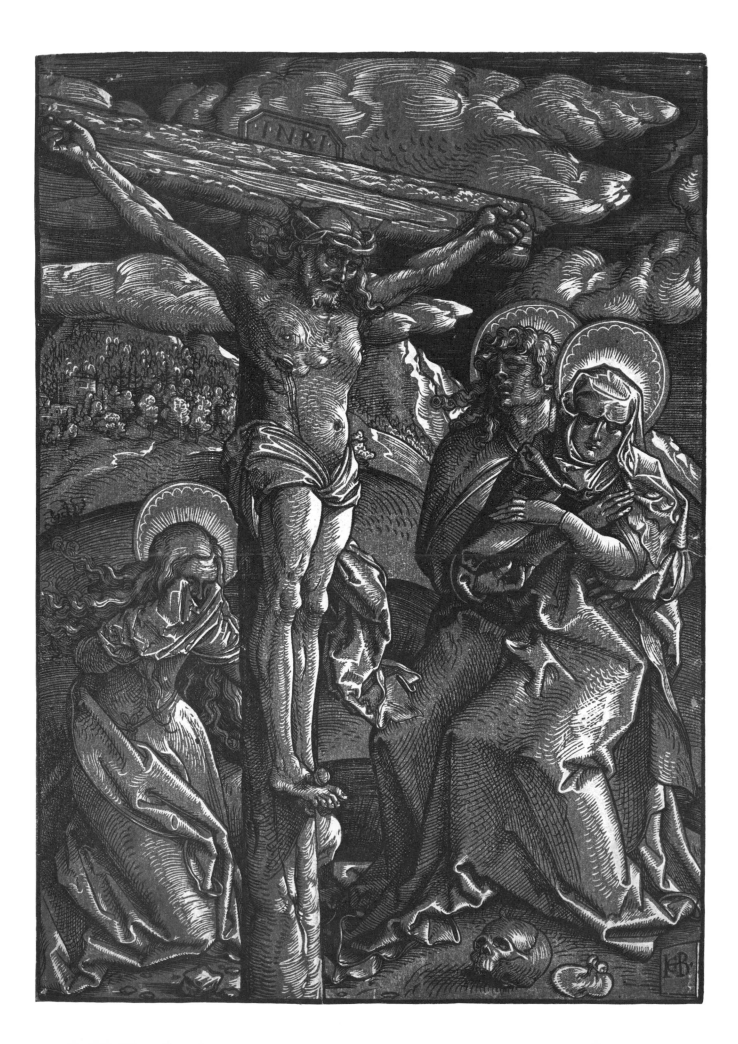

BARTEL BEHAM
German, 1502–1540

36
Saint Christopher, 1520

Engraving
6.9 x 4.8 (2¾ x 1⅞)
Holstein 11 II/II
PROVENANCE: Dresden Kupferstich-Kabinett (Lugt
1616, 1618); von Passavant-Gontard sale, Leipzig, 10
May 1929, no. 77; purchased from Charles Sessler,
1929; presented to NGA, 1943
B-3434

Fig. 36b. Hans Sebald Beham. *Double
Goblet with Two Genii*, 1531. Engraving.
B-3678.

Bartel Beham is one of a group of sixteenth-century German artists known as the Little Masters because of the tiny format of their work. The stimulus for this small-scale imagery apparently was transmitted to Germany through Albrecht Altdorfer's study of Italian nielli (see cat. no. 37). Prints by the Little Masters were among the earliest strengths of the Rosenwald Collection. Both Bartel Beham and his far more prolific brother Hans Sebald (1500–1550) were well represented by 1930, mainly from purchases made at the von Passavant-Gontard and Schloss "E" sales.

Saint Christopher, engraved when the artist was only eighteen years old, is one of twenty-seven prints in the collection by Bartel, whose work is more inventive as well as more difficult to find than his brother's. All but five of the prints were acquired early, and among the purchases from the von Passavant-Gontard sale was this second state of Saint Christopher. Most important among the few later acquisitions, however, was a rare first state of the subject (fig. 36a), before the inclusion of the tree against which the saint is meant to lean, the landscape with bushes and buildings in the distant background, the details of the sky, as well as additional work throughout the parts of the image already formed in the first state of the print. Included in the B. Beham collection, in addition to the religious subjects, are several portraits, as well as mythological and ornamental compositions.

The Rosenwald Hans Sebald Beham collection is quite substantial, consisting of about 175 engravings and a few etchings, as well as nineteen woodcuts. Religious scenes, genre scenes, and figure studies, at times with the erotic overtones typical of the Little Masters, are important, but the greater emphasis is on mythological themes, often in the form of friezes of figures and often in series—the Labors of Hercules, for example. Well represented, too, are ornamental motifs like the *Double Goblet with Two Genii* (fig. 36b), of the sort frequently made for craftsmen to use as working models for their designs.

The place in the Rosenwald Collection of some of the Little Master contemporaries of the Behams, such as Albrecht Altdorfer and Heinrich Aldegrever, is discussed elsewhere (cat. nos. 50, 78–79). Among the others collected are Virgil Solis and George Pencz, each of whom is represented by approximately thirty engravings.

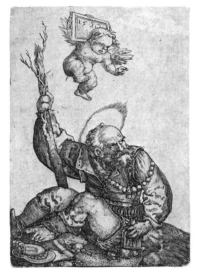

Cat. no. 36

Fig. 36a. *Saint Christopher*, 1520.
Engraving. B-4811.

MASO FINIGUERRA
Italian, 1426-1464

37
Cupid carrying a fowl accompanied by a dog, and another cupid playing a trumpet, c. 1450

Niello engraving
3.1 x 4.2 (1¼ x 1¹¹⁄₁₆)
Dutuit 405; Levenson, Oberhuber, Sheehan *Italian Engravings* 1
PROVENANCE: Purchased from Charles Sessler, 1929; presented to NGA, 1943
B-11,153

Cat. no. 37

This tiny image was printed from a metal plate engraved for ornamental rather than printing purposes. The term "niello" derives from the Latin world *nigellum*, which is a black powder composed of sulphur, several metallic ingredients, and borax. When applied to a heated engraved plate, the nigellum melts and flows into the engraved furrows, and then becomes hard upon cooling, like enamel. The surface of the plate is then cleaned and polished, and one is left with black enamellike lines forming a decorative image which stands out in contrast to the bright metal plate. These decorative plates were used to adorn crucifixes, reliquaries, and other ritual objects, as well as secular pieces, such as knife handles and buckles. Occasionally, however, during the working process the engraver would fill the incised lines in a plate with ink and take an impression on paper in order to study the progress of the engraved image.

The Florentine engraver of this cupids subject, Maso Finiguerra, was the foremost master of the niellists's art and is often referred to as the inventor of the art of engraving. Generally, nielli images were of an ornamental or genre nature, and authentic nielli prints are rather scarce. There are, however, numerous niello-like engravings, dating from the fifteenth and early sixteenth centuries, taken from plates conceived from the start to be printed, rather than to be used for decorative purposes. In addition, many pointedly fake nielli were produced in later centuries.

In the Rosenwald Collection, twenty-five prints are classified as nielli. Many, including Finiguerra's cupids, are excellent impressions from authentic nielli plates; several others are tentatively placed in the nielli category; and four have been catalogued as late eighteenth- and nineteenth-century fakes. Rosenwald often remarked that he personally thought even more of his nielli belonged in this latter group.

More than half of the Rosenwald nielli were purchased in 1928 and 1929. Among the later acquisitions was Peregrino da Cesena's (active c. 1419-1520 [?]) *Panel of Ornament with Satyress Feeding Two Children,* a print in the niello manner that came from the collection of Rosenwald's mentor, Paul J. Sachs (fig. 37a).

REFERENCE: Rosenwald, "Niello Prints"

Fig. 37a. Peregrino da Cesena. *Panel of Ornament with Satyress Feeding Two Children,* c. 1505-1520. Engraving in the niello manner. B-9052.

38
Adoration of the Magi (Virgin in the Grotto), c. 1475-1480

Engraving
39 x 28.2 (15⅜ x 11⅛)
Hind 13; Levenson, Oberhuber, Sheehan *Italian Engravings* 81
PROVENANCE: Friedrich August II of Saxony (Lugt 971); C. G. Boerner, 7-9 May 1928, no. 62; purchased from Charles Sessler, 1928; presented to NGA, 1943
B-3869

In addition to the nielli discussed in cat. no. 37, Rosenwald's early old master prints purchases included a number of other rare fifteenth-century Italian engravings, many, like the *Adoration of the Magi* seen here, from the collection of Friedrich August II. Prints by Giovanni Antonio da Brescia, Christofano Robetta, Benedetto Montagna, Master I•I•CA, and Domenico Campagnola were among them. Also included were a number of sheets by both the Master of the E Series Tarocchi (active c. 1465) and the Master of the S Series Tarocchi, the two mysterious sets of fifty engravings whose iconography relates to the conditions of man, Apollo and the muses, the liberal arts, cosmic principles, and firmaments of the universe (see Levenson, Oberhuber, and Sheehan, 81-157). One of these is *Polimnia* XV (fig. 38a).

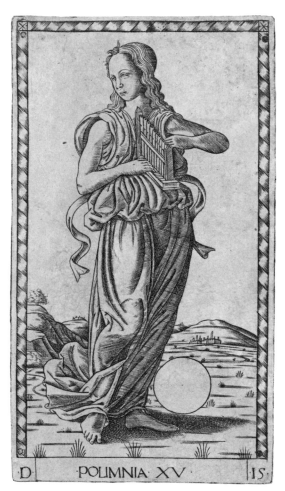

Fig. 38a. Master of the E series Tarocchi. *Polimnia*, c. 1465. Engraving. B-22,916.

Also among Rosenwald's earliest purchases were engravings by Andrea Mantegna (1431-1506), an important painter and the most influential of the Italian engravers of the period, as well as prints after Mantegna's designs produced in the important workshop of engravers that grew up around him. By 1930, five of the seven engravings attributed to Mantegna were in Rosenwald's collection. One of them, *Battle of the Sea Gods* (right half), included in the 1931 Philadelphia

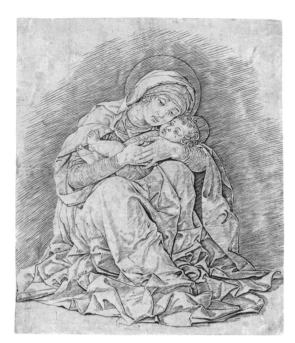

Fig. 38b. Andrea Mantegna. *Virgin and Child*, c. 1450-1455. Engraving. B-8271.

Print Club exhibition of the Rosenwald Collection, did not become part of the Rosenwald holdings in Washington, which do include the other six.

One of Rosenwald's favorite subjects was Mantegna's mature *Virgin and Child* (fig. 38b). The print was among his 1928 purchases, and the impression that he acquired at that time has remained in the collection. In other instances, however, Rosenwald exchanged the impressions of early Italian engravings that he purchased at the start for finer impressions of the same subjects brought to his attention later. Splendid impressions of Mantegna and Mantegna School engravings are quite rare, however, and although he improved his Mantegna holdings over the years, the engravings after Mantegna by his followers that Rosenwald acquired are superior to the impressions engraved by the master himself. Among the best of the Mantegna School pieces is this fine dark impression of *Adoration of the Magi*, the composition of which closely follows the lower right portion of the Mantegna panel of the same subject in the Uffizi Gallery in Florence. Distinctively Italian are the forceful parallel diagonal strokes, characteristic of prints of this region. (In the north, the engraving style was dependent upon shorter strokes and cross-hatching; compare, for example, the *Adoration of the Magi* with the engravings by Master E.S., cat. nos. 5-7.)

In addition to the *Adoration of the Magi*, the Rosenwald Collection includes ten other engravings not firmly attributed to a particular artist of the Mantegna School, as well as two attributed specifically to Zoan Andrea and eleven attributed to Giovanni Antonio da Brescia, two of the most prolific of Mantegna's followers. Most of these prints were purchased before 1931, and very few Mantegna, Mantegna School, or other Italian engravings were acquired or exchanged after the mid-1950s.

REFERENCE: Levenson, Oberhuber, Sheehan, *Italian Engravings*

Cat. no. 38

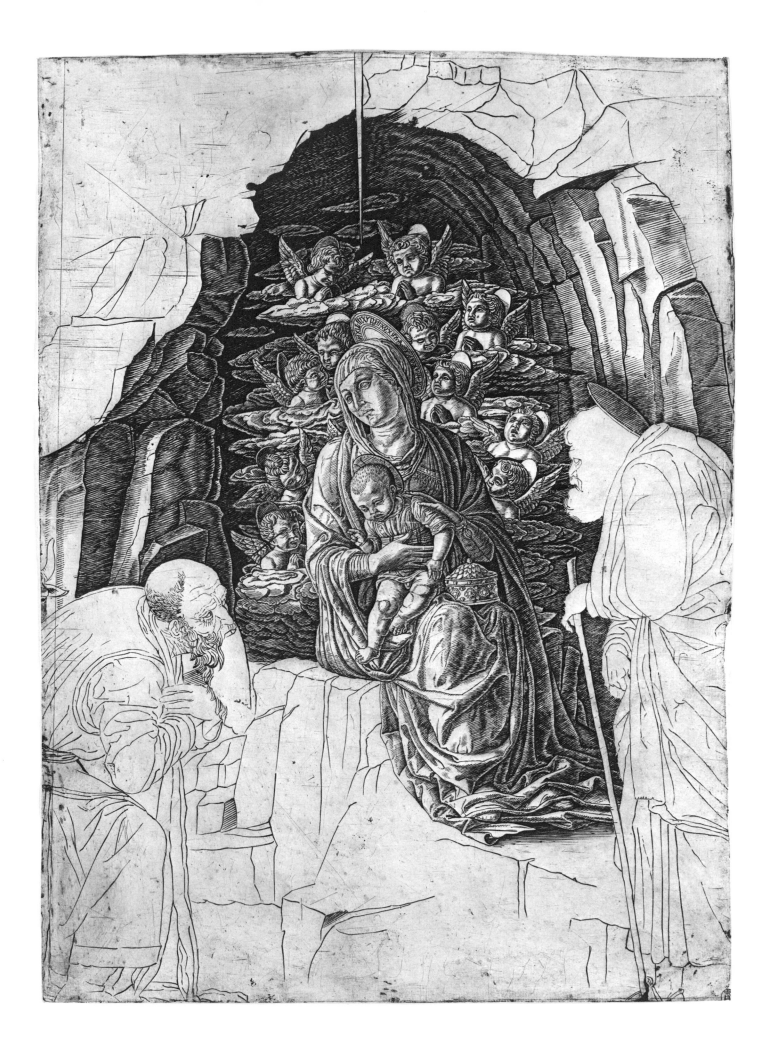

HERCULES SEGHERS
Dutch, c. 1589/1590-c. 1638

39
The Enclosed Valley

Etching and drypoint, printed in brown
10.7 x 18.7 (4³⁄₁₆ x 7³⁄₈)
Havercamp-Begemann 13 III-IV, impression u
PROVENANCE: R. Ritter von Gutmann; purchased from
Gilhofer and Ranschburg, Vienna, through Charles
Sessler, 1930; presented to NGA, 1943
B-10,043

40
Ruins of the Abbey of Rijnsburg: Small Version

Etching printed on linen and hand-colored with
watercolor
9.8 x 17.4 (3⁷⁄₈ x 6¹³⁄₁₆)
Havercamp-Begemann 47 I-II, impression d
PROVENANCE: J. Houbraken; K. Friedrich von
Heineken, Dresden; stamp of Kupferstichkabinett,
Dresden; F. Lugt (Lugt 1028); W. Bareiss, New York;
purchased from Richard H. Zinser, 1944; presented to
NGA, 1944
B-4658

With only about 180 impressions from Hercules Seghers's fifty-four etching plates known to exist, very few of them in American collections, Rosenwald was quite fortunate to have acquired two, particularly as they represent two substantially different directions in Seghers's approach to landscape. None of Seghers's prints is dated and no chronology has been established for them.

Seghers's working methods were diverse and experimental. Through the use of various printing surfaces (cloth as well as paper, often dyed or otherwise colored or coated), hand-coloring of the printed images, state differences, selective wiping of the ink from the surface of the etched plate, and, finally, cropping the prints themselves, almost all of Seghers's impressions were treated as unique objects. *The Enclosed Valley*, for example, Seghers's most common print, is known in twenty-two impressions in four states and a counterproof (see cat. nos. 80-81 for an explanation of counterproof), and each sheet is different from the others. The Rosenwald impression is printed in one color only, but enhanced by the tonal areas within the plate, quite delicate in this state, as well as by a rich film of ink left on the surface of the plate. Seghers's method of exploiting the plate's surface was picked up and amplified by his younger contemporary Rembrandt as seen in cat. nos. 13-15 and again later by Whistler as demonstrated by the two very different impressions of *Nocturne* (cat. nos. 84-85).

The Enclosed Valley is typical of a group of Seghers's images of immense, perhaps menacing, barren, jagged mountain ranges surrounding more serene and cultivated valleys. By contrast, *The Ruins of the Abbey of Rijnsburg: Small Version*, the later of the two Seghers purchases, is a far more intimate, if no less mysterious view. It is the smaller of Seghers's two versions of this destroyed cloister, and his obsession with the graphic description of minute details is able here to show itself in a riot of textures which represent clumps of leaves, for example, and discrete marks that stand for such elements as grasses.

The two Seghers etchings are perhaps the most important prints of the Dutch seventeenth century that Rosenwald acquired to surround the superb Rembrandt collection (see cat. nos. 12-15 and 82-83) formed almost immediately at the start of his collecting career. Early, too, he acquired single prints by Rembrandt's friend Jan Lievens and by Philips Koninck, Karel Dujardin (two more were added in 1947), Claes Jansz Visscher, Essais van de Velde, and Wallerant Vaillant (a second was added in 1946). Five of Jacob van Ruisdael's dozen etchings (one in two states) are also in the collection, all but one

Cat. no. 39

Cat. no. 40

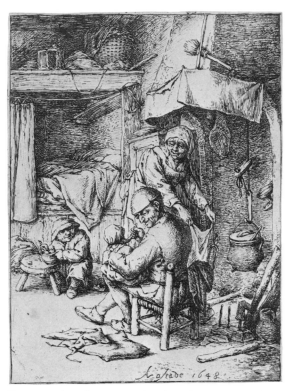

Fig. 39-40b. Adriaen van Ostade. *The Pater Familias*, 1648. Etching. B-10,370.

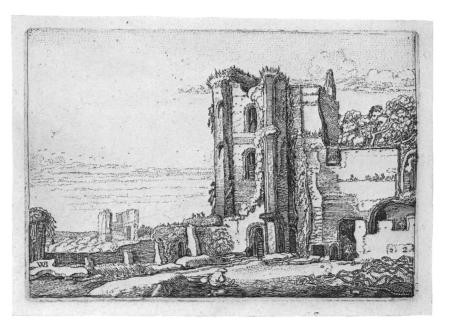

Fig. 39-40a. Willem Buytewech. *Various Landscapes* (plate 2), 1621. Etching. B-15,907.

purchased prior to 1930, and Willem Buytewech's series *Various Landscapes* (fig. 39-40a) was acquired from the Harrach Collection (see cat. no. 49). Among the Dutch artists of the period best represented in the collection is Adriaen van Ostade. Rosenwald acquired more than forty of his etchings, including *The Pater Familias* (fig. 39-40b). All but ten of the Ostade etchings, like most of those by the other Dutch artists noted above, came into the collection prior to 1930.

REFERENCE: Ackley, *Printmaking*

ROBERT NANTEUIL
French, 1623/1625-1678

41
Louis XIV, 1672

Engraving
68 x 59.2 (26¾ x 23⁵⁄₁₆)
Petitjean and Wickert 142 I/VII
PROVENANCE: Purchased from Charles Petitjean, 1928;
presented to NGA, 1943
B-8879

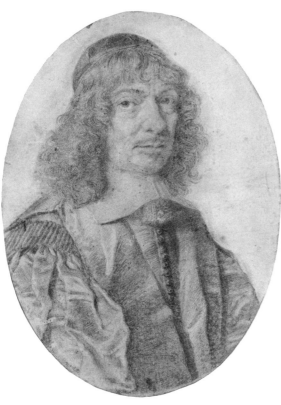

Fig. 41a. Study for *Marin Cureau de la Chambre*,
c. 1656. Pencil on vellum. B-11,198.

The Rosenwald holdings of the work of Robert Nanteuil, the most skillful and the most psychologically penetrating of the seventeenth-century French portrait engravers, rank with the foremost collections of the artist's work. One pencil drawing on vellum (fig. 41a), purchased from The Rosenbach Company in 1929, and more than 230 engravings are included. Almost all of the prints were acquired in one 1928 purchase of the Nanteuil collection formed by Charles Petitjean, co-author with Charles Wickert of the 1925 catalogue of Nanteuil's engraved works, still the major reference tool for the artist's prints.

The Petitjean Collection was brought to Rosenwald's attention by Ellis Ames Ballard, a Nanteuil enthusiast who knew Petitjean and was familiar with his collection. Ballard was a Philadelphia lawyer whose own Nanteuil collection was given to the Philadelphia Museum of Art. Petitjean wanted to sell his collection *en bloc*, and as it apparently was not convenient for Rosenwald to go to Paris to see it, if he was to purchase the collection, he would have to do so sight unseen, although at the strong recommendation of Ballard, whose opinion and knowledge he no doubt highly respected. In Rosenwald's *Recollections* (84-87), he indicated, "This was quite a staggering proposal. I am sure I would have said 'no' to a dealer, but to a fellow collector I succumbed."

Rosenwald did place one condition on his making the purchase. It was that Ballard fill in the gaps in his own Nanteuil collection with examples from the Petitjean holdings. The lawyer-collector at first reluctantly agreed, but in the end, he changed his mind, telling Rosenwald that he felt strongly that the Petitjean Collection had to be kept intact. As Rosenwald wrote, "And so it was that I became the beneficiary of Mr. Ballard's conscience and M. Petitjean's erudition and expertise." As one might imagine, the collection included extraordinary examples, many in first state impressions, including the extremely rare portrait of *Louis XIV* included here, engraved from life, one of eleven different Nanteuil engravings of the king in the collection.

A glimpse into one aspect of the formation of Petitjean's collection came in a June 1950 letter from one of the directors of P. & D. Colnaghi & Co., Harold J. L. Wright, to Rosenwald. In it Wright reminisces about some of his experiences in the print world, among them a particular transaction with M. Petitjean:

Since you now own Mons. Petitjean's Nanteuils, you must have amongst them those he once bought from me when I took a whole series of fine proofs over to Paris for his and Wickert's inspection. These had quite a story to them. They came, in a great folio album, from an old mansion in the West of England. We were invited down, to go through all the pictures and prints in the house, and to report on them, as it was proposed to dispose of any worth selling. Our representative had worked his way up through the house, looking carefully at everything on the walls, and was becoming more and more disappointed by what he saw, so that, by the time he reached the upper floors, he was almost in despair of finding anything whatever to purchase. At last, in an upper room, he spied a tall cupboard, and when he enquired what was in it, was told by the butler who was showing him round that it only contained 'a lot of old books—huge great books, with a lot of old prints in them; that the key of the cupboard had long been lost; and that it was therefore no use

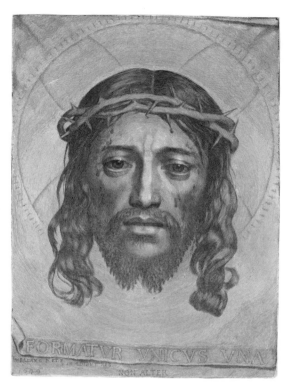

Fig. 41b. Claude Mellan. *Sudarium of Saint Veronica*, 1649. Engraving. B-8644.

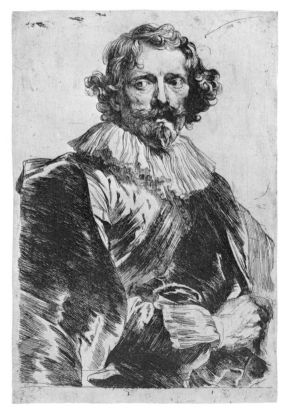

Fig. 41c. Anthony van Dyck. *Lucas Vorsterman*. Etching. B-10,321.

bothering about *that* stuff!' However, our representative insisted, and made the butler send for a man to burst open the cupboard. In it was the volume of Nanteuils—a really extensive collection, arranged with the Louis portraits first, then the Marshals, then the Prelates, and so forth. All the smaller plates were in fine state, quality, and condition; but the larger portraits had unfortunately been trimmed to get them to a size the album's pages would take.

One assumes that Petitjean purchased only the smaller pieces.

Rosenwald acquired very few prints by the other French portrait engravers of the period, four by Gerald Edelinck, five by Pierre Drevet, a Flemish artist who worked in France, and two by Antoine Masson. None of the portrait engravings by Claude Mellan (1598-1688) is in the collection, but the single Mellan print which Rosenwald did acquire held constant fascination for him. It was the *Sudarium of Saint Veronica* (fig. 41b), made by a single engraved line which starts at the point of Christ's nose and moves outward in a spiral to form the entire image.

There is, however, a second group of seventeenth-century portraits in the collection of which Rosenwald was very proud. These are the works of the Flemish artist Anthony van Dyck (1599-1641): portraits of artists and writers from the series known as the *Iconography*. Between 1928 and 1951, more than fifty van Dyck prints (including two from the Clendenin J. Ryan Collection) were acquired, most of them portraits. Eleven, including the portrait of *Lucas Vorsterman* (fig. 41c), are in the spontaneously etched first states of the plates, drawn by van Dyck himself, and before the plates were reworked and finished with the addition of engraving by the artists in his workshop. Also in the van Dyck collection is the impression, thought to be unique, of the third state of *Joannes de Wael*, with the inscription and lacking the arm, as recorded in the *Print Collector's Quarterly* 25 (April 1938): 156-165.

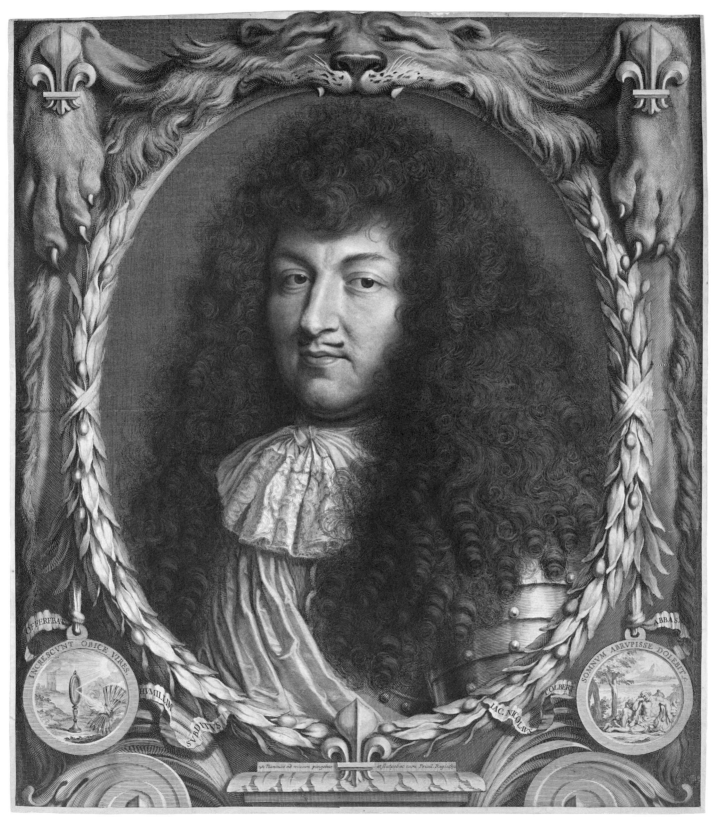

Cat. no. 41

SAMUEL PALMER
British, 1805-1881

42
The Sleeping Shepherd; Early Morning, 1857

Etching, hand-colored with watercolor and opaque
white with gold highlights
9.5 x 7.8 (3¾ x 3¹⁄₁₆)
Lister 6 I/IV
PROVENANCE: Purchased from Charles Sessler, 1930;
presented to NGA, 1943
B-9072

Given the extraordinary William Blake collection that Rosenwald assembled (see cat. nos. 16-18 and 96-97), it is interesting to realize that he did not simultaneously make extensive purchases of prints and drawings by Blake's circle of contemporaries and close followers. Of Blake's young admirers, Samuel Palmer is best represented in the collection. Palmer completed thirteen etchings (four more were begun by him and completed by his son A. H. Palmer), and Rosenwald acquired six of the thirteen subjects, one of them in two different states. *The Sleeping Shepherd; Early Morning*, unique in this impression, hand-colored by the artist himself, is typical of Palmer's pastoral motifs. In its final state the print was published as Plate 5 in *Etchings for the Art Union of London by the Etching Club*, 1857. One of two Palmer prints purchased in 1928, it was an important early addition to Rosenwald's holdings of English art.

Especially interesting among the later Palmer purchases (one in 1939, three in 1946, and one in 1972) is a heavily annotated impression of *The Weary Ploughman* (also called *The Herdsman* or *Tardus Bubulcus*) (Lister 8). The borders of the print are filled with instructions from the artist to his printer, and landscape diagrams amplify and clarify these directions.

Also complementing the Blake holdings are a number of drawings by sculptor John Flaxman, who executed many of the designs from which Blake engraved his commercial book illustrations. The Flaxman collection was begun prior to 1937 with more than 100 slight sketches, many for sculpture pieces yet to be identified. It was augmented in 1940 with an album of seventy-eight studies in pen and ink and pencil for Flaxman's own engraved illustrations for Dante's *Divine Comedy*. Six years later, in 1946, the purchase of four single sheet studies, the most interesting of which relate to architectural or sculptural projects, marked the end of the Flaxman acquisitions now at the National Gallery. Other Flaxman material was given to the Library of Congress.

A rare etching by Thomas Stothard, *The Camp of Stothard, Blake and Ogleby*, and several impressions (including two unique states) of *Lear and Cordelia* (fig. 42a) by Blake's patron and student Thomas Butts (1757-1845) after his teacher further enhance holdings related to Blake. The last addition to this miscellaneous material was a single wood engraving of 1831 by Edward Calvert (1799-1883), *Chamber Idyll* (fig. 42b). A miniature image juxtaposing a romantically inclined couple in a rustic interior with a lovely pastoral landscape, *Chamber Idyll* was not purchased by Rosenwald but rather was a gift from his longtime friend and associate Carl Zigrosser, the Curator of Prints at the Philadelphia Museum of Art from 1941 to 1964. Honoring Rosenwald's eighty-third birthday, the gift was accompanied by a note from Zigrosser indicating that

after some thought . . . I decided to give you the enclosed little wood engraving by Edward Calvert, which I am sure you do not have. It is in the rare and possibly unique first state with the inscription. Raymond Lister, who wrote a book and catalogue on Calvert in 1962 says that he does not know the whereabouts of any first state. It is appropriate, too, that you should have it, for it is reproduced in *Multum in Parvo* [plate 5] with which you had a great deal to do. [*Multum in Parvo, an*

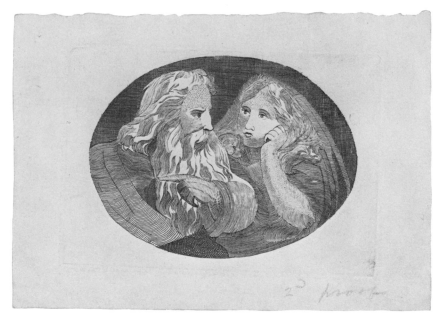

Fig. 42c. William Blake. *The Pastorals of Virgil . . . ,* 1821. Wood engraving. B-11,086.

Fig. 42b. Edward Calvert. *Chamber Idyll*, 1831. Wood engraving. B-31,636.

Essay in Poetic Imagination, published by George Braziller in 1965, was written by Zigrosser and is dedicated to Lessing J. Rosenwald.] Furthermore the print and Calvert had close associations with Blake of whose work you have a precious store. It came from the collection of Samuel Palmer and his son A. H. Palmer. From my point of view, I have been long concerned with finding a permanent home for it. What better permanent home is there than the Rosenwald Collection of the National Gallery of Art.

Chamber Idyll, like all of Calvert's wood engravings as well as Samuel Palmer's etchings, clearly pays spiritual homage to the wood-engraved illustrations Blake did late in his career for J. Thornton's 1821 edition of *The Pastorals of Virgil, with a course of English Reading adapted for schools.* Two rare proof sheets of Blake's Virgil wood engravings before the blocks were cut down (fig. 42c) were part of the Linnell family Blake collection that was acquired by Rosenwald in 1937 (see cat. nos. 16-18).

FRANCISCO GOYA Y LUCIENTES

Spanish, 1746-1828

43
The Disasters of War: "Nothing (The Event Will Tell)," 1810-1820

Etching, aquatint, lavis, drypoint, and engraving
15.7 x 19.5 (6¹⁄₁₆ x 7¹¹⁄₁₆)
Harris 189, working proof: 1/2
PROVENANCE: Purchased from Charles Sessler, 1930;
given to NGA, 1943
B-7361

As early as 1929, Rosenwald had purchased several of Goya's early etchings after Velázquez paintings as well as complete sets of the artist's four major etching series in their first published editions (both *The Disasters of War* and *The Proverbs* were published posthumously). *The Disasters of War* of 1863 was the first acquisition in 1928, and it was followed by *The Bullfights*, published in 1816, the rare 1799 edition of *The Caprices*, and lastly, in December 1929, the 1864 edition of *The Proverbs*. By this date, too, Rosenwald owned the four important lithographs produced in 1825 when the artist was seventy-nine, the *Bulls of Bordeaux* (in 1978, with the collector's agreement, the Rosenwald *Bulls* series was used in exchange for other important prints; a set from W. G. Russell Allen remains in the National Gallery collection). All of these early Goya purchases were made through Sessler.

In 1930, also through Sessler, four prints were added. Among them were a proof of "Two of a Kind" from *The Caprices* in a

Fig. 43a. *The Caprices:* "Two of a Kind," 1797-1798. Etching and aquatint, retouched with black chalk. B-7363.

splendid impression retouched with crayon and wash (fig. 43a) and this trial impression of "Nothing." In this early proof from the *Disasters* series, the figure of Justice, surrounded by rays of light and holding her symbolic scales in her left hand, is more clearly seen than in the completed print, and the demonic figures in the upper right are here more atmospheric, more mysterious, and less solidly defined than in the final version of the image. Like all of the prints in the series, which found its inspiration in the Napoleonic wars of 1808-1813 and the terrible famine in Madrid during 1811-1812, the subject is ominous, if not horrific.

After these important additions to the Goya collection in 1930, Rosenwald's acquisitions of the artist's work came to a halt until 1947, but between that year and 1953 he acquired several important prints, principally in 1951 from William H. Schab. They included several rare early proofs of plates from the various etching series, a proof set (c. 1854) of *The Proverbs*, additional subjects after Velázquez (including a working proof of Felipe IV [Harris 5] drawn into throughout with pen and ink), and an impression of the rare crayon lithograph *Bull Attacked by Dogs* (fig. 43b). The single Goya lithograph now in the Rosenwald Collection, it is important not only within the context of Goya's printed oeuvre, but also as a representation of the early artistic use of the lithography medium.

Fig. 43b. *Bull Attacked by Dogs*, c. 1825. Lithograph. B-14,107.

HONORÉ-VICTORIN DAUMIER
French, 1808-1879

44
The Parisians: "The Idlers,"
published in *Le Charivari*,
5 December 1839

Lithograph, annotated in margins with pencil and pen
and brown ink as described below
25.9 x 19.7 (10³⁄₁₆ x 7¾)
Delteil 755 I/III
PROVENANCE: Purchased from Charles Sessler, 1930;
presented to NGA, 1943
B-6142

Flamboyantly contributing to the art of caricature, Daumier's lithographs, published in the popular journals *La Caricature*, a weekly, and *Le Charivari*, a daily, at first emphatically attacked King Louis Philippe I and other powerful political figures, but after the September 1835 laws requiring caricatures to receive official authorization, his work turned to poking fun at bourgeois society and contemporary customs and mores.

"The Idlers," of course, fits into the latter category, and it is one of many particularly interesting Daumiers in the Rosenwald Collection that are proofs before all printed captions. Some, like "The Idlers," have manuscript captions written by Louis Huart and the other writers for *Le Charivari* (not by Daumier), as well as notes of instruction to the printer. Many of the sheets are folded and show the address of the caption writer or the printer on the verso, and their condition often shows evidence of rather rough handling. Thus, they offer some idea of the speed essential in getting the proofs to all of the contributors to the publication effort.

Daumier himself had little to do with the actual production process apart from drawing on the stones, with which he was kept well supplied. His comments were of great concern to the editors, however, as demonstrated by the lower of the two annotations in the upper left corner of "The Idlers." It translates, "Daumier complains about the quality of the last proofs, take care of this one." The annotation above directs, "Take care of the title/have it pulled for Sunday," and below, to the left of the caption, "Take care of the caption," which itself, then, translates, "It is impossible to believe that this poor angler is the reason for this crowd. . . . No, in point of fact it is caused by a fish, which you do not see and which they do not see either."

Fig. 44a. *Young Courier.* Watercolor over black chalk.
B-11,040.

The Rosenwald Daumier collection includes about 650 lithographs and 30 drawings and watercolors, one example of which is the energetic crayon and wash sketch, *Young Courier*, depicting a wide-eyed young man in a hurry (fig. 44a). The collection got a firm start

Fig. 44b. Herbert Block (Herblock). "A Cloud No Bigger Than A Man's Future," 1955. Copyright © 1955 in *The Washington Post* and *Herblock's Here and Now*. Graphite and black ink retouched with white paint. B-23,030.

in April 1928 with the purchase of several prints from Sessler, and acquisitions, including seventeen sheets from the sale of the collection of Julius Model, continued quite steadily through September 1930.

The first public showing of the Daumier collection was at the Free Library of Philadelphia in 1930, and the checklist for the exhibition shows 207 entries (although two are left blank). In addition to lithographs, twelve items are drawings and one is an Auguste Lepère wood engraving after a Daumier watercolor. Daumiers continued to be added on many occasions over the years. Jean Goriany was a particularly important source during the 1940s, and in the 1950s and into the early 1960s, Henri Petiet brought to Rosenwald's attention many rare subjects and proofs taken before the captions were added, often with annotations.

Rosenwald also acquired a complete set of Daumier's thirty-six bronze busts of legislative figures, cast from clay models made in 1832-1833. The first group of twelve was acquired through Sessler in 1930, just after it was produced. Also in the collection is the rakish standing figure representing the police state, *Ratapoil*, and the relief composition *The Refugees*.

Rosenwald's interest in journalistic caricature was essentially focused on Daumier, although the Forain collection (see cat. no. 32) includes a number of examples as well. In addition, the collector showed moments of interest in two of Daumier's mid-twentieth-century counterparts: fourteen caricatures by the British cartoonist David Low were acquired in 1941 and 1942, and eighteen graphite drawings by Herbert L. Block (Herblock) for *Washington Post* cartoons were purchased from the artist in 1960 after his exhibition at the Corcoran Gallery of Art. "A Cloud No Bigger Than a Man's Future" of 1955 (fig. 44b) remains particularly timely.

REFERENCE: Kist, *Daumier*

Cat. no. 44

134

h. Daumier

PART III
The Alverthorpe Years

ANONYMOUS LOWER SAXONY

(Braunschweig?)

45
Paradise with Christ in the Lap of Abraham, 1239(?)

verso: late thirteenth-century copy of a letter from Pope Gregory IX to Elizabeth of Thuringia
Tempera and gold leaf on vellum
22.4 x 15.7 (8⅞ x 6¼)
PROVENANCE: In the bishopric of Hildesheim by the fourteenth century; R. Forrer (Lugt supp. 1941ᵃ); purchased from Erwin Rosenthal, 1946; presented to NGA, 1946
B-13,521

Rosenwald's gift to the National Gallery included more than sixty examples of medieval and Renaissance manuscript illuminations, both complete single leaves and cuttings (his several very fine illuminated volumes went to the Library of Congress). The earliest of these is a leaf from a central Italian Bible dating from the late eleventh century. The latest is Flemish, attributed to Simon Bening, c. 1540, possibly from a Book of Hours. Almost half of the manuscript illuminations are Italian in origin, including three late fourteenth-century leaves with illuminations attributed to Nicolò da Bologna, and a leaf from an Antiphonary (fig. 45a) illuminated by Belbello da Pavia, one of the most sought after Lombard masters of the mid-fifteenth century. Among the French leaves, one is from the Paris atelier of the Limbourg Brothers, and among the Spanish, there are thirteen initials attributed to the Master of the Cypresses (Pedro da Toledo?). German and Bohemian illuminations are represented as well.

Fig. 45a. Belbello da Pavia. *Annunciation to the Virgin*, 1450-1460. Tempera and gold leaf on vellum. B-14,851.

All but four of the leaves came from parent volumes of a liturgical nature: Bibles, choir books, missals, Books of Hours, sacramentaries, and Psalters. Their function was an ecclesiastical one, and their purpose was to glorify and honor God. The particular beauty of many of the leaves, then, is not surprising, as they would have been made with consummate care and love.

Paradise with Christ in the Lap of Abraham, taken from a German Psalter at one time in the library of the Duke of Arenberg and now in the Bibliothèque Nationale, Paris (cod. nouv. acq. lat. 3102), is

luxuriously illuminated with gold which serves as a background enhancing the rather graceful, if flat and schematic, expressionistic handling of the subject. The vivid reds, greens, and blues are beautifully fresh and well preserved. The Christ child sits on the lap of Abraham, who is enthroned in paradise with the tree of life behind him. These two central figures are surrounded by the elect, two of whom are receiving fruit from the hands of Christ. Several carry palm branches, which symbolize martyrdom. In the four corners, nude figures holding jugs from which water flows symbolize the four rivers of paradise—the Geon, the Physon, the Tygris, and the Euphrates.

Christ in the Lap of Abraham was among the earliest of Rosenwald's manuscript illuminations purchases. In July 1945, while on a trip to the west coast, the collector visited Erwin Rosenthal, a Swiss bookseller who was in California for a number of years during the 1940s. Rosenwald became interested in a group of illuminations that Rosenthal showed to him, and when the dealer next came east, some months later, the paintings were brought to Jenkintown for more careful study. Rosenwald bought several of them and continued to add examples during the rest of the 1940s, throughout the 1950s, and up to 1963 with a single acquisition from Bernard M. Rosenthal of San Francisco in 1972. Although leaves were also acquired from H. P. Kraus and Vladimir G. Simkovitch, among others, almost the entire collection was purchased over the years from Erwin Rosenthal, who also was a source for important additions to the reference library.

In 1973, as part of the research for the catalogue of the exhibition of Rosenwald illuminations held two years later at the National Gallery, it was discovered that one of the leaves purchased from E. Rosenthal years earlier and published in the 1950 National Gallery catalogue, *Rosenwald Collection, An Exhibition of Recent Acquisitions* (no. 3, reproduced), was spurious. When Rosenthal learned about this he immediately sent to Rosenwald (who had not himself contacted the dealer about the matter) a group of five early fifteenth-century Austrian cuttings from a Biblical manuscript which he hoped would be compensation for the earlier error. In acknowledging the gift, Rosenwald wrote to Rosenthal, "Considering the number of miniatures that I have acquired through you, one error seems to me to be an exceedingly good record in this highly technical field." He went on to indicate his delight in owning the Bible cuttings, which constituted the last addition to this aspect of his collection.

REFERENCE: Vikan, *Miniatures*

ANONYMOUS FRANCO-FLEMISH

46
The Death of the Virgin, c. 1390

Silverpoint on green prepared paper
29.1 x 40 (11½ x 15¾)
PROVENANCE: The Princes of Liechtenstein from whom
purchased 1948; presented to NGA, 1950
B-17,723

Fig. 46-47a. Martin Schongauer. *Bust of a Monk Assist-ing at Communion.* Pen and brown ink. B-20,669.

As a beginning collector, Rosenwald purchased several significant old master drawings. Among them are the Dürer silverpoint portrait of his brother Hans (fig. xxvi), Schongauer's *Bust of a Monk Assisting at Communion* (fig. 46-47a), and several Rembrandts and Blakes (see cat. nos. 15 and 17). Rosenwald's interest in drawings, however, never equaled his interest in prints, and the emphasis of his drawings collection was on studies related to prints (see cat. nos. 78-79 and 88-92) and drawings by printmakers whose work he collected. Nevertheless, the drawings collection did substantially expand over the years, and one particular transaction was of paramount importance. This was the purchase of a group of drawings from the collection of the Prince of Liechtenstein, a purchase which came about through a rather circuitous set of circumstances.

In February 1948, a cable came to Elizabeth Mongan from Sotheby and Co. regarding the availability of the Liechtenstein print collection. Begun in the seventeenth century by Francis Joseph, the collection had grown to about one hundred thousand prints. Included were more than fifty van Meckenems and two hundred forty Rembrandts, both artists already strongly represented in the Rosenwald Collection, as well as fifteenth-century Italian engravings and prints by most of the important fifteenth- and sixteenth-century German printmakers and by many seventeenth- and eighteenth-century masters. English sporting prints and a selection of modern masters were also well represented. The cable suggested that if Rosenwald and the National Gallery of Art might wish to consider the collection *en bloc*, immediate action would be necessary, as the intention was to hold a sale of part of it a few months later, in May. In his *Recollections* (47) Rosenwald indicated, "While I had no desire to acquire such a tremendous collection as this, I thought that there might be a chance of obtaining some of the rarer fine examples and that many museums throughout the United States would be willing to purchase most of the prints I did not want to retain." An agreement was made that the collection would not be offered elsewhere until Mongan was able to examine the prints and offer her opinion as to the desirability of making the purchase.

In March she sailed for Europe, making brief visits to London and Paris before she arrived in Zurich, where the Liechtenstein prints were being held. After a week of intense study she came to her decision. While acknowledging that the collection comprised some splendid items, among them an impression of the important Burgkmair *Maximilian* woodcut in gold on vellum (Hollstein 323), Mongan found the early Italian and early German prints, the Dürers, and the Rembrandts lacking in quality, and further, she realized that the sporting prints and seventeenth-century reproductive engravings would be of little interest to Rosenwald. Thus she indicated that she could not recommend to him and the Gallery the purchase of the entire Liechtenstein print holdings.

Once Mongan's recommendation was made and discussed via transatlantic cable and telephone, Walter Feilchenfeldt, the agent for the Prince, no doubt somewhat upset by Mongan's opinion, offered to show her the Liechtenstein drawings, which up to this point had

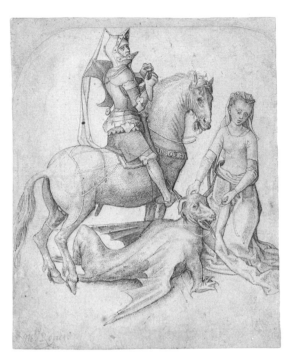

Fig. 46-47b. Hugo van der Goes. *Saint George and the Dragon*. Pen and brown ink. B-17,724.

been neither for sale nor available for viewing. She then spent several additional days in Zurich studying the drawings and finding them quite marvelous, but it remained uncertain whether they would be made available for purchase. Tentative offers apparently had been made by at least three dealers interested in purchasing either the prints or the drawings *en bloc*, sight unseen. By contrast, Rosenwald's curator had made the effort to come to Zurich personally to see the material, and this had made a strong and favorable impression on the Prince's agent. Perhaps as a result of this, on 30 March, Mongan was able to cable Rosenwald that she had secured several splendid drawings. Of the eleven she had obtained, one, a *Saint George* misattributed to a fifteenth-century Nuremberg master, was returned but replaced the following year by a Girolamo dai Libri silverpoint drawing, *God the Father*. Among those that were retained were the Franco-Flemish *Death of the Virgin* and Wolfgang Huber's *Annunciation to Joachim* seen here. Others were a second Huber pen drawing, *Landscape on the Danube*, Hugo van der Goes's *St. George and the Dragon* (fig. 46-47b), Campagnola's *Landscape with Boy Fishing* (Robison, *Drawings*, 42), two landscapes now attributed to the Master of 1544 rather than to Hirschvogel, to whom they were then given, and three sketches by Jacopo Palma il Giovane. A single etching, *A Castle Yard*, by Hirschvogel was also acquired in this transaction. All of the drawings and the etching were sent directly to Washington via diplomatic pouch about three weeks after agreement was reached.

Eventually, a number of individual prints from the Liechtenstein Collection were purchased for the Rosenwald Collection (see cat. nos. 53 and 57), mainly through Richard H. Zinser; and a number of books from the Prince's library were purchased by Rosenwald in 1949 through the London bookseller Heinrich Eisemann. Principally incunabula, they became part of the Library of Congress Rosenwald Collection.

The Liechtenstein drawings are among the highpoints of the Rosenwald drawings, but among the others there is a group of fifty drawings, far less known, and indeed less splendid, but interesting

Cat. no. 46

WOLFGANG HUBER
German, c. 1490-1553

47
Annunciation to Joachim, 1514

Pen and brown ink
21.9 x 14.7 (8⅝ x 5¹³⁄₁₆)
PROVENANCE: The Princes of Liechtenstein from whom
purchased 1948; presented to NGA, 1950
B-17,727

Fig. 46-47c. Giulio Benso. *Birth Scene*. Pen and ink and wash. B-10,963.

nonetheless. The group includes Giulio Benso's (1601-1668) *Birth Scene* (fig. 46-47c, first published as Benso by Mary Newcome in *Genoese Baroque Drawings*, exh. cat. [New York: State University of New York at Binghamton and Worcester: Worcester Art Museum, 1972]), and it was purchased in 1940 from William H. Robinson, Ltd., the London dealer responsible for Rosenwald's 1937 acquisitions from the Linnell family Blake collection (see cat. nos. 16-18). According to information furnished at the time, these study drawings had been in the collection of Lord Leigh of Stonleigh Abbey, Warwick. None of the drawings individually was considered of great importance; many are anonymous copies after works by artists of stature. Most of these had, in the past, been wrongly attributed to the more important masters. As a lot, the drawings remained essentially unstudied for years, referred to as "The Robinson Drawings," and only recently has serious attention allowed proper attributions to be established for many of them.

MARTIN SCHONGAUER
German c. 1450-1491

48
Christ before Pilate, c. 1480

Engraving
16.4 x 11.7 (6⁷⁄₁₆ x 4⁵⁄₈)
Lehrs 24; Shestack *Engravings* 57
PROVENANCE: G. Guttler (Lugt supp. 2807ᵇ); purchased
from Oskar Stoessel, 1940; presented to NGA, 1943
B-2595

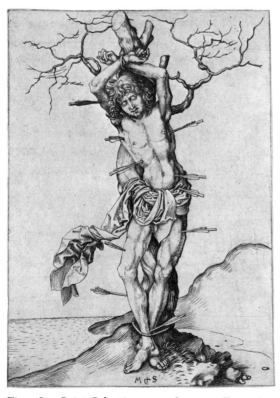

Fig. 48a. *Saint Sebastian*, c. 1480-1490. Engraving.
B-2619.

If the Master E.S. (cat. nos. 5-7) placed particularly high in
Rosenwald's pantheon of fifteenth-century northern engravers,
Martin Schongauer, the most influential graphic artist of his time in
northern Europe, took a very close second position. Unlike Master
E.S., Schongauer is thought to have been primarily a painter
(although very few of his paintings survive), rather than a goldsmith
and engraver, and he carried E.S.'s engraving technique to a far
more refined level of accomplishment, evolving his own pictorial
ideals and moving toward a classical lucidity from a late-Gothic
complexity of form.

The Rosenwald Schongauer collection, one of the finest in the
country, includes more than eighty prints and a drawing (fig.
46-47a). It was started in 1928 with about ten sheets (some of which
were later exchanged for better impressions), but its importance was
very firmly established in 1929 when almost thirty prints were
acquired from Knoedler and Co. and Charles Sessler. Nine more
prints were purchased in 1930, and between 1937 and 1959,
additional Schongauers were added on a fairly regular basis. Among
these later purchases was *Christ before Pilate*, one of a series of twelve
scenes illustrating Christ's Passion, a subject popular among
engravers of the period whose series were sold to be used for both
didactic and devotional purposes (like the woodcuts discussed earlier,
cat. nos. 1-4).

The largest single group of Schongauer prints to be added after
Alverthorpe opened came from the sale of the collection of
Clendenin J. Ryan. The January 1940 auction at Parke-Bernet was
considered one of the most important print sales to be held in New
York in years, and it made big news. To accompany an article
headlined "Museum Chief Angrily Quits Ryan Print Sale," the *New
York Herald Tribune* for Thursday, 19 January (20), reproduced the
impression of Schongauer's *Saint Sebastian* (fig. 48a) purchased for
Rosenwald at the sale by Richard H. Zinser. The article relates the
clash between William M. Ivins, curator of prints and then acting
director of the Metropolitan Museum of Art in New York and Zinser
at the first session of the sale, which included only the Schongauers
and Dürers (by contrast with today's rather inflated market, the 108
Dürer and Schongauer lots in the Ryan sale were reported to have
brought a total of $57,235).

The Schongauer *Saint Sebastian* was the initial impetus for Ivins's
anger: he thought the print had been awarded to him, although
Zinser had actually been the purchaser. The bidding was reluctantly
reopened, but Zinser eventually was awarded the print, which
brought the highest price of the evening. He also obtained most of
the other Schongauers on sale, and Ivins repeatedly complained that
his bids were being ignored. Eleven of Zinser's Schongauer purchases
came into the Rosenwald Collection. So did four of the Dürers and
several other items included in the second session of the sale the
following evening.

Among Rosenwald's favorite instructional comparisons were his
two impressions of Schongauer's late version of *The Archangel
Gabriel*. The impression he had bought in 1929 was weak and worn

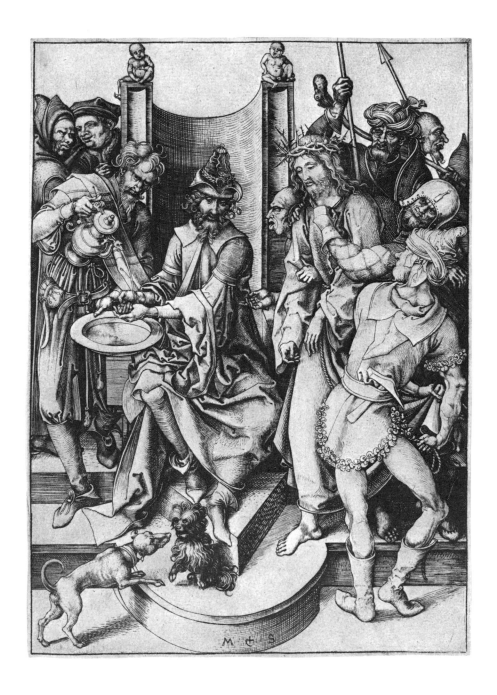

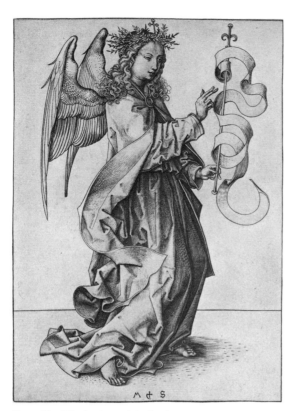

Fig. 48b. *The Archangel Gabriel*, c. 1490-1491. Engraving. B-11,167.

down in contrast to the finer impression which he was able to acquire ten years later (fig. 48b). No doubt Rosenwald retained his earlier purchase specifically to emphasize the importance of upgrading the quality of one's holdings by pointing out the extraordinary difference between bland impressions and stronger, more expressive ones of the same image.

REFERENCE: Shestack, *Engravings*

LUCAS CRANACH THE ELDER

German, 1472-1553

49
The Passion: "The Crucifixion," 1509 or earlier

Woodcut
24.8 x 17 (9¾ x 6¹³⁄₁₆)
Hollstein 20
PROVENANCE: Count Harrach; purchased from William
H. Schab, 1949; presented to NGA, 1950
B-15,928

The Rosenwald Collection includes more than sixty of Cranach's woodcuts including two chiaroscuro impressions of *Saint Christopher* (Hollstein 79), one printed in warm brown and black, the other in black and slate gray. Three of the artist's eight engravings are included as well, among them the exquisitely delicate *Penance of Saint John of Chrysostom* (Hollstein 1). Four woodcuts by Cranach's son, Lucas the Younger, as well as five after him including four variations of a portrait of *John Frederick the Magnanimous, in Electoral Robes* (Hollstein 34) complete the Cranach family holdings.

"The Crucifixion" is from a set of fourteen woodcuts (Hollstein 10-23) depicting Christ's Passion. Rosenwald acquired the group from the Harrach Collection (see cat. no. 51), and he was particularly proud of them, musing in his *Recollections* (103), "One could almost picture the sixteenth-century Count Harrach purchasing the earliest and finest impression from Cranach himself." The compressed and crowded composition of the crucifixion scene is typical of several sheets in the series, and the expressiveness of Cranach's rendition of this subject (which one might contrast with Baldung's [cat. no. 35] and Rembrandt's [cat. nos. 82-83]), is most fully visible here in this clear dark impression.

About half of the Rosenwald Cranachs were purchased before Alverthorpe Gallery was opened. Others purchased during that time, including several sheets from the *Passion* series, were later exchanged for the finer impressions that are now in the collection.

Sixteenth-century northern chiaroscuro woodcuts were mentioned earlier (cat. no. 35). All of the artists noted there are represented in the collection in black and white sheets as well, by works such as Hans Burgkmair's *Samson and Delilah* (fig. 49a) formerly in Paul Sachs's collection. So, too, are a number of other artists of the

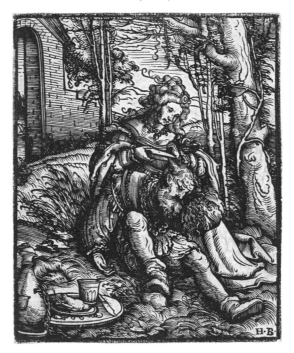

Fig. 49a. Hans Burgkmair. *Samson and Delilah*. Woodcut. B-5328.

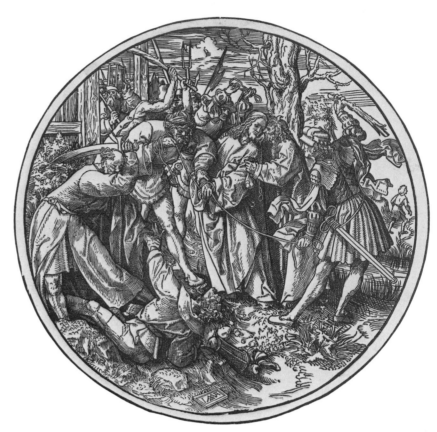

Fig. 49b. Jacob Cornelisz van Oostzanen. *The Passion:* "The Kiss of Judas." Woodcut. B-19,180.

period, both well known and more obscure. Among them are the Master of the Miracles of Mariazell, Hans Holbein the Younger (including several proof impressions for his *Dance of Death* and *Alphabet of Death*), a number of sheets by Leonard Beck, and an interesting series of twelve woodcut roundels depicting the Passion by the Dutch artist Jacob Cornelisz van Oostzanen (fig. 49b, "Kiss of Judas"). Like the Cranach *Passion* set, the series by Cornelisz also was formerly in the Harrach Collection.

Cat. no. 49

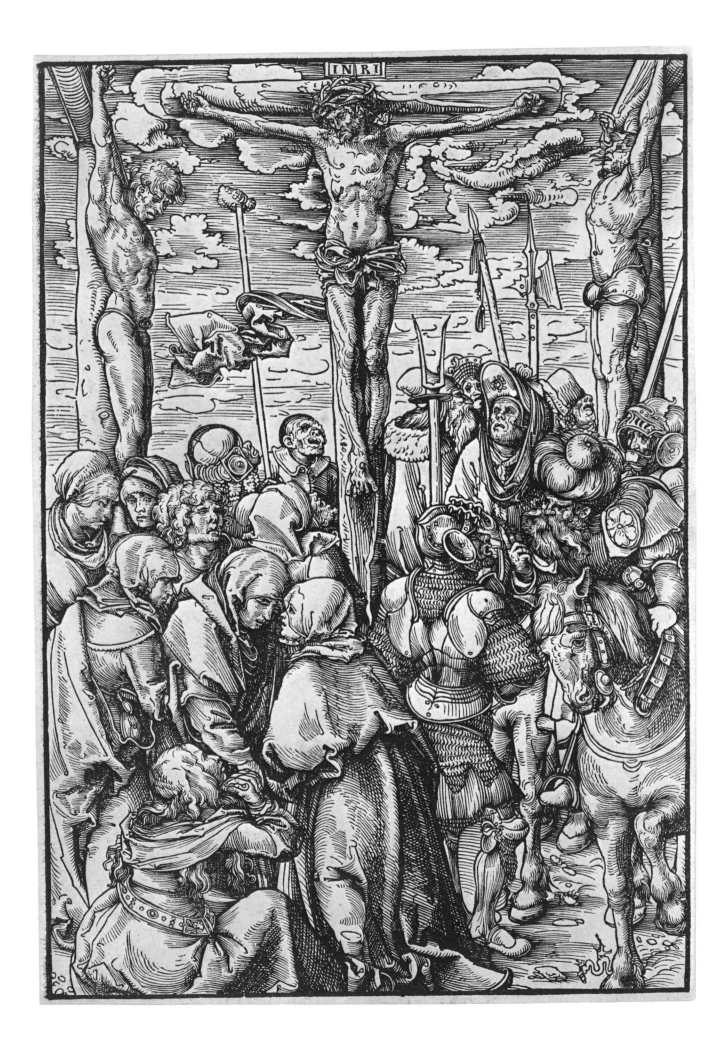

ALBRECHT ALTDORFER
German, before 1480-1538

50

The Beautiful Virgin of Regensburg, c. 1519

Woodcut, printed in red, green, blue, light orange,
brown, and black
33.9 x 24.6 (13⁵⁄₁₆ x 9¹¹⁄₁₆)
Winzinger 89 1/4
PROVENANCE: Purchased from Erwin Rosenthal, 1960;
presented to NGA, 1962
B-22,307

Albrecht Altdorfer was a contemporary of Albrecht Dürer, and like Dürer, he was a prolific engraver and woodcut artist as well as a designer of fortifications and silver. The influence of his work as a landscape artist was felt in the work of his Danube School followers (see cat. no. 51) while his small-scale religious and ornamental prints were of importance to the German Little Masters (see cat. no. 36).

The Beautiful Virgin of Regensburg is Altdorfer's only multicolor print. It is historically one of the earliest color prints of such great complexity, chiaroscuro woodcuts like the Hans Baldung Grien *Crucifixion* (cat. no. 35) being more the norm for the period. The figures of the Virgin and Child are based on the thirteenth-century Byzantine icon housed in the Regensburg chapel, and the print was probably made as a souvenir for pilgrim visitors to this shrine of the Virgin, built in 1519.

The Beautiful Virgin was the last Altdorfer print to enter the Rosenwald Collection. Numbering more than fifty-five woodcuts (forty of them part of the *Fall and Redemption of Man* series [Winzinger 25-64]), and almost as many engravings and etchings, the Altdorfer collection was almost entirely formed between 1928 and 1930, with fewer than five examples acquired after those years. The sale of the collection of Friedrich August II contributed a number of sheets, but the largest group of prints by Altdorfer was acquired at the von Passavant-Gontard sale in Leipzig, in May 1929.

152

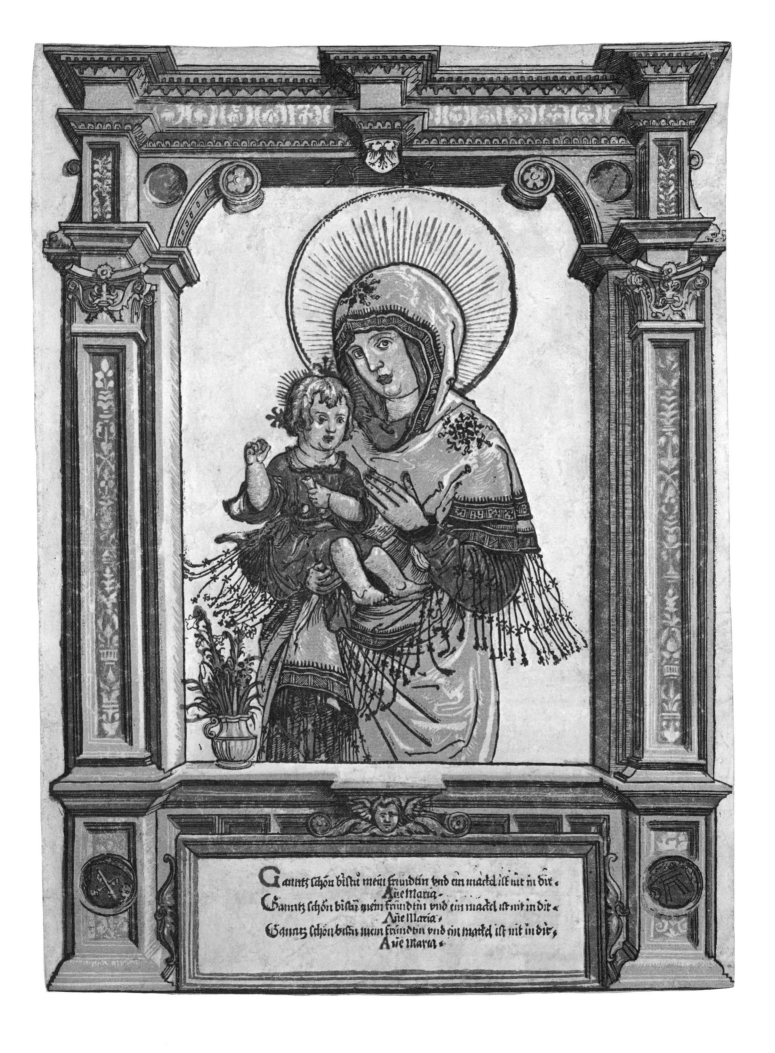

AUGUSTIN HIRSCHVOGEL
German, 1503-1554

51
Landscape with a Village Church, 1545

Etching
15.4 x 18.8 (6$\frac{1}{16}$ x 7$\frac{3}{8}$)
Schwarz 68
PROVENANCE: Purchased from Gutekunst and Klipstein, 1950; presented to NGA, 1950
B-19,054

The Hirschvogel collection was begun with the purchase of a single etching in 1930, and throughout the 1940s and 1950s, it steadily grew to include more than 130 sheets: landscapes, portraits, and Bible subjects, as well as two sets (one hand-colored) of Hirschvogel's six-plate *Map of Vienna* (Schwarz 143). Two landscape drawings, attributed to Hirschvogel when they were purchased in 1948 from the Liechtenstein Collection, are now given to the Master of 1544.

Hirschvogel acquisitions came from a number of sources, but two extensive purchases were the principle contributors to the importance of Rosenwald's Hirschvogel holdings. One was the acquisition in May 1950 from Gutekunst and Klipstein of an almost complete set (99 of 113 subjects) of Hirschvogel's *Concordance* of Old and New Testament illustrations. At the time of this important purchase, Rosenwald also acquired the splendid impression of the artist's *Landscape with a Village Church* seen here. Typical of Hirschvogel's Danube landscapes, the scene is a rustic village nestled in a valley with the river defining the space. The straggly twigs hanging from the trees have become Hirschvogel's trademark. Surface tone left on the plate when it was printed, particularly in the sky, enhances the light falling on the central cottages.

The other major Hirschvogel purchase had occurred just seven months before the Gutekunst and Klipstein acquisitions. In November 1949, Rosenwald was able to purchase more than forty prints and series of prints through William H. Schab from the Viennese collection of the Harrach family. Among these were twelve Hirschvogel etchings: nine landscapes, one portrait, and two animal subjects, one of them *Stags and Monkeys in the Forest* (fig. 51a).

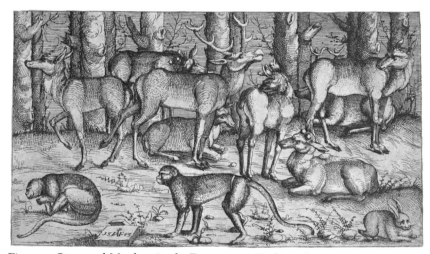
Fig. 51a. *Stags and Monkeys in the Forest*, 1545. Etching. B-15,961.

Fig. 51b. Hans Sebald Lautensack. *Landscape with Pierced Rock*, 1554. Etching. B-11,259.

According to his *Recollections* (101-103), Rosenwald was particularly proud of the prints from the Harrach Collection that he was able to obtain, although unfortunately their availability was attributable to the fact that the widow of Count Harrach (killed during World War II) required funds for the restoration of the family estate, which had been badly bombed.

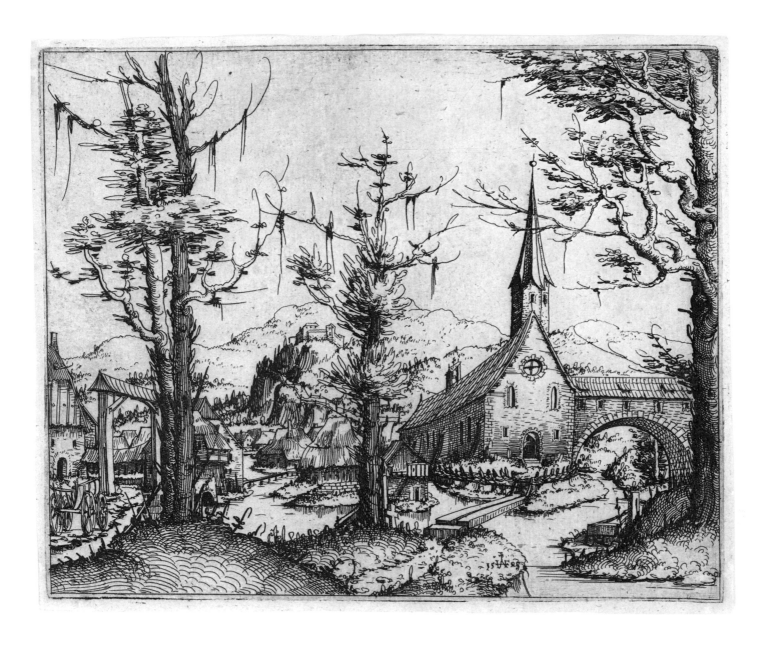

In addition to the Hirschvogels, the Harrach purchase included a set of Callot's *Miseries of War*, four works by Goltzius, two by Bruegel, one each by Urs Graf and Dürer, and, of particular importance in this context, eleven etchings by Hans Sebald Lautensack, one of Hirschvogel's Danube School contemporaries. Most of the eleven were landscapes, including *Landscape with Pierced Rock* (fig. 51b), and the large multiple plate *View of West Nuremberg* and *View of Nuremberg* (Bartsch 58 and 59), but three of the artist's portraits were included as well. The Harrach Lautensack prints, which reflect the connoisseurship for which the Viennese collection was known, account for a sizable portion of the artist's work that Rosenwald acquired—twenty-seven prints in all, two of which were purchased as early as July 1928 from C. G. Boerner.

JACOPO DE' BARBARI
Italian, 1460/1470-c. 1516

52
Large Sacrifice to Priapus,
c. 1499-1501

Engraving
23 x 16.8 (9¹⁄₁₆ x 6⅝)
Hind 23; Levenson, Oberhuber, Sheehan *Italian
Engravings* 136
PROVENANCE: Purchased from William H. Schab,
1948; presented to NGA, 1948
B-3493

Numerous additions to the collection's important representation of early Italian engravings were made after Alverthorpe was opened. Among them was Giulio Campagnola's *Saint John the Baptist* (fig. 52a), the only print solely by the artist to enter the collection, although *Shepherds in a Landscape* (Hind 6) by Giulio and his adopted son Domenico had been acquired in 1928.

The collection also grew during this period to include thirteen engravings by Jacopo de' Barbari as well as the monumental woodcut *View of Venice* thought to have been designed by Jacopo and published by Anton Kolb in 1500. Jacopo was the first of the important Italian Renaissance engravers to travel to the Netherlands and to Germany, and he was much admired by his German contemporary Albrecht Dürer. Six of Rosenwald's engravings by Jacopo were acquired between 1928 and 1930, two of these through Charles Sessler from the collection of Friedrich August II, the source of several Italian engravings in the collection. Two more were added in the late 1930s, and several more a decade later. The *Large Sacrifice to Priapus*, executed early in Jacopo's career, was among these last acquisitions, the purchases of 1948 and 1949. This particular impression was acquired in exchange for another one (presumably of lesser quality) that Rosenwald had purchased earlier, in 1939.

Priapus was the Greco-Roman god of procreation—both animal and vegetable—and the guardian of gardens and vineyards. In this, the earlier of Jacopo's two engravings of the subject, set into a shallow

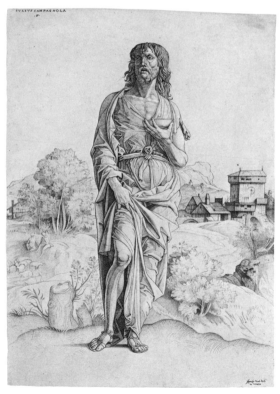

Fig. 52a. Giulio Campagnola. *Saint John the Baptist,*
c. 1505. Engraving. B-11,139.

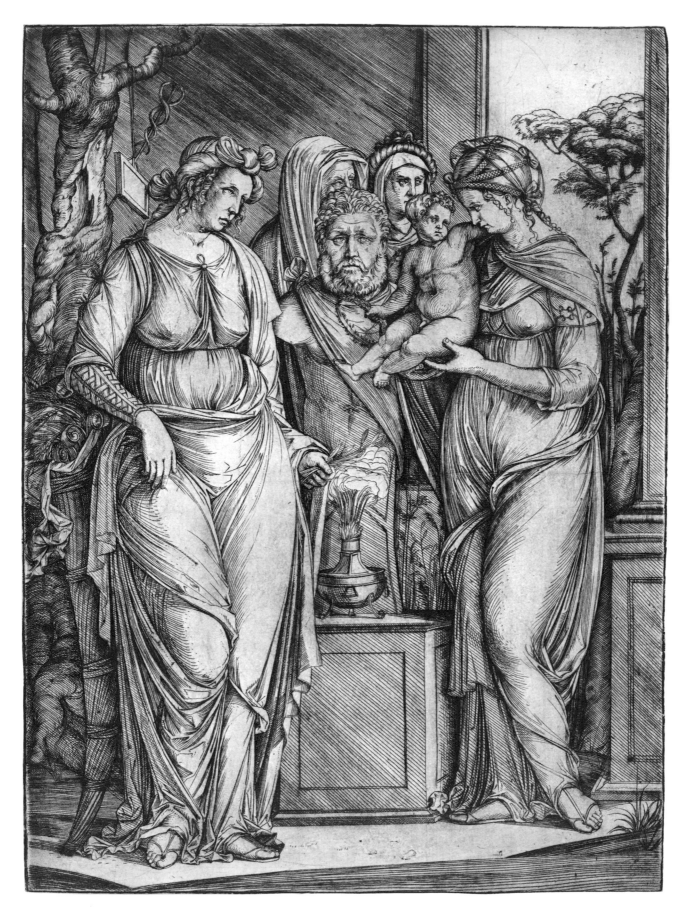

157

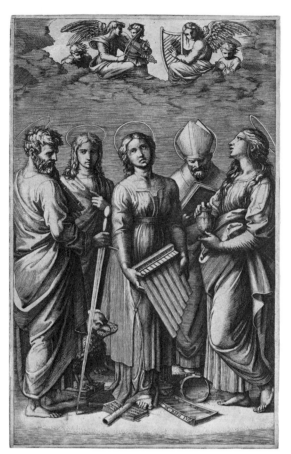

Fig. 52b. Marcantonio Raimondi. *Saint Cecelia*. Engraving. B-14,144.

space with landscape and architectural elements rather awkwardly combined, we find a young mother at the right presenting her child to the god, while at the left a second woman is burning leaves in the flame of the sacrificial lamp. This latter figure holds her right arm above a cornucopia, a suggestion that nature's bounty will come to these women in return for their devotion to Priapus.

The Italian engravings purchases of the late 1940s also included several prints by Marcantonio Raimondi, principally a reproductive engraver who seems to have entered the Rosenwald Collection almost on the sly. In his *Recollections* (14) Rosenwald, in discussing gaps in his collection, indicates, "I have never been partial to prints by Marcantonio Raimondi whose oeuvre is important and should be represented but is not because of my own personal taste." Nevertheless, more than twenty prints by the artist were acquired between 1928 and 1957. Among the earliest was a set of the *Seven Virtues* after Raphael which came from Sessler. Additions were made from the von Passavant-Gontard sale in 1929, but almost half of the Marcantonios, including *Saint Cecelia* (fig. 52b) were acquired after Alverthorpe was opened.

REFERENCE: Levenson, Oberhuber, Sheehan, *Italian Engravings*

LUCAS VAN LEYDEN
Dutch, 1494-1533

53
The Raising of Lazarus, 1508

Engraving
28.3 x 20.3 (11⅛ x 8)
Hollstein 42 I/II
PROVENANCE: The Princes of Liechtenstein; purchased
from Richard H. Zinser, 1949; presented to NGA,
1950
B-15,985

The Raising of Lazarus is one of almost a hundred engravings by Lucas van Leyden, the earliest Dutch engraver of great stature, in the collection. About three-quarters of them were purchased by 1930, including the unique known impression of *The Savior Standing with the Globe and Cross in His Left Hand* (fig. 53a). The sheet was one of several acquired from the von Passavant-Gontard sale, and also the Schloss "E" sale in 1929, the year that the largest number of Lucas purchases were made.

This extremely rich *Raising of Lazarus*, the finest Lucas impression in the collection, is one of several of the artist's engravings acquired in 1949 from the Liechtenstein Collection, the others including *Saint Simon* (Hollstein 97), *Saint Matthew* (Hollstein 98), and *Saint Christopher Carrying the Infant Christ* (Hollstein 109). The Lazarus subject shows Lucas's distinctive propensity for combining schematized form with highly realistic rendering, often conveying strange juxtapositions of flattened volumes set within a rather deep and fluid space.

Lucas's woodcuts are also represented in the collection, the first two of them coming from the von Passavant-Gontard sale. Between then and 1951, the year of the last Lucas purchases in either medium, about a dozen of the artist's woodcuts were acquired.

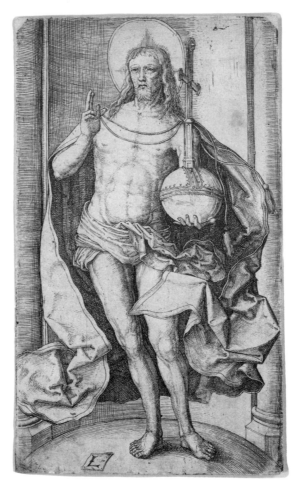

Fig. 53a. *The Savior Standing with the Globe and Cross in His Left Hand*, c. 1510. Engraving. B-8173.

(AFTER) PIETER BRUEGEL
Flemish, c. 1528-1569

54
The Festival of Saint George,
c. 1559

Etching and engraving
23.4 x 52.4 (13³⁄₁₆ x 20¹¹⁄₁₆)
Lebeer 52 I/II
PROVENANCE: Purchased from William H. Schab,
1959; presented to NGA, 1964
B-23,089

Rosenwald did not acquire an impression of the only etching which Bruegel drew onto the plate himself, *The Rabbit Hunt* (which is, however, in the National Gallery's collection), but he did purchase more than eighty-five of the prints engraved after Bruegel's designs by Cornelis Cort, Frans Huys, and others. Among them are a series of twelve Alpine landscapes and many complex allegorical compositions. Several subjects are held in multiple impressions, and a number of Bruegel duplicates were sold during the late 1960s.

The earliest Bruegel purchase was the series of *Seven Virtues*, purchased at the same May 1928 Boerner's sale from which Rosenwald acquired several Italian engravings formerly in the collection of Friedrich August II. The Bruegels, however, came from the collection of the painter Fritz Rumpf that was formed by his grandfather, Andreas Finger, and they included a superb impression of *Prudence* (fig. 54a). Between these 1928 acquisitions and 1964, the date of a major Bruegel purchase described below, additional engravings after Bruegel drawings were purchased sporadically, mainly from William H. Schab. Among these was *The Festival of Saint George*.

Fig. 54a. *Prudence*, 1559-1560. Engraving. B-5225.

Village festivals such as this one were the subjects of several of Bruegel's most appealing paintings as well as his designs for prints, and this particular scene is considered to be one of his finest. The fête site is filled with events to be enjoyed as one's eye moves among the frolicking peasants—from the woman on a swing inside the hut at the far left, to the wheeled winged-dragon creature spouting smoke near the center of the scene, to the dog tugging at the child's skirt slightly below, and the tiny birds, perched at the upper right, observing the bustle of activity. Like many of Bruegel's subjects, *The Festival of Saint George* was published by Hieronymous Cock.

The most important event in the development of Rosenwald's Bruegel holdings took place rather late in the life of the collection, in 1964. That year, during a visit to Los Angeles, Rosenwald acquired an important collection of seventy-four Bruegel prints, spanning the artist's oeuvre, belonging to Josephine Ver Brugge Zeitlin. The Zeitlin Collection had been formed by Josephine and Jacob Zeitlin over a period of several years. Directly prior to its purchase by Rosenwald, it had been circulating for some time in the manner that the Rosenwald Collection prints had traveled from institution to institution more than thirty years earlier. Rosenwald's decision to buy the Zeitlin Collection placed Bruegel prints among the strengths of his Dutch and Flemish holdings.

163

ANONYMOUS MASTER OF THE BATTLE OF FORNOVO
Lyons (?), active late 1400s

55
The Battle of Fornovo, c.1495

Engraving, printed on two sheets of paper joined at center
40.9 x 62.9 (16⅛ x 24¹³⁄₁₆)
Shestack *Engravings* 261
PROVENANCE: Purchased from William H. Schab, 1952; presented to NGA, 1952
B-20,218

This panoramic battle scene, thought to be a unique impression, depicts the Battle of Fornovo, fought on 6 July 1495, in the Taro River valley in northern Italy. Ferdinand and Isabella of Spain, the Borgia Pope Alexander VI, the Emperor Maximilian, the forces of the Venetian Republic, and the Milanese under Ludovico Sforza had come together in a Holy League to oppose the French king, Charles VIII, who was returning to Paris from Naples where he had settled his disputed claim to that Italian kingdom. His forces comprised French knights and foot soldiers, mercenaries from Switzerland, Scotland, and Germany, and also a number of Italians. As they crossed into the Taro valley, Charles's advance guard discovered the Holy League encamped in their path on the bank of the river beyond the town of Fornovo. The Italian troops, who greatly outnumberd the French, mainly comprised Milanese soldiers and an assemblage of Venetians to whom were attached a band of light cavalry, primarily mercenaries (called Stradiotti) from Albania and Greece.

The engraving depicts the encounter of all of these forces. At the center of the scene are the French troops, specifically the Swiss infantry, poised to attack the heavily armored Italians about to emerge from the woods at the left. King Charles, identifiable by his crown, is in battle at the lower right, where one of the Italian knights is about to lunge directly at him. The Stradiotti, rather large in scale when compared with the rest of the figures, are wearing tall hats and distinctive coats, and are seen at the lower left corner, where they are looting the French baggage rather than aiding the battle. According to eyewitness accounts, the Stradiotti's preoccupation with the treasure helped to lose the battle for the stronger Italian troops.

On the far bank of the Taro, which stretches across the entire width of the scene, one sees the tents of the Italian forces as well as large numbers of the Venetian and Milanese soldiers (Sforza's device, a serpent, may be seen on two standards set off by the trees at the upper left corner of the print). The intensity of the melee is clearly communicated by the hundreds of small overlapping forms of figures and animals and weaponry, all in the postures of battle as they move through the field. One's interest in the subject is further enhanced by the artist's attention to details of costume as well as the surrounding landscape environment.

If this engraving is from Lyons as suggested by Elizabeth Mongan, it is the one fifteenth-century French engraving in the Rosenwald Collection.

REFERENCE: Mongan, "Fornovo"

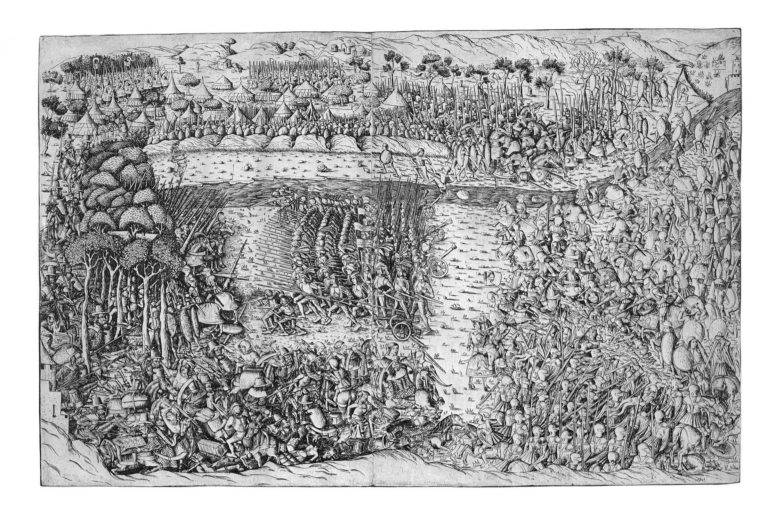

JEAN DUVET
French, 1485-c.1570

56

Apocalypse figurée: "Saint Michael and the Dragon," 1546-1556

Engraving
29 x 25 (11⁷⁄₁₆ x 8¹⁄₁₆), tablet-shaped
Eisler *Duvet* 51
PROVENANCE: Comte Octave de Behague; purchased from William H. Schab, 1946; presented to NGA, 1946
B-13,920

Fig. 56a. Jacques Bellange. *Three Marys at the Tomb*, c. 1615-1620. Etching with engraving. B-15,902.

Jean Duvet was a designer of tapestries and stained glass, as well as the goldsmith to two French kings, Francis I and his son, Henry II. Of the artist's seventy-three extant engravings, twenty-three are known in unique examples only. Rosenwald acquired thirty-two of the remaining fifty. All but four of them were purchased from William H. Schab between 1946 and 1954, and most of them have distinguished provenances, coming from important collections like that of the Comte de Behague, Friedrich August II, and the Dukes of Arenburg, from whose library Rosenwald acquired a splendid collection of early Dutch and Flemish volumes in 1956.

The first of Rosenwald's Duvet acquisitions, one of the *Apocalypse figurée* series, was an early purchase from Sessler in 1929. Eventually, he obtained nineteen of the twenty-three engravings in the series illustrating "The Revelation of Saint John the Divine," one of which is "Saint Michael and the Dragon." The Saint Michael image is based on chapter 12, verses 7-12. In the text, Michael and his angels fight with "that old serpent, called the Devil, and Satan . . . And they [overcome] him by the blood of the Lamb. . . ." Duvet's rendition of his subject is typical of the eccentric vision, mannered style, and crowded, tumultuous imagery that characterize the series.

In addition to the *Apocalypse* prints, Rosenwald obtained four of the six prints in Duvet's cycle devoted to a unicorn hunt, as well as six of the eight additional tablet-shaped plates related in format to the *Apocalypse figurée* series.

Another French mannerist engraver, introduced into the Rosenwald Collection in the late 1940s when most of the Duvets were purchased, is the court painter, Jacques Bellange (1594-1638), a contemporary of Callot (see cat. no. 58). Bellange, like Callot, worked in Nancy, a crossroads of European culture during the seventeenth century. The *Three Marys at the Tomb* (fig. 56a) is one of six Bellange prints acquired by Rosenwald. Almost disdainful of the religiosity of his subject, Bellange depicted elegant, willowy women, both human and divine, whose sensuousness is typical of his distinctive figural style.

William H. Schab, the source of most of the Duvets, was also the source of all of the Bellange etchings as well as a pencil drawing thought to be by Bellange at the time of its 1961 purchase, but since reattributed as an anonymous drawing after one of the central figures in Bellange's etching *The Bearing of the Cross* (Robert-Dumesnil 7).

REFERENCE: Eisler, *Duvet*

GEORG HOEFNAGEL
Flemish, 1542-1600

57a-d

Ignis. Animalia Rationalia et Insecta: plate I
Terra. Animalia Qvadrvpedia et Reptilia: plate XXXVIII
Aier. Animalia Volatilia et Amphibia: plate XXXVIII
Aqua. Animalia Aqvatilia et Cochiliata: plate XIII
c. 1575-1580

Four volumes: watercolor with opaque white on vellum, alternating with manuscript text on paper, bound in red morocco stamped in gold with original brass clasps
14.3 x 19.5 (5⅝ x 7¼), approximate page size
PROVENANCE: H. Huth; A.H. Huth (Sotheby's, 2-13 June 1913, no. 3722); C.F.G.R. Schwerdt (Sotheby's, 12 March 1946, no. 2216); purchased from The Rosenbach Company; promised gift on deposit at NGA by Mrs. Lessing J. Rosenwald

Thousands of birds, fish, beasts, and insects as well as flowers, fruits, plants, and trees fill the more than 275 leaves of these four volumes. They are meticulously rendered with an abundance of naturalistic detail, at times rather fancifully presented (cat. no. 57c). The volumes were commissioned by Emperor Rudolph II, himself an astrologer and astronomer keenly interested in natural history. The paintings are categorized within a framework of the four elements—fire (*Ignis*), earth (*Terra*), air (*Aier*), and water (*Aqua*). Rational animals and insects are ascribed to fire; quadrupeds and reptiles to earth; flying and amphibious animals to air; and fish and shelled creatures to water.

Among the most striking of the leaves is cat. no. 57a, depicting two figures, one of whom is a hairy man, who, according to the Latin inscription on the facing page, is Pedro Gonzalez. The inscription explains that Gonzalez was born at Teneriffe, the largest of the Canary Islands, his body covered with hair, and was raised in France, where he set aside his savage customs to learn the liberal arts and the Latin language. He married a beautiful woman and they had several children. Some resembled their mother, and others, two of whom are depicted on the following leaf, were covered with hair like their father. Apart from these first two leaves (which are followed by two that remain blank) the rest of the volume is devoted to insects.

Cat. no. 57b is unusual in its use of an architectural setting, although the range of images in this particular volume is the most varied of the four. Cat. nos. 57c and 57d display typical examples, although each individual leaf in all of the books is exquisite. The paintings as a group are surely among the most spectacular natural history compendia extant.

The books were a gift from Rosenwald to his wife Edith, and it is apt that she should own these extraordinary volumes. The gardens at Alverthorpe, and later the community park on the land the Rosenwalds gave to the township, have always been among her great interests. In fact, not only the Rosenwald Collection of graphic art, but also the Alverthorpe gardens, handsomely planted with dozens of species of trees and varieties of flowers, over the years drew many visitors to the Jenkintown estate.

In addition to her interest in the beauty of her own natural surroundings, and in sharing them with the community, Mrs. Rosenwald, like her husband, has contributed actively to the life of Philadelphia in a variety of ways. She, too, has been a force in the arts community, for example, and for many years has been a member of the board of trustees of the Philadelphia College of Art. She has also made several very special gifts to the National Gallery, among them, five drawings by Jean-Honoré Fragonard (1732-1806) for *Orlando Furioso* (fig. 57a) and Hans Baldung Grien's *Half Figure of an Old Woman with a Cap* (Robison, *Drawings*, 24).

Fig. 57a. Jean-Honoré Fragonard. *Orlando Furioso: Rinaldo Astride Bayardo Flies Off in Pursuit of Angelica*, c. 1795. Black chalk with brown and gray washes. B-11,147.

Omni miraculo quod fit per Hominem maius miraculum est HOMO
Visibilium omnium maximus est Mundus, Inuisibilium DEVS
Sed mundum esse cospicimus, Deum esse Credimus

HOMO natus de MVLIERE, breui viuens Tempore
Repletur multis miserys Job 14

Cat. no. 57a

LVPVS LVPINĀ NON EST NEc CANIS CANINAM

CORONA IMPERIALIS

XXXVIII

Non ita difficile est, natura cùm sit amicus,
Conciliare tibi Catulum, Custodia fida:
Inconcussus amor canis est per tempora multa

Cat. no. 57b

XXXVIII.

Cat. no. 57c

XIII.

Cat. no. 57d

JACQUES CALLOT
French, 1592-1635

58
The Siege of La Rochelle, c. 1631

Etching and engraving
Sixteen plates, approximate sizes: six central panels:
56.9 x 45.4 (22⁷⁄₁₆ x 17⁷⁄₈); four vertical border panels:
57.6 x 16.2 (22¹¹⁄₁₆ x 6⁷⁄₁₆); two central horizontal
border panels: 16.3 x 46.2 (6⁷⁄₁₆ x 18⅛); four outer
horizontal border panels: 16.2 x 59.9 (6⁷⁄₁₆ x 23⁷⁄₁₆)
Lieure 655 II/II; Russell *Callot* 189
PROVENANCE: Purchased from P. & D. Colnaghi,
1951; presented to NGA, 1952
B-20,310–20,325

Fig. 58a. *Stag Hunt,* c. 1619. Etching. B-13,570.

Jacques Callot grew up in the important cultural trade crossroads of Nancy, and in his own lifetime, his work was highly respected by nobility in France, Italy, and the Netherlands. The Rosenwald Callot collection, which includes two drawings and approximately 530 of the artist's more than 1400 prints as well as two of the many sets of copies after Callot (the *Balli of Sfessania* and *The Beggars*), was begun in July 1928. In 1929 additions were made from the von Passavant-Gontard and Schloss "E" sales. Among them were *The Fan with View of Florence* (Lieure 302) and the *Large Miseries of War* (Lieure 1339-1356). A few sheets were added in 1930 and a few in 1944-1947. Among these was the brilliant impression of the *Stag Hunt* (fig. 58a), purchased from Sessler in 1946. The banner year for

the Callot collection, however, was 1949. In January, Rosenwald acquired from Pierre Bères forty-eight lots, including more than three hundred Callot prints. The group was selected from a collection of approximately eight hundred formed by a nineteenth-century French nobleman according to the correspondence from Bères, who exhibited the prints at his West 56th Street address manned at the time by Lucien Goldschmidt. Sets of several of Callot's most important series including both the Florence and Nancy *Caprices, The Gobbi,* and *The Beggars* were in the group. With this purchase, the Callot collection became a strength within Rosenwald's increasingly important holding.

The Siege of La Rochelle, however, was not among this impressive lot, but Rosenwald was fortunate to acquire a complete set of the sixteen plates (along with impressions of one of Callot's two other military subjects, *The Siege of Breda*) from Colnaghi two years later. *The Siege of the Citadel of Saint Martin on the Isle of Ré* (in the National Gallery's Baumfeld Collection) is the third. Both the *Saint Martin* and the *La Rochelle* projects were commissioned by Louis XIII, and both depict victories organized by Cardinal Richelieu. At La Rochelle, the French Huguenots (assisted by the English) surrendered to the Richelieu forces in October 1628, the year the Callot print was commissioned. The border plates which surround the central image depicting the king and other luminaries, coats of arms, and miscellaneous scenes and events were the work of Callot's assistants, including Abraham Bosse, who is otherwise represented in the collection by about a dozen prints.

REFERENCE: Russell, *Callot*

Cat. no. 58

Cat. no. 58, detail.

173

JAKOB CHRISTOF LE BLON
German, 1667-1741

59
Louis XV, King of France
(after Blakey)

Mezzotint with etched details printed in red, blue,
light brown, dark brown, and black with additions in
white paint
59.9 x 44.3 (23⁹⁄16 x 17⁷⁄16)
Singer 40
PROVENANCE: The Princes of Liechtenstein; purchased
from P. & D. Colnaghi, 1954; presented to NGA,
1954
B-21,575

Fig. 59a. Ludwig von Siegen. *Amelia Elizabeth, Mar-
gravine of Hesse*, 1642. Mezzotint. B-10,301.

The mezzotint process, like the chiaroscuro woodcut process (see cat. no. 35), historically has been used to produce images related in large measure by characteristics of the medium salient enough to be more powerful than distinctions of time, place, and personality. Two soldiers working as amateurs are credited with the invention of the technique: Ludwig von Siegen (1607-c.1676) and Prince Rupert, Count Palatine. The print cited as the first mezzotint is von Siegen's *Amelia Elizabeth, the Margravine of Hesse* (fig. 59a), which became part of the Rosenwald Collection in 1930. In the mid-1940s, two of Prince Rupert's subjects were added.

Briefly, the mezzotint requires that the copper plate be given a uniformly rough surface which holds the ink and from which the image is formed by making certain specific areas more smooth, thus eliminating their capacity to hold ink. A toothed implement called a "rocker" is worked back and forth repeatedly across the plate in varying directions following an established pattern. Thus, a drypointlike burr is created, capable of holding a quantity of ink that will produce the rich dark velvety surface that is inherent to the mezzotint process. Lighter tonal areas of great subtlety are produced by reducing the burr to varying degrees, dependent upon the grayness required by the composition.

By means of experiments with mezzotint plates printed in color, Jakob Christof Le Blon attempted to demonstrate Sir Isaac Newton's theory that mixtures of red, yellow, and blue were the source of all other hues. He published his investigations in a rare volume called *Coloritto; or The Harmony of Colouring in Painting* (London, 1725), a copy of which is in the Library of Congress Rosenwald Collection. The *Louis XV* portrait seen here is an important example of Le Blon's work, which eventually moved away from his strict three color theory to incorporate black as well as other hues. Fewer than 100 impressions of Le Blon's color mezzotint portraits are known to survive. Among them are four of Louis XV. This subject is one of two rare color portraits by Le Blon in the collection. The other depicts Sir Edmund Spenser. Both of them were among several prints from the Liechtenstein Collection that Rosenwald acquired individually after he decided not to purchase the collection *en bloc* (see cat. nos. 46-47).

Mezzotint plates have a tendency to wear out rapidly, and late impressions from them are often grayish and blotchy. Additionally,

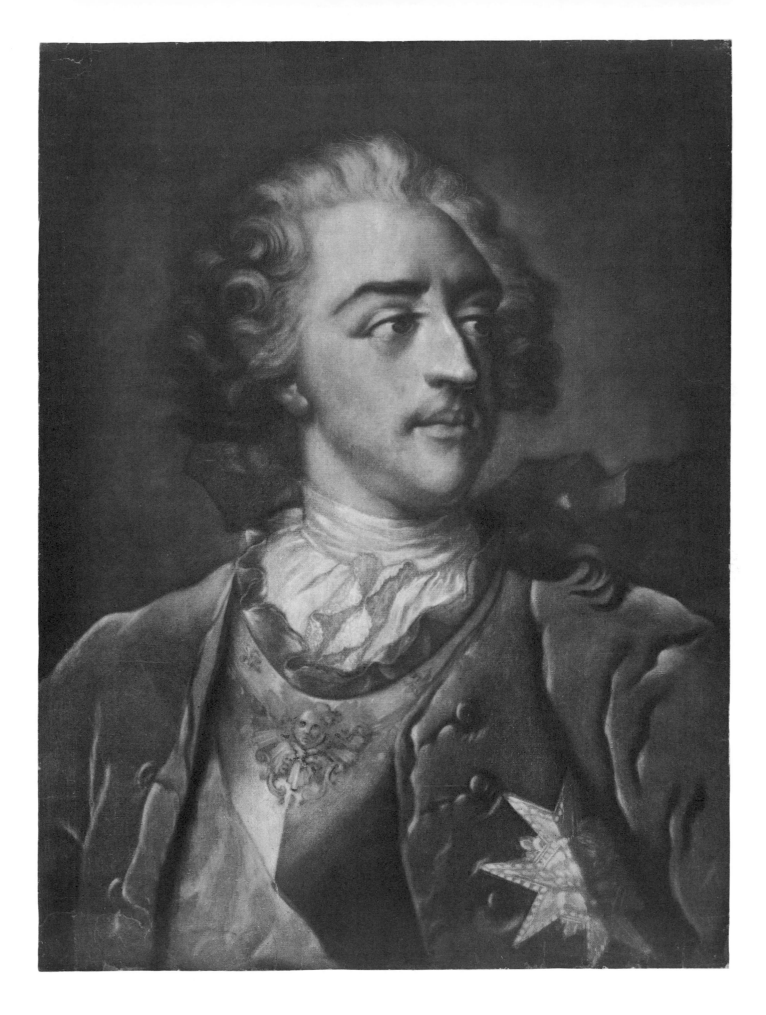

Fig. 59b. Carlo Lasinio. A *Huntsman Visiting a Lady*.
Mezzotint. B-13,570.

large color prints like the Le Blon portrait were sometimes heavily
varnished, making them appear to be paintings when they were hung
on the wall. Clear, bright impressions like the *Louis XV*, therefore,
are difficult to find.

The heyday for the mezzotint came in eighteenth-century
England, when the process was used to make reproductions of
paintings by the hundreds. Rosenwald acquired a small group of the
prints of this period: by Richard Earlom, Valentine Green, and others
after the paintings of John Hoppner, Joseph Wright of Derby, and,
again, others. Many of them came from the fine collection of Martin
Erdmann. As a group they are early proof states in fresh vivid
impressions.

Another interesting group of prints made by this process are Carlo
Lasinio's (1759-1838) artist portraits purchased in 1959 and a color
mezzotint by Lasinio after Gabriel Metsu, *A Huntsman Visiting a
Lady* (fig. 59b), acquired in 1963. Interest in the process has been
revived, occasionally, in our own century, and examples by Picasso
and Escher are also in the collection.

WENCESLAUS HOLLAR
Bohemian, 1607-1677

60
Parallel Views of London before and after the Fire, 1666

Etching
22.2 x 67.2 (8¾ x 26⁷⁄₁₆)
Parthey 1015
PROVENANCE: Purchased from Lucien Goldschmidt,
Inc., cat. 47, no. 61, 1978; presented to NGA, 1980
B-31,643

Rosenwald acquired approximately 225 etchings by Wenceslaus Hollar, an artist of great originality as well as an excellent copyist. The sale of the Rumpf Collection in Leipzig in 1928 followed by the Schloss "E" and von Passavant-Gontard sales in 1929 formed the base of the Hollar holdings, all but about twenty-five items of which were acquired by 1929.

The large and intricate *Antwerp Cathedral* (fig. 60a) was the Hollar print that appeared in most of the early Rosenwald Collection exhibitions, but also among the early purchases were complete sets of several of Hollar's series: *The Satirical Passion* after Holbein (Parthey 116-131), the views of various German cities (*Amoenissimae Aliquot Locorum* . . . [Parthey 695-718]), the series of eight butterflies (*Diversae Insectorum Aligerorum* [Parthey 2176-2183]), and the costumes for theater (*Theatrum mulierium* . . . [Parthey 1804-1907]) to name just a few.

Other Hollars were added on various occasions with *The Great View of Prague* (Parthey 880), the artist's birthplace, printed on three sheets, among the last of them. The very last of the Hollar purchases was the *Parallel Views of London before and after the Fire*, and the print actually was Rosenwald's very last old master print purchase. As such, perhaps it should take a place of equal interest with Rosenwald's first purchase, D. Y. Cameron's *Royal Scottish Academy*, in the annals of the Rosenwald Collection. After acquiring the Hollar *Views of London*, Rosenwald indicated that it was a subject he had wanted for some years but had never come across for sale.

In addition to the prints, there is one Hollar drawing in the Rosenwald Collection, *View of Antwerp* (fig. 60b), a delicate pen and brown ink study, purchased in 1952 from Richard H. Zinser.

Fig. 60a. *Antwerp Cathedral*, 1649. Etching.
B-11,143.

Fig. 60b. *View of Antwerp*. Pen and brown ink. B-21,021.

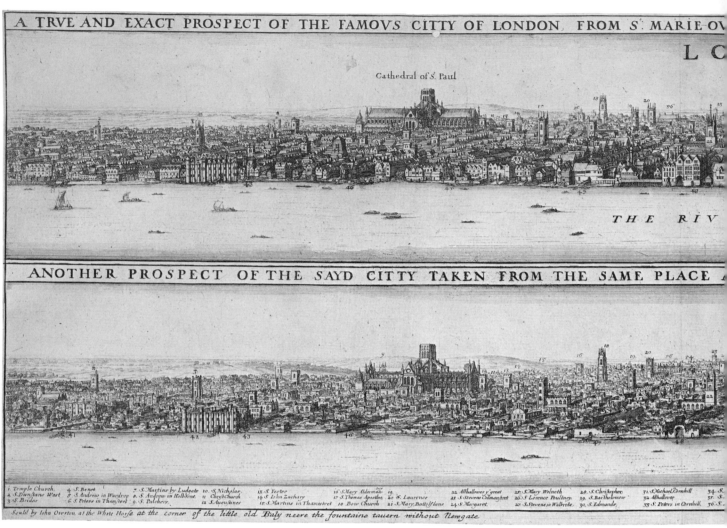

1 Temple Church. 4 S. Benet 7 S. Martins by Ludgate 10. S. Nicholas. 13 S. Foster 16 S. Mary Aldarman 19. 22 Althallowes y'great 25 S. Mary Wolnoth 28 S. Christopher 31 S. Michael, Cornhill 34 S.
2 S. Dunstans West 5 S. Andrew in Wardrop 8 S. Andrew in Holborne 11 Christchurch 14 S. John Zachary 17 S. Thomas Apostles 20 S. Laurence 23 S. Stevens Colmanstret 26 S. Lorence Poultney 29 S. Bartholomew 32 Althallowes 35 S.
3 S. Brides 6 S. Peters in Thamstret 9 S. Dulcheur. 12 S. Augustines 15 S. Martins in Thamestret 18 Bow Church 21 S. Mary, Buttolf lane 24 S. Margaret. 27 S. Stevens in Walbroke. 30 S. Edmunds. 33 S. Peters in Cornhill 36 S.

Sould by Iohn Overton, at the White Horse at the corner of the little old Baly neere the fountaine tauern without Newgate

Cat. no. 60

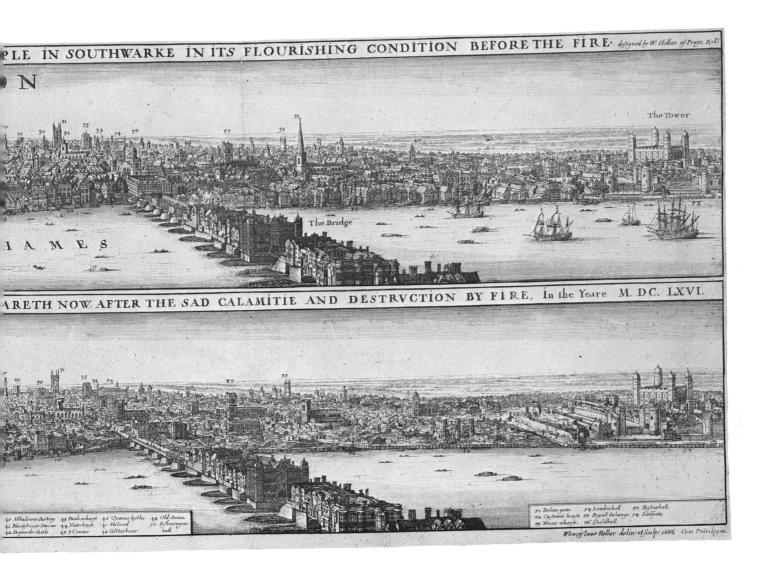

PLE IN SOUTHWARKE IN ITS FLOURISHING CONDITION BEFORE THE FIRE. *designed by W: Hollar of Prage, Boll:*

N

The Tower

The Bridge

IAMES

ARETH NOW AFTER THE SAD CALAMITIE AND DESTRVCTION BY FIRE, In the Yeare M.DC.LXVI.

40. Allhallowes Berking	43. Pauls wharfe	46. Queene hythe	49. Old Swan.
41. Blackfriars-Staires	44. Waterhouse	47. Stiliard	50. Bishopsgate-
42. Barnards Castle	45. 3 Cranes	48. Colstarbour	hall.

51. Beline gate.	54. Leadenhall	57. Basinghall.
52. Custome house.	55. Royall Exchange	58. Ludgate.
53. Tower wharfe.	56. Guildhall.	

Wenceslaus Hollar delin: et sculp: 1666. Cum Privilegio.

GABRIEL-JACQUES DE SAINT-AUBIN
French, 1724-1780

61
Allegory Celebrating the Marriage of the Count of Provence, 1771

Etching, reworked with pencil and brown and black ink
26.2 x 21.1 (10⅚₆ x 8⅚₆)
Dacier (1914) 46 I/III
PROVENANCE: Robert-Dumesnil (Lugt 2200); Atherton Curtis; Hôtel Drouot, June 1955, sale 6, no. 77; purchased from Henri Petiet, 1955; presented to NGA, 1958
B-21,997

In his *Recollections* (51), Lessing Rosenwald indicated that "whenever I could obtain examples of this artist [Gabriel de Saint-Aubin] I tried to get them because he is one of my favorites in the French eighteenth-century group." Saint-Aubin actually was among the artists who attracted Rosenwald's attention during his later years as a collector. The first of his Saint-Aubin purchases date from the mid-1940s, the last from the late 1960s. But most of the Saint-Aubin collection (numbering more than thirty prints, including many special proofs in early states and/or retouched by the artist, like the *Allegory* included here) was purchased in the 1950s through Henri Petiet. The first of these Petiet transactions was at the June 1950 sale of part of Henri-Jean Thomas's collection. At the sale, Petiet was able to obtain only one of the three prints for which Rosenwald had given him bids, and the other two were bought back at the sale by Thomas himself. Not long after the sale, however, apparently as the result of much cajoling, Petiet managed to pry loose the other two items directly from Thomas. The most coveted of these was the *View of the Exhibition at the Louvre in 1753* in a retouched first state impression (fig. 61a). In recounting the incident (*Recollections*, 52), Rosenwald was most enthusiastic: "I think I have the same feeling toward these prints that M. Thomas had, so the prints did not suffer any loss of prestige through the exchange."

Fig. 61a. *View of the Exhibition at the Louvre in 1753*, 1753. Etching, reworked with pen and wash. B-19,253.

In 1951, another print from the Thomas Collection was acquired, and in 1955 the largest group of Rosenwald Saint-Aubins came from two sales at the Hôtel Drouot, one in June and the other in October. The *Allegory Celebrating the Marriage of the Count of Provence* in this first state impression with drawing added throughout, offering

180

Composé et gravé a l'eau forte par Gabriel de St Aubin

181

evidence of the artist's visual thinking, was among ten Saint-Aubins acquired at the June sale.

The densely constructed allegorical composition celebrates the 14 May 1771 marriage of the future Louis XVIII to Louise-Marie Josephine of Savoy. Wisdom in the guise of Minerva is showing the king (who wears the royal mantle) the book of destiny which is supported by the tusks of an elephant, a symbol of long life. To the right of the king, Love is exchanging torches with Hymen, the god of marriage, and behind them is the conjugal bed. Above, two genii hold aloft the arms of France and Savoy, and between the two are two hearts, pierced by a single arrow. At the very top, a figure encircled by stars and holding a globe in each hand signifies destiny. In the lower right corner, a lion, a lamb, and a rabbit rest together peacefully celebrating the grand royal union, while in the upper left corner, we find the god Terminus who has chained the wheel of destiny.

During the 1950s, Rosenwald acquired two of Gabriel's black crayon drawings as well as a single pen and ink sketch, and the Rosenwald Collection at the Library of Congress includes a copy of the 1727 *Description des tableaux du Palais Royal, avec la vie des peintres à la tête de leurs ouvrages* (LCRC 1621) with marginal illustrations in pencil by Saint-Aubin.

In June 1955, from the same sale at which Rosenwald acquired so many of Gabriel de Saint-Aubin's prints, he also purchased thirteen etchings (of the twenty-seven catalogued by Baudicour) by Gabriel's older brother Charles-Germain de Saint-Aubin (1721-1786). Included was a splendid impression of the rare and possibly unique *The Butterfly and the Tortoise* (fig. 61b), in which a butterfly is enthroned upon a tortoise chariot, as well as complete sets of two series of humanized butterflies in which decorative butterflies are fancifully engaged in various human activities including fencing, dancing, and playing board games.

REFERENCE: Carlson, D'Oench, Field, *Saint-Aubin*

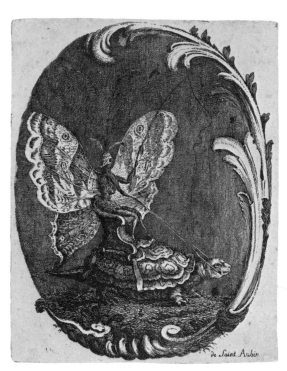

Fig. 61b. Charles-Germain de Saint-Aubin. *The Butterfly and the Tortoise*, c. 1750. Etching. B-22,007.

GIOVANNI BATTISTA TIEPOLO

Italian, 1696-1770

62

Scherzi di Fantasia: "Magician and Other Figures before a Burning Altar with Skull and Bones," c. 1745-1750

Etching, reworked with pen and brown ink, opaque white and gray wash
23.3 x 17.3 (9³⁄₁₆ x 6¹³⁄₁₆)
DeVesme 20 I/II; Russell *Tiepolo* 20
PROVENANCE: A.M. Zanetti; A. Caironi, Milan (Lugt 426); purchased from Pierre Bères, 1951; presented to NGA, 1951
B-19,907

Fig. 62a. Binding of Tiepolo volume showing coat of arms of Anton Maria Zanetti.

Giovanni Battista Tiepolo's "Magician and Other Figures before a Burning Altar with Skull and Bones" is part of an album comprising, with the exception of one subject, the artist's entire printed oeuvre: the set of twenty-three etchings known as the *Scherzi di Fantasia,* Tiepolo's other etching series, the *Vari Capricci* (ten prints), and one of his two single prints, *Saint Joseph Holding the Infant Christ.* (Tiepolo's other single sheet, *The Adoration of the Magi,* was acquired in 1956 from Nathan Chaiken.)

The *Scherzi* series is the most unusual and important of the prints in the album. Not only are the etchings generally in beautiful impressions but fifteen of them (as well as the *Saint Joseph* single sheet) are reworked with drawing, particularly in brown ink. In some instances the drawn additions are very minor, but in others, such as the "Magician and Other Figures before a Burning Altar," the pen and ink and wash additions, occasionally with opaque white corrections, are considerable. In working on the copper plate for this particular sheet, the artist apparently was plagued by technical problems both in the etching and printing processes. The reworking on the print, then, attempts both to clarify the image and to account for lines that did not print. It gives a clear idea of how the artist would have wanted his image to look had he taken the time to go back and work further on the copper plate, which, in fact, he did not do.

The album containing Giovanni Battista's etchings was one of two Tiepolo albums acquired from Bères. The second contains two series of etchings by Giambattista's son, Giovanni Domenico Tiepolo, a more prolific printmaker than his father. The series are *The Way of the Cross,* comprising sixteen prints and title and dedication pages after Domenico's own paintings, and the twenty-four prints, title and dedication pages, and coat of arms of the *Flight into Egypt,* often considered to be the artist's most significant print series. This album, too, is of special importance in that eight rare proof impressions before the addition of numbers from the *Flight into Egypt* series are bound in.

The two Tiepolo volumes are almost identical in size and are bound in mottled calf tooled in gold front and back with the coat of arms of publisher-printmaker Anton Maria Zanetti (fig. 62a) indicating their presence in his distinguished library. Zanetti (see cat. no. 35) was very highly regarded by his contemporaries. Throughout his lifetime, he was a friend of the Tiepolos as well as an enthusiastic promoter of their prints, circumstances that would account for his possession of the many rare sheets of particularly high quality in the two Tiepolo albums.

Eighteenth-century Italian prints, particularly by the Venetians, came into the Rosenwald Collection long before these Tiepolo acquisitions. Thirty-one of Canaletto's thirty-five etchings, for example, were acquired from Sessler in June 1928 bound together in

Fig. 62b. Giovanni Battista Piranesi. *Imaginary Prisons* (plate XIV), 1748-1750. Etching. B-14,043.

a single volume, and four of Giovanni Domenico's *Flight into Egypt* subjects were acquired in 1942. Piranesi's *Imaginary Prisons* in first (fig. 62b) and second edition impressions were acquired in 1946 and 1930 respectively, and in 1947 the first Paris edition of the complete works of the artist was added to the collection. In 1951, the same year that the Tiepolo volumes were acquired, Rosenwald purchased twelve large etched views of Dresden (fig. 62c) by Bernardo Bellotto (1720-1780), Canaletto's nephew.

REFERENCE: Russell, *Tiepolo*

Fig. 62c. Bernardo Bellotto. *View of the Bridge of Dresden across the Elbe with the Side View of the Catholic Church*, 1748. Etching. B-20,269.

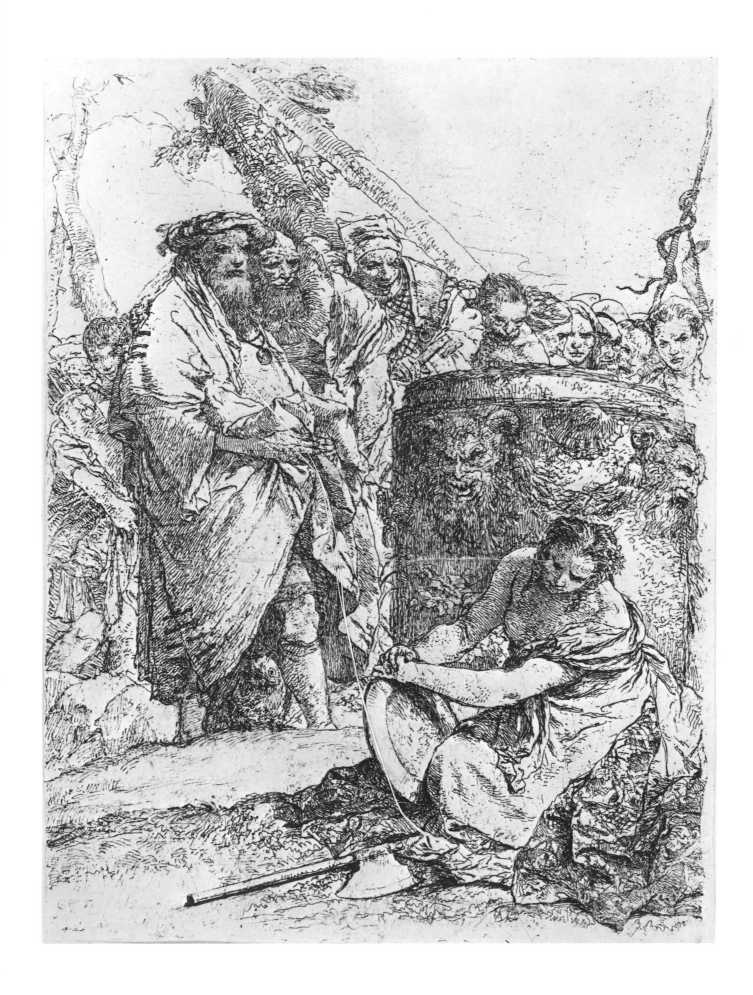

WILLIAM HOGARTH
British, 1697-1764

63
Beer Street, 1751

Etching and engraving
38 x 32.1 (15 x 12⅝)
Paulson *Hogarth* 185 II/III
PROVENANCE: Purchased from Goodspeed's Book Shop,
1944; presented to NGA, 1944
B-4612

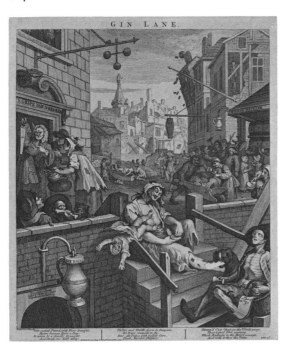

Fig. 63a. *Gin Lane*, 1751. Etching and engraving.
B-4613.

Apart from a single Hogarth engraving, *Simon Lord Lovat* (Paulson *Hogarth* 166), purchased in 1931, and two impressions of William Blake's *Beggar's Opera* after Hogarth (Paulson *Hogarth* 276), all of Rosenwald's acquisitions of engravings by Hogarth, or by the workshop of engravers who worked after his paintings and drawings, came in a single 1944 purchase. *Beer Street* is typical of the 114 sheets included, in that they were generally very fine, bright impressions of early states. One of them was an engraved receipt for "the first payment for six prints called *Marriage à la Mode*" signed by Hogarth.

Many of Hogarth's prints are part of sequential, moralistic narrations *(Marriage à la Mode, The Four Stages of Cruelty, The Rake's Progress)*, and *Beer Street* has a companion work, *Gin Lane* (fig. 63a). Paulson (vol. 1, p. 207) quotes Hogarth's *Autobiographical Notes* regarding the intention of these two prints:

> Bear St and Gin Lane were done when the dredfull consequences of gin drinking was at its height[.] In gin lane every circumstance of its horrid effects are brought to view, in terorem nothing but ‹Itleness› Poverty misery and ruin are to be seen[.] Distress even to madness and death, and not a house in tolerable condition but Pawnbrokers and the Gin shop. Bear Street its companion was given as a contrast, w[h]ere the invigorating liquor is recommend[ed] in order [to] drive the other out of vogue. here all is joyous and thriveing[.] Industry and Jollity go hand in hand[;] the Pawnbroker in this happy place is the only house going to ruin where even the smallest qantity of the linquer flows around it is taken in at a wicket for fear of farther distress.

Rosenwald's collection of the prints of Thomas Rowlandson, a contemporary of William Blake who worked in the spirit of Hogarth, was formed, like the Hogarth collection, with a single purchase. It consisted of seven volumes bound in red morocco tooled in gold containing 1,202 caricatures, mainly from the collection of Sir William Augustus Fraser. Included were many rare subjects; most of the sheets were hand-colored in the assembly-line fashion based on a Rowlandson model, as one would expect, and they are particularly bright and fresh as a result of having been kept in albums rather than on walls, where the color would have been faded by light.

REFERENCE: Paulson, *Hogarth*

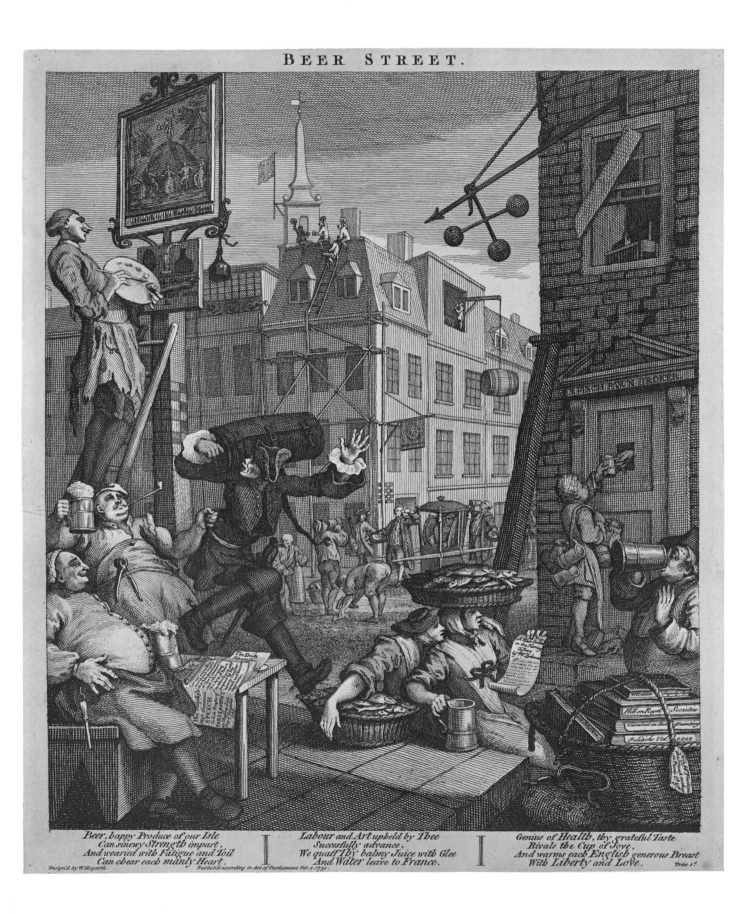

Beer, happy Produce of our Isle
Can sinewy Strength impart,
And wearied with Fatigue and Toil
Can chear each manly Heart.

Labour and Art upheld by Thee
Successfully advance,
We quaff Thy balmy Juice with Glee
And Water leave to France.

Genius of Health, thy grateful Taste
Rivals the Cup of Jove,
And warms each English generous Breast
With Liberty and Love.

Design'd by W. Hogarth. Publish'd according to Act of Parliament Feb. 1. 1751. Price 1.s.

JEAN-BAPTISTE-CAMILLE COROT
French, 1796-1875

64
The Saltarelle, 1858

Cliché-verre (salt print method)
21.9 x 16.2 (8⅝ x 6⅜)
Delteil 75 II/II
PROVENANCE: Purchased from Peter Deitsch and Robert
M. Light, 1967; presented to NGA, 1967
B-25,200

The landscape artists of the Barbizon School played an important role in the revival of interest in printmaking on the part of painters working in France at the mid-nineteenth century. Mainly, the process of etching was used by the Barbizon artists, but the newly developed technique of cliché-verre, a hybrid of etching and photography, was of great interest to them as well. Briefly, in the cliché-verre process, a drawing is placed by one of a number of methods onto a transparent surface, usually a glass plate. The plate is then placed over a sheet of paper that has been made light sensitive, again, by one of a number of methods. As light penetrates the glass at the areas where the drawing has left the plate exposed, the image is transferred to the paper to produce the cliché-verre print.

The first of the Barbizon artists to enter the Rosenwald Collection was Jean-François Millet (1814-1875) whose etching *The Diggers* (fig. 64a) was the Barbizon example in Frank Weitenkampf's *Famous Prints*. Rosenwald acquired a total of only five of Millet's etchings, however, and the work of Camille Corot and Charles-François Daubigny (1817-1878) eventually came most fully to represent the Barbizon aesthetic in his collection.

All of the Corots and Daubignys were acquired after Alverthorpe opened in 1939. The first Corot purchase, two etchings, from Jean Goriany, came in May 1941, along with thirty other prints by nineteenth-century French artists including Delacroix, Chassériau, Ingres, Charlet, Géricault, and Isabey. The following year, twelve of Corot's twenty lithographs were acquired as well as impressions of two Corot clichés-verre. Eventually Rosenwald purchased eight Corot etchings and fifteen lithographs, and in 1967 he completed his acquisitions of the artist's work with the purchase of forty vintage clichés-verre. One of them is this wooded landscape with two dancing figures, *The Saltarelle*. The image is an unusual one for the artist, whose figures are generally embedded in the landscape, rather than imbued with a sense of monumentality. This 1967 purchase

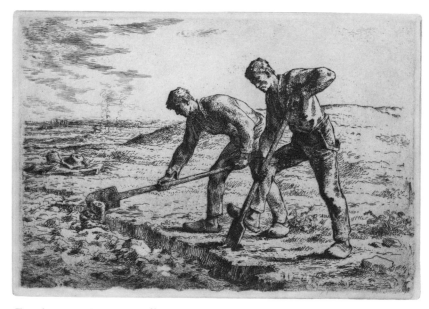

Fig. 64a. Jean-François Millet. *The Diggers*, 1855-1866. Etching. B-8760.

Fig. 64b. Charles-François Daubigny. *Apple Trees at Auvers*, 1877. Etching. B-4785.

placed the Rosenwald Collection among the largest collections of Corot's clichés-verre in this country.

The Daubigny collection is both smaller and less comprehensive than the Corot collection: it comprises fourteen examples, representing the artist's etchings alone. No Daubigny clichés-verre or lithographs were acquired. The Rosenwald etchings, however, do include several early states of Daubigny's subjects, and among them is *Apple Trees at Auvers* (fig. 64b) in a rare proof of the first state before the two figures in the path were removed. Nine of the Rosenwald Daubignys were purchased during the 1940s, with two additions in 1952 and three more in 1962.

REFERENCE: Glassman and Symmes, *Cliché-Verre*

VINCENT VAN GOGH
Dutch, 1853-1890

65
The Potato Eaters, 1885

Lithograph, printed in dark brown
26.5 x 31.6 (10 ⁷⁄₁₆ x 12½)
de la Faille 1661
PROVENANCE: Purchased from Myrtil Frank, 1951;
presented to NGA, 1951
B-18,879

Van Gogh made only ten prints—one etching and nine lithographs—all of which are exceedingly rare. Rosenwald acquired three of them. The single etching *Portrait of Dr. Gachet (Man with a Pipe)* (de la Faille 1664), in an impression formerly in the collection of the subject Dr. Paul Ferdinand Gachet, was acquired in 1939. The two lithographs, *Orphan Man, Standing* (de la Faille 1658), known in only four impressions, and *The Potato Eaters*, after a painting of the same subject, were both acquired in 1951. The Rosenwald impression is one of seven known of this somber and poignant dinner scene which van Gogh drew directly onto the stone (this is his only lithograph not produced from a transfer drawing). He then further defined both light and form with sharp white lines made by scratching into the bold drawing on the stone.

Rosenwald's acquisitions of prints by van Gogh's friend Gauguin

HILAIRE-GERMAIN-EDGAR DEGAS

French, 1834-1917

66

The Ballet Master, c. 1874

Monotype
56.8 x 70 (22⅜ x 27⅝)
Signed upper left: *Lepic* and *Degas*
Janis 1
PROVENANCE: A. Vollard; purchased from Henri Petiet, 1950; presented to NGA, 1964
B-24,260

Fig. 65-66a. Camille Jacob Pissarro. *Woman Emptying a Wheelbarrow*, 1880. Drypoint and aquatint. B-9674.

are mentioned elsewhere (cat. nos. 98-100) as are his acquisitions of prints and drawings by Degas's friend Mary Cassatt (cat. nos. 67, 88-92). One might note in passing, however, that the collection also includes interesting examples by other of their contemporaries, painter-printmakers who broke with tradition to set the stage for the modernism of the twentieth century. For example, there are five Cézannes in the collection, and Renoir is represented by about twenty-five etchings and lithographs (fig. iv) as well as the pastel counterproof mentioned in cat. no. 67. About twenty-five Pissarro (1831-1903) prints, too, both etchings and lithographs, were acquired. Some subjects are exceedingly rare, like the *Portrait of Paul Signac* (Delteil 92), known in only a few impressions. Included, too, are several very beautiful aquatint landscapes such as *Woman Emptying a Wheelbarrow* (fig. 65-66a). A preparatory pencil drawing for *The Cabbage Field* (Delteil 29) and a single monotype landscape (see below for an explanation of the monotype process) round out the Pissarro collection.

The Degas monotype *The Ballet Master* is one of four monotypes by this artist in the collection, all of them figure compositions. *The Ballet Master* is Degas's first essay in the medium. Worked in collaboration with Vicomte Lepic, who taught Degas the process, the sheet is signed by both men. The monotype process is something of a hybrid of painting and printing. The image is applied directly to a surface using a slow-drying medium such as oil paint in much the way a painting is applied to canvas. Often a fresh, unused etching plate is the surface on which the painted image is applied. Then, a clean sheet of paper is pressed against the "painting's" surface either by sending the two through a press or by applying pressure directly by hand, thus transferring the image from the plate (or board or whatever other surface is used) to the paper. Only one rich, sharp impression is possible, hence the name monotype, although often second and even third pulls, each increasingly weaker, are taken. Degas, like Blake (cat. no. 16), in fact, often did make more than one impression, and he then drew into the duplicate impressions to enhance and clarify the images. A second impression of *The Ballet Master*, heavily reworked in pastel, is in the William Rockhill Nelson Gallery, Kansas City.

In addition to the four Degas monoprints, all acquired between 1948 and 1952, the Rosenwald holdings include twenty-five of the artist's etchings, drypoints, and lithographs as well as the copper plate for the portrait *Alphonse Hirsch* (Delteil 19). A few of the Degas works were acquired in the late 1920s, but most of them, like most of the prints by Cézanne, Renoir, and Pissarro, were acquired in the late 1940s and the 1950s.

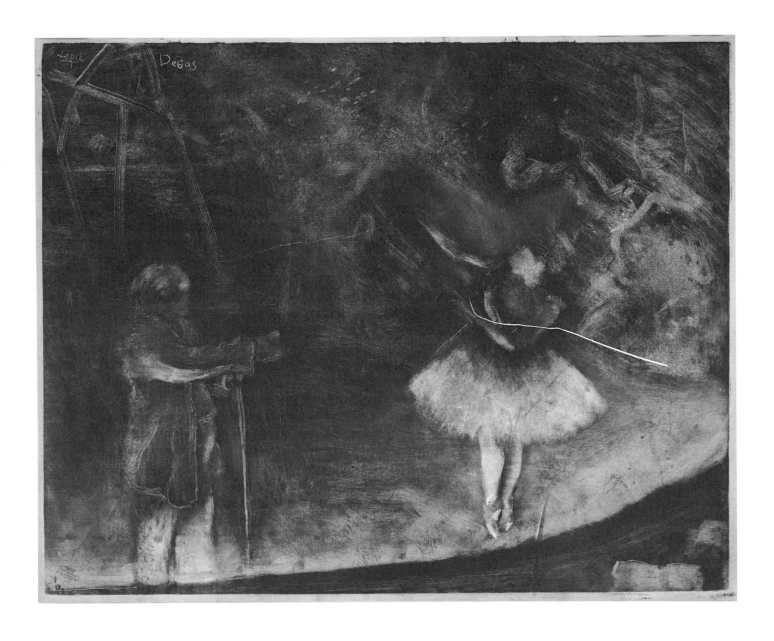

MARY CASSATT
American, 1845-1926

67
Sara Wearing a Bonnet and Coat, c. 1904-1906

Counterproof of a pastel, chine collée and reworked
72.9 x 58.1 (28¾ x 22⅞)
Unrecorded counterproof of Breeskin *Paintings* 454
PROVENANCE: Purchase untraced; presented to NGA, 1980
B-31,637

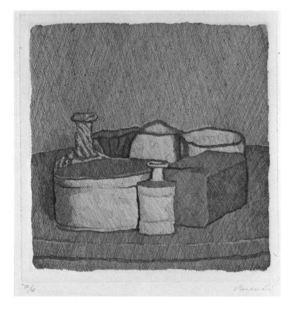

Fig. 67a. Giorgio Morandi. *Still Life with Four Objects and Three Bottles*, 1956. Etching. B-31,646.

This Mary Cassatt pastel is one of two pastel counterproofs among approximately one thousand prints, drawings, and bound volumes left to the National Gallery by Lessing Rosenwald's estate. The other counterproof is Renoir's *Mlle. Diéterle,* and both of them were probably made for the Paris publisher-dealer Ambroise Vollard about 1906. The Cassatt piece provides an excellent contrast to the ten pencil drawings by the artist already in the collection (see cat. no. 88). It is related to both a lithograph (Breeskin *Prints* 198) and a more finished pastel in the Metropolitan Museum of Art in New York. The original from which the counterproof impression was taken is last recorded in a French private collection. The Rosenwald counterproof has been extensively reworked throughout the image and consequently is amazingly fresh in appearance.

Both the Cassatt and the Renoir reflect Rosenwald's tendency to acquire drawings either related specifically to prints or by artists whose prints he also collected. As with the old master drawings briefly described in cat. nos. 43-44 and touched upon elsewhere, Rosenwald's collection of modern watercolors and drawings, though small, includes some wonderful examples. Several, including Forain's *Standing Woman with a Fan* (cat. no. 32) and Schmidt-Rottluff's *Yellow Iris* (cat. no. 72) are seen in the exhibition while many others are reproduced throughout this catalogue: Whistler's *Study for Weary* (fig. 27-28b), Bonnard's *View of Paris* (fig. 68a), and Heckel's *Three Figures* (fig. 71a) are among them. Additional modern drawings in the Rosenwald Collection, including sheets by Delacroix, Redon, Egon Schiele, Matisse, and Gauguin are found in Robison, *Drawings.*

The bequest of which the Cassatt counterproof was a part mirrored the collection as a whole, ranging from the fifteenth century through the twentieth, although the emphasis was on the latter. Among the most special of the modern prints included was Giorgio Morandi's (1890-1964) *Still Life with Four Objects and Three Bottles* (fig. 67a), the only work by this important Italian artist in the Rosenwald Collection.

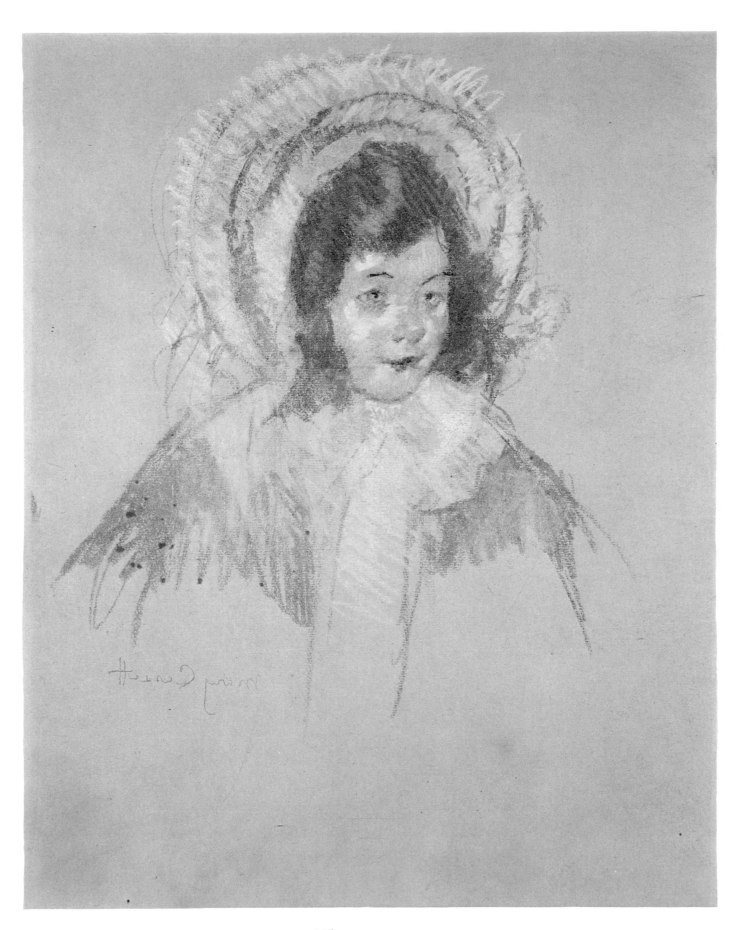

EDOUARD VUILLARD
French, 1868-1940

68

The Garden outside the Studio, 1901

Lithograph, printed in green, two shades of gray, orange, and light red
63.3 x 48 (25 x 18⅝)
Signed lower left within image in pencil: *E Vuillard*
Roger-Marx *Vuillard* 45 II/II
PROVENANCE: Purchased from Gérald Cramer, 1952; presented to NGA, 1952
B-20,861

The Garden outside the Studio is one of approximately twenty-five Vuillard lithographs in the Rosenwald Collection, half of them the 1899 portfolio published by Ambroise Vollard, *Landscapes and Interiors* (Roger-Marx *Vuillard* 31-43), which are among the artist's most popular prints. Most of the Rosenwald Vuillards were purchased during the 1950s, the decade in which late nineteenth and early twentieth-century French lithography in general received the collector's most serious attention.

Although Rosenwald had purchased a few French lithographs of this period during the 1920s, 1940 really marks the beginning of this facet of the collection. That year, Rosenwald made a number of purchases of modern French art from Jean Goriany, Henri Petiet's associate in New York. Among them were prints by Bonnard, Gauguin, and Matisse as well as Vuillard, and these acquisitions began to set the stage for Rosenwald's more active interest a decade later. During the 1950s, the collector worked mainly with Petiet himself, who, along with the Swiss publisher and dealer Gérald Cramer, was the main source for acquisitions in this area. Apart from the Kleinmann Toulouse-Lautrecs (see cat. nos. 86-87), however, this part of the collection never became as distinguished as Rosenwald's twentieth-century British holdings or his old master collection, either in quantity or in rare impressions of a unique or special nature.

Rosenwald's Bonnard collection was started with his 1940 purchase from Goriany of the Vollard publication *Some Views of Paris Life* (Roger-Marx *Bonnard* 56-68). The Bonnard holdings went on to grow only to the same extent as the Vuillard, about twenty-five lithographs, mainly in color, as well as book illustrations as described below. Among the Bonnards are two posters, an aspect of turn-of-the-century lithography in great demand in recent years that was of little interest to most collectors of fine prints a few decades ago. It is not surprising, therefore, that apart from the two Bonnards, a few Toulouse-Lautrecs, and examples by Alphonse Mucha and Kollwitz, poster art is sparsely represented in Rosenwald's collection.

In addition to his prints, Rosenwald owned one drawing by Vuillard, a sheet of charcoal studies of a female nude, purchased

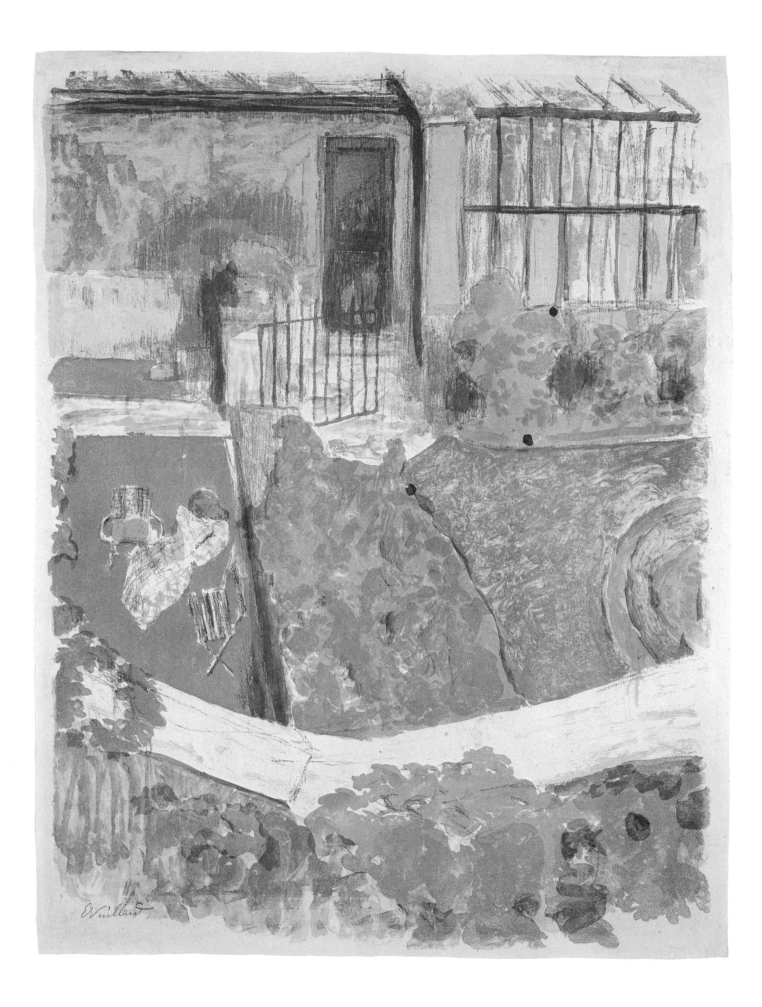

Fig. 68a. Pierre Bonnard. *View of Paris*. Watercolor and oil over charcoal. B-14,345.

from Lucien Goldschmidt in 1961, and one Bonnard drawing in oil and watercolor over charcoal, *View of Paris* (fig. 68a), acquired from Richard H. Zinser in 1947.

Among the other French artists of the period included in the collection are Maurice Denis (whose work essentially is represented by another Vollard publication, the portfolio of thirteen lithographs, including title page, *Love*) and Signac, Cross, Lunois, Maillol, and Aman-Jean, all represented by fewer than five examples. In a number of instances, however, the holdings of their work, as well as that of Bonnard and others among their contemporaries, are augmented by a rather unusual means. It was Rosenwald's practice when acquiring special copies of twentieth-century *livres des peintures* with extra sets of plates to give the volumes with text to the Library of Congress and the extra sets of separate plates to the National Gallery. Among the titles divided in this way were Montherlant's *La rédemption par les bêtes* (Paris, 1959), with lithographs by Bonnard, and Elouard's *A toute épreuve* (Geneva, 1958), with a suite of eighty color woodcuts and collages by Miró.

PABLO PICASSO
Spanish, 1881-1973

69
Minotauromachy, 1935

Etching
49.5 x 69.1 (19½ x 27¼)
Inscribed lower right in ink: *State proof for Valentine Hugo/10/Paris 14 March XXXVI/Picasso*
Bloch 288
PROVENANCE: V. Hugo; purchased from Buchholz Gallery, 1950; presented to NGA, 1950
B-17,718

Perhaps Picasso's single most important print, the heroic, anti-war statement *Minotauromachy* is one of about 130 Picasso prints in the Rosenwald Collection. Most of them are from the group of one hundred prints known as the *Vollard Suite*, not because Vollard commissioned them, as he did the Vuillard and Bonnard suites mentioned in cat. no. 68, but because he brought them together for publication. Executed between 1930 and 1937, they were not issued until after World War II, and Rosenwald purchased the *Suite* from Petiet in 1950. Apart from the *Minotauromachy* and the *Vollard Suite*, the collection includes several of Picasso's early drypoints of acrobats, the most beautiful impression of which is *The Family of Acrobats with a Monkey* (fig. 69a) in the early state before the plate was steel-faced to reinforce and protect the drypoint marks during the printing of the edition. (It is the rarest of the Saltimbanque series because oxidation destroyed many other impressions.) There are also two of the 1905-1906 woodcuts of female heads (Bloch 16 and 1304, variants), a few prints from the cubist period, and a few of the

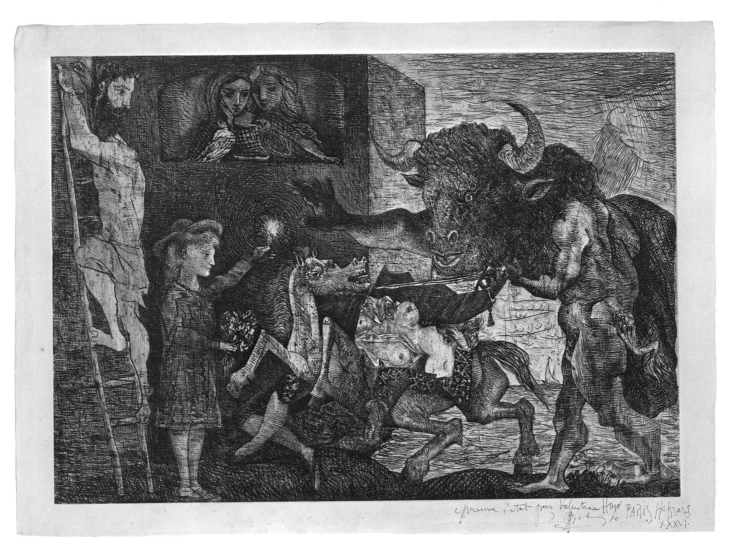

Fig. 69a. *The Family of Acrobats with a Monkey,* 1905. Drypoint. B-17,585.

lithographs of doves of the 1940s. Beyond that, the collection includes a single lift-ground aquatint, *Goat's Head,* 1952 (Bloch 691) and a single linoleum cut *The Picador,* 1959 (Bloch 920). This linoleum cut was the latest of the artist's works to be acquired apart from a signed poster of a 1960 Picasso exhibition in Nice.

The first Picasso acquisition was the portfolio of the six etching illustrations to Aristophanes's *Lysistrata,* individually signed and numbered, published apart from the book with text that was issued at the same time in 1934 by the Limited Editions Club in New York. The rest of the prints were purchased sporadically between 1938 and 1964 from a number of dealers including Ferdinand Roten, Weyhe Gallery, Kleemann Galleries, and Saidenberg Galleries among others.

Rosenwald's collection of the prints of Georges Braque (1882-1963) consists of ten examples purchased between 1941 and 1963, principally from Gérald Cramer. Included are two of the artist's important cubist etchings, *Fox,* one of the earliest Braque purchases, from Buchholz Gallery in 1941 and *Job* (fig. 69b), one of several prints by a variety of artists purchased from Robert M. Light during the 1960s.

To form a more complete picture of the Rosenwald Picasso and Braque material, one must note that sixteen volumes are indexed to Picasso in the Library of Congress 1977 Rosenwald Collection catalogue, while eight of the volumes recorded there include illustrations by Braque. In several instances, extra suites of prints from deluxe copies of the books have been removed and given to the National Gallery as described in cat. no. 68.

Fig. 69b. Georges Braque. *Job,* 1911. Drypoint. B-23,078.

HENRI MATISSE
French, 1869-1954

70
Odalisque with Striped Pantaloons, 1925

Transfer lithograph
54.5 x 44 (21⅜ x 17¼)
Pully 113
PROVENANCE: French customs stamp; purchased in
1944 (?); presented to NGA, 1964
B-24,322

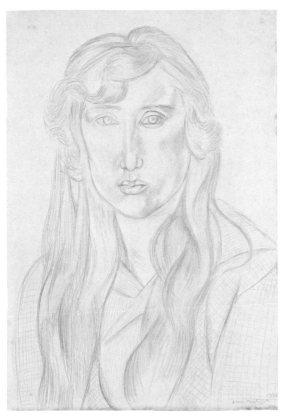

Fig. 70a. *Young Girl with Long Hair—Antoinette*,
c. 1919. Pencil. B-14,844.

Fig. 70b. Georges Rouault. *The Little Suburbs:* "The
Burial of Hope," 1929. Lithograph. B-4385.

The *Odalisque with Striped Pantaloons* is one of Matisse's most important and dramatic lithographs and, as such, it ranks with Picasso's *Minotauromachy* as a monument of the art of the print produced during the early twentieth century. It is one of more than thirty-five Matisse prints in the Rosenwald Collection. Most of these are lithographs, while seven are etchings including the portfolio of six soft-ground etchings for James Joyce's *Ulysses*, issued separately from the volume with text, published by the Limited Editions Club in 1944. One aquatint and a single linoleum cut are included as well.

The Matisse collection, unlike most of the modern French material, dates to the earliest years of the collection: two of the artist's prints, including the single line etching that Rosenwald acquired, a portrait, *Irène Vignier*, were among the 1928 acquisitions. The other Matisses were purchased between 1939 and 1963, with the largest group, eight lithographs, coming from the sale of Frank Crowninshield's collection at Parke-Bernet in June 1948.

Rosenwald also acquired three Matisse drawings: a black chalk study of a young woman, and two pencil drawings, one an *Odalisque*, and the other, the beautiful *Young Girl with Long Hair—Antoinette* (fig. 70a), purchased in 1948 from Pierre Matisse.

While several Matisses entered the Rosenwald Collection from the 1948 sale of the Crowninshield Collection, an earlier Crowninshield sale, in 1943, was the source for some of the prints by his contemporary Georges Rouault (1871-1958) in the collection. Among the Crowninshield purchases was the series of six lithographs, *The Little Suburbs* including "The Burial of Hope" (fig. 70b).

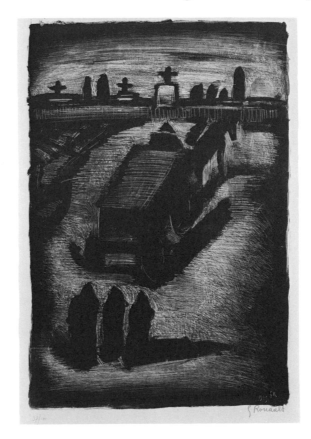

Fig. 70c. Jacques Villon. *Chevreuse*, 1935. Etching. B-17,700.

Rosenwald's Rouault collection was formed between 1940 and 1952 and includes the *Misery and War* series, twelve color plates for *The Flowers of Evil*, commissioned by Vollard and printed by Roger Lacourière in 1934 but not published, thirteen trial proofs for the Suarez *Passion* and color separation proofs for "The Juggler" and "The Clown" from *Circus of the Shooting Star* as well as a number of other individual prints—a total of approximately one hundred sheets by the artist.

The collection of the work of another Matisse contemporary, Jacques Villon (1875-1963), was formed rather late; the first purchases were in the mid-1940s and they continued until 1964. Seventeen were acquired, ranging from the artist's early color aquatints, through the cubist period and the lovely landscapes of the French countryside of the 1930s such as *Chevreuse* (fig. 70c), printed in 1935 in a small edition of only twenty-five impressions, to the later, more loosely formed still lifes and interiors. In addition, the suite of twenty-seven lithographs illustrating the 1953 edition of Paul Valéry's translation of *The Bucolics* of Vergil were separated from the Library of Congress copy of the title as described in cat. no. 68 and given to the National Gallery. The Library of Congress Rosenwald Collection also includes other volumes with illustrations by Villon as well as titles illustrated by Matisse and Rouault.

Cat. no. 70

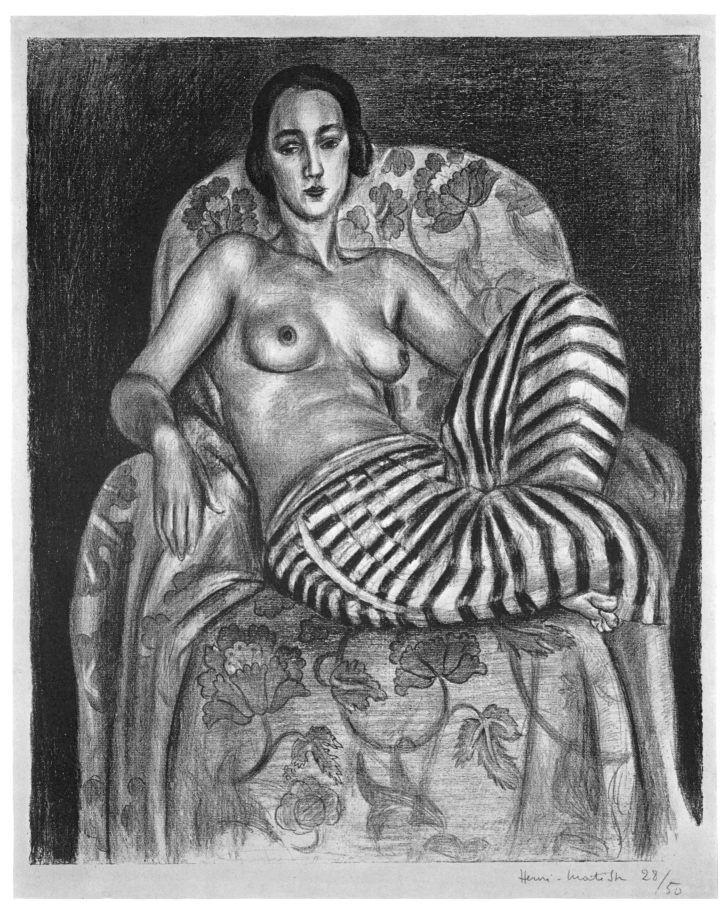

Henri-Matisse 28/50

ERNST LUDWIG KIRCHNER
German, 1880-1938

71
Figure of a Woman, 1912

Woodcut
31.1 x 24.9 (12¼ x 9¾)
Signed lower right in pencil: *Kirchner*
Dube (woodcuts) 206
PROVENANCE: Stamp of the Secretary General of the
National Commission of Museums and Monuments;
purchased from Claude Schaefer, Montevideo,
Uruguay, 1950; presented to NGA, 1951
B-19,611

Fig. 71a. Erich Heckel. *Three Figures*, 1913. Pencil.
B-18,953.

Figure of a Woman is one of six woodcuts by Ernst Ludwig Kirchner in the Rosenwald Collection. It was acquired as part of a lot of approximately twelve hundred prints and forty drawings, including *Three Figures* (fig. 71a) by Erich Heckel (1883-1970), purchased from Claude Schaefer in 1950. Rosenwald came upon this impressive lot of material while he was on a business trip in Montevideo, Uruguay. The collection, however, had already been cleared by South American authorities for shipment to Antwerp, Belgium, by the time he learned of its scope. Although Rosenwald indicated his interest in purchasing the prints and drawings *en bloc*, the problems of shifting their destination were apparently insurmountable. The crates, thus, went first to Europe and were then redirected via the S.S. *American Lawyer* to the United States, arriving intact about two months after their South American departure.

Along with the group of drawings, Rosenwald selected approximately three hundred prints to keep for his own collection. He then distributed the rest of the purchase among other institutions.

More than fifty artists' work was represented in the part of the collection that Rosenwald retained for himself. In addition to this single woodcut by Kirchner, eleven prints and drawings by Erich Heckel and more than twenty by Otto Müller (fig. x) were included. Substantial numbers of pieces by other major figures—Christian Rohlfs, Max Beckmann, Ernst Barlach, Edvard Munch, Lovis Corinth, Emil Nolde, Max Pechstein, and Oscar Kokoschka—were included too, as well as works by a number of lesser known artists, among them Hans Purrmann and Herman Struck. Northern expressionists were most strongly represented, although the purchase also included a few prints by Manet, Signac, Toulouse-Lautrec and other French artists. An abstract pencil composition by Fernand Léger was also in the collection, and it was the only drawing by him that Rosenwald acquired.

This important purchase essentially defined Rosenwald's collection of twentieth-century German art, with the exception of his important holdings of works by Käthe Kollwitz (described in cat. no. 93-95), none of whose art was included in the South American collection. According to correspondence from Schaefer, certain prints by Félicien Rops and André Louis Armand Rassenfosse were removed from the lot at Rosenwald's request, although other works by both artists remained part of the transaction.

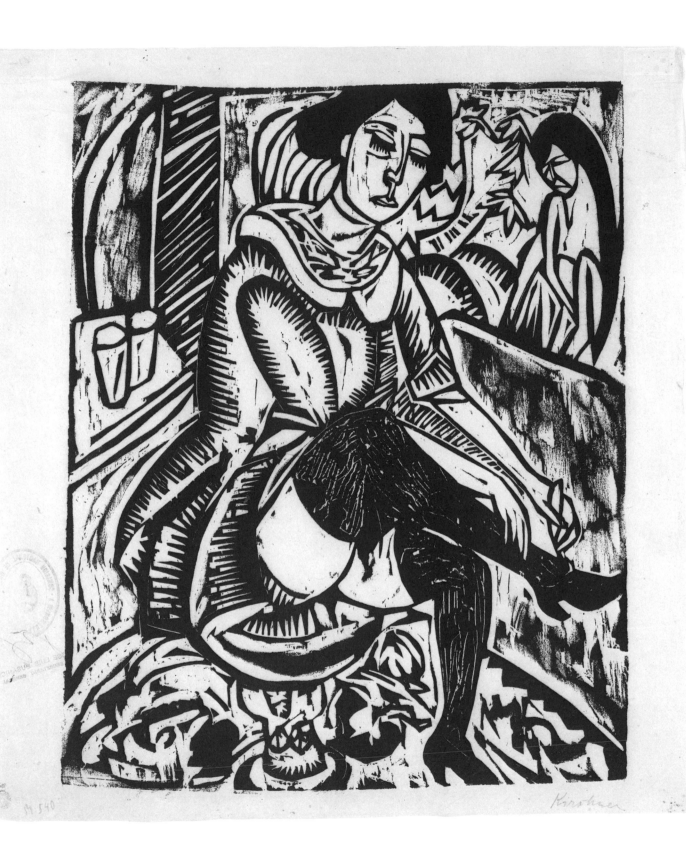

KARL SCHMIDT-ROTTLUFF
German, 1884-1957

72
Yellow Iris, c. 1935

Watercolor over pencil
68.8 x 48.7 (27$\frac{1}{16}$ x 19$\frac{3}{16}$)
PROVENANCE: Karl Buchholz; purchased from the
Office of the Alien Property Custodian, 8 December
1944, no. 75; presented to NGA, 1945
B-12,499

Yellow Iris is one of three watercolors by Schmidt-Rottluff in the collection. The other two, equally fresh and direct in their approach to the medium, are landscapes (see Robison, *Drawings*, 125). All three drawings as well as three Schmidt-Rottluff woodcuts, four prints by Max Beckmann, and three prints and a seascape watercolor by Emil Nolde (fig. 72a) were acquired through the sealed bid public sale held by the Alien Property Custodian in December 1944. The

Fig. 72a. Emil Nolde. *Sailboats.* Watercolor. B-11,268.

sale included objects of art within the United States owned by Karl Buchholz, a Berlin art dealer, and other foreign nationals of designated enemy countries—in this instance, Nazi Germany. All of the pieces had been vested in accordance with wartime orders, and notices of the sale had been widely placed. *The New York Times, Art Digest,* and *Art News* had all been sent the announcement, and nine days were set aside for public inspection of the works of art. Included were ninety lots of 319 paintings, sculptures, prints, and drawings, the largest numbers being works by Ernst Barlach, Käthe Kollwitz, Gerhard Marcks and Rénée Sintenis. All of this material had been placed on consignment in Curt Valentin's Buchholz Gallery (see cat. no. 73) between January 1937 and December 1939 by Karl Buchholz, for whom the gallery was named. The Schmidt-Rottluffs, Beckmanns, and Noldes that Rosenwald acquired comprised three of the ninety lots. The others were acquired by museums, dealers, and collectors throughout the country.

In addition to the three watercolors and three woodcuts by Schmidt-Rottluff purchased at the alien property sale, the Rosenwald Collection includes thirteen other woodcuts by the artist as well as two of his lithographs, although none of his etchings or drypoints was acquired. The four watercolors (three by Schmidt-Rottluff and one by Nolde) acquired at the sale are part of a sizable number of twentieth-century German drawings in the collection, many of them coming as part of the major 1950 purchase described in cat. no. 71.

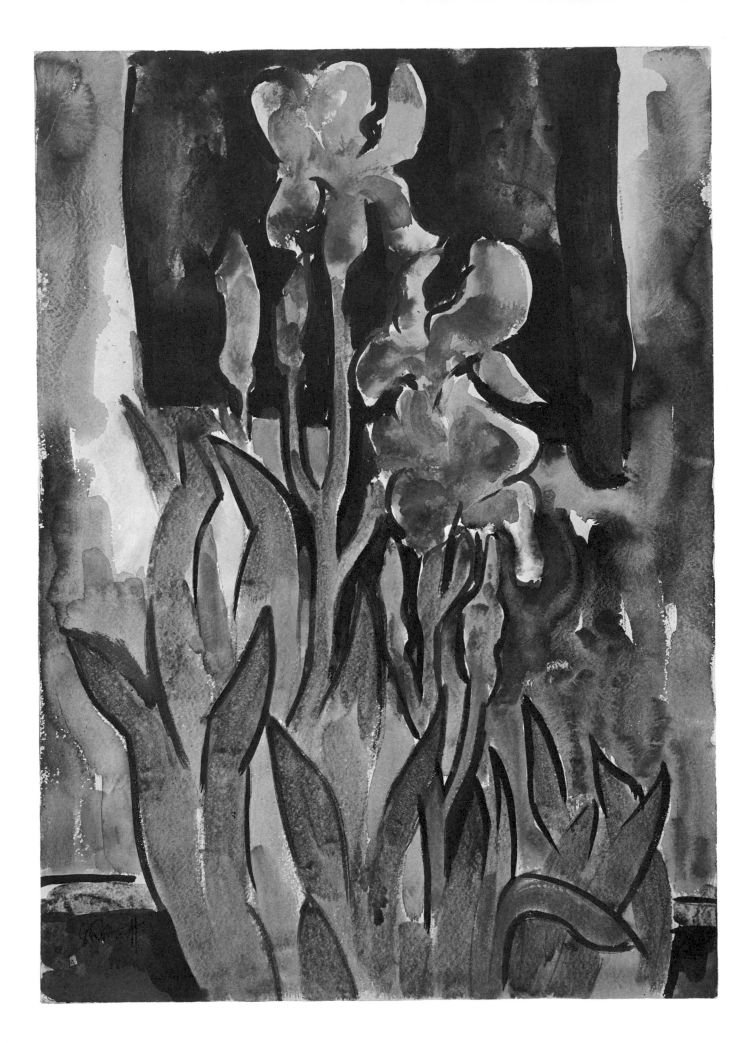

EMIL NOLDE
German, 1867-1956

73
Young Couple, 1913

Lithograph, printed in gray and black
61.3 x 50.5 (24⅛ x 18⅞)
Inscribed lower left in pencil: *OF 3 impressions this version, No. 3* and signed lower right: *Emil Nolde*
Schiefler (lithographs) 52
PROVENANCE: Unidentified stamp, verso; purchased from Buchholz Gallery, 1941; presented to NGA, 1943
B-9061

In May 1941, Rosenwald bought Nolde's boldly drawn, rather humorous *Young Couple*. It was among his first purchases in twentieth-century German art. By the end of 1950, he had completed his acquisitions of work by the artist—nine woodcuts, seven etchings, five lithographs, and a delicate watercolor of sailboats (fig. 72a). Many of these were included in the 1950 purchase of twentieth-century expressionist prints and drawings from Claude Schaefer (see cat. no. 71), but in addition to *Young Couple*, another lithograph as well as one of the woodcuts was purchased from Buchholz Gallery.

Between 1941 and 1952, Curt Valentin sent prints on approval from New York to Jenkintown on a fairly steady basis. In spite of such encouragement from Valentin and other proponents of modernist art, as we have seen, Rosenwald's collection of this material never became as extensive as his old master holdings. Reflecting on his disappointment at this circumstance, in 1949 Valentin wrote to Elizabeth Mongan, "I have so little luck with things I send to Mr. Rosenwald on approval and I am sorry about it." Nonetheless, although Rosenwald bought only about seventy-five prints from his gallery, Valentin did make his mark on the collection by introducing into it a number of important twentieth-century European artists. For example, Rosenwald purchased his first prints by Braque, Kirchner, Munch, Schmidt-Rottluff, Villon, Giacometti, Marc, Klee, and Ensor from Valentin. He also purchased his two Miró (apart from the *A toute épreuve* plates mentioned in cat. no. 68) and three Marcks works from this New York printseller who had come to this country from Germany in 1937 bringing with him the exciting contemporary German art then considered "degenerate" in its home country.

Another dealer in modern material who sold Rosenwald a number of pieces during the 1940s was Robert Carlen, whose Carlen Galleries in Philadelphia was the source of Rosenwald's first two Max Beckmann (1884-1950) drypoints in 1941, the year that *Young Couple* was acquired. Four Beckmanns were included in the material purchased at the alien property sale in 1944 (see cat. no. 72) and several prints and three drawings were part of the 1950 expressionist

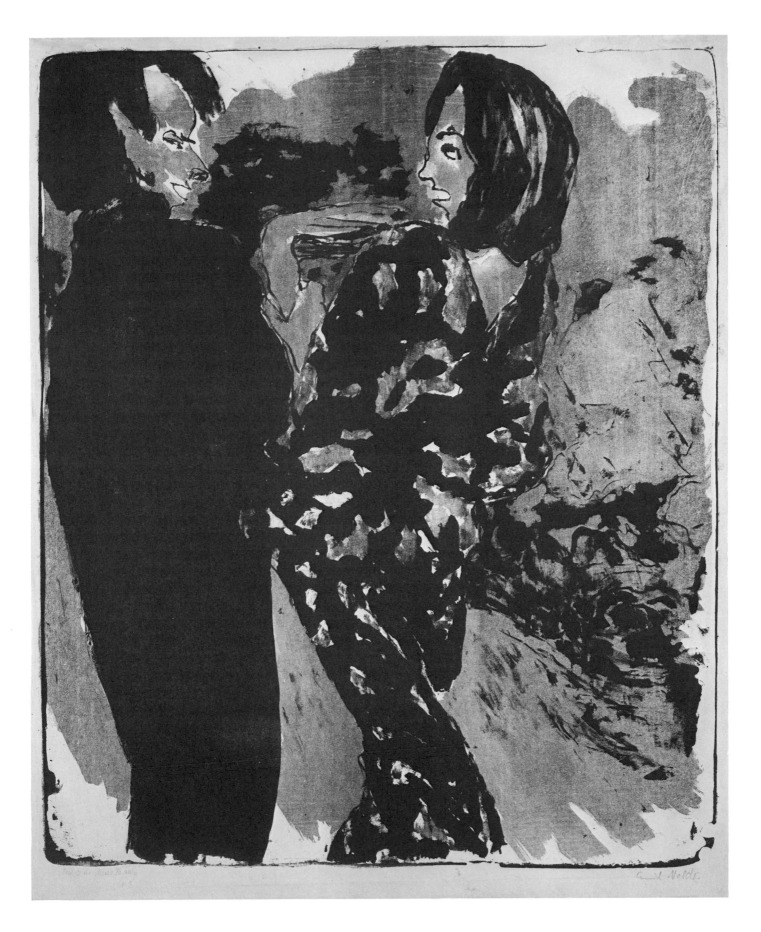

Fig. 73a. Max Beckmann. *Group Portrait*, 1923.
Woodcut. B-18,953.

purchases (see cat. no. 71). Two were crayon sketches, a horse and a café scene, and the third was a pencil portrait. In all, these three drawings and a total of sixteen prints (three woodcuts, four lithographs, and nine etchings and drypoints) by Beckmann entered the collection, the last of them the bold woodcut, *Group Portrait* (fig. 73a), acquired in 1964 from Peter Deitsch. Deitsch was the source of several interesting sheets during the 1960s, among them the only Maurice Prendergast (1859-1924) monotype to enter the collection, *Outdoor Café Scene* (fig. 73b).

Fig. 73b. Maurice Prendergast. *Outdoor Café Scene*,
c. 1900-1905. Monotype. B-23,931.

MAURITS CORNELIS ESCHER
Dutch, 1898–1973

74
Genesis: The Second Day of Creation, 1925

Woodcut
27.9 x 37.6 (11 x 14¹³⁄₁₆)
Signed lower left in pencil: *M.C. Escher*
Locher 19
PROVENANCE: Purchased from A. L. Van Gendt, Co.,
1971; presented to NGA, 1980
B-31,639

Of his artist-contemporaries whose work Rosenwald began to purchase during the last decades of his life, Escher was undoubtedly his greatest enthusiasm. In 1957, the collector acquired his first two Escher woodcuts from Mickelson's Gallery in Washington. One of them was the more than twelve feet long *Metamorphosis* (Locher 117) scroll, and Rosenwald's continued fascination with this print spurred him to look for other prints by the artist during a trip to Amsterdam a few years later in 1960. As a result, in October of that year, Rosenwald acquired from the Dutch printseller Bernard Houthakker thirty-three additional Escher prints: woodcuts, wood engravings, lithographs, and mezzotints, ranging in date from 1935 to 1960. In a letter to the artist shortly after this major purchase, Rosenwald wrote, "I like [the prints] which I got immensely, and I think many of your ideas are novel. I do not think I know any printmaker today—other than yourself, who has in any way endeavored to combine mathematics and original prints. I think many of the results are fascinating."

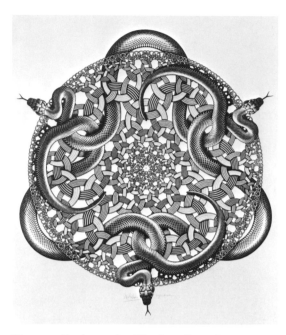

Fig. 74a. *Snakes*, 1969. Woodcut. B-31,640.

As he had done in the late 1920s, in organizing exhibitions of the Rembrandts, Whistlers, Daumiers, etc., that he had recently acquired, Rosenwald began almost immediately to formulate plans for an exhibition of his new Escher prints. The show was held at the Philadelphia Art Alliance a few months later, from 20 February to 12 March 1961. In preparing for it, Rosenwald came across references to several Escher prints he had not seen at Houthakker's, and he wrote directly to the artist inquiring about these particular works. Escher responded that the six prints in question were lithographs printed in small editions, and as few as two impressions of some remained unsold. He offered to send Rosenwald the best copy available of each of them, however, if the prices quoted were agreeable. They were, and the prints arrived in time to be included in the Art Alliance exhibition, which was very successful in introducing Escher's work to an admiring Philadelphia public. Much to the artist's delight, he was able to sell twenty duplicate impressions of nine of the prints on display.

At one point during the correspondence surrounding the show, Escher explained to Rosenwald a bit about his aesthetic stance: "My position between my colleagues is a peculiar one. In general I do not agree at all with the ideas of modern abstractly working artists and I feel far better at home in the company of exact scientists, especially crystallographers, though I am myself a perfect layman in the scientific field."

After Rosenwald's burst of interest in 1960, no further Escher acquisitions were made until the end of the decade, at which time he received an Escher print as a gift from a friend. In 1970, he purchased *Snakes* (fig. 74a) directly from the artist. The jigsaw-puzzle-like qualities of the interlocking colors of the snakes fascinated the collector. In 1971, the last of the Eschers to enter the collection were purchased. They included several rare early subjects, among them *Genesis: The Second Day of Creation*. The print readily demonstrates that as early as 1925, Escher was interested in the schematized forms, dramatically presented, that he continued to use throughout his life and for which he is best known.

In all, Rosenwald acquired forty Escher prints. Within the context of the National Gallery collection, however, several of them were duplicated by the gift of the comprehensive Escher collection of Cornelius Van Schaak Roosevelt, and the Rosenwald impressions have occasionally been released to facilitate other acquisitions in recent years in accordance with Rosenwald's wishes.

STANLEY WILLIAM HAYTER
British, born 1901

75
Tropic of Cancer, 1949

Etching, soft-ground etching, and engraving
55 x 69.1 (21¹¹/₁₆ x 27³/₁₆)
Numbered lower left in pencil: 7/50; titled lower center: *Tropic of Cancer*; signed and dated lower right:
SW Hayter 1949
PROVENANCE: Purchased from the artist, 1950; presented to NGA, 1950
B-18,945

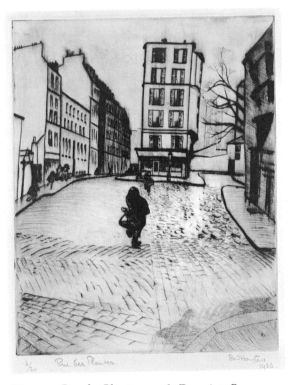

Fig. 75a. *Rue des Plantes*, 1926. Drypoint. B-13,929.

World War II brought Stanley William Hayter from France to New York where he established an experimental printmaking workshop, Atelier 17, modeled on the workshop of the same name he had set up in Paris in 1927. Rosenwald apparently met the artist in 1944, and that year he purchased several of Hayter's pieces, among them the copper plates for *Tarantelle* and *Laocoön*, both from 1943, impressions of which are also in the collection, and two experimental plaster reliefs as well as twelve engravings. Between then and the late 1960s, a total of two Hayter drawings and thirty prints was acquired, among them, *Rue des Plantes* (fig. 75a), an early drypoint from a small edition of only thirty impressions.

The Hayter collection includes a number of the artist's late multicolor mixed intaglio images as well as several of the mid-career titles for which he is best known, among them *Tropic of Cancer*. With its energetic play of soft-ground etching surfaces against deeply engraved lines, it is a showpiece of Hayter's interrelated aesthetic and technical concerns.

During the 1940s, Hayter ran monthly intaglio workshops at the Philadelphia Print Club, and during these trips away from New York, he often visited Jenkintown to talk with Rosenwald about the exciting work that was being done in the New York workshop. Rosenwald like Hayter was interested in the technical aspects of printmaking. He was no doubt as excited as the artist, for example, about the relief printing experiments that Hayter and Ruthven Todd conducted with his copper plate fragment of one of William Blake's plates for *America*. The plate is thought to be the only surviving copper made for Blake's relief etching process (see Ruthven Todd, "The Techniques of William Blake's Illuminated Printing," *The Print-Collector's Quarterly* 29 [November, 1948]: 25-37, reprinted with revisions of the notes and new illustrations, in Robert N. Essick, ed., *The Visionary Hand* [Los Angeles, 1973], 19-44).

Beyond his interest in Hayter's work and the technical explorations taking place at his Atelier, Rosenwald apparently also admired Hayter's efforts in championing modern printmaking in this country. For many years, while Hayter was in New York, and continuing after he reopened his Paris workshop, Rosenwald anonymously sponsored several annual fellowships for artists from all parts of the world who were interested in working with Hayter at the Atelier. In return, Hayter kept Rosenwald informed of the Atelier's activities, often reporting on prizes and commissions won by the fellows, and he also brought the work of many of his artist associates to Rosenwald's attention.

The first of these associates was the Polish-born engraver Joseph Hecht (1891-1951). Hecht had settled in Paris, where he ignited Hayter's own interest in engraving by demonstrating that the medium had potential for expressive purposes beyond the reproductive use for which it mainly had been exploited throughout the nineteenth century. *The Ferocious Chase* (fig. 75b) is one of seventeen prints by Hecht in the collection, one of which, *The Deluge*, of 1946 was actually a joint Hayter/Hecht effort. Most of the seventeen Hecht prints were purchased by Rosenwald through Hayter in 1945 and

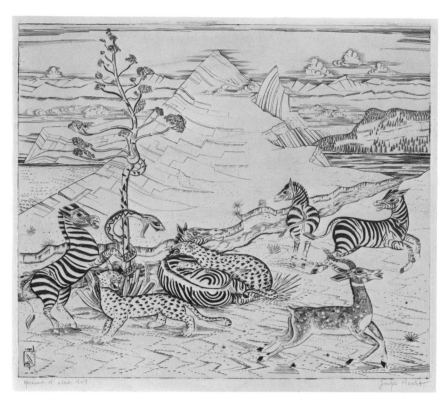

Fig. 75b. Joseph Hecht. *The Ferocious Chase*. Engraving. B-14,108.

1946. *The Ferocious Chase* is typical of the artist's skillful directness and his distinctive simplification of form, often bordering on the naïve.

Among the other artists whose work was added to the Rosenwald Collection through Hayter's introductions, either by his bringing the work to Rosenwald, or by suggesting to the artists that they do so directly, are Sue Fuller, Peter Grippe, Karl Schrag, Pierre Courtin, and Roger Vieillard.

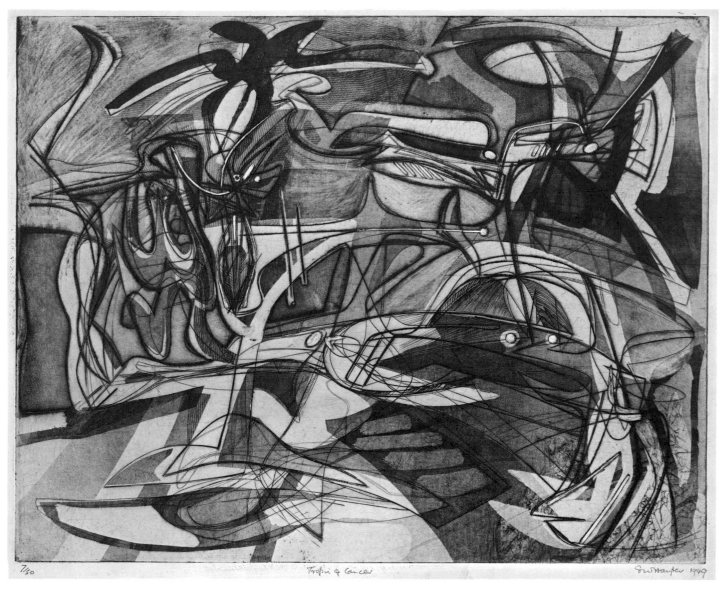

7/50 Tropic of Cancer SWHayter 1949

Cat. no. 75

JASPER JOHNS
American, born 1930

76
Coat Hanger, 1960

Lithograph, printed at Universal Limited Art Editions
with the ULAE blindstamp at lower left corner
65.5 x 53.7 (25¾ x 21⅛)
Numbered lower left in pencil: 35/35; signed and dated
lower right: *J. Johns '60*
Field *Johns* 2
PROVENANCE: Purchased from Universal Limited Art
Editions, 1961; presented to NGA, 1964
B-22, 677

Jasper Johns's *Coat Hanger* is one of three Johns prints in the Rosenwald Collection. The other two are *0 through 9* (Field *Johns* 4) and *Flag I* (Field *Johns* 5), which Rosenwald purchased with a group of prints including Robert Motherwell's *Poet I* and *Poet II*, Helen Frankenthaler's *First Stone*, Grace Hartigan's *Pallas Athene*, and Larry Rivers's *Jack of Spades*, all issued by Tatyana Grosman's Universal Limited Art Editions. Mrs. Grosman visited Alverthorpe in August 1961 to show Rosenwald some of her recent publications, and these purchases came into the collection at the time of this visit.

Coat Hanger was included in the second (1962) of two exhibitions of contemporary American prints organized by the Print Council of America, a nonprofit organization, principally of print curators, that was formed in 1956 for the purpose of "fostering the creation, dissemination, and appreciation of fine prints, new and old." Lessing J. Rosenwald was the council's first president and remained its guiding spirit from the time of its formation until his death.

Both of the *American Prints Today* exhibitions (the first was in 1959) were held simultaneously at several American museums—sixteen in 1959 and twenty-four in 1962. The latter show then circulated for two years, demonstrating Rosenwald's continuing interest in bringing art to as broad a public as possible, something he had been doing for more than thirty years.

These two Print Council exhibitions were mounted to fill a need which was subsequently more than eliminated by the extraordinarily popular place the contemporary print soon took in the public eye. Indeed, in retrospect, the inclusion of Johns's *Coat Hanger* in the 1962 show foretells a new turn in direction in the American print world. *Coat Hanger* was one of the very few entries (Hartigan's *Pallas Athene* was another) printed not by the artists who made the images, but, rather, by professional printers at a print publishing workshop, in this case, ULAE. And this form of print collaboration became the wave of the future.

Rosenwald, however, remained quite aloof from this era of collaboration. His preference stayed with those printmakers who remained committed to the craft of printing as well as to the aesthetics of image-making, in the manner of Hayter (cat. no. 75), for example. Rosenwald also liked personally to know the artists whose prints he bought, liked to talk with them about their ideas and their methods. He was more apt, therefore, to buy prints from artists who brought their work to him themselves, rather than from artists, like Johns, who preferred and were able to have gallery owners and publishers handle the business end of the art business.

REFERENCE: *American Prints Today*

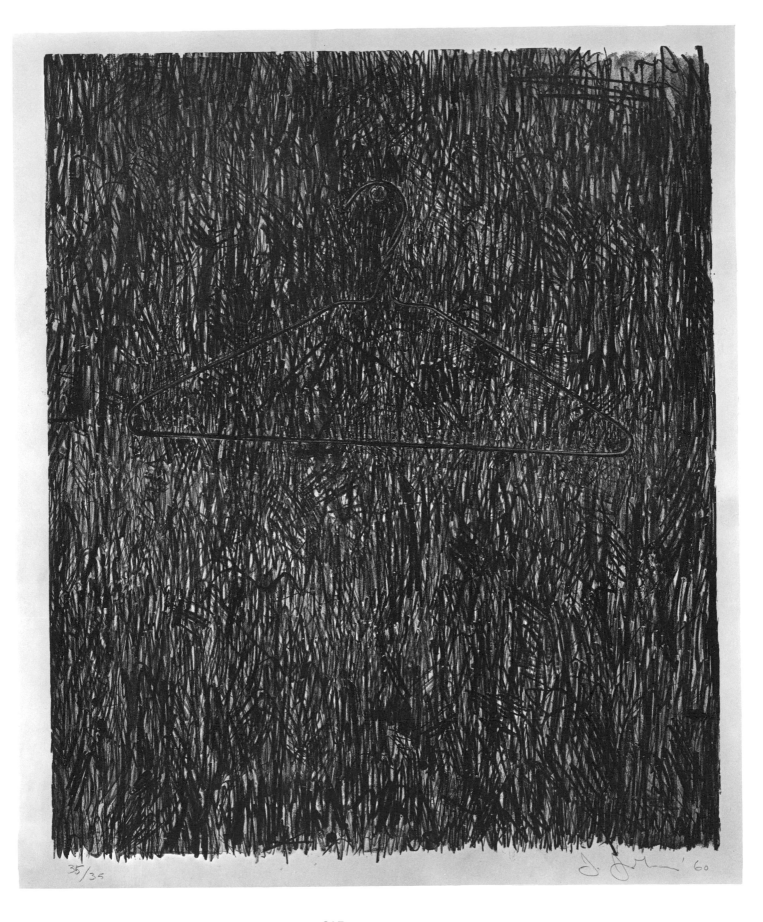

35/35

217

BENTON MURDOCH SPRUANCE

American, 1904-1967

77

The Whiteness of the Whale, c. 1967

Gouache
56 x 76.5 (22 x 30⅛)
PROVENANCE: Purchased from the estate of the artist, 1968; presented to NGA, 1968
B-25,296

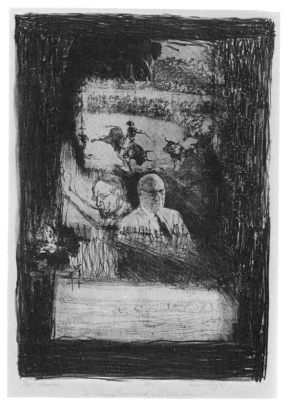

Fig. 77a. Arthur Flory. *The Collector*, 1967. Lithograph. B-31,641.

Benton Spruance has been considered by many Philadelphians to be the dean of the city's lithographers, and from the late 1930s until the artist's death in 1967, Spruance was Rosenwald's closest artist friend. As chairman of both the Printmaking Department at the Philadelphia College of Art and the Art Department of Beaver College, a liberal arts college located quite near to Alverthorpe, Spruance brought his classes to the Rosenwald Collection on a regular basis. Rosenwald frequently attended "Ben's" classes, and he repeatedly remarked on his admiration for the artist's knowledge, thoroughness, and energy as a lecturer on print history as well as his respect for his work as a lithographer.

Rosenwald's Spruance collection includes approximately one hundred prints ranging from his early social realist subjects to his last major project, *Moby Dick, The Passion of Ahab.* Several sets of trial and/or progressive proofs, the only six monotypes the artist is known to have produced (all related to the *Moby Dick* series), and two pencil studies along with the final lithograph version after William Blake's *Illustrations to the Book of Job*, plate 21, executed especially for Rosenwald, make this collection particularly important.

Rosenwald also acquired five additional Spruance drawings, including *The Whiteness of the Whale* and two other gouache studies for the *Moby Dick* series. This preparatory gouache study drawing is bold evidence of Spruance's interest in balancing narrative content and abstract form, a direction he followed throughout his career.

The other Philadelphia printmaker of Spruance's generation whose work Rosenwald purchased rather extensively was Arthur Flory (1914-1972). Seventy-five of his lithographs and drypoints, among them Flory's portrait of Rosenwald, *The Collector* (fig. 77a), are in the collection. The head of the collector, facing right, is placed in a collagelike format which includes the artist's self-portrait facing left and one of Goya's bullfight images.

Flory also had another impact on the Rosenwald holdings. In 1960 he established the first fine arts lithography workshop in Tokyo, and upon his return to the United States, he was responsible for Rosenwald's acquisition of about forty lithographs produced by the Japanese artists who had worked in his shop. All stamped with Flory's printer's mark, there are lithographs by Toshi Yoshida and Hideo Hagewara, among others. If one excludes work done by artists who became part of the international schools of Paris and New York, these lithographs from Flory's shop, along with a number of twentieth-century Japanese woodcuts acquired from several sources, make up the only part of Rosenwald's collection devoted to non-Western art.

PART IV

Multiple Images: The Educational Aspects of the Collection

HEINRICH ALDEGREVER
German, 1502-1555/1561

78
The Nativity, 1552

Pen and black ink with gray wash
10.8 x 6.9 (4¼ x 2¹¹⁄₁₆)
PROVENANCE: Czeczowitza Collection; purchased from
Charles Sessler, 1930; presented to NGA, 1964
B-24,233

79
The Nativity, 1553

Engraving
10.8 x 6.8 (4¼ x 2¹¹⁄₁₆)
Hollstein 39
PROVENANCE: Purchase untraced (possibly a companion
to cat. no. 78); presented to NGA, 1964
B-24,234

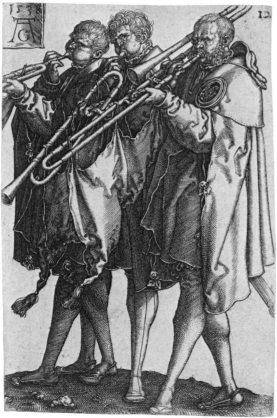

Fig. 78-79a. *Large Wedding Dancers* (three musicians),
1538. Engraving. B-2838.

Studies for prints, which offer a revealing picture of the artist's mind at work, form an interesting facet of Rosenwald's collection (see also cat. nos. 88-92). *The Nativity* drawing is one of two Aldegrever studies for engravings that Rosenwald purchased in 1930, the other being a similar study for *The Annunciation* (Hollstein 38). As only three other Aldegrever drawings for engravings are listed by Hollstein, the pair is particularly special. Aldegrever carefully worked out the architectural composition, the placement and essential gestures of the figures, and the general distribution of tonalities throughout the scene in the drawing. The engraving after it, however, completed a year later, is hardly a slavish copy. Rather, in the engraved version the architectural surfaces, the landscape elements, and the facial expressions of the participants in this great event as well as the details of their clothing, have all been carefully reconsidered. Each of these aspects of the image differs from its drawing counterparts. The composition was clearly engraved onto the copper plate in the same direction that it was conceived in the pen and ink and wash version, thus producing a printed image in reverse of the drawing.

Aldegrever, like Bartel and Hans Sebald Beham (cat. no. 36) and the other German Little Masters, made prints of a variety of subjects. Biblical themes, like *The Nativity*, mythological and allegorical compositions, portraits and genre subjects, such as the three musicians (fig. 78-79a) from Aldegrever's *Large Wedding Dancers*, were all undertaken. Ornamental motifs for the use of metalworkers and other craftsmen were produced in large numbers as well. All of these categories are included in the Rosenwald Aldegrever collection. This aspect of the collection, like the Altdorfer collection (cat. no. 50) which is slightly smaller, was essentially formed between 1928 and 1930, starting with acquisitions from the collection of Friedrich August II. The greatest number of Aldegrever's engravings, however, came from the Schloss "E" sale in Berlin in May 1929. Eight of the approximately one hundred twenty prints in the collection were added in the late 1930s and 1940s. None were added later.

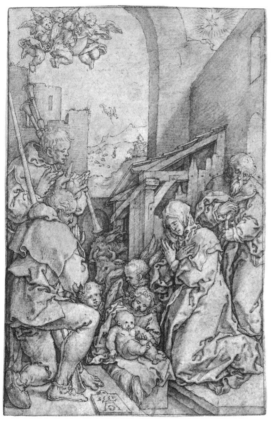

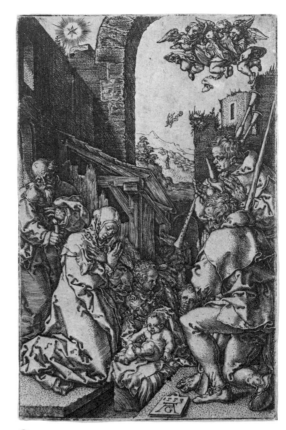

Cat. no. 78

Cat. no. 79

ALBRECHT DÜRER
German, 1471-1528

80

Dream of the Doctor, 1498-1499

Engraving
18.7 x 11.8 (7⅜ x 4¹¹⁄₁₆)
Hollstein 70
PROVENANCE: D. B. Hausmann (Lugt 377); Clendenin
J. Ryan (Parke-Bernet, 17 January 1940, no. 82);
purchased from Richard H. Zinser, 1940; presented to
NGA, 1943
B-6505

81

Dream of the Doctor, 1498-1499

Engraving
18.7 x 11.9 (7⅜ x 4¹¹⁄₁₆)
Hollstein 70, counterproof
PROVENANCE: Purchased from Oskar Stoessel, 1947;
presented to NGA, 1947
B-14,085

Dürer's *Dream of the Doctor*, a powerful representation of Sloth as the target of both a Satanic demon and carnal temptation, is here seen in two impressions. The first (cat. no. 80) is a direct print from a copper plate, and the second (cat. no. 81) is a counterproof. The counterproof would have been produced by pressing a clean sheet of paper against a freshly pulled impression, transferring the wet ink to the second sheet to produce a mirror image.

Another important example of a counterproof, Rembrandt's *The Goldweigher's Field* (fig. 12-15b), is among those in the Rosenwald Collection. These rare backwards images were, in fact, images in the same direction as the copper plates from which the prints were pulled, and they would most likely have been made to facilitate the artist's considerations of future work on the plates. The Dürer is particularly interesting as it appears to be the earliest known counterproof.

This Dürer pair is one of more than twenty instances in which Dürer compositions are found in multiple impressions in the Rosenwald Collection.

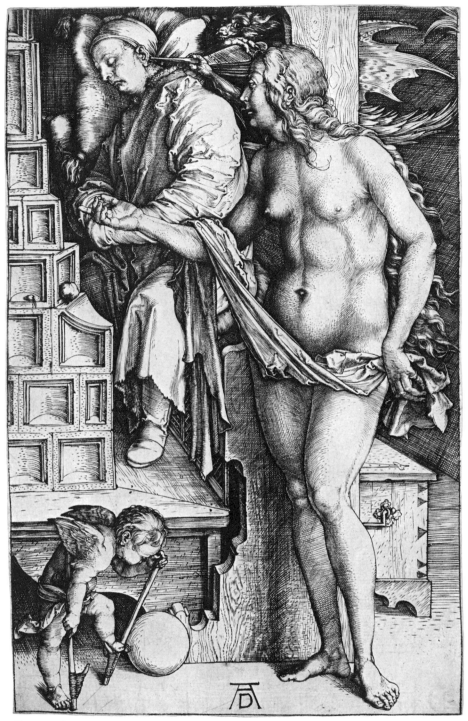

Cat. no. 80

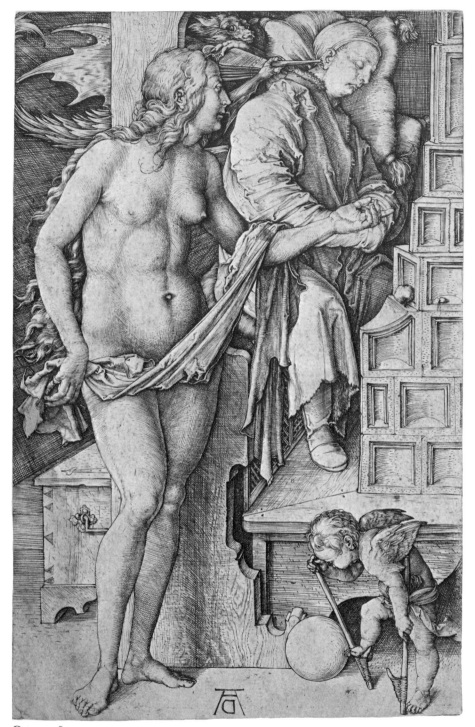

Cat. no. 81

REMBRANDT VAN RIJN
Dutch, 1606-1669

82
Christ Crucified between the Two Thieves: 'The Three Crosses,' 1653

Drypoint and engraving
38.9 x 45.6 (15�5/16 x 17¹⁵/₁₆)
Hollstein 78 III/IV
PROVENANCE: C.G. Boerner, 5-7 November 1929,
no. 592; purchased from Charles Sessler, 1929;
presented to NGA, 1943
B-11,182

83
Christ Crucified between the Two Thieves: 'The Three Crosses,' probably 1660 in this state

Drypoint and engraving
39 x 45.5 (15¼ x 17¹³/₁₆)
Hollstein 78 IV/IV
PROVENANCE: W. Esdaile (Lugt 2617); Alfred Morrison?
(Lugt 144); purchased from E. Stetson Crawford, 1936;
presented to NGA, 1943
B-9537

Rembrandt developed his etchings through several states, taking proof impressions at a number of points in the process. When the plates were completed, he generally printed the editions himself, often on a number of different papers, and experimented with the expressive possibilities of tonal variations within images by altering the placement and quantity of ink residue on the surface of the copper plate as it was being wiped for printing. Thus, different impressions of the same state of a subject often vary from each other considerably because of the effects of the surface plate tone (the best demonstration of such variance in this exhibition is not an example by Rembrandt but rather, the two Whistler *Nocturnes* [cat. nos. 84-85], in which Whistler is following Rembrandt's technical example).

The Rosenwald Collection is particularly rich in multiple impressions of Rembrandt's works, thus allowing for careful study of proofs of different states as well as a number of variant printings. The Rembrandt holdings exceed 275 impressions, and all of the artist's subject categories are represented: portraits, self-portraits, landscapes, religious subjects, and genre scenes. Forty-seven subjects may be found in two to four different impressions, allowing one to see the scope of Rembrandt's etching oeuvre and the variations in his working processes. For example, the first and last states of *The Great Jewish Bride* (figs. 82-83a and b) show that the image evolved in a rather straightforward manner with the upper half of the subject laid in lightly, complete with her architectural framework, and then developed more fully as the lower portion of the plate was established. The two impressions of *The Three Crosses*, on the other hand, rather than showing the development of an image as it was first conceived, present the monumental changes made to the plate as Rembrandt revised his composition after a period of several years.

In the third state (cat. no. 82), light (resulting from Rembrandt's selective wiping of the plate) bathes the scene. One's attention is directed not only to the dramatic historical event taking place, but also to the individuals there to witness Christ's crucifixion. The tenderness with which Rembrandt drew Mary and the other women, limp between Christ's cross and that of the thief at the right, the anguish which one senses in the gestures and expressions of the men at the lower left, the diffidence of the horsemen conducting their duties, and the mysterious hooded figure almost hidden beyond the foliage above the cavernous space at the right, all acting as individual visual moments, enhance the human aspects of the scene in this version of the print.

In the fourth and final state (cat. no. 83), completed approximately seven years later, the drama of the moment, the forces beyond man's control, rather than the human response to those forces, are the powerful focus of the image. The anguish and the diffidence and the mystery remain, but they are subordinate to the overpowering force of the scene as a total image. Rembrandt has not simply darkened his plate; rather, he has burnished it down, removing most of the image of the third state, and then has reworked it almost in its entirety.

227

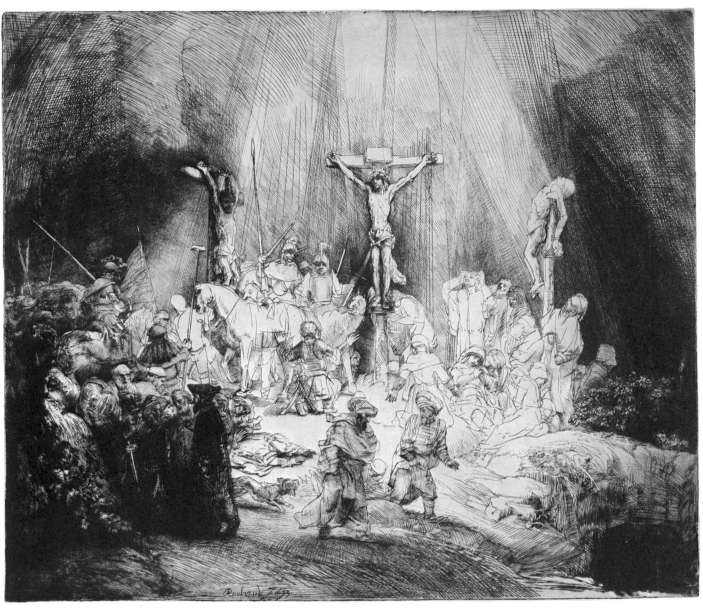

Cat. no. 82

Fig. 82-83a. *The Great Jewish Bride,* 1635. Etching
with drypoint and engraving. B-9459.

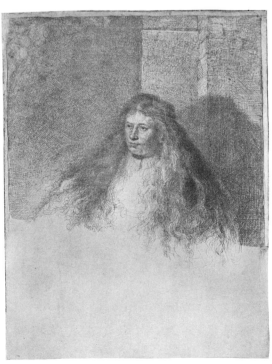

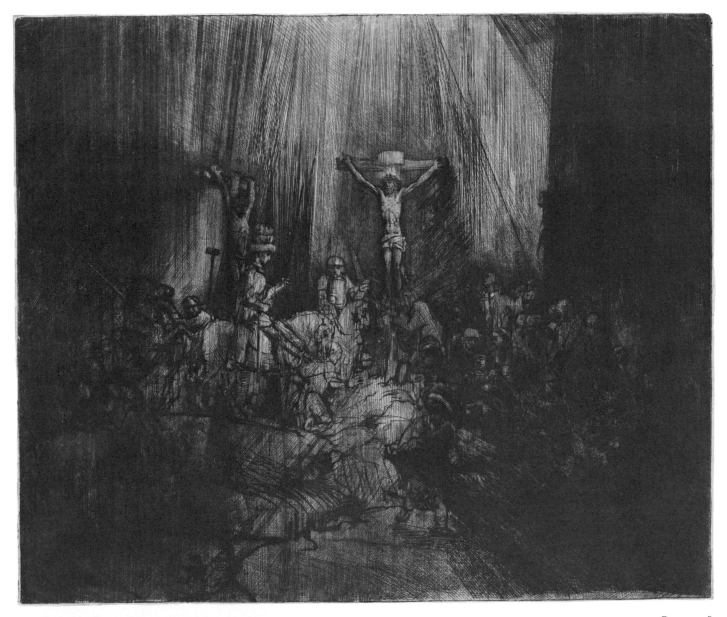

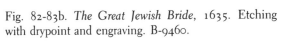

Fig. 82-83b. *The Great Jewish Bride*, 1635. Etching
with drypoint and engraving. B-9460.

Cat. no. 83

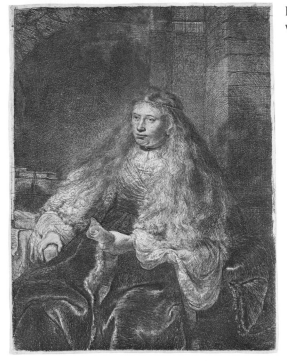

229

JAMES ABBOTT MCNEILL WHISTLER
American, 1834-1903

84
Nocturne, 1879

Etching and drypoint, printed in brown
20 x 29.5 (7⅞ x 11⅝)
Signed lower left in pencil with Whistler's butterfly tab
signature
Kennedy 184 IV/V
PROVENANCE: Purchased from Charles Sessler, 1928;
presented to NGA, 1943
B-10,581

85
Nocturne, 1879

Etching and drypoint, printed in brown
20 x 29.5 (7⅞ x 11⅝)
Signed lower left in pencil with Whistler's butterfly tab
signature
Kennedy 184 IV/V
PROVENANCE: Purchased from Charles Sessler, 1930;
presented to NGA, 1943
B-10,582

Rosenwald's extensive Whistler collection (see cat. nos. 25-26) includes two working proofs of etchings drawn into by the artist (*Maude Standing*, Kennedy 114 and *The Boy*, Kennedy 135), and one lithograph colored by hand (cat. no. 26). It also includes thirty-five etchings and sixteen lithographs in multiple impressions. In most instances, these multiple impressions represent different states of the subjects, and, particularly with the etchings which went through many state changes, these variants are key to understanding Whistler's visual thinking.

Although they look quite different from one another, these two impressions of *Nocturne* are actually taken from the same state of the plate. Rather than showing how Whistler developed his imagery, therefore, they highlight the artist's use, modeled on Rembrandt's, of the printing method: selective tonal wiping. *Nocturne* is one of twelve plates in the "First Venice Set" published in 1880 by The Fine Art Society, London. Different prints of the highly impressionistic subject tend to show greater tonal variations than most of Whistler's etchings, which generally make use of tone in a rather consistent manner within each edition. Here, however, the time of day represented and the mood of the scene are substantially dependent upon the quantity of ink remaining on the plate's surface when it is printed. In one instance (cat. no. 84), a quiet dawn is evoked. In the other (cat. no. 85), night has fallen and the air is far less calm.

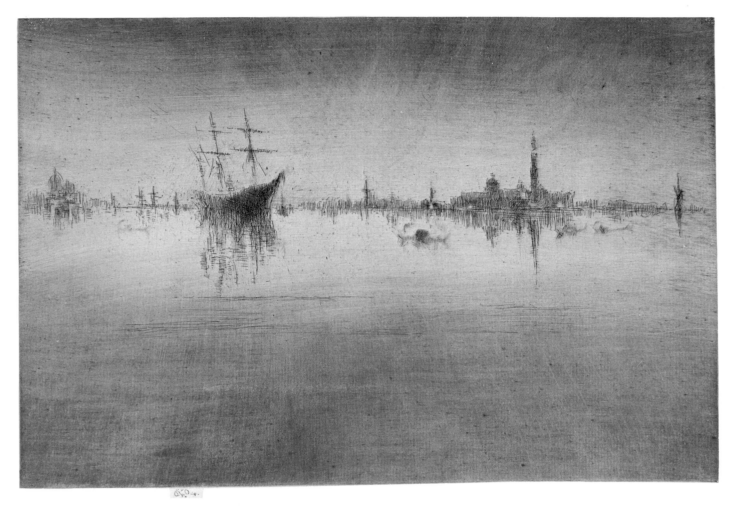

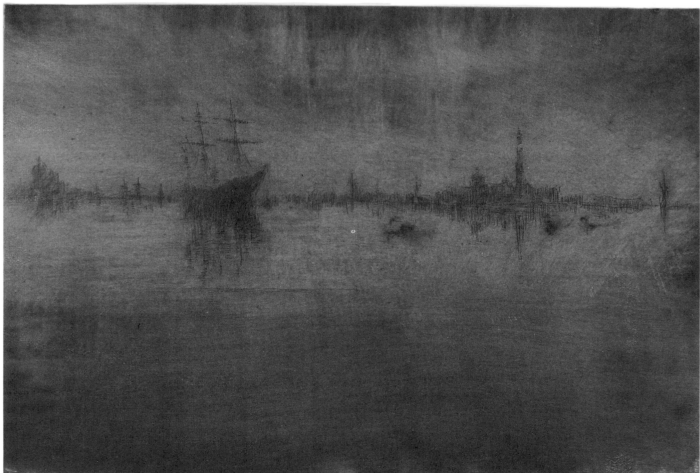

HENRI DE TOULOUSE-LAUTREC
French, 1864-1901

86
Miss Loie Fuller, 1893

Lithograph printed in brown, red, two shades of blue, two shades of orange and gold, with pencil annotations within the image
38.5 x 28.1 (15³/₁₆ x 11¹/₁₆), sheet
Signed, lower right in pencil: *T-Lautrec*
Delteil 39
PROVENANCE: Purchased from Jean Goriany, 1946; presented to NGA, 1947
B-14,230

87
Miss Loie Fuller, 1893

Lithograph printed in brown, yellow, two shades of blue, two shades of orange and gold
38.1 x 27.9 (15 x 11), sheet
Delteil 39
PROVENANCE: Blindstamp of Edmond Sagot, Paris; E. Kleinmann; purchased from Gérald Cramer, 1951; presented to NGA, 1952
B-20,712

The Toulouse-Lautrec holdings are one of the highlights of the Rosenwald Collection. Included are approximately 250 sheets representing more than 183 of the artist's compositions. Drypoints, lithographs, and proofs of illustrations for the journal *Le Rire* are all to be found, along with a single sheet of early pencil sketches (recto/verso). In almost fifty instances, subjects are represented more than once, the two impressions of *Miss Loie Fuller* being one example.

An American actress and dancer, Loie Fuller was a pioneer in the coordination of stage, costume, and lighting design. Her performances used colored spotlights to highlight the motion of her swirling costume, emphasizing the elusiveness of her presence on stage, and they attracted a number of artists, among them, Toulouse-Lautrec.

Miss Loie Fuller is Lautrec's earliest color lithograph that is not a poster. In his attempt to capture the range of visual possibilities he saw in the shimmering rhythms and flow of Miss Fuller's dance, the artist produced this hovering rendition of his subject in an edition of fifty impressions—each of which is thought to be unique. Study of these two very different Rosenwald impressions under high magnification has indicated that differences in color and shape may be attributed to variant inkings of the several stones used to produce the image, rather than to hand-coloring. The gold, too, appears to have been printed from stone, given evidence including gold ink residue printed from the edge of the stone in the margin of cat. no. 86.

Although there is some confusion in the records, Rosenwald's earliest Toulouse-Lautrec acquisition appears to have been an unspecified portfolio of thirteen lithographs purchased from Sessler in 1944 (perhaps it was one of the portfolios of thirteen bust portraits of actors and actresses [Delteil 150-162], but if so, it has since been replaced by another set). Two years after this 1944 purchase, Jean Goriany sold Rosenwald fourteen Lautrec prints including the signed and inscribed "bon a tirer" for *The Motorist* (Delteil 203) and one of the two impressions of *Miss Loie Fuller*. In 1947, the *Café Concert* portfolio was acquired, and that same year, four prints by Toulouse-Lautrec were brought at the Parke-Bernet sale of the collection of Mrs. George A. Martin at which time Rosenwald also purchased an impression of Manet's color lithograph *Polichinelle* (fig. 86-87a) and prints by George Bellows, Daubigny, Palmer, and Redon, among others.

In 1950, several Toulouse-Lautrecs were included with the purchase in Uruguay of hundreds of prints and drawings, mainly by German expressionist artists (see cat. no. 71), and more than twenty Lautrec sheets came from Petiet in 1950 and 1952. Among these was the cover for the ballads of Jean Goudezki, *Les Vieilles Histoires* (Delteil 18), printed in black and hand-colored with watercolor.

There were a few other Toulouse-Lautrec purchases, but the largest and most important part of the collection was acquired in 1951, through Gérald Cramer. The purchase consisted of approximately two hundred prints from the collection of Edouard

Miss Loïe Fuller

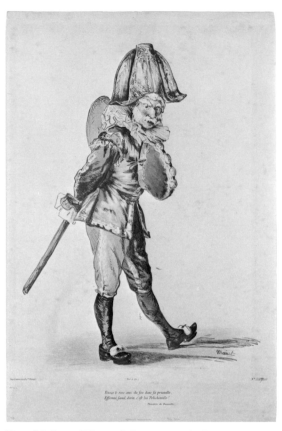

Fig. 86-87a. Edouard Manet. *Polichinelle*, 1874.
Lithograph. B-14,129.

Kleinmann, Toulouse-Lautrec's publisher and agent during the mid-1890s. The second impression of *Miss Loie Fuller* was one of them. Rosenwald was able to view the splendid Kleinmann Collection while visiting Paris in October 1951, and by December, shipped in two lots, the prints had arrived in Jenkintown.

The Kleinmann Collection featured many beautiful standard impressions of the artist's work, but more important, it included several trial proofs, printed in black for the color lithographs; unusual first state impressions, including some not recorded by Delteil; a number of instances of proofs of the same subject printed on two different papers, no doubt in order to study the papers' effect on the image; and a number of sheets inscribed by the artist to Kleinmann and others. With the purchase of the Kleinmann Collection, the Rosenwald Toulouse-Lautrec material, like the Rosenwald Blake collection, became crucial to any study of the artist's work.

Cat. no. 87

MARY CASSATT
American, 1845-1926

88

In the Omnibus, c. 1891

Pencil and black chalk
37.9 x 27.1 (14⅞ x 10¾)
Signed lower right in pencil: *Mary Cassatt*
Breeskin *Paintings* 804
PROVENANCE: Durand-Ruel, 1921; H. G. Whittemore
(Parke-Bernet, 19-20 May 1948, no. 60); purchased
from The Rosenbach Company, 1948; presented to
NGA, 1948
B-14,881

Rosenwald acquired ten drawings (see also cat. no. 67) and more than sixty-five etchings and drypoints by Mary Cassatt. Particularly rich are the holdings of Cassatt's splendid series of color prints inspired by an 1890 Ecole des Beaux-Arts exhibition of Japanese *Ukiyo-e* woodcuts with their characteristic flatly colored, bold, patternlike shapes and forms. Fourteen of the artist's seventeen color prints are in the collection in as many as eight variant impressions, among them *In the Omnibus* seen here in the drawing study and four trial proofs.

The drawing (cat. no. 88) was used to transfer the composition to the copper plate, and as one would expect, it is in reverse of the printed image. More interesting, however, is its revelation of the artist's initial working process. Visible is Cassatt's tentative structural searching by means of very light and sketchy marks, and we can also see how her initial forms were firmly revised and finalized with darker continuous lines which strengthen and delineate particular contours. Moreover, the right portion of the drawing shows the figure of a seated man and the remnants of a standing woman who probably preceded him on the sheet, both of which were eliminated from the scene as Cassatt developed her idea.

Our earliest printed version (cat. no. 89) shows an early state of one plate alone with the image defined solely by line and in which the landscape outside the omnibus windows is sketched in pencil rather than part of the printed image. The next stage in the subject's development represented in the collection (cat. no. 90) is a proof in color taken from the three plates used for the final version and in this state most of the major color areas appear as they do in the finished print. It, too, however, is a proof prior to the landscape addition and other work, such as adjustments to the child's hand, which in the final state grasps a ball. The next proof (cat. no. 91), printed in black rather than color but taken from two of the three plates used for the color prints (lacking the one carrying the color areas of the two women's attire), now shows the landscape additions and the child holding the ball. In addition, the base of the omnibus seat is now separated.more clearly from the floor at the left.

The Rosenwald Collection does not include an impression of the final state of the print, which was issued in an edition of twenty-five impressions (one was given to the National Gallery by Chester Dale, however). But the proof of the next to the last state (cat. no. 92) differs from the edition impressions in minor details only.

Rosenwald purchased his first four Cassatt prints, all drypoints printed in black, in 1928, and a fifth the following year. The bulk of the Cassatts, however, entered the collection a decade later. In 1940 and 1941, thirty sheets were purchased through Jean Goriany. Many of the splendid trial proofs of the color prints were included, among them three of *In the Omnibus,* reportedly from the collection of Ambroise Vollard, the publisher of Cassatt's important series. In

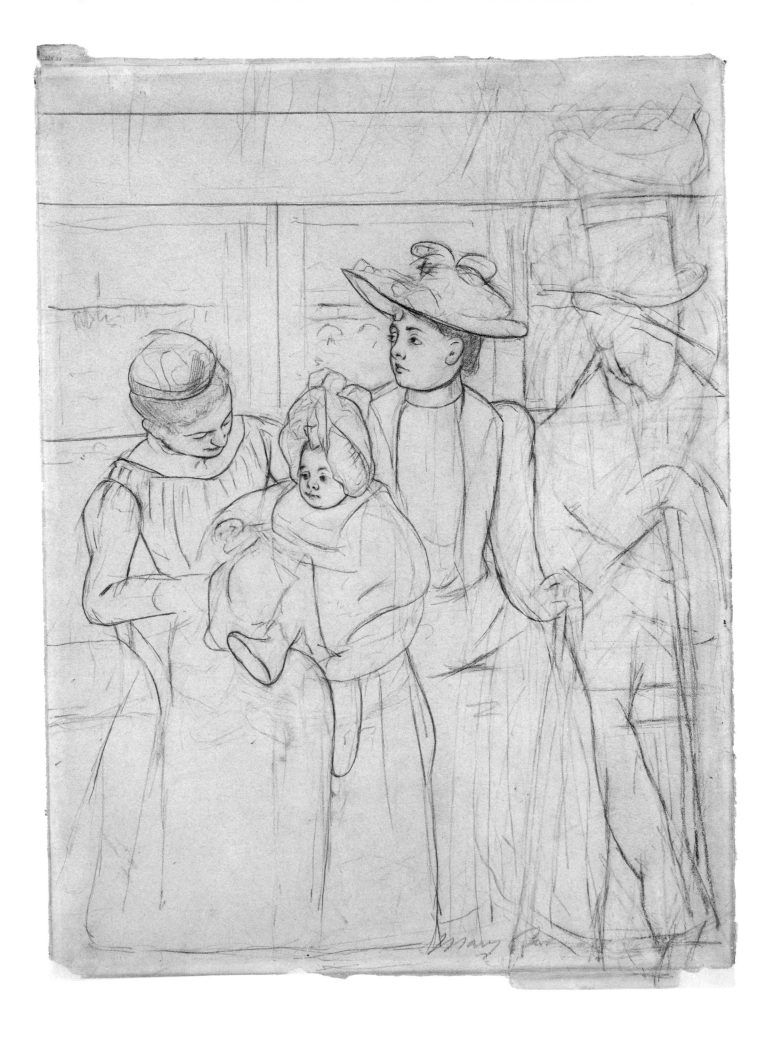

89

In the Omnibus, c. 1891

Soft-ground etching and drypoint, printed in black, reworked with pencil
36.7 x 26.7 (14⁷⁄₁₆ x 10⁹⁄₁₆)
Breeskin *Prints* 145 I/IV
PROVENANCE: C. Roger-Marx (stamp other than Lugt supp. 1800ᵇ); R. Hartshorne (Lugt supp. 2215ᵇ); purchased from Charles Sessler, 1946; presented to NGA, 1946
B-13,603

90

In the Omnibus, c. 1891

Soft-ground etching, drypoint, and aquatint, printed in blue, brown, tan, light orange, yellow-green, red, and black
36.4 x 26.3 (14⅜ x 10⅜)
Signed lower left in pencil: M.C
Breeskin *Prints* 145 II/IV, Proof A
PROVENANCE: A. Vollard; purchased from Jean Goriany, 1941; presented to NGA, 1943
B-5834

91

In the Omnibus, c. 1891

Soft-ground etching, drypoint, and aquatint, printed in black
36.8 x 26.3 (14⁷⁄₁₆ x 10⁹⁄₁₆)
Signed lower right within image in pencil: M.C
Breeskin *Prints* 145 II-III/IV
PROVENANCE: A. Vollard; purchased from Jean Goriany, 1941; presented to NGA, 1943
B-5833

92

In the Omnibus, c. 1891

Soft-ground etching, drypoint, and aquatint, printed in blue, brown, tan, light orange, green, yellow-green, red, and black
36.4 x 26.3 (14⅜ x 10⅜)
Signed lower right in pencil: M.C
Breeskin *Prints* 145 III/IV, Proof J
PROVENANCE: A. Vollard; purchased from Jean Goriany, 1940; presented to NGA, 1943
B-5845

1946, Rosenwald purchased several more sheets, again from Goriany; but of greater significance to the Cassatt collection that year was the acquisition, through Sessler, of seventeen prints and one drawing from the important Cassatt collection of Robert Hartshorne. Several of these had come into the Hartshorne Collection from that of Cassatt's contemporary, writer and critic Claude Roger-Marx.

In 1948, Rosenwald added three Cassatt drawings, including the study for *In the Omnibus*. He acquired them through Rosenbach from the sale of the Harris Whittemore Collection at Parke-Bernet; several of Cassatt's prints were purchased at a second part of the Whittemore sale the following year. Also in 1949, a small group of Cassatts came through Sessler from the sale of the holdings of Princeton collector Alfred E. McVitty, whose major interests had been Rembrandt and Cassatt. Rosenwald's Cassatt purchases ended in 1953 when he bought from Henri Petiet four drawings and three prints, one of them a then undescribed and unique drypoint, *View of Venice* (Breeskin *Prints* 93 +).

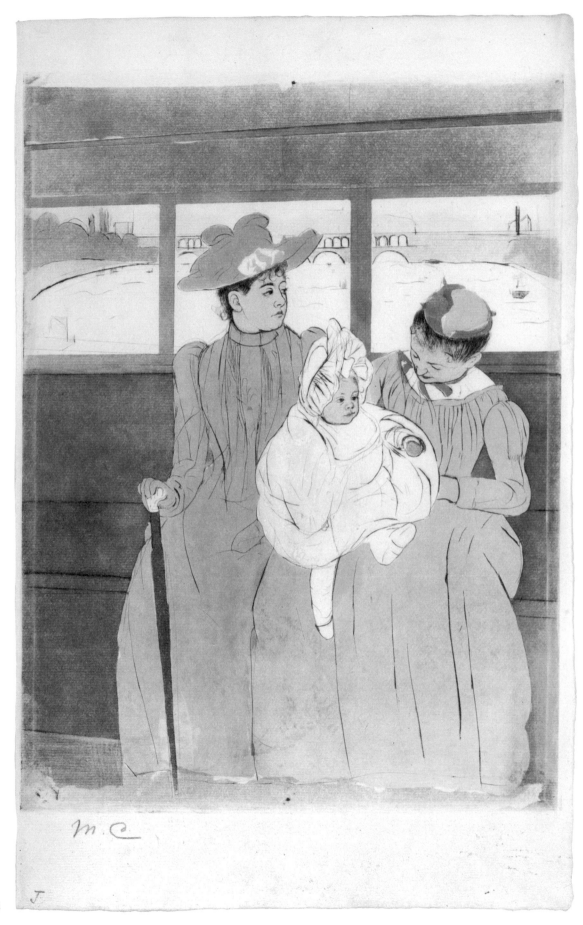

m.c

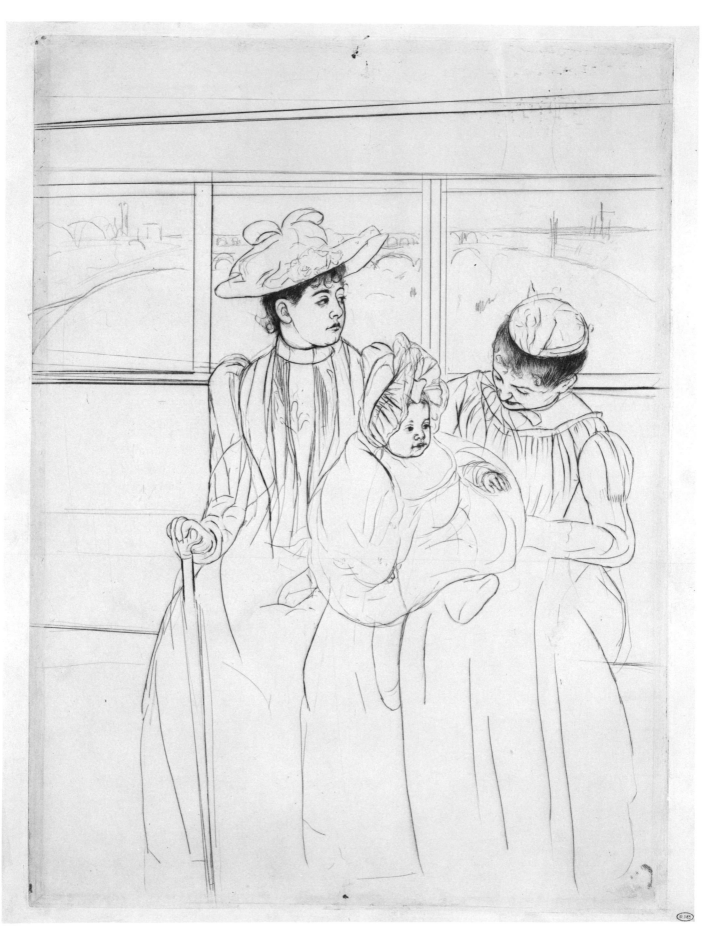

no. 8c

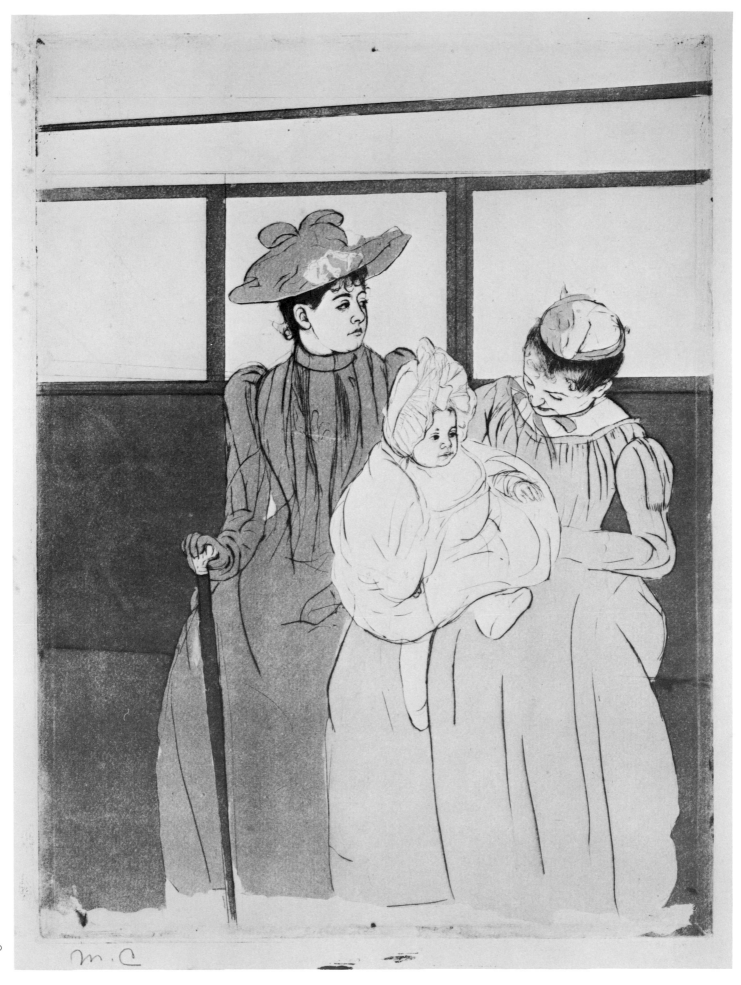

m.C

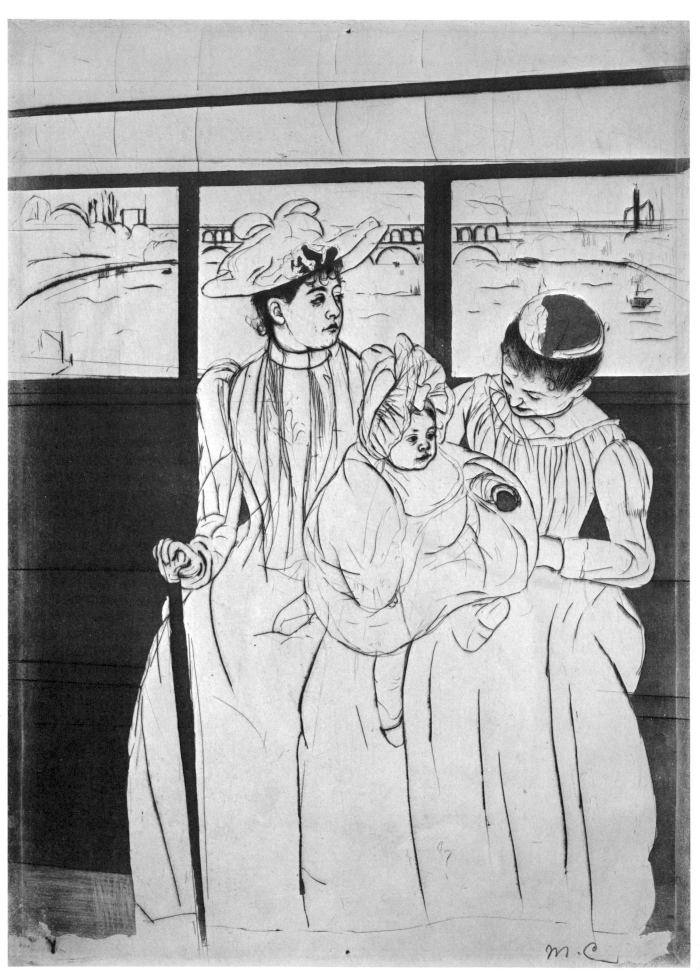

M. C

KÄTHE KOLLWITZ
German, 1867-1945

93
War: "The Sacrifice,"
1922/1923

Woodcut, retouched with white, gray, and black paint
37.2 x 40.2 (14¹¹/₁₆ x 15⅞)
Numbered lower left in pencil: *2nd state* and signed
lower right: *Kathe Kollwitz*
Klipstein 177 II/VII
PROVENANCE: A. Klipstein; purchased from Buchholz
Gallery, 1946; presented to NGA, 1947
B-14,111

94
War: "The Sacrifice,"
1922/1923

Woodcut
37.2 x 40.2 (14¹¹/₁₆ x 15⅞)
Numbered lower left in pencil: *4th state* and signed
lower right: *Kathe Kollwitz*
Klipstein 177 IV/VII
PROVENANCE: A. Klipstein; purchased from Carlen Gal-
leries, 1946; presented to NGA, 1946
B-13,634

95
War: "The Sacrifice,"
1922/1923

Woodcut
37.1 x 39.9 (14¹¹/₁₆ x 15⅞)
Numbered lower left in pencil: *87/100* and signed and
inscribed lower right: *Kathe Kollwitz/War Pl.. 7 The
Sacrifice*
Klipstein 177 VII/VII
PROVENANCE: Purchased from Hudson D. Walker,
1941; presented to NGA, 1943
B-7764

These three impressions of "The Sacrifice" are from Rosenwald's collection of more than 115 Kollwitz etchings, lithographs, and woodcuts, including a number of early trial proofs, redrawn working proofs, and particularly fine impressions of the edition states of many subjects,. Only three of the five impressions of "The Sacrifice" in the collection are included here, and they were drawn from a group of eleven possible subjects, all of which were purchased by Rosenwald in more than one impression. "The Sacrifice" is the first in a series of seven prints on the theme of war that Kollwitz had worked first as etchings and then as lithographs, prior to executing the woodcut versions. The earliest of the three states included here (cat. no. 93) is a trial proof reworked by the artist with gray, white, and black paint. For example, the contours of the mother's hips, as well as the lines which appear in the background to her left and right are indicated by painted, rather than incised, strokes. In the second proof (cat. no. 94), we can see how the artist followed through with her painted plans by cutting the contours and the lines in the left background into the block, allowing them to appear white in the print; evidently, she reconsidered the marks painted at the right of the figure in the earlier working proof (cat. no. 93), as they never were added to the image. Further, the area between the mother's head and the baby's bottom is painted in both white and black in the working proof (cat. no. 93), then left unpainted in the second proof (cat. no. 94), and in the edition print (cat. no. 95), we find that the block has been plugged in this area, allowing it to print solidly black. In this final version (cat. no. 95), too, we see further work throughout the image, particularly in the modeling of the mother's torso, and in the strokes of light along the inner edge of the dark background arch.

Rosenwald's Kollwitz prints nearly span the artist's career as a graphic artist; the earliest sheet, an etching, dates from 1892, two years after her first works, and the latest is her last self-portrait, a lithograph of 1938. The Kollwitz collection was started in 1939. That year, Rosenwald purchased more than twenty prints by the artist from Carlen Galleries in Philadelphia, the source for most of the Kollwitz acquisitions. Hudson D. Walker was the other dealer of importance in the formation of this aspect of the collection: Rosenwald bought more than forty prints from him in a single 1941 purchase. (At the same time, in consultation with Carl Zigrosser, newly appointed Curator of Prints at the Philadelphia Museum of Art, Rosenwald purchased several prints by Kollwitz for that institution's growing collection. This, no doubt, was one of the first joint print ventures by the collector and the curator after the latter's appointment.) Twenty-three works by Kollwitz were purchased from Carlen in 1943, and after that, sporadic additions to the collection took place throughout the 1940s with the last acquisitions in 1956, from William H. Schab.

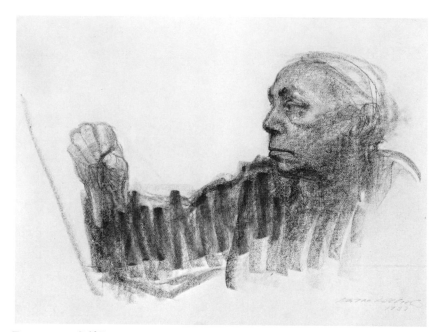

Fig. 93-95a. *Self-Portrait*, 1933. Charcoal. B-7713.

During this same period, from 1939 to 1953, Rosenwald also acquired twenty-seven Kollwitz drawings, ranging from brief sketches to more finished sheets, about half of them studies for prints. Worked in various media—pencil, pen and ink, charcoal, chalk, gouache, wash, and combinations of these—like the prints, the drawings span most of Kollwitz's career. The earliest is a sheet of pen and ink studies dated 1891, and the latest is the favored charcoal self-portrait of the artist at work of 1933 (fig. 93-95a).

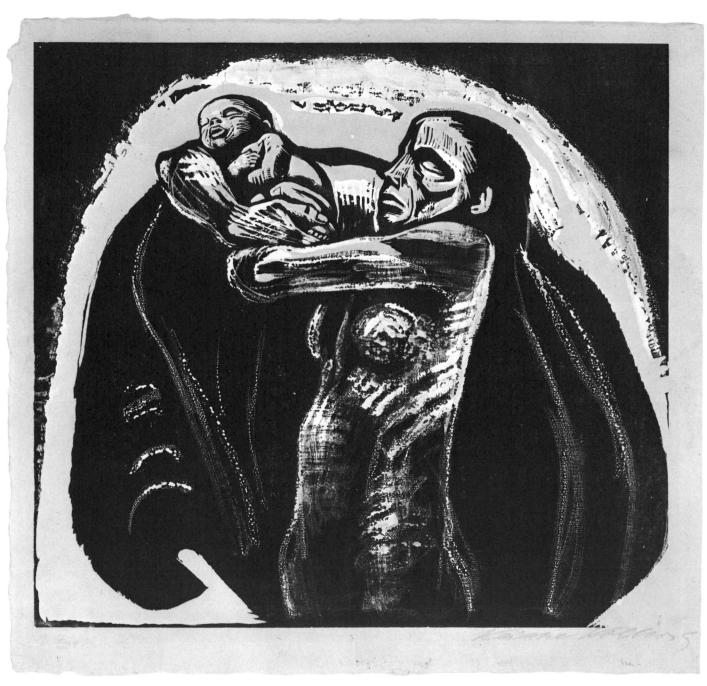

Cat. no. 93

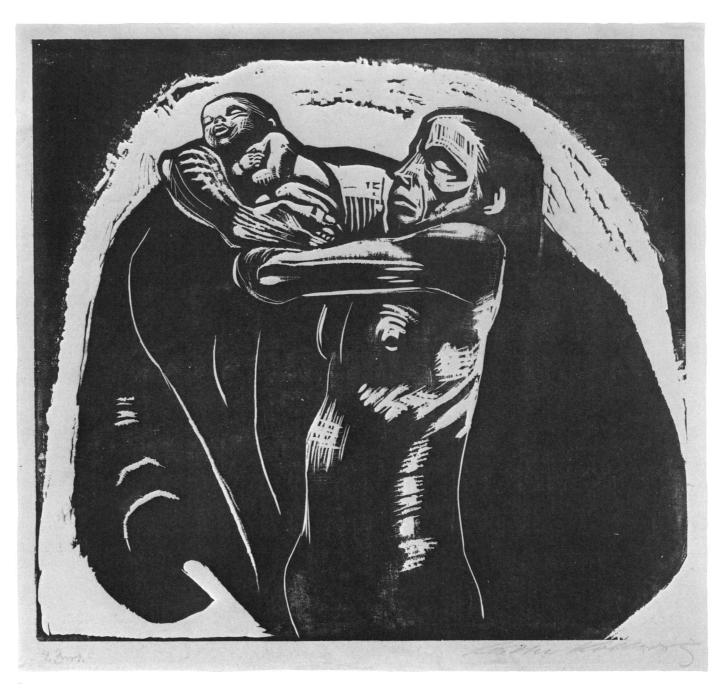

Cat. no. 94

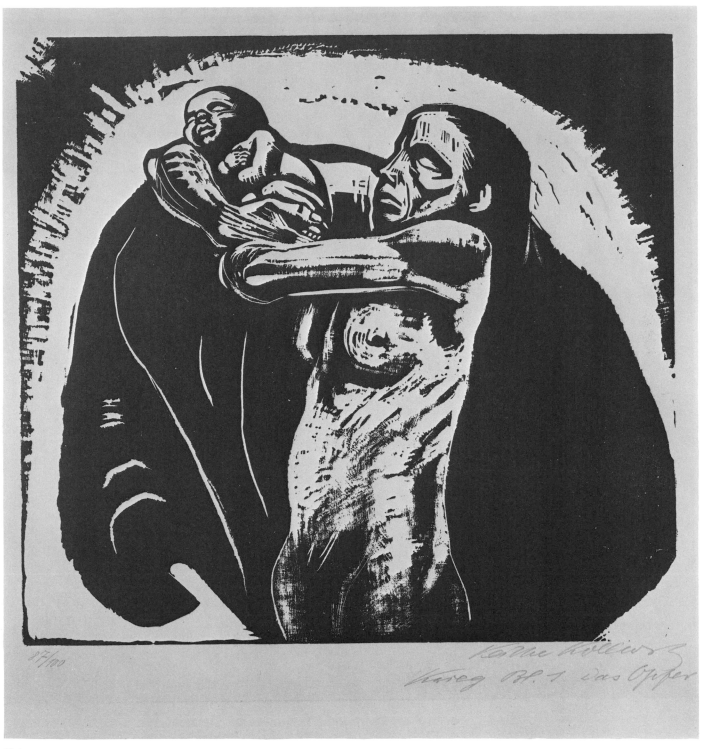

87/100 Käthe Kollwitz
 Krieg Bl. 1 das Opfer

Cat. no. 95

WILLIAM BLAKE
British, 1757-1827

96

War or *The Accusers of Theft, Adultery, Murder*, 1793-1796 in this state

Engraving, printed intaglio and relief in blue, blue-green, red, yellow, brown, and several shades of gray with details in other colors, and overpainted with watercolor
21.5 x 11.9 (8⁷⁄₁₆ x 4¹¹⁄₁₆)
Keynes *Separate Plates* VII 2/3; Bentley *Blake Books*, copy H (incorrectly given to the Library of Congress); Butlin 285; Essick *Separate Plates* (forthcoming) VIII 2/3, copy C
PROVENANCE: I. D'Israeli or his son, the first Earl of Beaconsfield; Hodgson's, 14 January 1904, no. 227; W. A. White; purchased from The Rosenbach Company, 1929; presented to NGA, 1943
B-11,038

There are two kinds of differences to be found when comparing the Rosenwald impressions of *War* or *The Accusers of Theft, Adultery, Murder*. These two prints, therefore, present yet another facet of the richness of the printmakers' art. First, cat. no. 96 is printed in a number of colors by means of a combination of processes outlined below, whereas cat. no. 97 is a conventionally printed black and white engraving. Beyond that, the two impressions are taken from different states of the plate, the color version being the earlier.

Although a great deal of scholarship has focused on Blake's art in recent years, his complex technical methods and, with his prints, the variations which exist between impressions, remain difficult to define and describe, particularly as his important prints are rare and widely dispersed. *The Accusers of Theft, Adultery, Murder* was first published in 1793. Only one impression in the Bodleian Library, Oxford, printed intaglio like the third state impression seen here (cat. no. 97), is known. The Rosenwald second state (cat. no. 96) is also quite special, being known only in this and one other impression in the British Museum. Like the one shown here, the British Museum impression is printed in color. Study of the Rosenwald sheet shows that parts of the image are printed from the lowered engraved lines in the copper plate, and other parts are printed from the higher relief surface. It appears that both the intaglio- and relief-printed color were run through the press simultaneously. The sheet was then reworked with watercolor.

The intricateness of the "à la poupée" printing process, in which several colors are carefully applied to small areas of the plate (but usually applied either intaglio or relief, rather than both simultaneously), in Blake's hands is quite extraordinary. Attention is paid not only to the delineation of the large color masses, but also to such small details as the modeling of forms in the heads with blue shadows. Other areas—the features of the faces, for example—are essentially modeled with fine watercolor lines. All of the engraved marks of the faces were left free of ink at the time of printing. The scalelike shapes in the tunic worn by "Theft," the figure at the left, as well as the folds of his skirt, are also entirely worked as part of the painting, rather than the printing, process. The image is carried to the edge of the plate, entirely covering the border, which bears the inscription found in the other Rosenwald impression, state 3.

In addition to the fact that the third state sheet is uncolored, there are many changes in the engraved plate itself. For example, "Theft" now has flamelike hair, and "Murder," on the right, wears a laurel wreath on his head. Flames have been added at the feet of the three figures, and they extend up both sides of the image. Although one might suspect that these flame forms could have been covered by the coloring in the earlier version, the color layer is translucent enough to show that in fact they did not exist when the plate was in that state. This third state impression, the final version of the image, like the earlier two states, is also quite rare, with only six examples recorded.

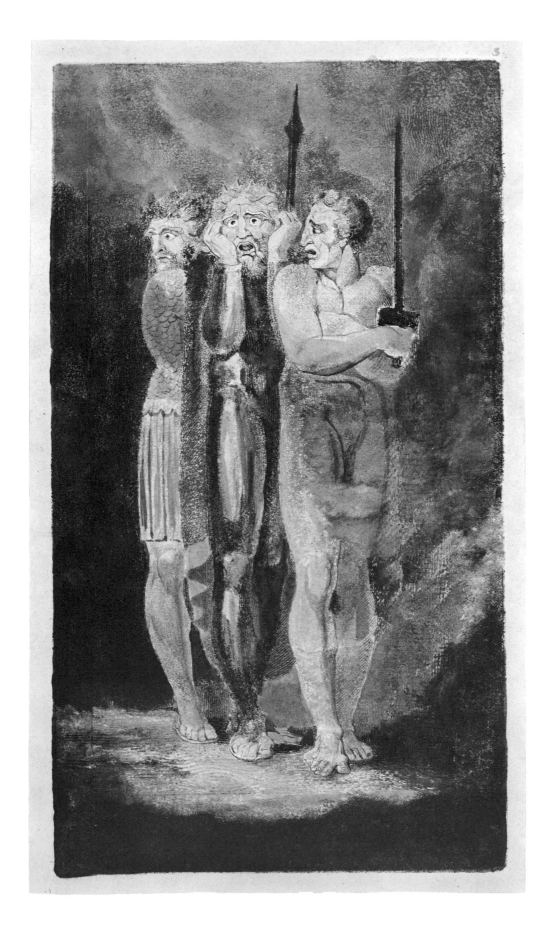

97

War or *The Accusers of Theft, Adultery, Murder,* c. 1805-1810 in this state

Engraving, printed intaglio in black
21.8 x 12 (8⁹⁄₁₆ x 4¹¹⁄₁₆)
Keynes *Separate Plates* VII 3/3; Bentley *Blake Books*, copy F (incorrectly given to the Library of Congress); Essick *Separate Plates* (forthcoming) VIII 3/3, copy G
PROVENANCE: G.A. Smith (Christie's 1 April 1880, no. 168); W. Muir?; B.B. MacGeorge (Sotheby's, 1 July 1924, no. 133); Maggs Bros., cat. 456, no. 53 (1924); George C. Smith Jr. (Parke-Bernet, 2 November 1938, no. 42); purchased from The Rosenbach Company, 1938; presented to NGA, 1943
B-11,037

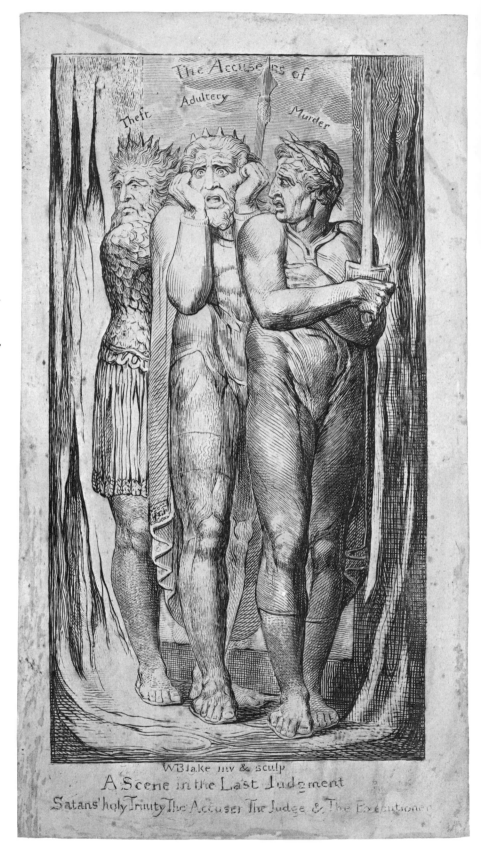

PAUL GAUGUIN
French, 1848-1903

98
The Universe is Created, c. 1894

Woodcut, printed by Gauguin in tan, reddish brown, red, and black
20.5 x 35.6 (8¹⁄₁₆ x 14)
Guérin *Gauguin* 26, trial proof
PROVENANCE: Purchased from Richard H. Zinser, 1947; presented to NGA, 1947
B-14,396

99
The Universe is Created, c. 1894

Woodcut, printed by Louis Roy in reddish brown, red, and black
20.5 x 35.7 (8¹⁄₁₆ x 14⅛)
Guérin *Gauguin* 26
PROVENANCE: A. Vollard; Maurice Alquier; purchased from Henri Petiet, 1950; presented to NGA, 1950
B-17,499

100
The Universe is Created, c. 1894

Woodcut, printed by Pola Gauguin in black
20.4 x 35.3 (8 x 14)
Inscribed by the printer lower left in pencil: *Paul Gauguin fecit* and lower right: *Pola Gauguin imp* and numbered upper left: *no 55*
Guérin *Gauguin* 93
PROVENANCE: Purchase not traced; presented to NGA, 1943
B-4349

The Universe is Created is one of a group of woodcuts celebrating the exotic world Gauguin discovered during his first voyage to Tahiti, and these three very different impressions afford the opportunity to explore another aspect of print connoisseurship—the role of the printer as an active collaborator in the development of the image. Gauguin's own trial proof (cat. no. 98) shows the artist's efforts at making the printing process itself alter the rather sparsely carved image. The use of loosely defined color areas and the variation in printing pressure applied to different parts of the woodblock both help to facilitate the unrefined and tentative effects which contribute markedly to the image's mystery and power.

The second impression (cat. no. 99), printed professionally by Louis Roy, is better by conventional standards of printing—the ink is consistently applied—but harsh and antithetical to Gauguin's own attempts. The Roy impressions did not, therefore, please the artist and a number of the sheets are now found having been reused for other images on their versos.

The last impression (cat. no. 100) is a more recent one, printed by Gauguin's son Pola in an edition of one hundred in 1921. The soft Oriental paper of this print is more sympathetic to the nuances of the wood than the hard sheets used for the other two impressions and it allows all of the details to sing out. No attempt was made to simulate Gauguin's color ideas; rather, a light gray has replaced Roy's red-brown, and, like the paper, it emphasizes the delicate work on the black block. The detached red shape of the Roy impression has been eliminated entirely. What becomes apparent is that the art of printmaking, when engaged in collaboratively, is as dependent upon a printer keen and sympathetic to the concepts of the image as it is upon the artist.

These three impressions are among almost fifty Gauguin woodcuts in the collection, including a number of unusual proofs and multiple examples of a subject as seen here. Rosenwald also purchased the recto/verso woodblock for *Mahana Atua* (Guérin *Gauguin* 75 and 76) and the *Title for Sourire* (Guérin *Gauguin* 43). So, too, ten lithographs, a single etching, six monotypes including *Arearea no Varua Ino* (fig. 98-100a), and one drawing, *Nave Nave Fenua* (Robison, *Drawings*, 105). The first Gauguin acquisitions were from Jean Goriany and Richard H. Zinser in 1940, including one of the monotypes. The greater part of the material, however, was bought in the early 1950s, principally from Henri Petiet and Gérald Cramer.

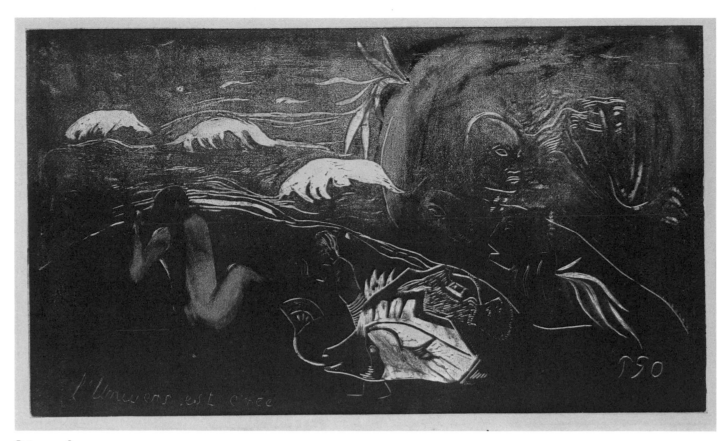

Cat. no. 98

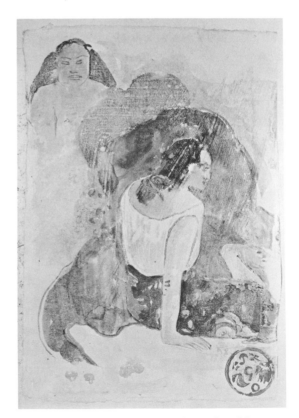

Fig. 98-100a. *Arearea no Varua Ino*, 1894. Monotype.
B-11,145.

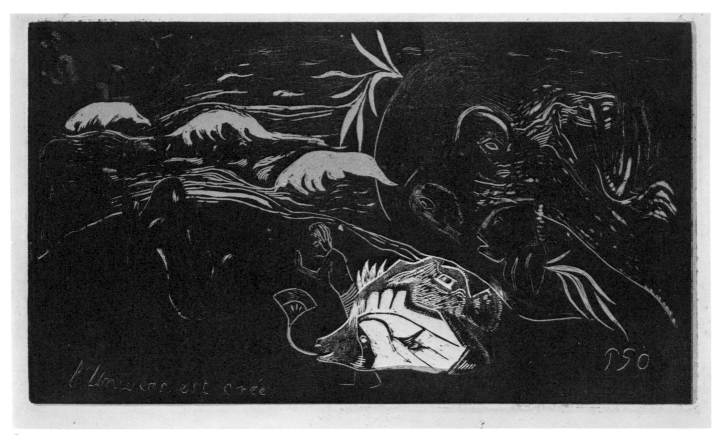

Cat. no. 99

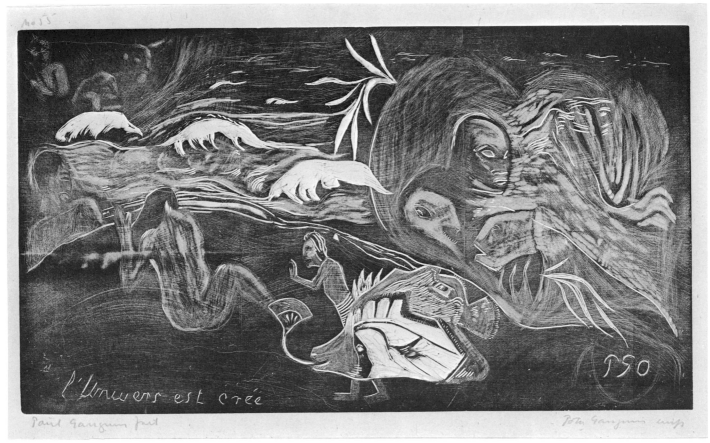

Cat. no. 100

Rosenwald Collection Bibliography

The Lessing J. Rosenwald Collection: A Catalog of the Gifts of Lessing J. Rosenwald to the Library of Congress, 1943 to 1975 (Washington, D.C., 1977) includes an annotated bibliography (461-469) "Works about or Derived from the Rosenwald Rare Book Collection," a section of which is subtitled "The Collector and His Collection." Much of this is pertinent to the Rosenwald print collection as well. An addition, focusing on the print collection, is Katharine Kuh's article, "The Rosenwald Collection: America's Greatest Gallery of Prints," published in the *Saturday Review*, 23 September 1961 (33-44).

Print exhibitions are more readily circulated than book exhibitions, and the Rosenwald print collection was the source of many more exhibitions than the rare book collection. These exhibitions were the subject of countless brief notices in various journals beginning in 1929. The checklists accompanying the exhibitions often were of an ephemeral nature, and one suspects that many have disappeared. The listing that follows includes catalogues and checklists of exhibitions drawn solely from the Rosenwald Collection or designated as coming chiefly from the collection, and it is based on the Alverthorpe files alone. It is important to note, however, that most of the Rosenwald Collection exhibitions were not accompanied by any kind of printed record. The list, therefore, gives no indication of the number of exhibitions sent out over the years, but rather an indication of their scope. It is arranged chronologically by year, alphabetically within each year.

1929 *Line Engravings by Robert Nanteuil, 1623-1678 (Petitjean Collection) Lent by Lessing J. Rosenwald, Esq.* The Free Library of Philadelphia, 1929.

A Special Exhibition of Engravings by Albrecht Dürer from the Collection of Lessing J. Rosenwald of Philadelphia. Baltimore Museum of Art, 1-30 November 1929.

A Special Exhibition of Etchings by Rembrandt from the Collection of Lessing J. Rosenwald of Philadelphia. Baltimore Museum of Art, December 1929.

1930 *Catalogue of Rembrandt Etchings Lent by Mr. Lessing J. Rosenwald of Philadelphia.* Morse Hall Galleries, Cornell University, 8-31 May 1930.

Etchings by Martin Schongauer from the Lessing Rosenwald Collection. The Art Alliance, Philadelphia, 7-31 March 1930.

Illustrated Books and Original Drawings of William Blake / Drawings, Etchings, Lithographs by Muirhead Bone, Loaned by Lessing J. Rosenwald. The Print Club of Philadelphia, 17 February-1 March 1930.

Lithographs and Drawings by Honoré Daumier, 1808-1879, Lent by Lessing J. Rosenwald, Esq. The Free Library of Philadelphia, 1930.

Prints and Drawings by Rembrandt van Rijn from the Collections of Lessing J. Rosenwald (introduction by Boise Penrose). Pennsylvania Museum of Art, December 1930.

Rembrandt Etchings Lent by Mr. Lessing J. Rosenwald (introduction by Lessing J. Rosenwald). The Art Alliance, Philadelphia, 7-30 October 1930.

1931 *Etchings, Lithographs, Original Drawings and Autograph Letters by James A. McNeill Whistler, 1834-1903, Lent by Lessing J. Rosenwald, Esq.* The Free Library of Philadelphia, 1931.

Five Centuries of Print Making from the Collection of Lessing J. Rosenwald. The Print Club of Philadelphia, 1931.

The Little Masters: Loan Exhibition from the Collection of Lessing J. Rosenwald. The Print Club of Philadelphia, 20 March-18 April 1931.

1932 *Etchings by Rembrandt van Rijn, 1606-1669, from the Collections of Lessing J. Rosenwald and Other Works of Art.* Sears, Roebuck and Co. Art Galleries, Washington, D.C., 5-31 May 1932.

Forain: The Collection of Lessing J. Rosenwald (checklist by Elizabeth T. Pearson). Pennsylvania Museum of Art, 8 October-7 November 1932.

Prints from the Collection of Lessing J. Rosenwald, Philadelphia (compiled by H. M. Dunbar). The Lakeside Press Galleries, Chicago, January-March 1932.

1933 *An Exhibition of Prints from the Collection of Lessing J. Rosenwald.* Department of Fine Arts, Carnegie Institute, 6 April-21 May 1933.

Twentieth Century Prints by American, British and European Artists through the Courtesy of Lessing Rosenwald, Esq. of Philadelphia (exhibited with displays of Finnish

255

Art Craft and Ryijy Rugs). Sears, Roebuck and Co. Art Galleries, Washington, D.C., 6-30 April 1933.

1935 *Fine Impressions of Well Known Prints from the Collection of Lessing J. Rosenwald* (foreword by Lessing J. Rosenwald). Howard University Gallery of Art, 1-23 March 1935. A College Art Association Exhibition.

1936 *A Descriptive Hand-List of a Loan Exhibition of Books and Works of Art by William Blake, 1757-1827, Chiefly from the Collection of Mr. Lessing J. Rosenwald* (introduction by Mrs. George M. Millard). The Little Museum of La Miniatura, Pasadena, 16-28 March 1936.

 Exhibition of Jean-Louis Forain Lent by Lessing J. Rosenwald. Honolulu Academy of Arts, January 1936.

 Ninety-seven Etchings, Engravings and Drypoints by Albrecht Dürer from the Collection of Mr. Lessing J. Rosenwald. A College Art Association Exhibition.

 Texas Centennial Exposition: Exhibition of Paintings, Sculpture and Graphic Arts, "Old Master Prints from the Collection of Lessing J. Rosenwald, Philadelphia" (102-103). Dallas Museum of Fine Arts, 6 June-29 November 1936.

1936-1937 *Etchings and Lithographs by James Abbott McNeill Whistler from the Collection of Lessing J. Rosenwald* (foreword by J. LeRoy Davidson). A College Art Association Exhibition.

1945 *Catalogue of a Loan Exhibition of Prints from the Lessing J. Rosenwald Collection in the National Gallery of Art, Washington.* John Herron Art Museum, Indianapolis, 11 February-18 March 1945.

1952 *Opening Exhibition of The George Thomas Hunter Gallery of Art,* "Prints from the Lessing J. Rosenwald Collection, the National Gallery of Art, Washington, D.C." (exhibited with a variety of old master paintings, many also borrowed from the National Gallery of Art), Chattanooga Art Association, 12 July-3 August 1952.

1960 *Graphic Masterpieces of 500 Years from the National Gallery of Art, Rosenwald Collection* (introduction by Elizabeth Mongan). Louisiana State University, January-February 1960.

1961 *Blake* (from the Rosenwald Collections of the National Gallery of Art and the Library of Congress and Lessing J. Rosenwald's private collection; introduction by Elizabeth Mongan). Art Gallery, State University of Iowa, 17 November-8 December 1961.

1961-1962 *The Graphic Art of Edvard Munch: 40 Prints from the Rosenwald Collection.* A Smithsonian Institution Traveling Exhibition Service exhibition.

 A Picasso Retrospective in Prints from the National Gallery of Art, Rosenwald Collection. An American Federation of Arts circulating exhibition.

 Rembrandt's Etchings (loaned by the National Gallery, Rosenwald Collection, and Lessing J. Rosenwald). University Gallery, University of Minnesota, 12 November 1961-7 January 1962.

1963 *Georges Rouault: Printmaker*, through the courtesy of the National Gallery of Art, Rosenwald Collection, and the Library of Congress, Rosenwald Collection. University Gallery, University of Minnesota, 7 January-3 March 1963.

Prints by Post-Impressionists from the National Gallery of Art, Rosenwald Collection. An American Federation of Arts circulating exhibition.

1963-1965 *Where Every Prospect Pleases: Landscape Prints from the National Gallery of Art's Lessing J. Rosenwald Collection.* An American Federation of Arts circulating exhibition.

1964-1966 *Old Master Prints from the National Gallery of Art Rosenwald Collection.* A Smithsonian Institution Traveling Exhibition Service exhibition.

1965 *Drolleries and Demons: Six Centuries of 'Fantastic' Prints / Selections from the National Gallery of Art, Rosenwald Collection.* IBM Gallery, New York, 30 August-24 September 1965.

Master Prints from the Rosenwald Collection: An Exhibition Selected by Lessing J. Rosenwald (introduction by Lessing J. Rosenwald), Virginia Museum of Fine Arts, 5 February-21 March 1965.

Selected 15th Century Prints from the Lessing J. Rosenwald Collection, National Gallery of Art (notes by Richard S. Field). The Pennsylvania State University College of Arts and Architecture, April 1965.

1966 *Jean-Louis Forain, 1852-1931* (principally from the National Gallery of Art, Rosenwald Collection). Ackland Art Center, University of North Carolina at Chapel Hill, 11-30 January 1966.

Masters of Etching and Engraving from the Lessing J. Rosenwald Collection (introduction by Alan Shestack). Lakeview Center for the Arts and Sciences, Peoria, Illinois, 21 September-30 October 1966.

1967 *Master Prints on Biblical Themes: An Exhibition of Prints from the Rosenwald Collection, National Gallery of Art, Washington, D.C.* Moellering Memorial Library, Valparaiso University, 4 October-7 November 1967.

1968 *Fifteenth Century German Woodcuts: National Gallery of Art, Rosenwald Collection* (introduction by Mark Lansburgh). The Colorado College, 1968.

1969 *Fifteenth Century German Engravings: National Gallery of Art, Rosenwald Collection* (introduction by Mark Lansburgh). The Colorado College, 1969.

1969-1971 *Rosenwald Collection: Prints by James Abbott McNeill Whistler.* The Virginia Museum of Fine Arts, Artmobile Program of circulating exhibitions.

1970 *National Gallery of Art, Rosenwald Collection: Historical Survey of Printmaking.* Charleston Art Gallery, Charleston, West Virginia, 13 September-4 October 1970.

Toulouse-Lautrec: An Exhibition of Original Lithographs from the Lessing J. Rosenwald Collection of the National Gallery of Art. Southeast Arkansas Arts and Science Center, Pine Bluff, Arkansas, 7 January-13 February 1970.

1971 *Fifteenth and Sixteenth Century Prints from the Rosenwald Collection, National Gallery of Art, Washington, D.C.* (various student authors). Mary Washington College of the University of Virginia, Fredericksburg, 8 February-15 March 1971.

 An Impressionist View on Paper from the Lessing Rosenwald Collection of the National Gallery, Washington, D.C. Art Gallery, University of Notre Dame, 7 October-12 December 1971.

 A Selection of 15th and 16th Century Book Prints from the National Gallery of Art Rosenwald Collection. New Jersey State Museum, 30 April-5 July 1971.

 A Selection of X-XV Century Medieval Miniatures from the National Gallery of Art, Rosenwald Collection (with statements by Kenneth W. Prescott, Lessing J. Rosenwald, and Fred Cain). New Jersey State Museum, 9 January-14 February 1971.

1971-1972 *Master Prints from the Rosenwald Collection of the National Gallery of Art* (introduction by Dennis Adrian). Circulated by the Illinois Arts Council.

 A Selection of 17th Century Intaglio Prints from the National Gallery of Art, Rosenwald Collection. New Jersey State Museum, 20 November 1971-9 January 1972.

1972 *Lithography in the 19th Century: Selections from the National Gallery of Art, Rosenwald Collection.* New Jersey State Museum, 28 October 1972-1 January 1973.

 Mediaeval Manuscripts from the Lessing J. Rosenwald Collection (various student authors). Art Gallery, University of Notre Dame, 1 October-19 November 1972.

1973 *Fifteenth and Sixteenth Century Prints of Northern Europe from the National Gallery of Art Rosenwald Collection* (introduction and notes by Ruth H. Schlesinger). Herbert F. Johnson Museum of Art, Cornell University, 23 May-1 July 1973.

1976 *Old Testament—New Testament: A Selection of Prints from the Lessing J. Rosenwald Collection.* Newcomb College, Tulane University, 14-29 October 1976.

1981 Ruth E. Fine, "Jenkintown to Washington: Moving the Lessing J. Rosenwald Collections," *American Book Collector*, n.s. 2 (September-October 1981): 45-52.

CATALOGUES ISSUED BY THE NATIONAL GALLERY OF ART SOLELY OR CHIEFLY COMPRISING ROSENWALD COLLECTION MATERIAL:

Selections from the Rosenwald Collection, National Gallery of Art (compiled by Elizabeth Mongan with a foreword by Lessing J. Rosenwald). Washington, D.C., 1943.

Rosenwald Collection: An Exhibition of Recent Acquisitions (compiled by Elizabeth Mongan with a foreword by Lessing J. Rosenwald). Washington, D.C., 1950.

Fifteenth Century Woodcuts and Metalcuts from the National Gallery of Art, Washington, D.C. (compiled by Richard S. Field). Washington, D.C., 1965.

Fifteenth Century Engravings of Northern Europe from the National Gallery of Art, Washington, D.C. (compiled by Alan Shestack). Washington, D.C., 1967.

Rare Etchings by Giovanni Battista and Giovanni Domenico Tiepolo (compiled by H. Diane Russell), Washington, D.C., 1972.

Early Italian Engravings from the National Gallery of Art (compiled by Jay A. Levenson, Konrad Oberhuber, and Jacquelyn L. Sheehan). Washington, D.C., 1973.

Medieval & Renaissance Miniatures from the National Gallery of Art (edited by Gary Vikan), Washington, D.C., 1975.

List of Works Illustrated

261

Index

*T*his index includes the following: artists; dealers; collectors, collections, and important sales; authors, printers, publishers, and print workshops; academics, critics, and museum professionals; institutions and professional organizations; and the Rosenwald family. Lessing J. Rosenwald, Alverthorpe Gallery, and the National Gallery of Art, mentioned on almost every page, have been omitted.

A

M

MacGeorge, B. B., 80, 82, 250
MacLeish, Archibald, 31
Maggs Bros., 80, 250
Maillol, Aristide, 33, 198
Mair, Nicolaus Alexander (von Landshut), 60, 109-110, 112
Maltzan, S., 60
Manet, Edouard, 204, 232, 233
Mansfield, Howard, 96
Mantegna, Andrea, 28, 31, 119-120
Mantegna School, 26, 28, 119-121
Marc, Franz, 208
Marcks, Gerhard, 206, 208
Mariette Collection, 66
Martin, Mrs. George A., 232
Masson, Antoine, 126
Master of the Amsterdam Cabinet, see: Master of the Housebook
Master of the Bandaroles, 110
Master of the Cypresses (Pedro da Toledo?), 138
Master E. S., 56, 60-63, 109, 120, 146
Master E. S., follower of, 62
Master of the E Series Tarocchi, 119
Master of 1544, 142, 154
Master of the Housebook, 28
Master I·I·C·A, 119
Master LCz (Lorenz Katzheimer), 109-111
Master of the Miracles of Mariazell, 150
Master of the S Series Tarocchi, 119
Matisse, Henri, 194, 196, 201-203
Matisse, Pierre, 201
McBey, James, 25, 30, 35, 36, 37, 88, 90, 108
McKinney, Roland, 43
McVitty, Alfred E., 238
Meckenem, Israhel van, 26, 27, 28, 110, 141
Meek, F. U., 72
Mellan, Claude, 126
Mensing, A. W. M., 52
Menzel, Adolph, 29
Meryon, Charles, 25, 26, 30, 44, 66, 81-85, 104, 105
The Metropolitan Museum of Art, 30, 146, 194
Metsu, Gabriel, 176
Meyer-Hildburghausen Collection, 60
Mickelson's Gallery, 211
Millet, Jean-François, 188
Miró, Joan, 198, 208
Model, Julius, 26, 27, 134
Mongan, Elizabeth, 29, 31, 32, 38, 39, 40, 46, 141, 142, 164, 208
Monnier, Henri, 27
Montagna, Benedetto, 26, 119
Montherlant, Henry de, 198
Morandi, Giorgio, 194
Morrison, Alfred, 227
Morse, Mrs. Sydney, 76
Moss, W. E., 76
Motherwell, Robert, 216
Mucha, Alphonse, 196
Muir, W., 250

Müller, Otto, 33, 204
Munch, Edvard, 30, 204, 208
Museum of Science and Industry, 20

N

Nanteuil, Robert, 28, 30, 31, 42, 44, 125-127
Newcomb College, 45
Newton, A. Edward, 78
Newton, Sir Isaac, 174
Nicolò da Bologna, 138
Niel, J., 82
Nolde, Emil, 30, 204, 206, 208-209
Nowell-Usticke, Gordon W., 33, 72

O

Oil Shale Corporation, see: TOSCO
Order of the Crown of Belgium, 21
Orozco, José Clemente, 30
Ostade, Adriaen van, 124

P

Palma, Jacopo (il Giovane), 142
Palmer, A. H., 128, 130
Palmer, Samuel, 128-130, 232
Palser Collection, 76
Panofsky, Erwin, 46-47
Parke-Bernet, 32, 33, 64, 78, 80, 82, 95, 98, 146, 201, 224, 232, 236, 238, 250
Parmigianino (Francesco Mazzola), 113
Pasquali, Jo. Baptistam, 114
von Passavant-Gontard sale, 26-27, 52, 116, 152, 158, 159, 171, 177
Pechstein, Max, 204
Pedro da Toledo, see: Master of the Cypresses
Pencz, George, 116
Pennell, Joseph, 25, 30, 46, 99-100
Pennsylvania Museum of Art, see: Philadelphia Museum of Art
Peregrino da Cesena, 118
Petiet, Henri, 33, 38, 82, 106, 134, 180, 192, 196, 199, 232, 238, 251
Petitjean, Charles, 28, 125-126
Philadelphia Art Alliance, 70, 212
Philadelphia Award, 21
Philadelphia College of Art, 168, 218
Philadelphia Free Library, see: Free Library of Philadelphia
Philadelphia Labor Mediation Tribunal, 21
Philadelphia Museum of Art (and Pennsylvania Museum of Art), 19, 31, 42, 43, 45, 46, 70, 72, 106, 125, 128, 243
Philadelphia Orchestra Association, 19
Philadelphia Print Club, 19, 25, 34, 44, 64, 119-120, 213

Z